GLOUCESTER MASSACHUSETTS

THE LITTLE BOOK OF
BIG
PACKAGING IDEAS

by catharine fishel + stacey king gordon

ROCKPORT PUBLISHERS

First published in the United States of America by
Rockport Publishers, Inc., a member of
Quayside Publishing Group
33 Commercial Street
Gloucester, Massachusetts 01930-5089
Telephone: (978) 282-9590
Fax: (978) 283-2742
www.rockpub.com

Library of Congress Cataloging-in-Publication data available

ISBN-13: 978-1-59253-353-4
ISBN-10: 1-59253-353-1

10 9 8 7 6 5 4 3 2 1

Cover Design: Dania Davey
Layout: *tabula rasa* graphic design
 Platinum Design
 Art & Anthropology

Grateful acknowledgment is given to Catharine Fishel for her work from *Design Secrets: Packaging* on pages 8-157; and her work from *The Perfect Package* on pages 158-235; and Stacey King Gordon for her work from *Packaging Makeovers* on pages 238-347.

Printed in China

contents

PART I DESIGNING PACKAGES

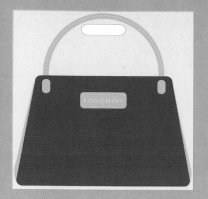
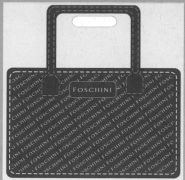
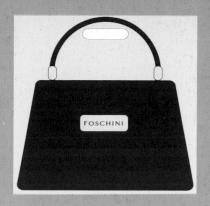

PART II REDESIGNING PACKAGES

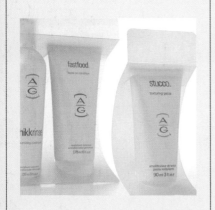

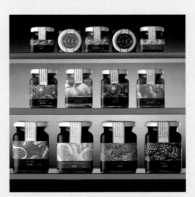

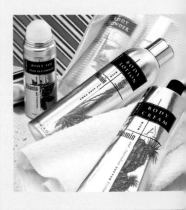

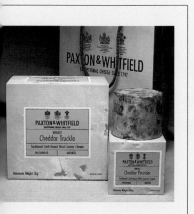

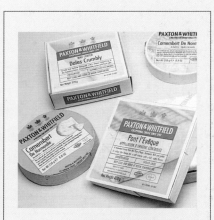

PART I

Chase Design Group has been working for Kama Sutra—not surprisingly, a purveyor of sex products—for eight years; although the company has been in existence since 1965.

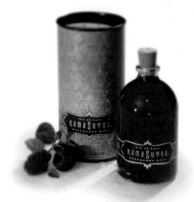

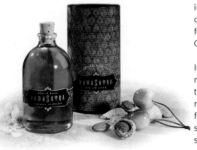

"Registering the Kama Sutra name internationally was the smartest thing he ever did," says agency executive creative director Margo Chase of her client, Joe Bolstad. "As a result, there are no other competitors in the market with that name. He has competitors in the sex aid market, but none have been able to cross over into the mainstream gift market as successfully."

A great deal of that success is attributable to Chase and her designers, who have taken the products—through gorgeous packaging designs—from items that might be bought furtively at sex or head shops to a line of products that are beautiful enough to sell in all levels of gift and specialty stores. Even more significantly, they look artful enough to leave out on the counter or bedside table at home.

The client had two sets of packaging designs before the work Chase Design Group created. The original packaging was created in 1965. It used brown ribbed paper with a circular logo. These designs were rather dingy looking, but the line also contained a few special packages that used Indian-style illustrations, which Chase thought had potential.

In the 1980s the entire line of packaging was redesigned. All the new containers were matte black with red type and gray stone texture. Chase describes the look as "not very sexy." Part of the redesigned suite included some phallic-looking bottles that—unfortunately—leaked. The client was not happy with the new look, so he let some of the original designs stay on the market. The result was a disjointed brand image.

Chase Design Group was inspired by the challenge to tie together, through packaging design, an almost 40-year-old brand of sex aid products. The new packaging for Kama Sutra was so lush and beautiful that it successfully maneuvered its way into more mainstream retail venues. Previously, it was only sold in sex and head shops.

To make the next step in expanding his line into larger gift and department stores, the client needed packaging that was more palatable to mainstream consumers. Originally, Chase recalls, Bolstad wanted to simply go back to and update the original brown packaging. Chase didn't want to abandon the core of this idea, but felt that bringing in Indian art and more color would give his products more appeal and visual diversity.

This was the genesis of the green ribbed paper that is used throughout Chase's redesign. "The paper is actually just the brown shipping paper they use in Europe. We scanned it and shifted the color to create a rich, jewel-toned green," she explains. On top of the green, the designers added a gold metallic leaf overprint together with a new brand identity. It was important to maintain some elements from the original design, Chase adds, so that long-time customers wouldn't feel as if they had been abandoned.

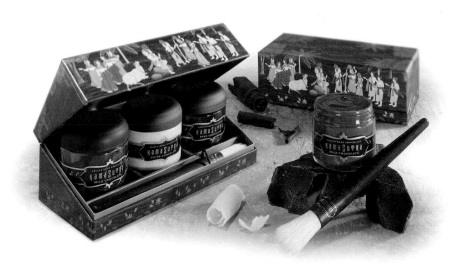

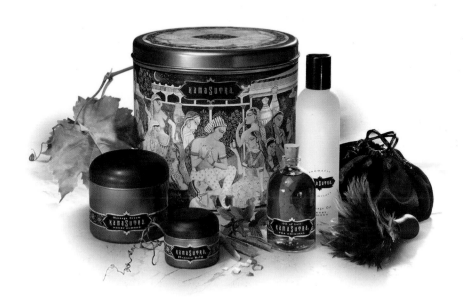

The team also explored Indian artwork, frescos, and textiles for inspiration. From these sources, rich, detailed artwork was developed for use on canisters and bottle bellybands. Two different looks were built from the green paper and floral illustrations: The core product line—which includes Oil of Love, Pleasure Balm, and Honey Dust—is wrapped in the green ribbed paper. Each flavor has a different bellyband design to distinguish it and tie it into the second look, which was used on the gift product line. This line is decorated with similarly colored illustrations based on the art of the original Kama Sutra.

"We felt that color was an important aspect that was missing in the old packaging. The Oil of Love is manufactured in various beautiful colors, but they were hidden inside brown or black tubes, which are necessary to keep the glass bottles from breaking. We decided to bring the color to the outside of the containers," Chase says. She notes that the consistent green paper theme gave the client a single, ownable color on store shelves and helped him carve out an identifiable space. "But we wanted to break that up with floral patterns and illustrations to keep everything interesting, inviting, and friendly."

The art served another, more subliminal purpose. Many people are uncomfortable buying sex products. "We hope that the beautiful art would help people feel like they were buying a gift or a piece of art rather than a sex aid. That's one big reason for Kama Sutra's success: It still does a huge amount of business in sex shops because its products are the only ones that look tasteful, and he has been able to break into the mainstream gift market for the same reason," Chase says.

Today, the Kama Sutra product line is found in high-end gift stores all over the world, as well as at mainstream retailers. Its business has grown dramatically every year since Chase Design Group began its work; in 2002 alone, sales doubled.

Chase doesn't claim that the new packaging is the only reason for such impressive improvement, but both she and the client like to think it has had a huge impact. She also credits client Joe Bolstad—the only client she has ever had who graduated from Art Center with a degree in design—with being incredibly receptive to their ideas.

"We often make comps in several versions. He takes them away and sits with them until he's sure which one is right. He'll have thought everything through and offer great input, often making the designs even better than they were," she says.

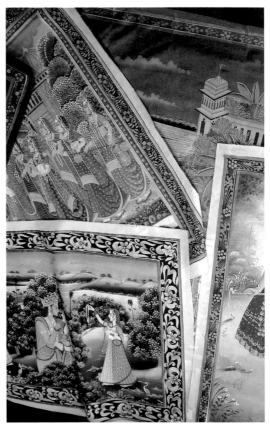

Rich fabrics from India were one of the visual resources that Margo Chase and her designers studied for guidance on color and illustration.

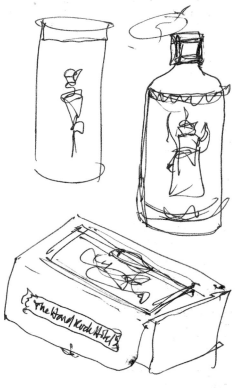

P.O.P. — booklet container
— more substantial —
holds booklets
or collection oils as tester

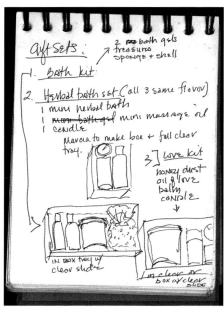

updated

3½-5
testers
collection
size

w/ dropper tops
for testing

add
demonstration
instructing

Gift sets:

2 bath gels
treasures
sponge + shell

1. Bath kit

2. Herbal bath set (all 3 same flavor)
1 mini herbal bath
1 mini massage oil
1 candle
Marcia to make box + full clear
tray.

3] Love kit
honey dust
oil + love
balm
candle

In box tray w/
clear slide

In clear or
box or clear
slide

A range of sketches completed during early discussions with the client.

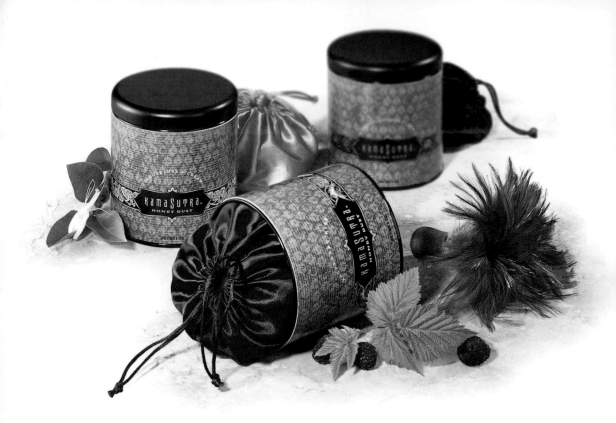

Kama Sutra's original packaging was wrapped in brown ribbed paper, and the client had expressed a desire to return to that look, following an unsuccessful redesign attempt by another design firm in the 1980s and years of a disjointed identity. Chase delivered his wish, with a lovely twist: She used a ribbed paper (actually, a brown shipping paper commonly used in Europe), electronically gave it a rich green color, and added a leaf pattern colored with gold leaf on top. An illustrated bellyband added color. This core design was one of two looks the designers created for their client.

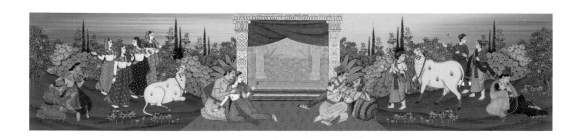

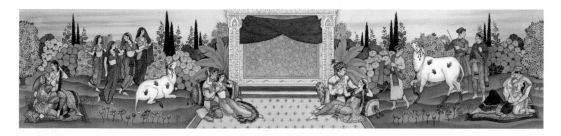

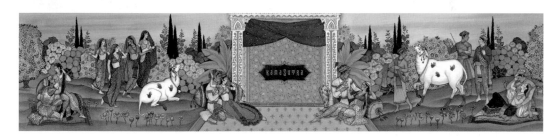

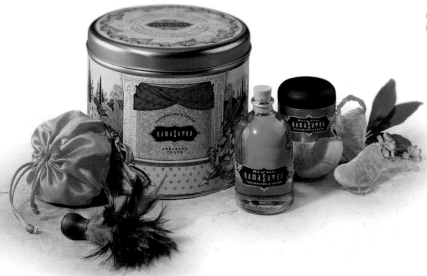

The second look created for the client is shown in the tins the designers created for the Kama Sutra gift product line. These carried more illustration and color. Shown here is the preliminary comp for the Tangerine Gift Tin; the approved art; the final wrap; and finally, photography of the finished product. The inspiration gained from studying Indian artwork, frescos, and textiles is evident.

A brand with **the good bones of heritage** can be a wonderful project for a designer. But a brand with good bones whose owners have a **vision for the future** is even better. Such was the case with **Adnams Brewery** of Southwold in the East Anglia region of England.

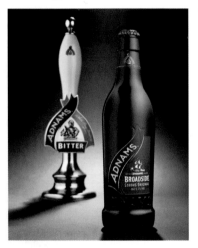

Design Bridge of London re-created the identity and packaging for Adnams, a brewery in the East Anglia region of England, founded in 1872. Both the labeling and the bottle shape were reworked.

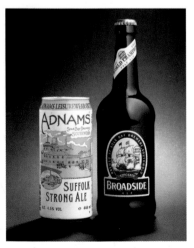

The company's identity had not been touched in more than 20 years, and each product in the line had a different look.

The company has been in business since 1872 and is among the last of the independent, locally owned breweries left in the country. At one time, hundreds of establishments brewed their own beers and served the beverages in their own pubs. But today, large corporations have swept through the market and have eliminated nearly all these historic companies. Adnams is one of the few strong, independent, regional brands left and is determined to stay that way.

The company's identity had remained essentially untouched for 20 years. Although the company's chair is a progressive thinker who wanted the company to do something different from any other regional brewer, Design Bridge, the London-based company brought on board to handle the ID and packaging redesign, knew that any redesign would have to be done with great care.

"This redesign was a big move for the company," says Jill Marshall, executive chairman for branding and packaging at Design Bridge. "The brewer is rooted in Southwold, a historic and charming part of the English countryside and coastline. It was important for them to feel whomever they entrusted with handling this untouched brand would treat it with a great deal of respect."

One thing to avoid, Marshall says, was making a patent play on the brewer's history to create an old-world feel. "We had to respect the actual history," Marshall says, "not treat it like it was some sort of bogus version of history."

Adnams' competition could be characterized in one of two ways: those that used the old-world approach (many are as old or older than Adnams) or those that remained completely static. Creative director for the redesign project Graham Shearsby compares the appearance of these identities to the metal badges from old steam engines—cold, unemotional, inflexible. Design Bridge felt that something with more life and movement—something with a more sculptural quality—would be more fitting in Adnams' packaging and mark.

After extensive conversations with the client on what it needed (Adnams includes 90-odd pubs, three hotels, and a wine business, as well as a full suite of beers), Shearsby visited Southwold to get a better feeling for the place. The visit turned out to be a meaningful one.

"It's flat there, with big beaches and big skies. Fishermen bring their boats right up onto the shore. You can imagine the winds coming across the beaches in winter, when you would want to find yourself tucked up in a pub with a pint of beer," he says.

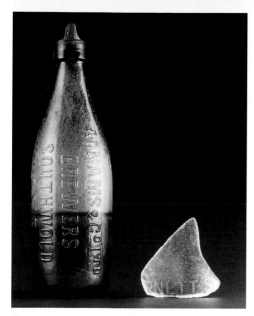

Two unique finds helped to drive the redesign of the new Adnams bottle: While visiting Southwold to get a better feeling for the place, Design Bridge creative director Graham Shearsby took a walk on the beach and found the fragment of thick glass shown here. The bottle was found in a wine cellar beneath the brewery. The appearance and heft of the items were combined in the new bottle shape.

In these sketches, the designers explored the relationship between the bottle shape and the label.

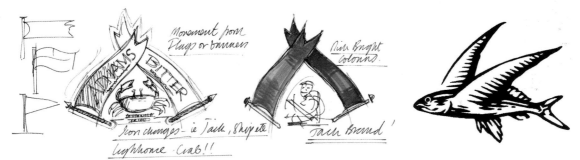

Initial sketches include visual references to flags and include icons that are representative of the area—a lighthouse, a crab, a ship, a flying fish.

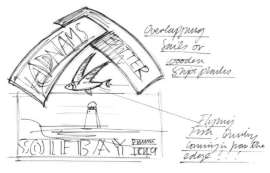

The overlapping sail design eventually won out. It had a three-dimensional feel that was adaptable for other uses.

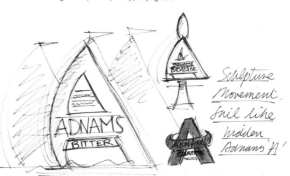

Here the sail idea moves into a more literal interpretation.

So the designers delved deep into the history of Southwold and came up with a series of icons and imagery from the area—a ship from a well-known battle right off the coast in 1692, a lighthouse, a longshoreman, and a 500-year-old carved wooden figure named Southwold Jack, who rings the bell at local St. Edmond's Church to announce services.

The latter was chosen as the symbol for the core brand and company identity; the others were used on individual beer products. The images were reproduced as linocut illustrations rendered by Chris Wormwell, an artist who knew and had a passion for the area.

The crossed flags were redrawn with more life and movement so they looked like ribbons, giving them an identifiable shape that would be recognizable on bottles, signage, pump clips, trucks, and more. Even better, the ribbons could be picked up alone and used elsewhere, such as on the company's wine bottles and collateral.

"This mark has movement and color, rather than being flat, dull, and dark. The imagery came from the notion of sails, and their curves suggest motion. When you walk into a pub and see the mark, it almost looks as if it is moving," the designer says.

For the packaging of individual products, Wormwell customized the ribbon with linocut-like illustrations, using the icons and imagery from the Southwold area created before.

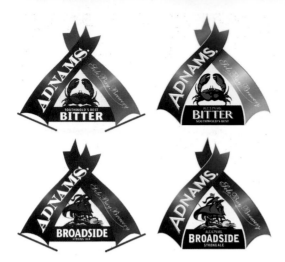

Here the label design has been refined; although the client asked that the crab be replaced with a more local image. The flag design was developed into the sail design.

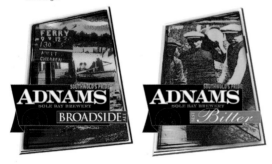

Another option that the designers explored was photography based.

On a walk on the beach, Shearsby found a thick fragment of old glass. "Inspiration for the entire project came from that piece of glass. It had a timeless feel, like when you pick up shells or pebbles on the beach. They are somehow imbued with memories of other times and places. They tell a story. We felt that we could use those qualities to inspire the redesign."

So the redesign of the core logo began. The old marks (each beer label had its own shape and illustration) had charm, but they also had the feel of a badge removed from an old engine. Shearsby's experiments centered on creating a single distinctive shape that could be used anywhere, from labels to buildings.

One of his first ideas was a pair of crossed flags, which came from the idea of using flags to send signals and was therefore closely linked to the town's maritime history. He chose a small crab, very much part of the company's coastal location, as a potential brand icon and positioned it between the flags. Although Adnams loved the idea of the flags, the company's representatives felt the crab was a step too far away from the brewery's heritage and asked Design Bridge to rethink the symbol.

The Design Bridge designers commissioned an entire alphabet, based on an old Adnams' font, for the new identity.

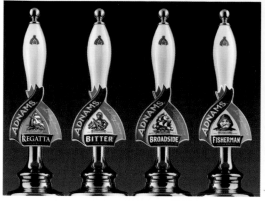

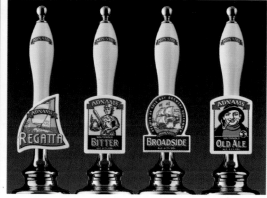

⊗ The new (above left) and old (above right) pump handles reveal how progressive the new identity is.

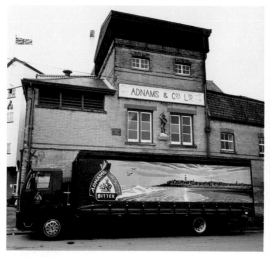

⊗ The contained, two-sail design is used on trucks, signage, pump clips, and other places where a defined shape is necessary.

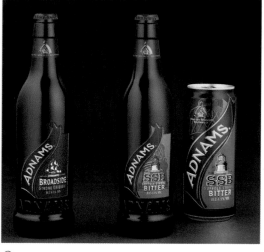

⊗ The one-sail design is used on cans and bottles, where the shape of the package is well defined. Just using one sail allowed the designers to make the name of the brand and the product larger.

Also part of the new packaging is a special Adnams' font, designed by freelancer Ken Wilson, especially for the company's new identity. The new type is based on the original Adnams' font, only crisper and more contemporary.

A new bottle was also created for the rejuvenated brand. Its shape was based on the strength and curve of an old beer bottle that the design team found while looking at old Burgundy wine bottles in a wine cellar beneath the Adnams' brewhouse.

Once the new core mark—the crossed flags—was designed, it had to be translated for use onto bottles and cans. The pump clips needed to be contained in their shape, but the designers had some freedom interpreting the mark for individual containers. So they decided to use only one flag for these applications, which allowed them to make the Adnams' name as large as possible and give the individual product names more prominence.

"It's almost as if you are taking a close-up, cropped view of the pump clip. It really emphasizes the movement and three-dimensional qualities of the identity," says Marshall.

The final packaging and logo work as well in a cozy country pub as they do in a smart city bar, says Shearsby, but the proof is in the business sense of the solution. Adnams reports that even with only limited advertising in the East Anglia region, sales have risen more than 30 percent. Sales of the Broadside beer alone have increased as much as 67 percent.

Shearsby is pleased with the outcome of the project for these and other reasons. "Together, Design Bridge and Adnams have challenged conventions and still captured the spirit of this unique area of England. These people love what they do—this isn't just some industrial project. This solution reflects their passion and involvement, as well as the human element of an independent company," he says.

What kind of packaging **appeals to consumers** for whom money is no object? Is it better to go **over the top** in terms of **opulence and quantity** of materials? Or is an **understated** approach more engaging? **Philip B** could go either way.

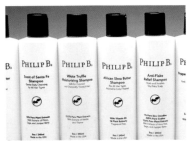

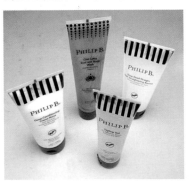

(◯) AdamsMorioka's bottle design for Philip B was understated to the extreme, but at $50-plus per bottle, it is sold to people who don't need to be sold to. The tube design took the concept to the next level: The clear containers carried more elaborate patterning, still in black and white. The product color showed through, which added yet another dimension.

Designers at AdamsMorioka (Los Angeles) believed in the latter philosophy when they created an extremely minimal packaging system for Philip B, a high-end line of shampoo and other personal care products that can cost up to $65 per container.

"The people we are talking to don't need to be sold to: They are already in the mode of wanting an understated product for their bath," explains principal Sean Adams. He compares the Philip B experience to patronizing the most exclusive restaurant in LA. "It's a sushi place that is not advertised and doesn't even have a sign on the door. You just have to know about it."

When AdamsMorioka began working with the client, the product had been in existence for several years and was selling well, but in limited venues. The client, who had designed the original packaging himself, was frustrated by not being able to convince high-end retailers such as Barney's or Sak's to carry his lines.

Adams felt that the original packaging design might be a liability: It just didn't speak to consumers on the shelf, so the store's buyers would not place orders. Clearly, a revamp was needed.

The design team began by doing an audit of many different hair care and personal care systems, from pricey to discount levels.

"We found out that the cheaper the brand was, the more flashy it became, with silver and pink and fancy bottles. One thing we knew about Philip B was that it was an honest product. He really used organic ingredients: When the label said 'avocado' or 'peppermint,' those things really were in the product. It was important to communicate that authenticity in the package design," explains Adams. "When you try too hard, it just ends up looking cheap."

He felt that this quality could be conveyed through good typography, decent but simple materials, and a basic design. The designers went out of their way to select the most generic bottle form available. This also conveyed the idea that the spending went into the product and did not need disguising. Adams says that he is highly annoyed by bottles that are shaped like flying saucers or anything other than what they are supposed to be. They smack of people trying too hard to be hip and get attention.

The formal elements of the packaging, although minimal, were chosen carefully. The typefaces Mrs. Eaves was chosen as the basis for the Philip B word mark; Avenir is the primary font used for all applications. In both instances, these faces are warmer and more casual than other traditional fonts like Bembo or Futura, Adams explains.

The black-and-white color palette was a nod to the client's previous packaging, but it was also chosen for its strength. The client had also alluded early on in the project to the essential nature of Fornasetti plates and Aubrey Beardsley prints. "Although most of us think of black and white as being basic, how often does it get used in a final product?" Adam asks. "This combination stood off the shelf amid the sea of color and became proprietary." Another consideration in selecting black and white, although minor, was that the bottles look good in any bathroom, regardless of tile color or decor.

The iconic system was set up to delineate the products in a subtle way. The icons were designed not to be literal—as in showing a white truffle for the White Truffle shampoo—but were organized by inspiration and spirit. For example, when developing the Chai Latte Body Wash, the client had been inspired by Eastern thought. So a lotus leaf was used as the basis for its icon.

The bottle's cap is nothing out of the ordinary—just a functional stock item. Used on a white bottle, the cap is like the classic Chanel suit that stands the test of time, as other products are repeatedly recreating themselves in fashionable colors and typography.

Almost immediately after the new packaging was launched, the client sales leaped nearly 300 percent, due in large part to new distribution agreements with Barney's, Sak's, Fred Segal, and selected high-end beauty supply stores, as well as an hour-long segment on QVC. From this strong foothold, the client was able to develop and release new product lines: lotions, styling gels, body washes, and more, many of which would be packaged in tubes.

Carrying the black and white scheme through on the tubes would be important, Adams recalls. The typography and graphics were simple enough to translate well to the new package shape. And what initially looked like a production problem turned out to be a design opportunity that opened up the project in unexpected ways.

Tubes usually have some sort of graphics covering their sealed end that hide the portion of the tube that is not filled: Some air is necessarily left in the tube to allow for natural expansion of the product due to changes in temperature or atmospheric pressure. The designers felt that, in keeping with the product's philosophy of complete honesty, it would be better to leave the area completely clear. But the manufacturer prevailed.

The result was a compromise: a series of black and white stripes that partially obscured and partially revealed the end area. The stripes inspired additional designs for other products, including dots, Kanji characters, and a dot pattern inspired by a Thai textile.

"The patterns match the personality of the product," Adams explains. The Thai pattern was obviously designed for the Thai Tea Body Wash, the falling drops worked with the Chai Latte Body Wash, and the simple stripe was appropriate for a base product like the conditioner. Says Adams, "I can only explain that if you use the Body Wash, you'll understand why the drops slowly and quietly disappear."

Because the word mark would be the centerpiece of the package design, the designers spent a great deal of time experimenting with different personalities.

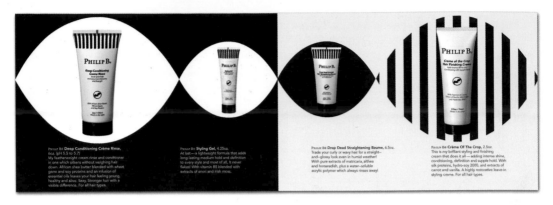

Philip B® Deep Conditioning Crème Rinse,
6oz. (pH 5.5 to 5.7)
My featherweight cream rinse and conditioner in one which silkens without weighing hair down. African shea butter blended with wheat germ and soy proteins and an infusion of essential oils leaves your hair feeling young, healthy and alive. Sexy. Stronger hair with a visible difference. For all hair types.

Philip B® Styling Gel, 4.25oz.
At last—a lightweight formula that adds long-lasting medium hold and definition to every style and most of all, it never flakes! With vitamin B5 blended with extracts of arari and Irish moss.

Philip B® Drop Dead Straightening Baume, 6.5oz.
Trade your curly or wavy hair for a straight-and-glossy look even in humid weather! With pure extracts of matricaria, althea and horseradish, plus a water-soluble acrylic polymer which always rinses away!

Philip B® Crème Of The Crop, 2.5oz.
This is my brilliant styling and finishing cream that does it all—adding intense shine, conditioning, definition and supple hold. With silk proteins, hydro-soy 2000, and extracts of carrot and vanilla. A highly restorative leave-in styling crème. For all hair types.

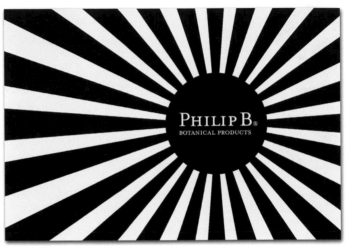

The simple bottle designs not only looked elegant but were also basic enough to be combined with other patterning and effects, some of which were quite exotic. Various marketing materials picked up on the patterning, some in dramatic ways.

Each package design was minimal from the start.

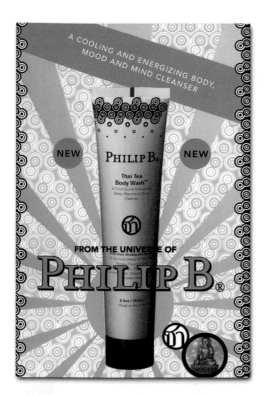

Where the design of the Philip B packaging is extremely simple, the materials that support sales of the products—ads, postcards, and other marketing materials—go in a completely different graphic direction. A postcard designed for a new body wash, for example, has everything in it but the kitchen sink, Adams says—lots of color, Asian cues, photos, different patterns, even the word "new" called out in small bursts. It is decidedly more forward.

"In the store, the products need to look consistent and clean," Adams says, "but in the home environment, the products need more sales support." The combination of simple and complex also reflects the client's personality: He is completely serious and committed to the integrity of the product, but he is also one of the most unique and exuberant people Adams knows. The client embraces the dichotomy of this situation and pushed the designers to explore it.

The whole system is essentially contradictory, Adams says. It is not an approach a designer could get away with for a Fortune 500 company product, but it has worked for Philip B, which had at this writing just opened its own store on très chic Robertson Boulevard in Los Angeles.

"When we first started working with the client, he was still working out of his living room, so to see his growth is really wonderful. He already had a really good product: We just made it possible for people to notice it," Adams says.

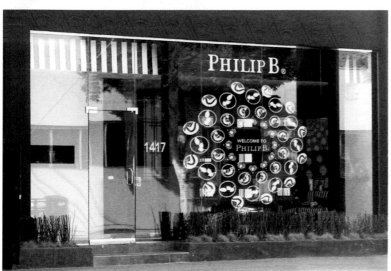

The various products carried many symbols that were representative of the personality of the package's contents. These symbols formed yet another design resource for the client. Here the designers used the symbols to form a mandala on the storefront window of the client's new store in Los Angles, California.

Blue—as a color and a distinguishing product characteristic— was important to the **Pepsi-Cola Company** for a number of reasons.

MLR Design combined many visual cues from youth culture for a new Pepsi soft drink, Pepsi Blue. Tattoos, snowboard graphics, neon lighting, and more all lent their influence.

First, it was a revolutionary color for the cola category, and it scored well with the 16-year-old male target customer the company wanted to woo with a line extension of its Pepsi product. But perhaps even more important, it gave the company a chance to integrate its own brand color right into the product itself.

After focus testing confirmed that the bottler was on the right track, Pepsi contacted MLR Design (Chicago) to collaborate with the Pepsi Design Group on the development of Pepsi Blue. Christy Russell, director of business development for MLR, explains what happened next.

"The proposed product had tested well, and now it needed some imagery," Russell recalls. "With the packaging design, Pepsi wanted to focus on the independent personality and on self-expression. The product was to be a celebration of independence—that drove our entire creative exploration."

Because the shape of the bottle itself was already dictated by pre-existing market requirements, the design team focused on the label. They began by studying imagery from extreme sports such as snowboarding and skateboarding and from youth magazines, the music field, and MTV. Another visual angle that they studied was the tattoo, which combines the notion of art and self-expression.

The designers created a diverse range of presentation roughs. Some early trials expressed the notion of nightlife or night energy by means of neonlike graphics. These had a sense of electric energy, and they also appealed to the 16-year-old's sense of wanting to be part of an older crowd with a later curfew.

Another direction had a definite extreme sports inspiration behind it. "Any activity that is a bit left of center appeals to this age-group," Russell says. "The drink itself has that quality, so visually tying it to alternate activities neatly connects the product to excitement for the buyer."

A third direction tapped into the notion of standing out in the crowd, as members of the less than mainstream youth culture would. Tattoos are a natural visual for this group. "Tattoos are a bold, personal identity—not like the rest of the crowd," says Jones.

One trial used the familiar Pepsi ball as a globe element. "The Pepsi Blue world is a different kind of place," Russell says. "Things are unexpected there, and there's a lot more energy." Another trial along these same lines used a background pattern to suggest a crowd of people in a cityscape.

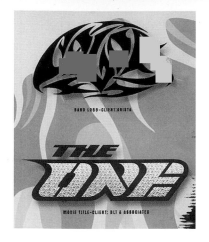

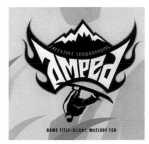

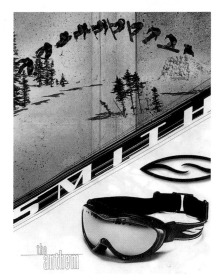

⬡ To find inspiration for the packaging design for the new Pepsi Blue product, targeted directly at 16-year-old males, MLR designers studied imagery from extreme sports, tattoos, youth publications, and the music field.

The Pepsi ball showed up in other experiments as well. One of Russell's favorites placed the ball so that it looked like the center of a throbbing speaker: This exploration suggested its own beat, but it also offered a subtle refreshment cue: The ripples surrounding the art could also suggest the product's liquid, thirst-quenching possibilities.

In all of the Pepsi Blue studies MLR presented to its client, the design team viewed the beverage product as a fashion statement. With a consumer profile that included the words "hip, edgy, bold, and independent," the energy level had to be high, says the project's creative director, Thomas E. Jones.

"A soft drink becomes a self-identity piece because we consume it in public. It's the same in the gum and mint category. Anything you consume in public is a statement of fashion, especially with kids who are so concerned with their images," Russell explains.

The comps created in this first stage of the project went into customer testing. Two strong directions emerged: tattoos and neon.

With the tattoo effect, the question was whether to make the name of the product a tattoo or to incorporate the name into tattoolike artwork. At this stage, the designers are developing the entire label. To up the impact of these new branding statements, they decided to make the graphics on the front larger and more prominent.

The neon studies tested very well, but in the end they were deemed to not contain enough action, even with lively backgrounds that added dimension to the designs. The tattoo approach eventually won out.

The time span for the project was extremely brief—only six weeks. Russell says that because the in-house design team at Pepsi is a very collaborative group, her firm had plenty of support. Also adding to the energy level is the fact that working on such a high-profile project is an enormous morale booster to her staff.

"The only way you end up having work like this in-house is to get through some very stiff competition," she says. "The huge boost we get from a project like Pepsi Blue helps us do that."

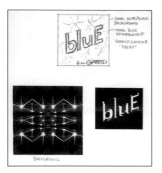

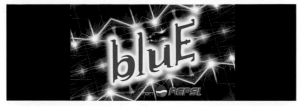

This trial expressed the notion of nightlife or night energy. The neon-like background and the neon-inspired logo communicate an electric energy.

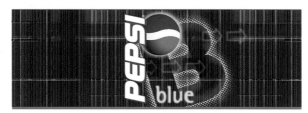

Here the designers looked at taking the "B" from "Blue" and turning it into a large icon. It is a hip look, inspired by logos on the labels of urban-styled clothing as well as on the large initial caps commonly used on sports clothing.

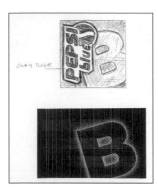

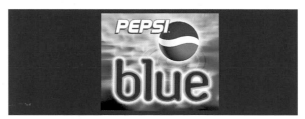

Cool and refreshing: That's the basis for this design. Although introducing the notion of water as a refreshment cue is visually effective, focus group studies revealed that this approach was far too sedate for the target audience.

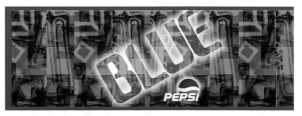

A background full of shapes and patterns suggests an urban landscape, bustling with crowds and energy. Blue, the color of both the product and the Pepsi brand, is also integrated right into the logo here, connecting the brand with the subbrand.

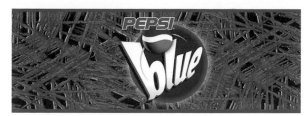

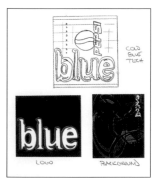

There was no sketch for this comp, because it was done entirely on the computer. The designers mimicked the Pepsi ball, but they used it here as more of a globe. The suggestion was that this is the "Pepsi Blue world," an unexpected place full of energy. The blue, frost-like background is a definite refreshment cue.

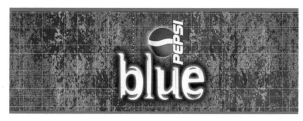

This comp was inspired by the club and nightlife scene. The designers reasoned that most 16-year-olds aspire to be older and take part in more mature activities, but this sophisticated approach also proved to be too subdued for the target audience.

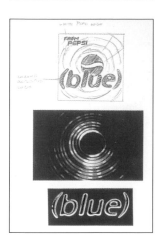

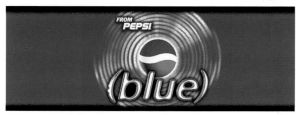

This trial emerged as a favorite with the design team: Viewed as the center of a speaker, it is a visual expression of a beat. This touched on the teenager's interest in music, especially loud, exciting music. But the circling rings can also be viewed as ripples in water, a refreshment cue.

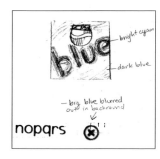

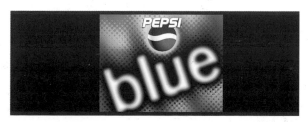

This design is another one that refers to the notion of staying up late and having fun. The logo almost looks like it is being viewed from the outside through a bubbled glass window: Inside, something fun is going on.

During the second stage of trials, the designers began developing complete labels for the client's review. These five comps are five different spins on tattoos. In some cases, the product name is the tattoo; in others, a tattoo-like form embraces the name. This was the direction that was eventually refined for the final design.

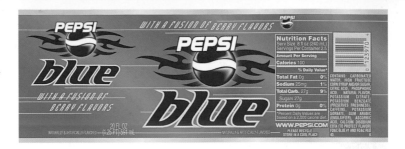

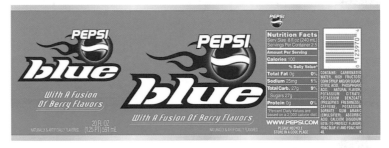

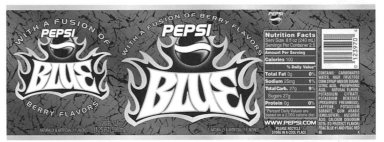

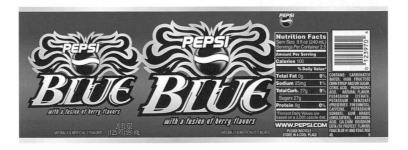

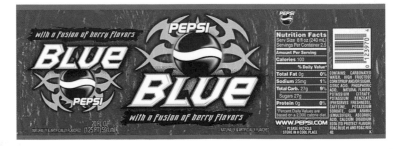

Another sketch done entirely on the computer. Here the ideas of extreme sports, music, and tattoos are combined. It was chosen as one of the initial ideas to be taken to the next level of exploration.

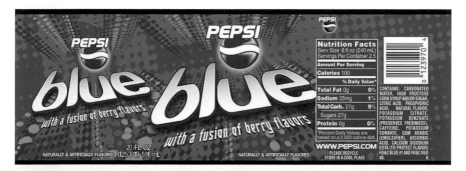

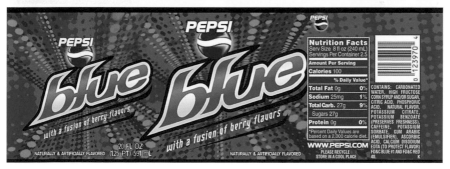

These glowing designs tested well with customers and received positive feedback from the client. In the first, a background dot pattern adds action to the design; in the second, the tunnel of lights is augmented by a tattoo element.

So many **package designs** are about "making the product hero." Is there ever a time to **make the packaging the star** of the show? David Richmond, principal of the London-based design firm, R Design, decided **the time was right for Selfridges,**

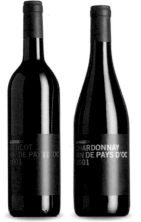

⊗ The Selfridges' packaging redesign project certainly makes the packaging—not the product—hero. R Design of London created a system that is sleek, elegant, and modern.

an enormous UK department store that sells high-end goods, including its own line of quality packaged foods. For the most part, consumers did not realize this, though. The store's products lacked impact on the shelves or its packaging mimicked other, better-known brands.

"Selfridges has a good reputation for fresh foods, but most shoppers didn't know that the store had its own packaged goods," Richmond explains. Not having a package design with impact was somewhat of an anomaly for the brand, because everything from the architecture of its buildings to the layout of its stores on down is all carefully planned to improve the shopping experience. Selfridges, as one of the most prestigious shops in London, usually paves the way for other retailers.

Another unusual twist to the project, according to Richmond: "They asked us for our opinion. Most clients just tell you what they want. Here Selfridges asked us to start fresh."

The client's forward-thinking request would be limited by only one thing: R designers would have to use stock containers.

The first design that Richmond's team developed was his favorite from the start. The store was one of the few around that could get away with a strong, modern statement, he reasoned. Simplicity could provide that message through design. From this evolved a concept in which all of the packaging was the same color—black—with no product showing and flavor insinuated through type and color. Given contemporary standards, the design was almost antipackaging.

The typography used would also be simple, restricted to a grid and kept at the same point size no matter what the size of the package was. The size and shape of the physical pack would play off of consumer's preexisting knowledge of packaging and let the shopper figure out what he or she was looking at—a bottle of wine or a package of coffee, for example.

Black felt timeless and classic to Richmond, but it is also a signature color for the store. "Color coding everything in black would make an incredible statement," he says. "Just the type would reflect what was inside—for example, strawberry jam would have pink type. People already believe in the store and its quality, so it is not necessary to show pictures of the product on a label or even show the product through clear glass or plastic."

Furthermore, because the black had such impact, the products would be easy to pick out, even if they were not displayed together in the store or were mixed among competitors' brands.

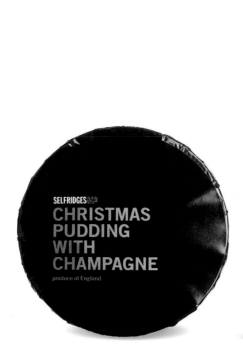

⊗ The first set of experiments that David Richmond and his designers created turned out to be everyone's favorite in the end. No product shows. The type is extremely simple. Everything but the type would be black, and the color of the words would offer flavor or product cues.

The design brief called for three designs, so Richmond's team continued with their explorations. Another idea was to design packages that people would treasure and keep. This concept would involve frosted, acid-etched containers—which turned out to be prohibitively expensive—with all of the product's information printed on an intriguing swing tag. Bottled water, for instance, would have a swing tag that carried the image of a rubber duck: The connection to water is immediate.

"Although the concept behind this was nice—that you could keep the jar or pack once it was empty—this design did not have the same impact as the black range. It just wasn't Selfridges," Richmond says.

Another concept brought the store itself onto the labels. They would photograph products that in some way related to the product in the package—for example, a high-end toaster that the store carried could be pictured on the jam label. Each label would end up being a mini-advertisement for something else that was for sale at Selfridges.

However, the logistics of matching up 70 different product pairs in this way would be a challenge. Plus if the store dropped the toaster shown on the jam label from its stock, the label would have to be redone.

The all-black idea won out. Originally, the designers envisioned that the graphics would be silk-screened onto black glass or tubes, but this proved to be cost prohibitive. The alternative, though, created what was an even more significant design statement: Graphics were printed onto plastic, which in turn was shrink wrapped onto all containers. The effect is complete uniformity in color and surface texture.

As of this writing, the new packaging has been out only a few months, but already it has been a smashing success: All holiday goods for the 2002-2003 season completely sold out.

A second set of trials was very different from the first. White or frosted containers would carry the product. A related product—actually, another Selfridges' offering—would be shown on the label. For instance, a refrigerator would be shown on a bottle of spring water. The client liked this approach, but it proved to be impractical: What if the store decided to drop that certain line of refrigerators? Visions of reprints followed by more reprints stopped this design.

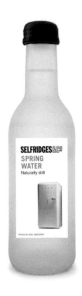

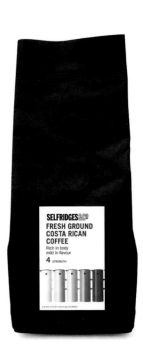

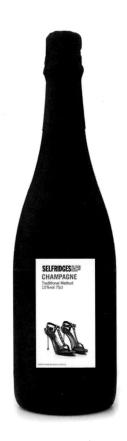

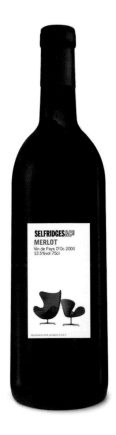

SELFRIDGES&CO
**WHITE WINE
(CHARDONNAY
VIN DE PAYS
D'OC 2000)**

SELFRIDGES&CO
**RED WINE
(MERLOT
VIN DE PAYS
D'OC 2000)**

SELFRIDGES&CO
**JUICE
(RASPBERRY
& VANILLA)**

SELFRIDGES&CO
**NATURAL
SPRING
WATER
(STILL)**

SELFRIDGES&CO
**GROUND
COFFEE
(COSTA RICAN)**

SELFRIDGES&CO
**JAM
(MIXED
FRUIT)**

⊘ A third approach could have used any color of container: It incorporated tags that carried images with themes related to the product. The spring water bottle would have a tag with a rubber duck printed on it, for example. The designers imagined that the containers used in this scheme would be attractive enough that consumers would want to keep them for reuse.

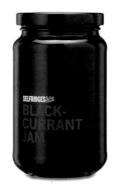

SELFRIDGES&CO
**CHAMPAGNE
BRUT**
product of France, N4-2651-20-00245,
Elabore a Pagny-Les-Perreux par Medot
et Cie a Romix, France.

SELFRIDGES&CO
**PURE
GROUND
COLOMBIAN
EMERALD
MOUNTAIN
COFFEE**
soft fragrant richness, smooth
strength 2

SELFRIDGES&CO
**BLACK-
CURRANT
JAM**

⊘ Black coats all packaging in the new line. Color as well as texture is similar across all SKUs. The type does change in color, but it is always positioned in the same place. There is no doubt that these products are from the same Selfridges family.

Floris is the oldest perfumer in London. Founded in 1730 by Juan Famenias Floris, it is now **being run by the eighth generation** of the Floris family from the fashionable address of

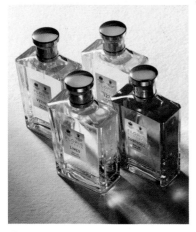

"To take a project with a fantastic name, which no one had really looked at graphically for 20-plus years, was a challenge," says Peter Windett, creative director for the entire Floris rebranding project, which included bags, men's products, home accessories, candles, and more. Trickett & Webb handled the redesign of the women's fragrances.

The original Floris packaging had a distinctively dated look and did not attract younger customers.

89 Jermyn Street, London, where it has sold fragrances since its founding. In fact, up until the 1960s, the company handcrafted and packaged all of its products in the basement of the elegantly appointed shop.

Among the company's more notable customers over the years have been Florence Nightingale, Mary Shelley, Beau Brummell, and even the fictional James Bond, who always wore Floris No. 89. Al Pacino's character in the movie, "The Scent of a Woman," said he could always "sight" a woman wearing a Floris fragrance.

All this heritage had served the company well until recently. The effects of the "Cool Britannia" movement had been hard on Floris. The brand was feeling stuffy and out-of-date, and its aging clientele base wasn't being topped off with new and younger customers.

Floris had other difficulties as well, reports Brian Webb of Trickett & Webb, London, the design firm who worked with Floris' creative director, Peter Windett, of Peter Windett Associates to ultimately give Floris an entirely new presence, mainly through its packaging.

"Their original packaging was as dreary as you could imagine," says Webb, "just a standard blue box stamped with their name. Each box had a gold fragrance label that was often stuck on inconsistently."

Floris wanted to increase its sales in Great Britain and the United States, but the big department stores either would not carry the product or they would not place the fragrances in the perfumery department. The packages' ho-hum appearance, combined with the brand's lack of apparent cache, was confining it to the toiletries department, a decided step down for a company whose home shop is outfitted with luxurious mahogany cabinets and shelving brought back from the Crystal Palace at the Hyde Park International Exhibition in 1851.

Heidi Lightfoot, director with Trickett & Webb, points out another serious problem with Floris' original packaging. "As the range of fragrances had expanded, it had become more and more difficult to tell what you were buying off of the shelf. You would come into the store and be faced with a huge bank of navy blue packs, each with only a tiny gold seal to differentiate it from the others. About the only thing you could tell from the box was whether it held a lotion or a fragrance," she explains.

The Trickett & Webb and Peter Windett Associates' designers were fortunate in their initial explorations for the client in that the original Floris shop has tucked behind it a museum of sorts, full of glass cabinets that contain samples of earlier versions of Floris packaging. The older labels were a great source of inspiration for the creative team.

The Trickett & Webb design team discussed for a time maintaining some continuity with the client's original packaging, basically blue boxes with gold stickers. After experimenting with a number of constructions and shapes, the approach was abandoned.

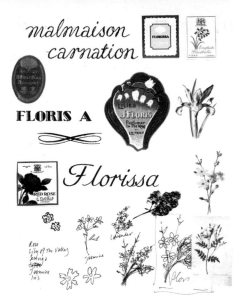

In their new approach, the designers considered fragrances separately. For traditional scents, they looked at imagery from the 1920s and 1930s.

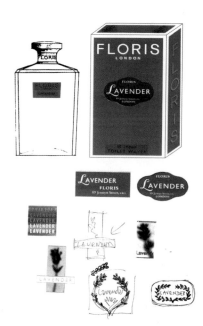

Peter Windett & Associates were developing a new logotype and new bottle shapes, which allowed the Trickett & Webb designers to settle on a box shape and size, as well as concentrate on graphics. The decision to use simple graphics was the next step.

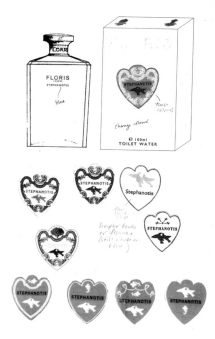

Stephanotis is a traditional fragrance, but it is also closely associated with weddings and young love. So its design was something of a crossover creature, based on the product's original design but with a decidedly modern appeal.

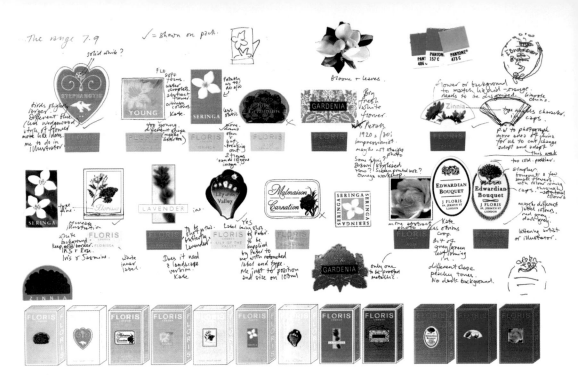

Several sheets similar to this one were produced by the Trickett & Webb team to not only finalize images, color, and typography but also compare one label to the others. All labels had to look independent, but still work together as a unit. Each fragrance has about a dozen product variants, so achieving the right mix was a bit of a challenge.

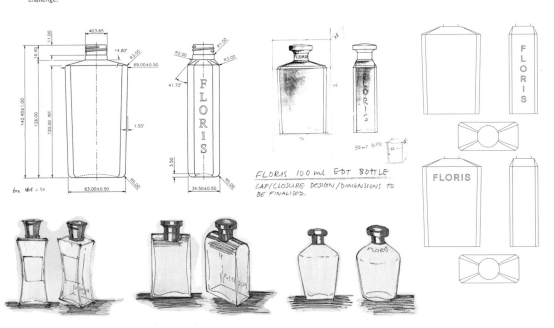

FLORIS 100 ml EDT BOTTLE
CAP/CLOSURE DESIGN/DIMENSIONS TO
BE FINALISED.

Bottle production studies produced by Peter Windett & Associates.

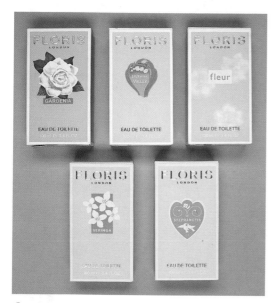

The color treatment for all products was made decidedly more modern, so that it would be more eye-catching in the department-store setting.

To tie modern and traditional together, the designers created a simple layout scheme. At the top front of each pack is the Floris name. At the bottom is the product variety name—eau de toilette, bath oil, and so on. But at each box's visual center is a different sticker-like element. Another connecting element: Each daytime scent box has a white border, whereas each nighttime scent box has a rich gold border.

"While we were working on the individual labels, we kept looking at the range as a whole. We needed a range of shapes [at the center of the boxes] to keep it interesting, but we still had to have balance among all of the packages," Lightfoot says. "It turned into a real melting pot of photography, illustration, type, takes from old artwork, and retouching."

The final suite of designs hangs together well as a block of products, much better for the retail environment found in large department stores today where "villages" of product lines are grouped tightly together on the shelves.

The original Floris bottles were square; the new molded bottles were designed with a wide front face to give greater shelf presence for pack graphics.

The end result is that sales and outlets for the products have increased enormously, reports Webb. "Saks, Nieman Marcus, Harrods, and other high-end stores, as well as specialty chemists are picking up the products for their perfume sections," he says.

Peter Windett says that the redirection of sales efforts has been a huge boon to the brand, which had been sold in less-than-high-end stores in the United States: Distribution to these destinations was closed down immediately.

The redesign grabbed the attention of the right people. "Floris got the product range and distribution corrected at the same time," Windett says.

The finished set of package designs works well together as a unit, even though some are traditional and others are contemporary, appealing to customers young and old.

"Some of the fragrances, such as rose and rose geranium, have been around for many years and have gone through many evolutions. We could look back at all of their old labels," Lightfoot recalls.

This archive became especially useful for the designers as they considered the personality of each fragrance. (Ultimately, Trickett & Webb created packaging for 10 fragrances and more than 100 products.) Some fragrances, like rose, were very traditional. Some scents were brand-new, created expressly to appeal to a younger audience. Each of these categories could be further subdivided into daytime or evening products.

The design team toyed briefly with the idea of sticking with the navy-and-gold color scheme and changing the product box's shape and construction. But the old colors were somber and masculine: The client wanted to bring back a sense of femininity, so pastels and other design cues were explored.

With the traditional scents in the line, the designers could hark back to older labels for visual cues. For one fragrance, they had metal type set to inspire an Edwardian feel. For others, they looked for archived images or borders to suggest tradition and, in part, keep existing and loyal customers comfortable with the products.

For the newer scents, abstracted art or photography could be used, and the type treatment for the scent's name could be decidedly more contemporary. Some fragrances, like lavender, are particularly traditional scents, but Floris wanted to give lavender a more contemporary feel for modern customers. So it is a mix of old and new elements.

Design Edge is an Austin (Texas)-based product development company that **normally does plenty of high-tech design** for clients such as Dell, Compaq, and 3M. But with **Wetnoz,** a project **released in late 2002,** the company's designers had a chance to **get in touch with their more animal instincts.**

The packaging for Wetnoz, a high-end line of products for pets, protects the stainless steel and rubber offerings, while communicating their design and uniqueness. Repeated color, pattern, and photos are hallmarks of the package design.

The owners of Design Edge, Mark Kimbrough and Pearce Jones, got an itch to do a self-initiated special project. A quick look around their homes and local stores revealed that there was a distinct lack of well-designed products for pets available. With people spending more and more time at home, as well as more and more money on their faithful companions—almost treating them like children, in some cases—it seemed to be an idea with enormous potential.

"A pet has its own toys, bed, and dishes. People want more interesting products in their homes today, even for their animals," explains Design Edge designer Lauren Sanders. She and her teammates went on to create a new brand—Wetnoz (pronounced "wet nose")—which was launched with a line of wonderfully sculptural pet dishes, as well as brand packaging that is one of a kind for the product category.

Wetnoz is "dedicated to producing innovative pet products with soul," according to its mission statement. Its pet bowls come in two varieties: plastic for the economy line, and stainless steel and rubber for the premium line. From a practical standpoint, the latter product would require some protection from scratching in the retail setting. From an aesthetic standpoint, because the other products on the shelves would have no packaging or unsophisticated graphics, the design team knew that their product would immediately feel special. They wanted to give the products a gift-like feel and special appeal to the upscale buyer.

The designers' goal for this project was to look at how the consumer experiences packaging. What does a customer see from the time of entering the store, be it a tier-one PetSmart retail outlet or a high-end specialty shop, to the time when he or she picks up a box, to the time when the box is taken home and opened? The experience had to be a consistent and unique one if the brand was to grow.

The WetNoz logo is decidedly unique: One company founder applied ink to his own dog's nose and applied a print of the nose to a piece of paper.

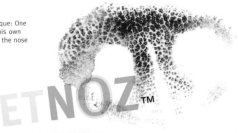

WET

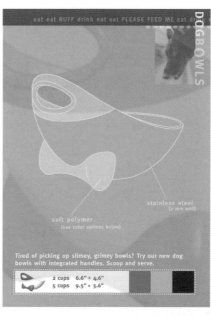

eat eat RUFF drink eat eat PLEASE FEED ME eat d

DOGBOWLS

stainless steel
(2 mm wall)

soft polymer
(see color options below)

Tired of picking up slimey, grimey bowls? Try our new dog
bowls with integrated handles. Scoop and serve.

	2 cups	6.6" × 4.6"
	5 cups	9.5" × 5.6"

Early experimentation for the
new line's packaging included
very informal photography, shot
by members of the design team,
and a sophisticated palette.

Pages from the Wetnoz catalog,
produced before the packaging to
inspire early orders, have a mod-
ern and progressive sensibility.

WET

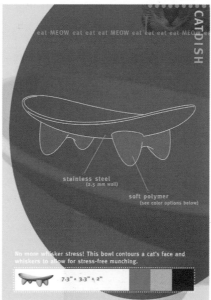

eat MEOW eat eat eat MEOW eat eat eat MEOW ee

CATDISH

stainless steel
(2.5 mm wall)

soft polymer
(see color options below)

No more whisker stress! This bowl contours a cat's face and
whiskers to allow for stress-free munching.

	7.3" × 3.3" × 2"

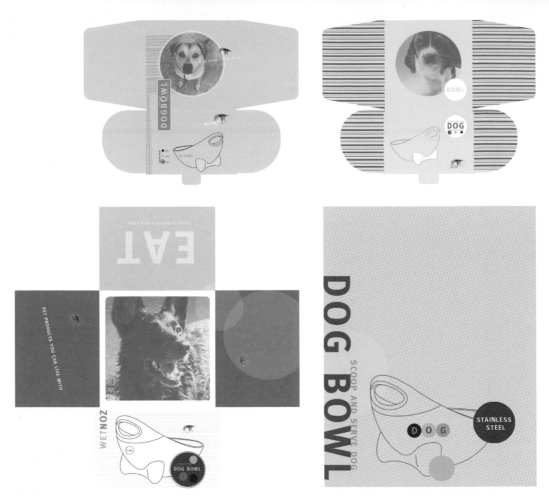

When it came time to designing the product packaging, the designers experimented with many different options. Favorite elements emerged in many trials, such as patterning, dots, and photography of real pets.

The entire packaging and collateral project centers on the image of a wet nose. Mark Kimbrough actually applied ink to his own dog's nose and impressed the image onto a piece of paper. It's a curious visual, Sanders says, one that is often misinterpreted to be an anteater. But somehow, it works with the brand name, which people often mispronounce. Deciphering the logo and trying to work out the name have become almost a game with consumers, the designer says, something that adds to the brand's playfulness and sense of fun.

On boxes and collateral pieces, three components were selected to be used on and around the unusual logo: color, pattern, and photography. The playfulness of pets drove the style of the photography. In fact, rather than use stock photography, which would be expensive as well as smell false, the design team instead took pictures of their own pets and of animals running and jumping at local parks.

"This design couldn't look too slick. It needed to look as if it were done by hand so that it had the sense of real happiness that a healthy dog has when it is running and playing," Sanders says.

Color would also be important in helping the design stand out in this category. To differentiate the brand from the bright, cartoon-like graphics that already existed on other pet-product packaging, the designers went with a more muted, but still colorful palette of green, orange, yellow, and a small amount of blue printed on light gray boxes. It's a contrary approach for the category, but it fits into the team's concept of creating a completely new experience in product and packaging for the consumer.

Color could also help organize yet-to-be-invented designs: A predominantly green box would signify one pet category, whereas another line would have blue boxes.

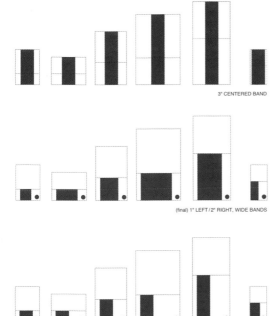

3" CENTERED BAND

(final) 1" LEFT / 2" RIGHT, WIDE BANDS

1" LEFT / 3" BAND + DOT

The design team could see how repeating specific, bold elements—a dot, a stripe, certain colors—could create a billboard-like effect with plenty of impact when the boxes were stacked together on the store shelf.

Here color and dimension are added to the experimentation. By isolating each element, the designers were able to study their individual impact and proportion.

Finally, pattern is important in creating a billboard-like effect on store shelves. From far away, as the consumer enters the store, the unusual Wetnoz color scheme grabs his attention. But as he comes closer, more and more information is delivered through patterning. The Wetnoz "wet nose" logo can be seen on the front of each box, centered in a large dot. A thick, vertical stripe also wraps around each box: When seen on the shelf, the products are easily recognizable as being from the same cleanly designed family.

At that point, Sanders says, the consumer would likely pick up the box and begin to read and understand what is inside. When the product is taken home, a product insert and the product itself continue the unusual visual experience.

Positioning the stripe and dot properly to create an appropriate pattern was easier said than done, however. In trying to work out the exact positioning of the stripe and dot, the designers took a systematic approach: They developed small thumbnails of the packaging in which all graphics were in simple black and white. With these skeletons, they experimented with different sizes and orientations of stripes and dots until the maximum, clean impact was achieved.

"We were trying to come up with as much repetition as possible for high brand impact and recognition, but some elements didn't look strong when they were repeated. So we played with the stripes and dots to create maximum impact while creating a consistent system," Sanders says.

The end result is a system of packaging that not only is noticeable on shelves but also complements the fine design of the products it holds. Each package has the nose-print logo, a stripe of color down the middle of the box, photography of animals, and a small amount of copy.

New products continue to be prototyped, and as they are developed, new packaging will also be required. But the Design Edge designers have already done the hard legwork necessary to make new lines feel comfortably accommodated under the Wetnoz brand name. Additions added to the shelf easily become part of the larger billboard for the brand.

The package is successful, she adds, because it protects the product, communicates the brand through design, and reinforces the brand through the consumer's experience with it. Breaking down the elements of the design was key.

"By isolating each element and doing studies of each design element, we could break the design of the information down into steps of an experience," Sanders explains.

Sanders says that the next step is to develop the plastic value line products that will appear in mass-market stores. Priority for this packaging is low cost rather than substantial product protection, because the plastic bowls are much more impervious to damage. Here the product speaks for itself in terms of design.

The finished design is shown here on store shelves. Note how the vertical stripes connect each of the products, whereas color and the dots attract the eye.

The final art for the finished goodie jar package reveals all of the elements.

Samples of the printed boxes.

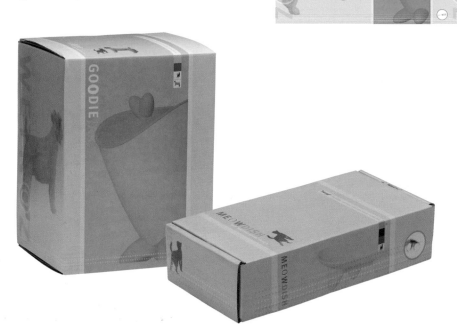

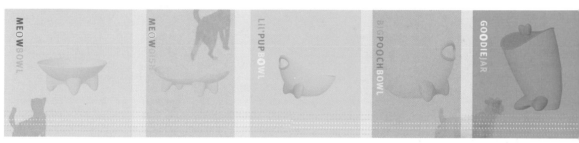

⊗ Inserts placed inside the boxes with the products take design cues from the packaging, creating a consistent feel across all elements.

⊘ The next set of package design for the Design Edge staff is for the WetNoz value line. Aimed at lower-priced retail outlets, the value line is made from plastic and so does not need a box to protect it. A hang tag will be used instead.

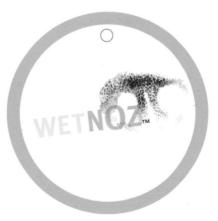

Who wrote the rule that dictates that when boxes are lined up on a shelf, **they must line up flat** and face side out, like a row of stiff soldiers? You say it is not a rule. Then why does everyone do it? Everyone, that is, except **Tea Tree skin-care products.**

The package design for Tea Tree, a new line of skin-care products, accomplishes two challenging goals: First, it visually explains a native Australian ingredient to consumers in other parts of the world, and second, its diamond-shaped box grabs the shopper's attention with its unusual, corner-out orientation.

These were the questions that Annette Harcus and Sydney-based Harcus Design asked as they created packaging for Tea Tree, a new line of skin-care products created by Trelivings. To achieve more presence and claim more real estate on store shelves, it would make more sense to cant the box into a diamond-shaped footprint and let it sit corner-side-out. As the project progressed, the idea held other benefits as well.

Harcus Design works regularly with Trelivings, having designed various ranges of packaging for the client in the past eight years. "Most are collections of body and beauty products based around a certain fragrance or flower—either endowed with great beauty or some kind of beneficial or restorative quality," Harcus explains.

Organic Tea Tree was no exception—although the actual scent of the tea tree, a graceful native Australian shrub, isn't widely acknowledged as having a desirable fragrance. It has a strong, bush smell, as eucalyptus does, but is highly regarded for its natural healing properties. Aboriginal mythology actually relates a tale of a warrior who finds his loved one by following a trail of tea trees. Tribes also sought healing by bathing in tea tree–infused waterways. Captain Cook, the explorer who navigated the east coast of Australia in 1770, brewed a beverage from the tiny leaves, and ever since, the family of shrubs has been named "tea tree."

The plant's aroma was not so appealing to modern tastes, so the new Trelivings' range was augmented with an additional scent of light fruity tones, which soothes and calms, making its benefits more appealing as a beauty-aid product.

The plant also has a flower. "It is a sweet, petaled bloom that ranges in color from white to pale rose-pink, but it is a very small flower," Harcus says. "They make up for their size with their profusion of flowers; they actually resemble peach blossoms."

Before Harcus and her designers presented the initial round of graphic work to the client, they decided to investigate a different-shaped box—not the usual rectangular shape. A diamond-shaped box would hold the container just as securely, and it would create a unique presentation on the shelves of department stores, gift shops, and boutiques. This diamond-shaped direction also gave designers the benefit of having two face panels for graphics. But the double face also meant they would have to contend with running graphics over a fold. The diamond theme would also have to be extended to create a family of boxes that could hold containers of various shapes—a bottle, a tube, a tub.

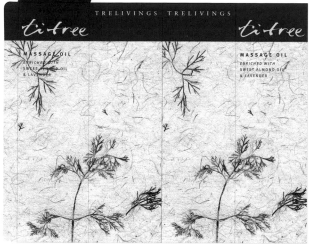

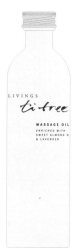

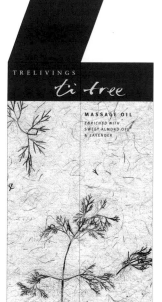

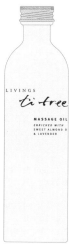

To help gauge her client's visual propensities for a project, Annette Harcus of Harcus Designs likes to present a number of very different ideas for early review. This approach suggested the use of a scan of paper, homemade with actual pieces of the tea tree embedded in it. It is perhaps the most Australian and earthy of the three early designs.

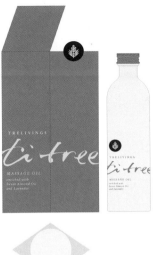

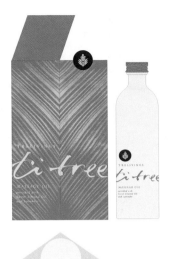

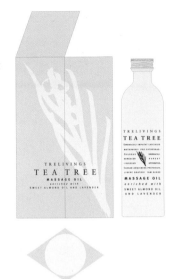

This trial balloon is on the modern edge of possibilities. It is a graphic approach that emphasizes the small size of the tea tree flower. Note how even the name is given a more daring twist with a new spelling.

This is another streamlined design that takes advantage of the two exposed faces of the carton. The radiating lines add the suggestion of a leaf, indicating that this is a natural product.

The scale of the tiny tea tree flower is greatly exaggerated in this design, which mixes classic design cues with an overall modernist approach. The bottle has a very different feel here, too.

With the shape decided, the Harcus team could move to round one of the graphic presentations. Because Harcus likes to begin such projects with an understanding of what visual direction the client wants to take, she will present many different visual cue starters.

The first design she presented in several variations was minimal: It was at the extreme end of the modern scale. It used a silhouette of a sprig of the plant, together with a calligraphic version of the name of the product, plus a brief descriptor.

"The client is very knowledgeable about the extracts and the botanical variants used in his products, but to highlight the problems of illustrating the flowers in a luxuriant manner we brought in real flowers to the meeting," Harcus says.

The second design was unusual. A wraparound scan of handmade paper that contained embedded foliage of the tea tree plant was used to form the background. This had a contemporary feel that exuded peacefulness and comfort. It was, Harcus points out, diametrically different from the first, sleek design.

"It felt the most 'Australian,' because it evoked its natural, plant origins," she adds.

The final design presented in the first round was built on soft lines that radiated from the corner of the box. The only flower or reference to the plant in this trial was a small sticker that carried a simple, silhouetted graphic representation.

After viewing all designs, the client indicated that he would like to go in a more traditional, feminine direction. Highlighting the flower was very important to him. To further gauge his interests, Harcus showed him a series of reproductions of Dutch Still Life paintings (veritas) from the 1600s. These hyperdetailed fruit and botanical images reveled in their own beauty and were exactly what he wanted.

"To heighten the sense of scale for the flowers, in the painting we came in very close—focusing on them in minuscule detail," Harcus says, "exaggerating them so the leaves also became large fields of green, filling in the background and giving the whole pack a dark, rich look. The white flowers with their yellow stamens pop out from the dark background."

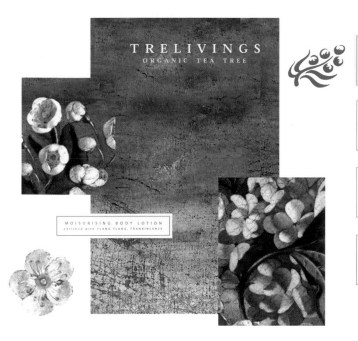

After reviewing Harcus' preliminary comps, the client indicated that he wanted to take a more classic, feminine approach. Harcus showed him a series of reproductions of Dutch Still Life paintings (veritas) from the 1600s. The hyperdetailed botanical images were exactly what he wanted. The simple, mostly open label design was eventually selected: It provides a ready and restful target on which the eye can focus.

The dark green also made an excellent ground for a cream-colored sticker that wrapped around the corner of the diamond-shaped pack. Whereas their earlier trials used large type to pull in the attention of the shopper, this design relied on the attraction of the simple, cream label centered on the rich, verdant field of foliage. With the delicate, restrained typography, the effect is understated elegance.

"These products are big in the gift market, so they need to express quality values, which also reflects the values of the person buying the product," Harcus says. The packaging not only looked beautiful but also felt sensuous to the touch with its matte, laminated finish. The inside of the boxes are dark green, and the bottles have a sand-blasted effect. Outside their boxes, the simple, translucent containers maintain their fresh appeal.

On the shelf, the innovative boxes take more space width-wise, as single units, but less space as a group when the packs are overlapped. With a dimensional front panel, they project forward: Shoppers are presented with a box face no matter from which direction they approach.

"The challenge of this project was the tea tree plant itself. We worked around its physical limitations and concentrated on evoking the essence of the flower—its inner and outer grace. We achieved this by commissioning an artist who painted with oils on the canvas. The artist, Paul Newton, recreated the atmospheric and textural detail of the veritas paintings, with a rich layered palette that highlighted the delicate beauty of the plant.

"It is the combination of the old world and the new world—the referential style of the painterly image with the contemporary shaped packs—that creates the shelf presence," Harcus explains of the design, which successfully and visually explains a uniquely Australian fauna to the international market, where the product has sold well.

IKD Design Solutions Pty Ltd. of Adelaide, South Australia, designs packaging for about 20 clients each year, including recently, Marquis Philips. At any one time, the office may have 30 to 50 wine projects in house, in various stages of development.

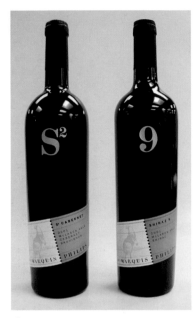

The success of the "roogle" brand led to two more entries into the line: S2 (for the winemakers, Sarah and Sparky Marquis), and 9 (the number of the vineyard). The packaging of these higher-quality products focuses more on the makers than the actual brand, although the brand precense is still evident. The S2 and 9 marks are applied directly to the glass.

Familiarity of this sort breeds an extreme sort of competence and assurance that allows the IKD team to stay at the front of design in this category worldwide. In fact, the company has earned numerous Australian and international awards in its 30-year history for its exemplary work.

"Some 60 percent of our business is in the wine industry—there are so many brands out there that the competition is huge," explains principal Ian Kidd. "It really is quite intellectually demanding to come up with solutions for any specific brand. A design has to say everything at the point of purchase and not look like someone else's brand. And it gets even worse on the international level when we have to be considerate of what else is already out there. We have to do more and more searches out front to generate solutions that are genuinely new."

The project described in this article emerged from a preexisting relationship IKD had with two clients: U.S. wine importer Dan Philips and Australian winemakers Sparky and Sarah Marquis, partners in a new venture to create a brand of wine made expressly for import to the United States, where Australian wines have proved themselves to be very popular.

The design firm had developed a number of brand identities and packaging solutions for the Marquis team, so its designers already had a sense of what the client was all about: Husband and wife Sparky and Sarah are exemplary winemakers who freelance their services to a number of small companies, Kidd explains. The newly formed, winemaker/bottling company, Marquis Philips, wouldn't have a budget for much advertising for the new brand, so the designers knew they had to create packaging with plenty of shelf appeal.

The design began by deciding on a name for the wine. The client initially had entertained abstract names options, but the IKD team eventually convinced the partners that the name Marquis Philips had real cache: "It looked good and sounded good," recalls Ian Kidd.

"If anything, it almost suggests European connections with the word 'marquis.' In addition, we felt that by putting their own names on the label, as a new brand starting from scratch, it was a good way to communicate not only who they were but also that they were willing to put their respected names behind the product."

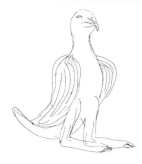

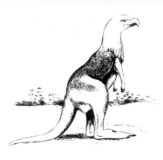

To combine the notions of Australia and the United States for the packaging of a new wine brand that would be imported from down under to the States, designers at IKD Design in South Australia happened on the concept of combining two familiar national icons: the kangaroo and the eagle.

The trick to creating a creature that was both convincing and not overtly humorous was to make the drawing look as though it came out of a zoological studies book from the 18th century. An animal that was silly in any way would devalue the quality of the wine.

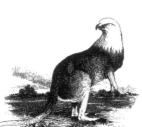

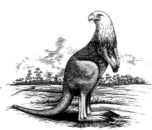

Here the designers established the stance they wanted for the creature, but it was still not perfect.

Finally, they create the right mix of light and dark tones, of whimsy and science, and of posture and scale. This drawing eventually made its way onto the packaging.

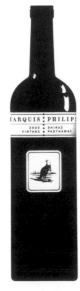

This simplified illustration shows the roogle label used in combination with the newly designed Marquis Philips label, which is a mix of traditional and contemporary elements.

The design problem was compounded by the fact that the label had to communicate something about a wine no one in the American market had ever heard of. Of course, the design had to say "Australia," but not in clichéd terms.

Because this brand was a collaborative effort between an American and Australian group, the design team looked for ways to visually merge the cultures, The result was the "roogle," a strange but somehow convincing half-eagle, half-kangaroo melange.

Ian Kidd says that they felt strongly that the new creature had to be illustrated so that it looked as if its likeness was pulled directly from a plate in an 18th century zoological book or a set of botanical prints. "People had to take it seriously at first glance," he says. "It could not be too humorous, or else the art would suggest that this may be inferior. A label should never devalue the product."

Enhancing the notion of an art print is the way the roogle's label was ultimately applied to the bottle: alone and almost like a framed print.

The art has a traditional feel, but the labels placed above the roogle on the bottle are a mix of traditional and modern design elements. The colors chosen for the upper labels of the various varieties are elegant and contemporary. The typefaces specified for the design are timeless—a design cue meant to suggest that this product was marketed by an experienced winemaker—but at the center of the labels is a very modern stroke: a simple line of perforation.

"The perforation is being retained for most labels in the Marquis Philips portfolio. It makes the labels almost like stamps," notes Kidd, adding that, as the price point rises in the wine line, the color in its label is softened, suggesting increased sophistication. "Stamps, as subtle graphic devices, indicate a connection between countries."

Kidd likes to take a more contemporary approach with wine, a product whose design is usually dripping with historical nudges. After all, designs that blindly cater to an antique sensibility run the risk of being dull and not standing out on the shelves.

"There is still a feeling among some in the wine world that you must use crests and leaves and other rubbish in a design. But wine is as contemporary as tomorrow," Kidd says. "You can think of wine packaging like housing. We design homes now that are far more intelligent and deal with our lifestyles better. We hang on to certain elements of tradition in our wine designs, but we focus on making a contemporary statement. I call it 'contemporary elegance'."

With so many wine projects coming through the door, how does Kidd and his team know when they have found the right solution? A knowledgeable, experienced designer will have an instinctual feel about it. Kidd says that properly evaluating the creative brief will reveal the issues that must be addressed: All answers to the problem are there.

⊗ This spec sheet lists all details and special production considerations for the client and printer, such as the fact that gloss black varnish was used to simulate the seration on these labels, rather than actually punching them.

195mm to top of 9

PRINT:
Black
Gloss Varnish
Ink to simulate
etched look-
textured?

STOCK:
Clear label or
coated self
adhesive

100mm label
tilt area

PRINT:
Black
Screen Black
Gloss Black Foil on dots
Matt Varnish
Orange
Cream

STOCK:
Coated self adhesive

Approved 5/6/02
Smarquis
SARAH MARQUIS

25mm from
bottle base

"We don't just design things that look good," Kidd says. "If we have the right answer, the design will look good in its own right. You have to do the hard work to answer these questions, or you will end up with something that is no better than wallpaper."

A design that does not answer the questions presented by the brief will not speak to the consumer, who, after all, knows nothing about the brief. "But the consumer will know if the design feels right, if it has the right depth and substance," he adds.

"Think of the process like designing a house," Kidd advises. "You aren't looking at the design you are going to make all by itself. You have to think of how climate will address the house, how many kids you may have, your lifestyle and personal interests. At the end of the day, the promise expressed on the label must be consistent with the imbibing experience, a bit like a beautiful home must be a joy to live in."

◁ The labels were applied to the bottles at an angle because off-square was more visually arresting, and because it implied that the application was done by hand, as a bond or tax sticker might be applied.

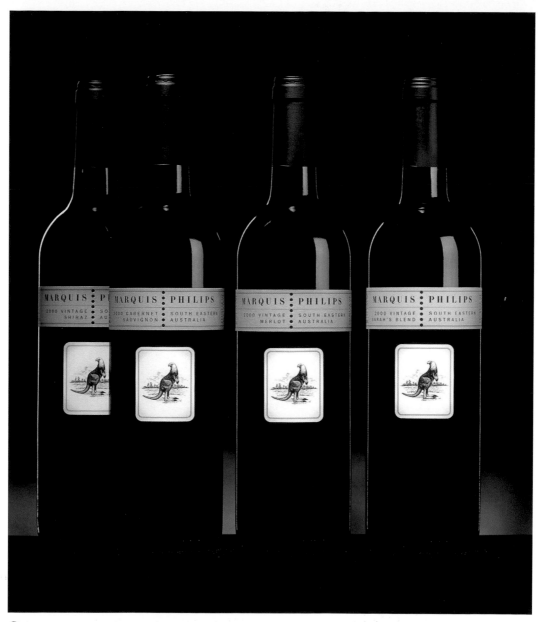

The complete packaging concept, with color coded labels to designate particular varieties. Principal Ian Kidd says that this design is effective because it is able to say everything on the store shelf: what the product is, where it is from, what its personality is, as well as what sort of quality it provides. "The worst wine labels around," he says, "are on the biggest brands. They have boatloads to put into advertising, so their bottles get no real assistance."

A reaction is good. That's the Jupiter Drawing Room's mantra. Whether the person at the **receiving end** of the design firm's work **laughs or cries,** it means success, as it did for **Foschini.**

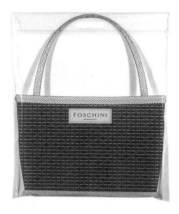

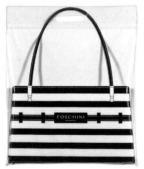

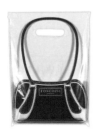

The final packaging is very convincing. It's hard to believe that each bag is printed with only two colors.

"Designing wallpaper has never been our business," says Joanne Thomas, creative director of design for the Cape Town, South Africa-based design and advertising agency.

Her office's work is strong in its concept and direct in its delivery. It's unusual "packaging" program for Foschini, a large, women's fashion retailer in South Africa, is a case in point. The client came to Jupiter suffering from a dowdy image. Its customers, aged from their early 20s to late 30s, were drifting away. An earlier corporate revamp had helped only marginally to convince consumers that Foschini was a purveyor of fashion, not a mere clothing retailer.

The Jupiter team started by improving the company's image through advertising and point-of-sale in the store. "This was done through a campaign that used fashion illustration. Whereas the competition had used the typical fashion shots featuring models on location, suddenly Foschini stood out with a style that immediately strikes you as fresh, modern, and fashionable," says Thomas. "It was brave of Foschini to break the mold in this way, and this bravery doesn't go unnoticed by the public."

The packaging project grew out of this bold move forward. The company needed special bags for the summer season—the Christmas season in South Africa, when tens of thousands of dollars worth of goods would be packaged into store bags and carted home for gifts. The shopping bag would essentially become an effective delivery mechanism for the revamped, illustrative brand.

The new bag could use only two colors, and it had to be plastic. The bag the store had been using was a white plastic bag with the Foschini logo printed on it in black and gray. It wasn't a very exciting package. The client wanted something different—but with no extra costs.

Thomas's initial ideas were to reuse some of the images and copy lines that Jupiter had developed for the advertising campaign. "But the two-color limitation meant that the illustrations—normally in glorious full color—just looked cheap and nasty," she recalls. The creative director and Jupiter's creative director of advertising Graham Lang had to come up with something else.

They knew that there was no reason to remain perfectly conventional. So why not put the concept of what a bag is on its ear? Why not turn the bag into another kind of bag—a handbag? They began to explore how they could print the image of fashionable handbags onto plastic so that the carrier would actually look as if she were carrying a real handbag.

Initially, they imagined photographs of the handbags printed on the plastic package, but the color limitation would make that impossible. So they turned to illustrations.

You don't have to be a stockbroker to buy, buy, buy.

Envy. Available in more than just green.

You can't buy love. But you can buy a lot of attention.

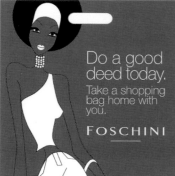

Do a good deed today. Take a shopping bag home with you.

FOSCHINI

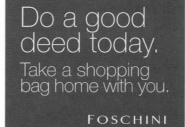

Do a good deed today. Take a shopping bag home with you.

FOSCHINI

Initially, Jupiter Drawing Room creative director of design Joanne Thomas thought she would design bags directly off of the graphics her team created for a summer poster program for Foschini, a large fashion retailer.

Converting the poster graphics into two-color graphics for the new package, however, was not tremendously successful. Thomas says that the art just didn't have the same punch.

In considering a different form of art for the bags, the Jupiter design team had an inspired idea: Why not make the bag mimic a handbag? They studied various styles that were in fashion that season.

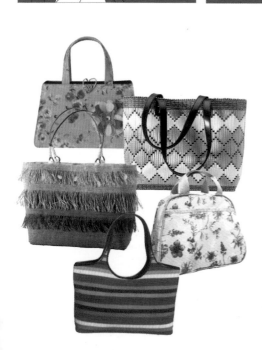

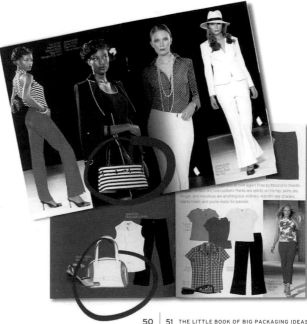

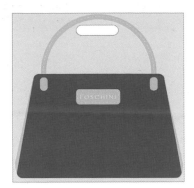

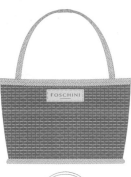

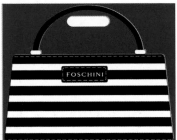

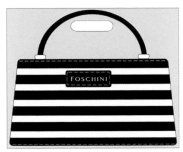

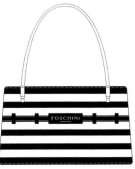

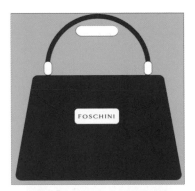

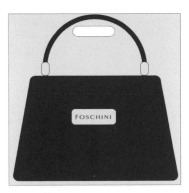

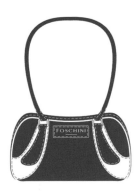

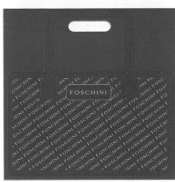

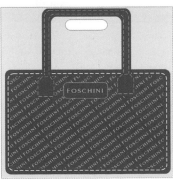

"The final solution of illustrating the bags seems obvious now, especially considering that was the same illustration style that we used for the advertising. But it took us a while to realize that by illustrating the bags, we could achieve the desired look with only two colors. I could keep the colors flat and not have to halftone anything," Thomas says.

Now the idea had to be executed. Thomas at first thought about printing the two colors of ink onto a third color—that of the plastic—but she soon recognized that putting the design onto transparent plastic would enhance the illusion of someone carrying the "handbag" even further.

The client loved the idea immediately as a fun, fashionable way to communicate their brand in an unforgettable package. Eventually, three bags that were in style for the season were designed and printed. "The handbags were designed with the dimensions of the shopping bag in mind—that is, the large shopping bag has a basket-style handbag printed on it," Thomas explains.

The bags were an enormous success. They were only used for one season, but one full year later, Thomas still sees people walking around town with a Foschini bag in hand. The reuse of the package is especially satisfying to her.

"It is important to me that the bags are reused. If a package is desirable enough, it will be kept and reused rather than thrown away," she says. "The Foschini bags definitely seem to have fallen into that category."

Rather than produce a mundane shopping bag, The Jupiter Drawing Room created a one-of-a-kind package for Foschini's bought goods. Customers not only use the bags to bring goods home but also continue to use them past the day of purchase.

⊗ To illustrate the straw bag, the team experimented with building different types of textures.

⊘ Foschini purchases, lunches, homework, and more—the new bags are reused again and again because customers like them so much.

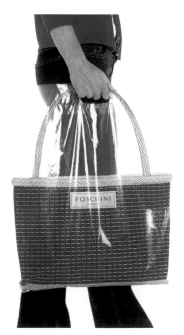

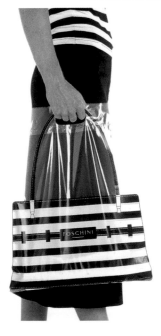

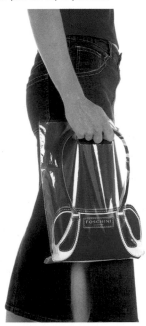

Sometimes a brand is built. Sometimes it just is. In the case of **Mr. Lee,** which happens to be the name of a range of noodle-based snack products as well as **the name of the man** who

A before and after comparison reveals what a drastic change the redesign presented.

began selling the fast food many years ago, this was a brand that had its own life and energy almost from its beginning.

Mr. Lee—the person—is an individual with plenty of personality. In the mid-1950s, he arrived in Norway, where his brand is now a household name, as a former chef and now-penniless war refugee who went into business doing what he knew—making noodles. To promote the brand, he often appeared in TV commercials, wearing his wild, trademark Hawaiian shirts and exuding endless cheer.

Mr. Lee—the noodle brand—is a popular food product, particularly among young people, but its packaging hadn't been touched in years and years. It had its own quirky personality in an "undesigned" way, but it had room to step up into something more.

Rieber and Son, a leading Norwegian food manufacturer, actually owns the Mr. Lee brand. It definitely wanted to build on the popularity of the Mr. Lee brand and expand the name into new products and new markets outside of Norway. The company also knew that Mr. Lee might want to retire someday, despite his enthusiasm for the brand, so it would not always be able to depend on the sparkle of his personality. That's when Rieber asked Design Bridge, a London branding and design consultancy the company had worked with since 1995, for advice on the situation.

Jill Marshall, the executive chairman for branding and packaging at Design Bridge, recalls that the original brief from the client simply asked the design team to take the founder's kitschy photo off the package and replace it with a caricature or another identifying device.

"But we challenged the client and suggested that the brand would benefit hugely from a complete overhaul," she says.

Almost from the beginning, designer Ian Burren began searching for a way to abstract Mr. Lee's countenance and turn it into a symbol that could be used on the packaging. As he distilled the image down further and further, the face became quite simple, but it was still recognizable.

But then Burren had a flash of inspiration that truly changed the entire nature of the brand. He enlarged the face and covered the entire noodle cup—the flagship container for the brand—with the image. Everyone in the office loved the effect, as did Rieber and Mr. Lee himself.

"When Mr. Lee saw the new packaging, he said, 'Now I can live forever,'" Marshall says. "It is unmistakably Mr. Lee. In addition to that, it allows us to have fun with the character, which has more flexibility than a photo [of a person] has."

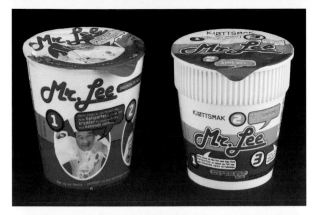

⊗ Two examples of the old Mr. Lee packaging. The designs had their own kitschy appeal, but the brand's owner felt that updating was necessary—in particular, removing the photos of Mr. Lee. Another difficulty was a production issue: Printing photos of food can be an inexact science, especially on the plastic used for the sachet bags. Products can actually end up looking unappealing if the printing is not carefully managed.

⊗ Asked to remove the photo of Mr. Lee and replace it with another likeness or identifier, designer Ian Burren distilled the essence of the brand's founder into a simple icon.

⊗ Applied to the brand's flagship noodle pot, the new
◁ Mr. Lee comes to life. Although the name of each variety is given on the cup, the visuals make the words almost superfluous: Note Mr. Lee's shirts and expressions. The brand's owner took a brave step by allowing the visual on the cup's front to actually be the brand identifier. The name "Mr. Lee" is only used on the pot top.

▷ The typography on the packaging was also updated, although its script style was maintained. The insertion of the two chopsticks is emblematic of the type of food Mr. Lee provides. The script and the chopsticks combined transforms the written name into a unified art element that is recognizable in any language, a requirement to expand the brand into other countries and languages. (The English version is above, and the Korean version is below.)

The character's expression can be changed to fit the flavor, size, or even the temperature of different products, whether they are noodle based or something completely different, such as ice cream. The irreverence of the brand is perfect for the brand's audience, and given the product's renewed popularity, brand expansion will no doubt follow.

"There are lots of product extensions in the pipeline, including nonnoodle products and potentially a Web site that will do even more with the Mr. Lee character. Mr. Lee transcends noodles—he could go anywhere," Marshall says.

This project shows that food packaging does not have to show the food it holds, she adds. The varying quality of printing, especially on a plastic like the kind used on the Mr. Lee noodle pack, can sometimes make food look unappetizing. The Design Bridge solution avoids that problem, but the designers did not ignore the shopper's natural desire to see the product before the purchase is made: They left unprinted, clear areas on the back of the pack where an open saucepan is shown as part of the cooking instructions.

She commends the client for allowing her team to create a brave design: "The Mr. Lee name is not on the front of the cups at all. The name only appears on the top," she points out.

If anyone had any doubts about the direction, those concerns evaporated when the design won a Clio in 2002 as well as recognition at the UK Design Week Awards. Mr. Lee—the person—and Mr. Lee—the design—are both still so recognizable that when the brand's founder went to the front of the room to accept an award at this second event, something spontaneous and gratifying occurred.

"When he went to the podium and bowed low, everyone realized who he was and gave him a standing ovation," Marshall says.

⬦ The new icon of Mr. Lee could easily be given just about any personality or attitude.

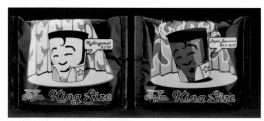

⬦ Who else but "The King" would be appropriate to announce the king-size packaging, so Mr. Lee gladly took on that new persona.

⬦ The Design Edge designers did not neglect to include the same fun on the back of the sachet package as was found on the front. The small saucepan in steps 1 and 2 of the cooking instructions actually let the consumer see the product inside. The UPC marker was even pulled into the play.

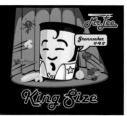

⬦ More line extensions of the king-size sachet packets.

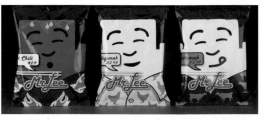

⬦ The newest Mr. Lee bags have a vertical orientation, which better fits the shape of the caricature's head and allows more of his "flavorful" shirt to be shown.

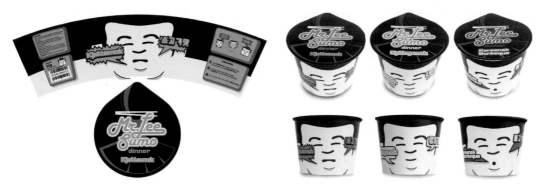

⊗ One of the newest products in the range is the "sumo size" pot. Again, Mr. Lee rises to the challenge.

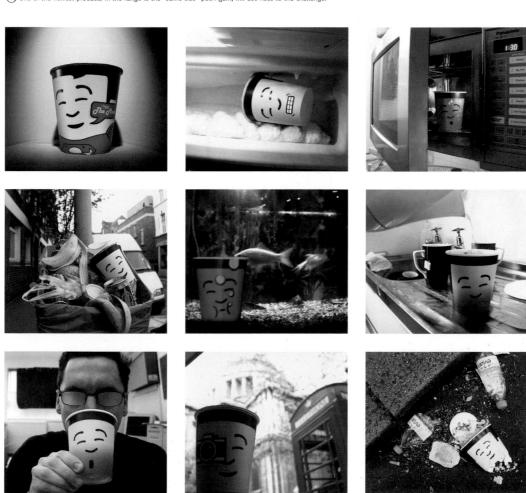

⊗ Because the character has taken on a life of his own, the designers are now imagining other situations he could operate in. Super Mr. Lee Man could be a treat at the movies. Or Mr. Lee might find himself wrapped around ice cream in a freezer or surrounding a cup of hot coffee or soup. Mr. Lee is definitely going places, the Design Bridge team says.

As the saying goes, **good things come in small packages.** But in today's crowded **retail environment,** small packages **could easily be overlooked,** no matter how fine their contents might be. This was definitely the case with **Vitalizers,**

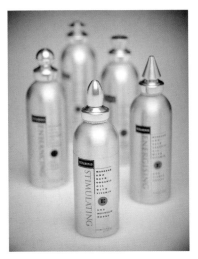

Faced with a preordained package shape and material for a new aromatherapy product, Vitalizers, the team at Harcus Design had to find another point of differentiation. The solution was to change the shape of the lids.

a unique line of therapeutic oils that can be used in the bath, for massage, or even burned in an oil burner (when diluted with water).

The oils were an offshoot of a much larger line of skin and body care products called Vitamin Plus. These products were based on specific vitamins—A, B, and E, for example—each combined with other beneficial plant extracts, such as aloe vera, sea kelp, and cactus. The two ingredients in each product were chosen to harmonize their benefits. The range is based on the simple philosophy of "feeding the skin" and replenishing the body's basic nutrients.

The other products produced by the brand owner, Trelivings, tended to be directed to an older demographic (traditionally female based). The company wanted a range of skin and body products that would attract younger consumers of both sexes and would be marketed under a different brand name. So evolved the concept for Vitamin Plus, and subsequently Vitalizers to increase their market share.

The packs, in line with appealing to the younger target market, were based on the contemporary approach of recyclable, lightweight, aluminum containers and tubes.

"Typographically there was a lot of information to express on the packs, so a hierarchical system was developed where the product type—such as Body Lotion—and the vitamin were the heroes. The plant extracts were highlighted by illustrative means rather than typography. Each product was attributed a color palette that gave it individuality, but that still coordinated it with the family."

The growing awareness of aromatherapy had given rise to the Vitalizers line—a series of organic oils enriched with vitamins and plant extracts. Each product would be packaged in an aluminum container, only 5 inches (12.5 cm) tall. The minute size of the package predetermined a number of design factors for Harcus Design, a Sydney, Australia–based design firm tapped to handle the project. A metal container was a must for protection because the oils degrade quickly when exposed to light.

"Whereas the original range Vitamin Plus implemented detailed plant drawings on the packs, the limited scale of the oil flasks didn't allow us to illustrate the individual variants of each oil," says principal Annette Harcus, "so we concentrated on heralding the resulting therapeutic effect. The individual 'moods' became the product names—such as "Stimulating," "Harmonizing," "Energizing," "Meditating," and "Enhancing.""

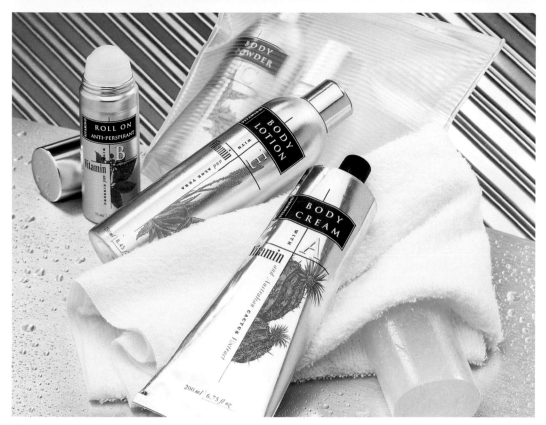

Another successful product line, Vitamin Plus, preceded Vitalizers. The design of this line established a number of parameters for the second project: polished silver metal, a sloped-shoulder bottle, and a relatively small size. The Vitalizer containers would only be 5 inches (12.5 cm) tall.

The lengthy line names would also have to be run vertically if they were to be run at a readable size. But the packages still needed something extra to distinguish them from other products and from each other: After all, the metal containers were sleek, but they looked tonally homogenous as a group. That's when the design team considered the container's lid. What if each variety had a differently shaped lid?

Because of their tiny scale, in the first design schemes, the designers suggested lids that enhanced their preciousness, making them look jewel-like. The lid shapes were based on the essential basic shapes of triangle, circle, square, and their three-dimensional forms—cone, tetrahedron, and sphere.

Custom-designing a lid brings with it a host of headaches, says Harcus. "Of course, products have to close efficiently. A perfect seal is so important," she notes. The exterior shape of a lid has ergonomic ramifications, as well. "Any shape we designed had to be easy for the fingers to grasp."

The first designs required a lot of hand assembly and finishing and therefore proved too costly. In the second round of concept drawings, the designers wanted the lids to match the polished metal of the containers. The team designed a number of shapes, then presented them to a metal fabricator for production feasibility assessment. The designers' specifications and guidelines were to result in a series of lids that were easy and comfortable to hold on to, that were not too difficult to produce, and that were cost efficient. The fabricator also provided some variations of the shapes, based on the production capabilities of the lathe.

The result was a differently shaped lid for each of the five oils in the line. Viewed as a group, there is no question that the bottles are part of a family.

"We had great fun attributing each of the product names with a lid shape," says Harcus. "The color differentiation that we initially were trying to impart in the lid was implemented into the pack graphics—a signature color for the product name and the vitamin circular device. The graphics in the form of a self-adhesive, clear label were applied 350 degrees around the containers."

The ranges have been a success, particularly in the younger demographic that the client was hoping to attract. "The oils are sold in drug stores, beauty shops, and homeopathy stores, not just the traditional gift market stores—so they are presented in an environment more accessible and more relevant to young people and those interested in aromatherapy.

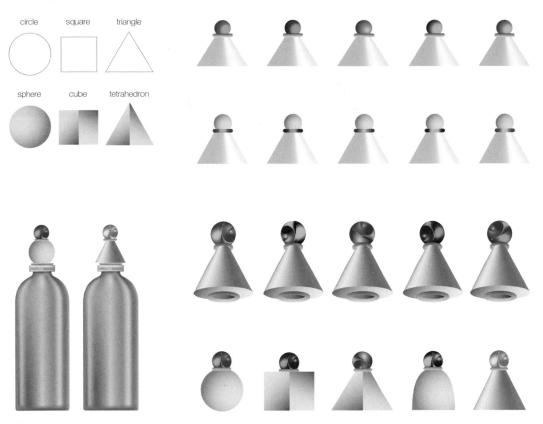

circle square triangle

sphere cube tetrahedron

◇ The new package's extremely diminutive size meant that any labeling or type on the containers would be small. This might make it difficult for customers to find the right variety on the shelf. That's when the designers suggested making each lid a different shape. Here, the designers experimented with various possibilities.

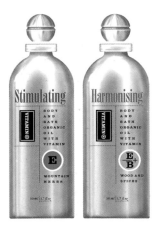

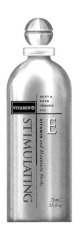

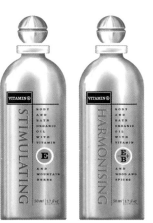

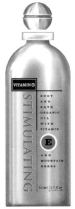

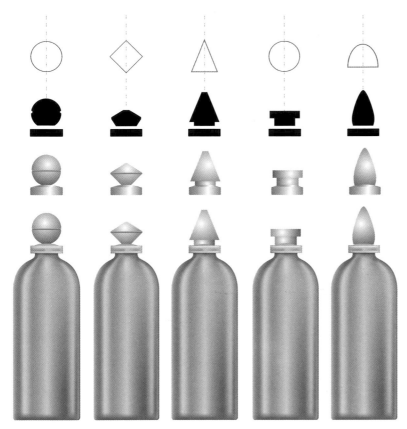

⬡ The new lids gave the varieties a precious, jewel-like appearance. Settling on these shapes was a challenge, because they not only had to look good, but they also had be practical in terms of production and ergonomic: The buyer would have to be able to grasp the lid comfortably with his or her fingers.

◁ Here the designers experimented with the labeling for the containers, working hard to get the type as large as possible.

▷ As on the front of the finished design, subtle changes in text and text direction helped to organize information in a very small place.

Ask someone who grew up in the **United Kingdom** in the past 20 years what you can **wear like a ring,** comes in a bag, and is crunchy, and in **less time than it takes to ask,** they will reply, **"Hula Hoops."**

⊘ These cheeky 2½ x 2½-inch (6.5 x 6.5-cm) squares are stuffed with tiny, ring-shaped, intensely flavored potato crisps. The package, designed by Jones Knowles Ritchie, breaks the rule that snacks should come in a bag.

Hula Hoops are ring-shaped potato snacks that have allowed kids to play with their food for years. These snacks successfully compete with crisps or chips for space on retailers' shelves and have remained popular among children. Although this was good news for the brand owner, United Biscuits, it also meant that most customers grew out of their affection for the treat: Hula Hoops were generally seen as a kid food. Even its name felt juvenile. Adults might crunch on a few, but the main snack food-buying demographic—teenagers and young adults—felt that they had passed the age when they wanted to wear food on their fingers.

United Biscuits decided to reshape the product into something that would be more palatable—visually and tastewise—to this market. It shrunk the circumference of the highly recognizable rings to where they could be strung on a drinking straw and then pumped up the flavor of the bead-like snacks to the point where they shock the tongue, whether eaten one at a time or by the handful.

That characteristic is what actually inspired the product's new name: Shoks. The only thing missing at that point was proper presentation.

United Biscuits came to Jones Knowles Ritchie, a London design consultancy, with a specific request: Create packaging with attitude for this brand extension that will cause young people to pick it up again and again.

Andy Knowles, a principal with the firm, says that their job was to get consumers to reengage with the product and also grab the attention of those who had never tried the product before. "The brief was tough, because the client wanted to communicate several things at the same time: 'intense flavor,' 'lots of hoops,' and 'they're small.' They also wanted to do this in an irreverent, more wacky way than the core Hula Hoops brand, because it was to be targeted at an audience of streetwise teens, who are more cynical and certainly know when they are being marketed to," he says.

The eye-catching 2½ x 2½-inch (6.5 x 6.5-cm) shape was unique for the snack-food category. Also, the product was stackable, meaning that it could be displayed right on the counter next to the register at the petrol station or quick mart, where customers waiting to pay are likely to make an impulse purchase.

Designer Simon Pendry tried several approaches. In his first trial, he filled the face of the package with type, placing the familiar Hula Hoops brand logo in the center of the design. Although a logical approach, it was difficult to say which message the consumer was supposed to receive: Hula Hoops or Shoks.

In another design, he focused on flavor and filled the front of the package with photos of the main flavor ingredient; however, it wasn't his favorite design. "Showing ingredients is a bit of a cliché—when all else fails, show a picture of the factory or the ingredients," Pendry says. "The design needed to be about more than just flavor. The people who would like these little beads would have to say, 'This product is for me.'"

A third trial began to center on a promising idea. He crammed people together in a subway car and in a telephone booth. It felt like something teens might do, he explains: "Muck about in a phone booth with their friends." The crowd also implied that the packs were stuffed with product.

Showing people made the package feel more immediate, so Pendry continued along that avenue. His next design showed the effects of the product on a loony-looking man. This spoke in the language of comics that so many teenagers like and was also very energetic, he says.

A fifth experiment was much more graphic. "When you put these on your tongue, they hit you quite hard. We say Shoks are exploding with flavor, so why not show it?" Pendry says.

Finally, he happened on an idea that really made him—and the client—smile: big, cheesy vignetted faces of people having fun with the product. This was the design that was eventually selected.

"These are people having a good time. They are charming, because they make you smile," he says of the faces, which he commissioned for the project. "With packaging, a smile in the mind is what you are trying to achieve. That's what a snack is—a spot of relief on a dull or busy day."

Using faces and bright colors to communicate the actual experience of eating the product, rather than literally show lots of little Hula Hoops and wacky type would have been clichéd category language and predictable. The way the expression-filled faces break convention for the category, he says, is decidedly irreverent, and they're—well, cheeky.

For Victorian Olive Groves, a cooperative of olive growers in Victoria, Australia, David Lancashire of David Lancashire Design **offered advice to the new group** that extended past simply selecting container shapes and **designing labels.**

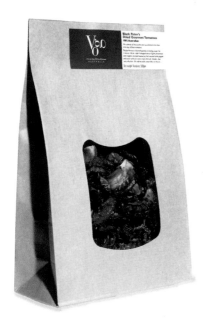

With packaging design, production issues such as how a product is bottled are always a concern. In some cases, they have to be examined by the designer as closely as he or she looks at the actual design of the package or labeling.

"I talked them into buying a labeling machine," says Lancashire. Joining together as a cooperative had been a bold move, as was going with the modern design that Lancashire, at project's end, had created for them. Now the client had to ratchet up its self-image to make the dream come true. Hand-labeling, as the group had done in the past, would no longer be practical if production was jumping to 10,000 cases of olive oil a year. The new labeling machine was a must.

"They were still thinking of where they were, not where they were going. The machine, plus the steps we took through design, moved this cottage industry to the next level," he adds.

Victorian Olive Groves was formed by four separate growers that had previously bottled their own products, including olive oils, bottled olives, and soaps. Up until the point that Lancashire Design was called in on the project, they had done their own packaging, which the design principal described as "pedestrian." It didn't reflect the quality of the product, and the cooperative hadn't really formed an image that it wanted to project.

Wanting to expand sales to the international market, however, a distinct image was critical. Many competitors used packaging with a folksy feel, showing photos of olives on their labels, which was logical but predictable. But Lancashire suggested that Victorian go with a more modern look, something that would not only make it stand out but also heighten its appeal to younger consumers who might be apprehensive about purchasing a high-end product with plenty of heritage.

It wasn't an easy sale, Lancashire recalls. The small growers weren't yet imagining their power as a cooperative. He had to gain their confidence to inspire their trust in his vision.

The first step in the label design process was to study the client's rather lengthy name. "Victorian Olive Groves," although an appropriate name for the group, did not sound modern. Lancashire suggested going to an acronym: VOG. Not only was the new name more memorable, it was also easier to work with in the new package design.

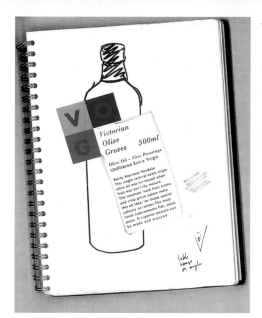

One of the first things David Lancashire did was to get the client's OK to shorten the name to "VOG," which was easier to deal with and certainly more memorable. Then he began experimenting with different looks. This idea—which was bold, simple, and evocative—would have been applied to the bottle at an angle.

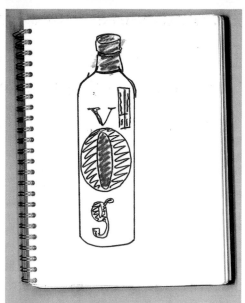

Here the "O" was turned into a focal point for the package. This held a lot of potential for bottles, but perhaps less promise for the shorter jars and bags.

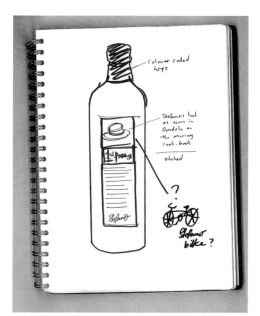

The new brand had the endorsement of chef and TV personality Stefano di Pieri, who is known for his white Panama hat. The designer tried to bring in elements that would refer to the personality in this design. In the end, only the signature was retained.

In this very Australian design, a piece of printed tape would extend over the top of the bottle, jar, or bag and end under the front label. Cost and production concerns made this design impractical.

Lancashire created five different label designs: Each kept the client's bottling and labeling concerns in mind: Stock bottles and jars were used, containers that fit the mechanics necessary for bottling oil and olives.

"For a packaging design project, I like to find out all of the technical problems first, such as what constraints the client's labeling machines have, or what type of pressure-sensitive stock they plan to use," the designer says. "If there is a preexisting bottle shape, you have to design a label that works dimensionally, with the bottle's curve."

The first idea Lancashire presented put the letters "VOG" in colored squares together with a block of evocative copy about the product. The entire composition would be placed on the container at an angle. It was a festive approach and one that the client liked. The slant and mix of colors called attention to itself.

A second design would have used the acronym in extremely large letters on the container front. The "O," much larger than the other two letters, served as a focal point—another idea that was very European. The cooperative had gained the endorsement of chef Steffano de Pieri, a well-recognized personality with a cooking show on Australian television. One very familiar image of the chef, from the introduction to his show, is of him riding a bicycle through olive and almond groves with a white Panama hat on his head. This design would have either featured the hat or the bicycle at the label's top, with the chef's signature at the bottom. Although an essential connection to the chef was kept in future designs—the signature was retained—the imagery was discarded.

⊘ This package design was the one the client ultimately selected. Here the designer turned "VOG" into a piece of readable art. The simple bands of strong color were easily translated onto all of the packaging in the line, as well as into any brand expansion lines.

◇ The finished design is decidedly progressive and not at all provincial. This level of sophistication will allow the product to be a contender on store shelves.

Lancashire calls the next design "pure Australian," with its winking sun and Mediterranean imagery. This idea called for a piece of printed tape that would reach across the top of the bottle or jar lid and end under the front label. Production concerns, particularly with the bottles, made this impractical.

A final design pulled together likable aspects from the previous designs: It had a bold color scheme of a dark mustard yellow, a dense green, and a rich olive green. The chef's signature was placed at the bottom again, and a descriptive copy block described the container's delectable contents.

The centerpiece of the new design is an unusual logo, which turns the brand's acronym into a graphic that sits simply on a field of color. The palette, and therefore the brand, can be extended easily as more products are added to the cooperative's offerings.

There is a lot of clutter on the shelves of the specialty stores where VOG will be sold, so the extreme simplicity of its new packaging stands out. The package has also worked extremely hard for the client. The launch was successful, and sales are strong. The new look also won a design award at a recent olive oil convention in Australia.

At the start of this project, Lancashire recalls that his client didn't have a clear picture of the future. The new package design shows the way. Very often, he says, with a forward-thinking design, it's possible to surprise a client and even change his or her mind about where the brand might go.

These facts are well known: Consumers are pressed for time these days. Their **schedules are so full,** many can't even find time to eat, much less **consume something healthy.** Fast food has become increasingly unpalatable to those concerned about nutrition. Missed meals lead to stress and fatigue. **Enter Frulatté.**

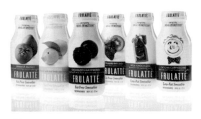

The Frulatté package design has achieved recognition and praise among consumers and the design industry for its charming range of characters.

Frulatté is a bottled smoothie that meets the caloric, nutritional, visceral, and cost needs of this busy crowd. But even with all of the product's positives, its inventor knew that he had to first convince the consumer to pick up a bottle, no easy task considering the number of competing products already on the market, many of which have huge advertising budgets.

There had to be a remarkable difference in the value proposition between Frulatté and the others, most of which were either weight-loss drinks, clinical calorie supplements, or uninspiring brand extensions of existing juice products. None of these products' packaging said "fun" or even "hello." In fact, the diet drinks even had something of an associated stigma: Who would drink them except for someone who had doubts about his or her physical appearance?

What Frulatté needed was more of a personal style statement. Its design had to be something that people would be comfortable leaving out on their desks at work, says Mark Brutten, grand strategist at Addis, the Berkeley, California, strategy and design firm that handled the project. Expressing good nutrition in a fun and engaging way was important on another level as well, he points out. "This would have to stand out on the shelf, because this would be the company's primary marketing vehicle."

Brutten and Addis principal Steven Addis agree that it would have been simpler and more direct to design beautiful and perfectly appetizing packaging with lots of pictures of cascading fruit. But where a package design can really come to life and speak to a consumer, says Addis, is by asking it to tell a story. A successful package has to do a lot more than just blurt out what's inside the box.

The designers honed in on the idea of the "happy body" and began to search for ways to express that visually. Concepts relating to spas and oases were explored: These yielded a clean, spare effect that didn't really exude personality or comfort. They also considered ways to focus on the goodness of the ingredients—on the seeds of a strawberry, for instance.

A natural extension of the "happy body" concept was to turn one of the main ingredients from each drink into a happy body itself. Actually creating these personalities turned out to be far more direct than any of them would have imagined: They played off pre-existing physical characteristics of the individual ingredients—an orange, lemon, raspberry, and strawberry—to create a series of charming faces.

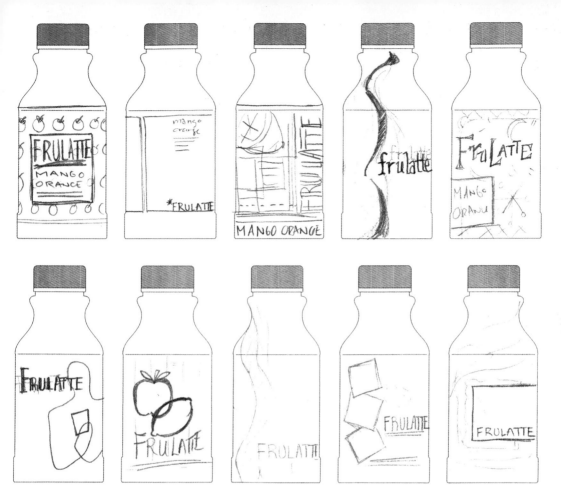

A pencil study of possible panel designs and shapes began the Addis exploration.

No Photoshop or other special electronic effects were used to create the faces—just simple styling on the set of the photo shoot as well as lots and lots of picking through crate after crate of produce to find the characteristics that would produce the richest, most expressive faces. "This was a natural product, so it had to have a design that was natural," Brutten says.

"This idea came from wanting to express the joy and exuberance of the product," he adds.

Printed on shrink-wrapped glass bottles, the characters speak of fast but friendly food. "It's almost like the fruit is calling to you," says Addis.

"Giving the packaging personality helps the consumer to form a relationship with the product in a literal way. Imagine whether a customer would rather have a Slimfast drink or this on his or her

desk. There is no question about what most people would rather interact with. This is not a drink that the consumer is going to pour into another container."

The designers say that the characters are so appealing that almost everyone who comes into contact with them quickly develops a favorite, which may or may not correspond with what flavor they prefer. And even though the client initially believed that the Frulatté packaging would have to carry the full weight of the campaign, the product has been so successful that monies have become available for an advertising campaign that features the characters.

The project demonstrates, Addis says, that the design of a package, when paired with a quality project, can create and even drive an entire brand from the ground up. The power behind the work, though, has to come from an idea with a story to tell, not just pretty pictures.

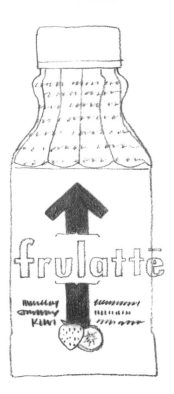

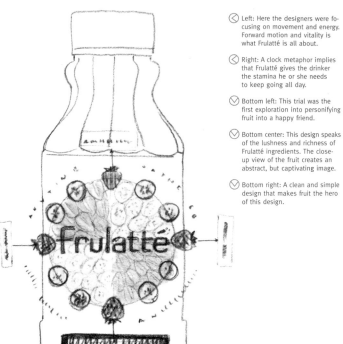

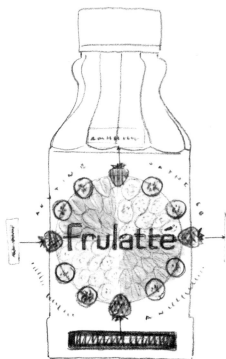

◁ Left: Here the designers were focusing on movement and energy. Forward motion and vitality is what Frulatté is all about.

◁ Right: A clock metaphor implies that Frulatté gives the drinker the stamina he or she needs to keep going all day.

▽ Bottom left: This trial was the first exploration into personifying fruit into a happy friend.

▽ Bottom center: This design speaks of the lushness and richness of Frulatté ingredients. The close-up view of the fruit creates an abstract, but captivating image.

▽ Bottom right: A clean and simple design that makes fruit the hero of this design.

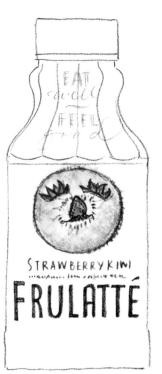

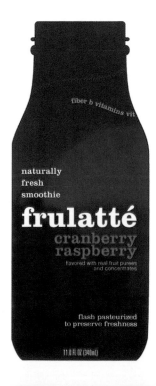

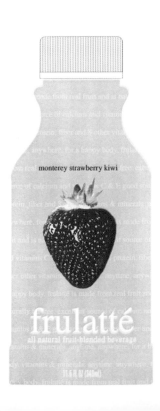

Left: This clean and quiet design speaks of the spa experience. It's fresh and simple.

Right: Some designs were more graphic, like this one. The overlapping fruit is used as more of a conceptual element than an object.

Left: A black bottle would give the product a certain sophistication and richness. This design also offered the experience to compare and contrast the texture of the fruit.

Right: The red mark at the center of this design is, on the surface, a stylized "F" for Frulatté. But it also suggests the letter S, for "supplement." It's length and shape suggests slenderness.

88 Phases is an atypical creative firm that is known for "recontexturalizing" the client products it deals with. It takes companies with no brand at all and **gives them awareness,** or it can take an existing brand, nurture it, and grow it as if the client's product was its own. **Soaptopia is such a client.**

Soaptopia products are tactile, smell great, and are good for the skin. They needed packaging that was just as wonderful. The design firm 88phases helped moved the brand into its next level of business.

"It is a small client, but for our two years together, we have put our hearts and souls into it," explains 88 Phases president Yu Daniel Tsai. His client actually earns her living as a television line-producer, but creating unusual and healthful soaps is a passionate sideline for her. "I see her belief in the product. We don't get involved in craft work, so I asked her what she really wanted to do over the next five to seven years. Was this all she wanted to be? If a client cannot see anything past that, we won't work for them. When she was able to say where she wanted her product to go, we put together a proposal for her."

The client's existing packaging for her line of 18 soaps was basically an envelope with a hand-applied label. It had the tactile, handmade feel that she wanted, but it wasn't sophisticated enough to move her to the next level in retail.

Tsai explains. "Initially, the client had started to make soap, and she would give it away on film sets. More and more people would ask her for the soap. Then a good friend who is a doctor ordered a big batch to give away to other doctors and nurses. That's how she got started."

The 88 Phases team had many dilemmas to consider: First, any design they created had to allow for line expansion and contraction. New soaps could be added to or removed from the range anytime. Second, the budget for the production of the packaging was very low. Third, the product had to look as if it had been touched by human hands. And, finally, the soaps had to be properly protected, to prevent them from drying out and leeching oils.

The designers considered an enormous range of ideas, including many that were outside of the project's budget constraints. But Tsai says that they try not to let anything restrict their creativity, at least initially: They can always go back and rework good ideas so that they are less expensive.

Clear wrapping paper was considered, as was a muslin bag that could serve as a loofah. Many cardboard containers were sketched out, including a half-box that would allow shoppers to easily smell the products, which have a wonderful aroma, Tsai says. Other boxes had interesting and clever folding or closures. One idea was to use a diecut box with many tiny holes on its top—so many that the colorful product would be visible while the box was still closed.

The designers also looked into branding or stamping the soaps themselves with ink.

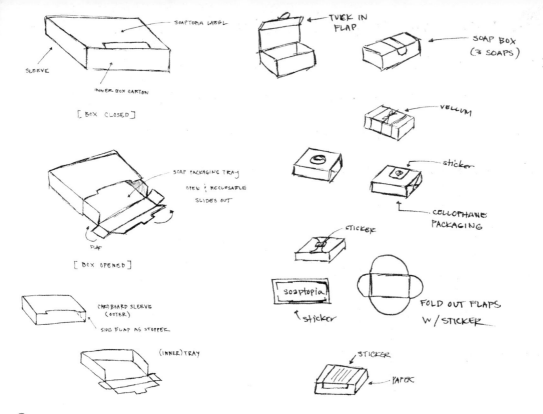

Labels within the sketches:

SOAPTOPIA LABEL

SLEEVE

INNER BOX CARTON

[BOX CLOSED]

SOAP PACKAGING TRAY
OPEN & RECLOSABLE
SLIDES OUT

FLAP

[BOX OPENED]

CARDBOARD SLEEVE
(OUTER)

SIDE FLAP AS STOPPER

(INNER) TRAY

TUCK IN FLAP

SOAP BOX
(3 SOAPS)

VELLUM

sticker

CELLOPHANE PACKAGING

STICKER

soaptopia
↑ sticker

FOLD OUT FLAPS
W/ STICKER

STICKER

PAPER

⊗ 88 Phases principal Yu Daniel Tsai performed extensive research for the Soaptopia brand. Although the client had a relatively strict budget and limited production capabilities, Tsia did not initially count out ideas that were impractical from a cost or time standpoint. Wonderful concepts or constructions can be modified to fit a client's needs, rather than be abandoned. Tsia also experimented with packaging designs for products that the client may produce in the future.

"It was so raw and simple, but the client was concerned that the ink might come off on the skin," Tsai says.

Other ideas included stitching the soap into a burlap sleeve, wrapping the soap in cheesecloth, sandwiching the soap with wooden plates and hemp rope, enclosing the soap in a papyrus-like net, and using intricate, Asian-inspired wooden boxes and bags as containers.

But the idea that emerged as both practical, affordable, and memorable was an imprinted vellum sleeve hand-tied with paper cummerbund, raffia, and a Soaptopia tag. The sleeve communicates what is in the product and what it represents, and it lets the consumer see, smell, and touch the soap. It also prevents the oils in the soap from seeping onto anything nearby—and the raffia actually prevents the soaps from touching each other.

"We really wanted to use bamboo rope, but she didn't have the budget for it. There is a lot of give-and-take on a project like this," Tsai says.

The color palette for the project has an Asian sensibility. Tsai compares it to a palette one might find on pottery discovered in a Chinese bazaar. The organic components of the soap ingredients were also considered in the selection of color and pattern on the packages.

The design team took the design to the next level when it decided to replace the plain paper cummerbunds originally specified with printed French wrapping papers. These add yet another layer of color and texture to what is already a rich package. It is also highly customizable.

"If she wants to change any of the designs, say, for the LA market, she can do it because the packaging is so modular. It would be easy for her to have different packages for the same products in different markets," Tsai points out.

Despite the smaller scale of this project, Tsai values it a great deal because it gives him perspective. Soaptopia is like a baby now, just learning to walk, he says.

"I am running a campaign for Gateway Computer right now, a very large project. Soaptopia is a different kind of work: It is very true to one person's love. Obviously, this is not a moneymaker for us, but we are learning, too, which is worth something."

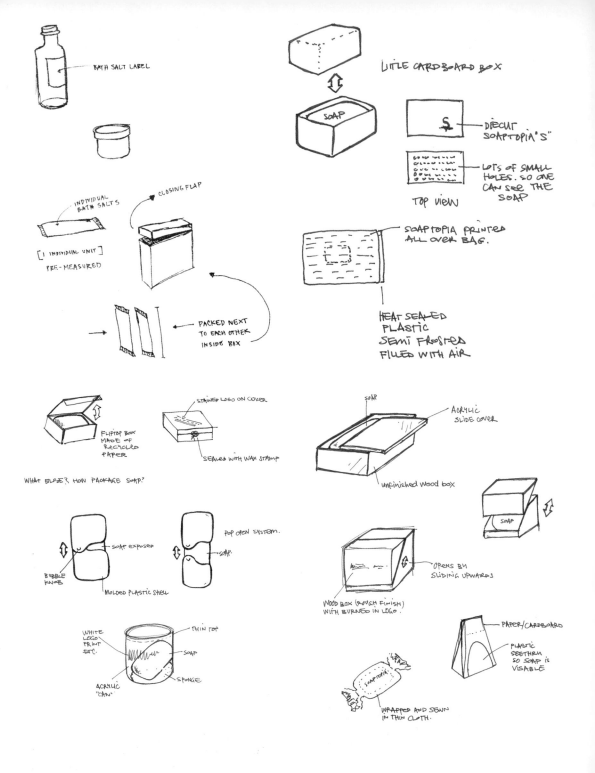

BATH SALT LABEL

LITTLE CARDBOARD BOX

SOAP

DIECUT SOAPTOPIA'S "S"

LOTS OF SMALL HOLES. SO ONE CAN SEE THE SOAP

TOP VIEW

INDIVIDUAL BATH SALTS

CLOSING FLAP

[1 INDIVIDUAL UNIT]
PRE-MEASURED

PACKED NEXT TO EACH OTHER INSIDE BOX

SOAPTOPIA PRINTED ALL OVER BAG.

HEAT SEALED
PLASTIC
SEMI FROSTED
FILLED WITH AIR

FLIPTOP BOX MADE OF RECYCLED PAPER

STAINED LOGO ON COVER

SEALED WITH WAX STAMP

SOAP

ACRYLIC SLIDE COVER

UNFINISHED WOOD BOX

WHAT ELSE? HOW PACKAGE SOAP?

SOAP EXPOSED

POP OPEN SYSTEM.

SOAP.

BUBBLE KNOB

MOLDED PLASTIC SHELL

SOAP

OPENS BY SLIDING UPWARDS

WOOD BOX (ROUGH FINISH) WITH BURNED IN LOGO.

WHITE LOGO PRINT ETC.

THIN TOP

SOAP

SPONGE

ACRYLIC "CAN"

PAPER/CARDBOARD

PLASTIC SEETHRU SO SOAP IS VISABLE

SOAPTOPIA

WRAPPED AND SEWN IN THIN CLOTH.

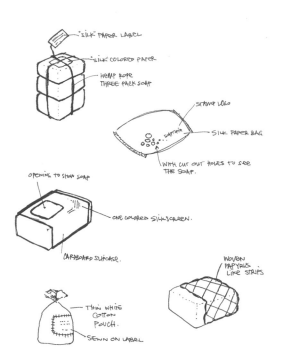

"SILK" PAPER LABEL

"SILK" COLORED PAPER

HEMP ROPE
THREE PACK SOAP

STAMP LOGO

SILK PAPER BAG

WITH CUT OUT HOLES TO SEE
THE SOAP.

OPENING TO SHOW SOAP

ONE COLORED SILKSCREEN.

CARDBOARD SLIPCASE.

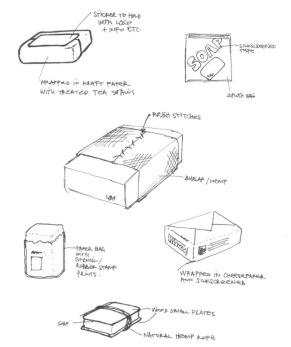

STICKER TO HOLD
WITH LOGO
+ INFO ETC.

WRAPPED IN KRAFT PAPER
WITH TREATED TEA STAINS

SILKSCREENED
TAPE

ZIPLOCK BAG

ROUGH STITCHES

BURLAP / HEMP

SOAP.

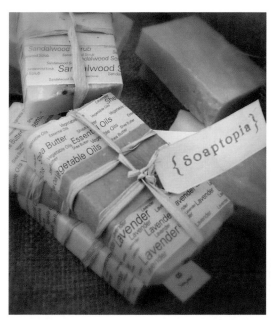

WOVEN
PAPYRUS
LIKE STRIPS

THIN WHITE
COTTON
POUCH.

SEWN ON LABEL

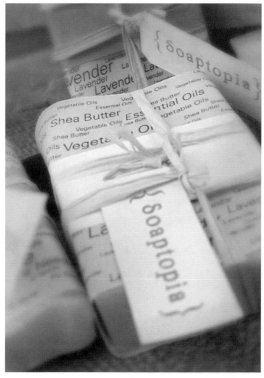

PAPER BAG
WITH
STENCIL /
RUBBER STAMP
PRINTS.

WRAPPED IN CHEESEPAPER
AND SILKSCREENED

WOOD SMALL PLATES

SOAP

NATURAL HEMP ROPE

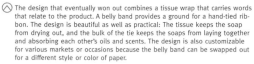

The design that eventually won out combines a tissue wrap that carries words that relate to the product. A belly band provides a ground for a hand-tied ribbon. The design is beautiful as well as practical: The tissue keeps the soap from drying out, and the bulk of the tie keeps the soaps from laying together and absorbing each other's oils and scents. The design is also customizable for various markets or occasions because the belly band can be swapped out for a different style or color of paper.

How do you maintain a brand's **star quality** while downplaying it at the same time? Make an identity **concrete but endlessly flexible?** Translate a normally RGB, on-air brand—in this case, the **Discovery Channel**—to hundreds of CMYK-printed packages?

Parham Santana (New York) managed these challenges and more when it took on the packaging program for the Discovery Channel. The client puts its name on thousands of toy, learning, health and beauty, and convenience items for men, women, and children. These products are sold in venues as disparate as high-end specialty stores to large retail outlets. The variables for the project seemed endless at the start.

But the Parham Santana team did have a head start. Five years ago, the firm helped Discovery launch its first licensed program in Target stores nationwide. In addition, principal John Parham recalls that Discovery's retail program for kids was fairly well coordinated already; although the adult products were being packaged manufacturer by manufacturer. So his team began thinking about how to coordinate the adult's and women's product lines within themselves as well as with the children's lines.

The client had four objectives at the start of the project. First, Parham reports, Discovery wanted to emphasize the product over the package or the brand.

"The product needed to be the hero," he says. "The color on the front of the package could not compete with the product, only frame it, for example. We needed to create a stage for the products where different types of stories could be told."

Second, Discovery wanted total flexibility in terms of cross-merchandising between children's, adult's, and women's products in the store setting.

"For example, at the front of a store, they may create a vignette where they want to promote a particular telecast. The in-store merchandising might bring together a pair of adult binoculars and a kid's archeology kit in one display," Parham says. Both products would need to sit comfortably together.

The third objective was to create the notion of a family destination or theme. From a design standpoint, this meant showing that the Discovery line had something for everybody.

"A lot of this has to do with the friendliness of the type we chose, as well as the approachability of the copy we included. Colors would have to be fun and upbeat, and of course, the product mix had to be sufficiently diverse," Parham says.

Finally, the fourth objective required Parham Santana to make it possible for Discovery Channel to gracefully promote its sub-brands: TLC, Discovery Health, and Animal Planet. The challenge

a universal color family

Color and pattern were the key elements the designers used to tie the product lines together. The blueprint-like "tech" pattern is used on goods for grown-ups, while the "orbit" pattern signals products for children. The same color palette is used across the board for adult, child, and women's products, but in different configurations.

Parham Santana was faced with a formidable challenge when it designed packaging for Discovery Stores. Not only were there thousands of SKUs, but the products were sold in various venues, from high-end specialty stores to large retail outlets. By using background pattern and a related color palette, the design firm was able to relate the disparate products, yet still provide distinction between adult and kid products.

here, Parham says, was to create a brand story that was unique to Discovery Channel but broad enough to accommodate individual members of its family.

He explains: "In a store, you might see a TLC poster there, promoting a series, and the Discovery packaging would have to feel comfortable with it."

From the beginning, Parham and his design team were influenced by what Discovery was doing on-air. They wanted to get at the essence of the Discovery way of doing business—a special sense of energy, excitement, and color—and translate that into packaging.

"We studied many different retailers to see how they presented their brands, but the Discovery brand was already distinct. We decided that the channel should be the driver for the feeling and tone of the package," Parham says. The channel's naturally "smart" sensibility could be graphically translated into "smart, simple, and clean."

Parham Santana first concentrated on establishing a universal color palette that would be gracious hosts to all consumers, no matter their age, sex, or interests. An eight-color palette of white, silver, red, orange, yellow, green, blue, and black was suggested. This extensive palette was selected for its flexibility. For the adult market, the main colors would be blue, green, and red, with yellow, orange and lighter shade of the same blue specified for accent colors. For children, the palette was flipped: The main colors would be yellow, orange, and the lighter blue, whereas accents would be pulled from the deeper, adult palette.

Women's product packaging colors pulled from the children's palette, but in a more sophisticated way. "A stereotypical, pastel take on the women's market would not have been appropriate: Discovery is just not pastel anyway. Market studies showed that women really identify more with a vibrant color palette," Parham says. As a result, the women's palette uses the Discovery Kid's bright colors, but in a more sophisticated way.

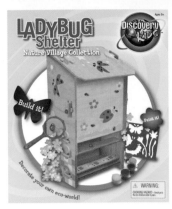

The design of the Ladybug Shelter illustrates how Parham Santana balanced many different package components. Here the designers have used bursts in the forms of a paintbrush and an arrow, and they have placed a white glow behind the product to make it pop off the box.

The logo is moved to the upper right-hand corner to make it more visible to shoppers. The glow was removed, being deemed difficult to produce for the number of products that the line contains. The "bursts" are simplified here, again to simplify future production.

To make the product jump off the box without a white glow, the designers introduced a "Discovery ring" graphic and placed the product on top of it. More icon "bursts" are introduced.

This comp shows a type variation that was eventually used in the final design. The description line was also moved above the title so it wouldn't run over the product image. Also, the "Discovery ring" now has two outer rings.

More type variations.

In this design the final "burst" choice emerges. The swirl would be easier for the designers to execute.

The designers also experimented with using a white front on the package, to make it stand out in the retail setting. The solid front also starts to "color code" product groups.

A busier type treatment, but one that is still consistent with the adult packaging program. (Both use Clarendon.)

The designers felt that this type treatment was too busy. They tried a gray orbit pattern, which was more neutral and less obvious than color orbit patterns.

In addition to creating a unifying color palette, the Parham Santana designers also used silver as a background in several ways. On some packaging, a solid silver background is a simple, classic design accent that allows the product photography to star as hero on the box. On other designs, a blueprint-like "tech" pattern is printed in silver on a white background. On children's packaging, where vibrant color is commonly used as a background color, an "orbit" pattern that complements the "tech" look is reproduced. Placed side by side, the familial connection between the silver "orbit" and "tech" backgrounds is evident.

Other connecting factors were the typefaces the designers specified. Clarendon Light and Trade Gothic Condensed were chosen, a serif and sans serif face, respectively, that are recognized for their friendly, energetic nature. The copy, too, has the same feeling, says Parham. "The voice is informative, but friendly," he notes.

Parham Santana also invented Discovery Facts(tm), which appears on every package back. This panel enhances the shopper's appreciation of the product while providing "current and mind-boggling truths about the world."

In the end, the designers provided their client with a set of building blocks with which any product or customer could be addressed. The system is now being applied to hundreds of SKUs by various manufacturers, who now have the visual information they need to stay within the Discovery brand parameters.

The new package design also permits every product in the Discovery Channel universe to live comfortably together on the shelf. Note how these TLC, Animal Planet, and Discovery Channel DVDs bear a strong family resemblance.

No details were overlooked, even the gift wrap incorporates the "tech" pattern for a seamless presentation.

Imagine being faced with **redesigning** 150 clamshell packages. This was **the unenviable task** faced by designers at Portland, Oregon–based **Sandstrom Design** when they began working with **Gerber Legendary Blades.**

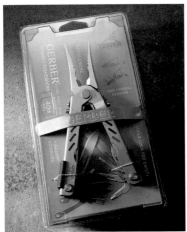

Designers at Sandstrom Design, through clever package architecture, discovered how to create clamshell packaging for Gerber knife and tool products that is safe, attractive, eminently shippable, easy to display in the store, and, in terms of simple style, miles beyond the competition.

Mention clamshell packaging to most designers, and a weary look will come over their faces. These hard plastic containers are a necessity for many products, whether they provide protection and an easy display method, discourage shoplifting, contain multiple pieces or whatever. Unfortunately, they can be as dull as they are practical. Plus, they can cause even a quality product to look somehow chintzy.

Even more challenging than the dull nature of the packaging, Sandstrom project director Kelly Bohls, creative director Jon Olsen, and their team had to deal with 27 different graphic looks within that population, the result of going from an in-house at Gerber, to a design group at Fiskars, which bought the company in the late 1980s. Here and there, an American flag or a photo would be added by different people, until the entire line had an uncoordinated feel.

The multiple clamshells were not only inadvisable from a design and identity standpoint but also expensive to produce and a nightmare to warehouse, Bohls points out. A standardized box would have accommodated many of the SKUs, which also included other tools, such as its 700 Series Multi-plier. But Target and other large retailers demanded clamshells in return for shelf space, so the designers would have to find another way.

But they didn't abandon the idea of a box altogether, Olsen recalls. They considered using corrugated boxes that were vacuum sealed in plastic, as well as making the boxes out of a thicker but still transparent kind of plastic.

"Then we started looking at different forms of boxes, boxes that could accommodate 5 to 10 different SKUs. We knew that retailers love clamshells for their visibility, durability, and security, so we tried to figure out how to use the clamshell in a new and different way."

A more interesting shape, no matter what that shape is made from, would be more intriguing than the awkward shapes of the previous clamshells. So why not shape the clamshell around a box? The product would still be secure and easily displayed, but it would have stronger, more elegant personality when displayed against the clumsy packaging of competing products.

That's when the design team began developing a board-stock tray—essentially, the J card—that would form the interior box. Most knife products fold but are displayed open. When open, they have a cavity in their backs into which the die for the cardboard could be fitted. It would hold the knife in place inside of the clamshell. But for added security and for a striking design touch, an orange rubber band was wrapped around the knife and

Custom Chip / corrugate board -
A. Common clamshell
B. Shrink wrapped

1a.

Custom Chip / corrugate board -
A. Common clamshell
B. Shrink wrapped

1b.

Custom Chip / corrugate board -
A. Common clamshell
B. Shrink wrapped

1c (Back).

Custom Chip / corrugate board -
A. Common clamshell
B. Shrink wrapped

2a.

Metal clip

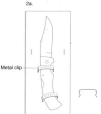

Custom Plastic tray -
A. Common clamshell
B. Shrink wrapped

2b (Back).

Custom Plastic tray -
Inside common clamshell

Custom Chip / corrugate board -
A. Common clamshell
B. Shrink wrapped

3a.

Custom Chip / corrugate board -
A. Common clamshell
B. Shrink wrapped

3b.

Common Chip / corrugate board -
A. Common clamshell
B. Shrink wrapped

4a.

Common Plastic tray -
A. Common clamshell
B. Shrink wrapped

Common Chip / corrugate board -
A. Common clamshell
B. Shrink wrapped

4b.

Custom Plastic tray -
Common clamshell

5a.

Corrugate box -
A. Common clamshell
B. Shrink wrapped

5a.

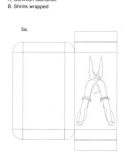

Corrugate box -
A. Common clamshell
B. Shrink wrapped

5b.

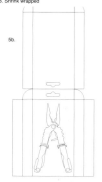

Custom Plastic case -
Custom Foam insert

6a.

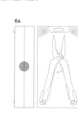

Custom Foam insert

6b.

The various products that Gerber offers spawned 27 different looks among 150 different clamshell packages. So the Sandstrom designers spent a great deal of time thumbnailing designs that would accommodate multiple SKUs. They even looked at ideas that revolved around corrugated boxes and vacuum-sealed plastic.

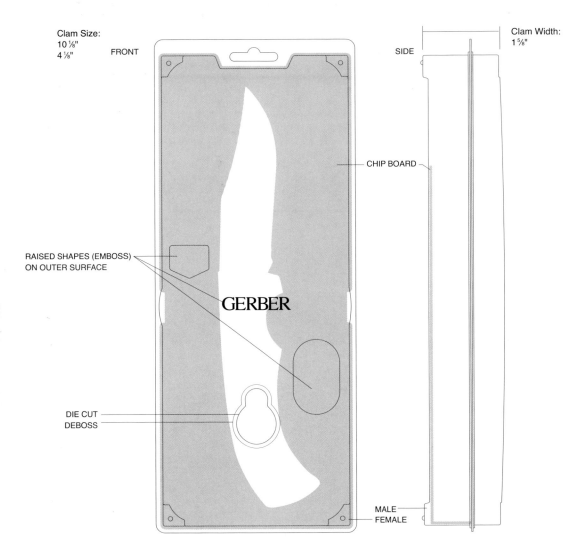

Clam Size:
10 ⅛"
4 ⅛"

FRONT

SIDE

Clam Width:
1 ⅝"

CHIP BOARD

RAISED SHAPES (EMBOSS)
ON OUTER SURFACE

GERBER

DIE CUT
DEBOSS

MALE
FEMALE

The finished clamshell design had an open area where shoppers could actually touch the tool, as well as several debossed areas that directed people to important information on the enclosed J card. In addition, the packaging was designed so the "feet" on the back of one package would sit neatly into the front of the package below it when they were stacked. This feature prevents packages from shifting during shipping, which had caused damage in the original designs.

the J card. The color is a nod to the predominant color of many a hunter's clothing—blaze orange. In the plastic of the clamshell directly above the rubber band, the designers debossed the Gerber name, and this casts a shadow onto the orange field, creating a three-dimensional effect.

Another problem that the designers addressed was the way the previous clamshells scratched and scarred each other in shipment. They designed feet into the bottom of the new box, so the clamshells are stackable, but do not rub together or shift during shipping.

Other new features included finger holes in the clamshell where shoppers could touch the knife handle, which historically had proven important to making the sale. The designers also debossed several shapes in the top of the clamshell that direct people to important information on the J card, such as the length of the blade or the number of the series.

The J card is slate blue, which is quite different from the wild patterning, American flags, and alligators that the competition uses. The look is technical and precise.

"Most products in this category seem to have to scream that this is a hunting product," says Bohls. "The people shopping for this already know what it is, though. We didn't have to make it look like a hunting knife: We wanted people to know that it is a precision instrument."

"We made the product the hero and didn't add too much design on top of it," adds Olsen.

In the retail setting, the combination of the orange rubber band and the slate blue backer card is strong and dramatic and provides a unique branding statement for the category. In particular, the horizontal orange stripe draws the eye immediately. There's no question about which products are Gerber's.

Amazingly, the designers were able to reduce the number of Gerber clamshells from 150 to only 6, an enormous, long-term cost-savings for the client, even with the price of the new dies. "The boxed product looks much more sophisticated than the competition, it is engineered to fit the product, and it functions effectively for retailers," says a proud Rick Braithwaite, Sandstorm Design president, of his group's efforts.

⬙ This close-up of the clamshell design shows how the packages fit together when stacked. It is both a functional and highly dynamic design.

Greg Norman Estates is definitely a case of, "If you build it, they will come" or **"If you have it, flaunt it."**

Tucker Design applied a logo that was normally used on clothing and golf gear onto a new line of wine. Greg Norman Estates has proven to be enormously popular, inspiring a new golf course in Australia, a possible vineyard, and incredible sales.

In 1999, Ted Kunkel, the CEO of Foster's Brewing, the company that owned Mildara Blass (now Beringer Blass), informed the chief executive of the wine company that his friend Greg Norman "wanted to have his own wine label" and that Mildara Blass was going to make it happen.

The idea was treated as something of a joke by the marketing people at Mildara Blass, but as the order had been given, a brand manager was appointed to launch and guide the Greg Norman Estates brand. Barrie Tucker, creative director of Tucker Design of Adelaide, South Australia, was briefed on the project and given the challenge to create the Greg Norman Estates brand identity and packaging design.

The marketing staff at Beringer Blass didn't think the concept would fly—particularly because there was no actual vineyard—but they were soon proven wrong. The initial vintage of 20,000 cases tentatively released in the United States sold out in about one month. The second vintage took only three months to sell out.

Today, the popularity of Greg Norman, the quality of the wine, and the distinctive use of the personality of Norman's Great White Shark identity with the design firm's graphics all combine to create a popular product.

Greg Norman's multicolored shark logo is well known the world over in sports and sportswear circles, and translating it to a wine product could not have been more of a stretch. In fact, the company that controls the merchandising for the brand (Reebok) asked Tucker to only use the logo in gold. Eventually, though, with the help of the Beringer Blass marketing people, he convinced them to allow the use of the color logo.

All but the sparkling variety in the line was already bottled when the design project was commissioned, so Tucker did not get to choose the shape of the bottles. He would have to accommodate several different bottle shapes and decided to keep the labels fairly conservative with a controlled elegance.

"Overdoing the shark logo would be garish. We decided to use the logo mildly on the label itself, but use it more boldly at the neck to catch attention in store," Tucker says.

The idea of the brand identity was based on the use of the well-recognized internationally established shark icon. Barrie Tucker believed that the Greg Norman wine brand had to have the use of that image to truly succeed. The Greg Norman signature inclusion was also a must to offer consumers (especially the golfing fraternity consumers) because it suggests authenticity from Greg Norman and creates the illusion of an exclusive personalized autograph.

GREG NORMAN ESTATES

™

SHARK METAL PIECE
163 MM FROM BOTTLE BASE

GREG NORMAN ESTATES

·RESERVE·
1998
McLaren Vale
Shiraz

PRODUCT OF AUSTRALIA 750ᵐˡ

GREG NORMAN ESTATES
LABEL

115 MM FROM BOTTLE BASE

RESERVE LABEL

50 MM FROM
BOTTLE BASE

△ The three main components of
the new design would be the
name of the new brand; a color
version of Greg Norman's Great
White Shark logo; and Norman's
signature.

◁ A hallmark on several bottles is
the split label, which allows the
color of the bottle to show
through. Here stickers are used
to apply the shark logo.

▽ The necks of some of the bottles
have a string of colorful sharks
swimming around it: It is such a
recognizable mark, that that is
the only identification needed.

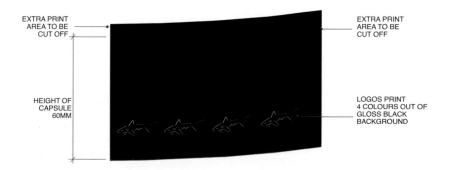

EXTRA PRINT
AREA TO BE
CUT OFF

EXTRA PRINT
AREA TO BE
CUT OFF

HEIGHT OF
CAPSULE
60MM

LOGOS PRINT
4 COLOURS OUT OF
GLOSS BLACK
BACKGROUND

It was deemed important to present a serious wine "face" to the brand. This was achieved with clean typography and an uncluttered layout, supported by the Greg Norman signature and the understated use of the shark icon. It is envisaged that any line extensions to the brand can be created using this simple but striking formula.

For the Chardonnay, Merlot, and Shiraz bottle designs, Tucker created a split label that highlights the brand name, which is contained in a smaller band above the larger variety label. The Reserve bottles use the same design, but their labels are black. The full color shark logo swims around the bottle neck and is presented on a hand applied metal label at the front of the Reserve bottle with the shark logo ceramic printed in color on black. The Reserve product was packaged in a handmade, black paper-covered cardboard box with the brand screen printed on the lid.

Tucker knew the designs would have to be understated because the demographics of the potential customers was wide, ranging from a Greg Norman fan who knew nothing about wine to a wine fan who knew nothing about Greg Norman.

"We had to make the product understandable to a wide range of people—the design couldn't be shocking," Tucker explains. "It also had to look like a serious wine in order for it to be internationally acceptable."

The wine and its design have been so successful that the line has grown in volume by well over ten times its original annual sales budget. New product extensions are planned at various retail price levels.

The Sparkling wine bottle was created with the Greg Norman signature ceramic printed in gold directly to the bottle with the brand and variety label printed in black low on the bottle. This design presentation was formulated to emphasize the bottle's elegant form, while highlighting the Greg Norman 'hero' signature as a status symbol.

Gift-boxed champagne glasses were also designed, with the signature printed also in gold on the outside surface of each glass and on the gift box lid, and reinforced the quality brand cues at the time of the Sparkling wine release.

Apart from branded glassware, in-store promotional cards and restaurant tabletop cards were produced bearing the brand identity. The cards were backed with a color photo presentation of Greg Norman holding two of the commercial wine products.

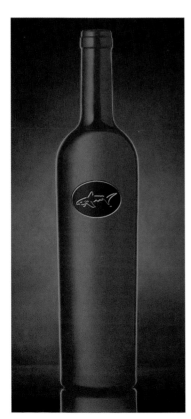
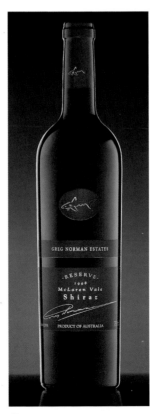
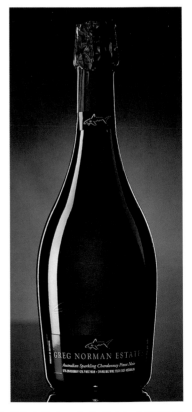

⬡ This concept drawing for the Greg Normal Reserve line shows how a hand-applied metal plate can also be used to extend the brand, but with an even more premium feel.

⬡ Despite the fact that Barry Tucker had to work with the bottle shapes the client had already selected, he was able to form a recognizable family resemblance between different lines of the new wine.

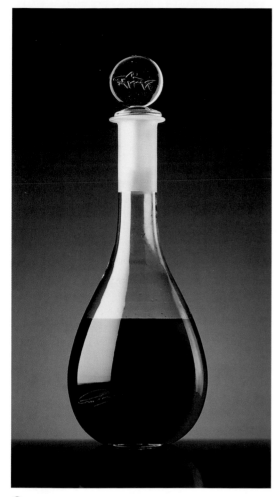

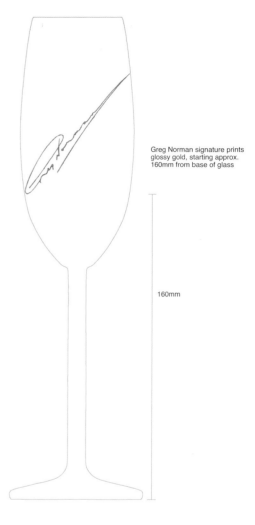

Greg Norman signature prints glossy gold, starting approx. 160mm from base of glass

160mm

⬡ The new design was also carried into gift and glassware.

For the release of the Greg Norman Estates Reserve wine, Barrie Tucker created a unique decanter especially for the occasion. The piece was mouth blown by Australia's foremost glass blower, Nick Mount, in an edition of 110 for the occasion. The decanter had the shark logo embossed on the stopper and the famous Greg Norman signature was etched into the bowl of the decanter.

The brand identity and packaging has been so successful that visitors from the United States have even traveled to South Australia to visit Greg Norman Estates, which, of course, still does not exist as of the time of this writing.

Reports of these visitors reached the wine brand's marketing manager, and now there is a move afoot to develop an actual place where people can visit and shop and, perhaps, stay in a quality hotel. A Greg Norman–designed golf course is now open.

The whole project has become a huge success, says Tucker, which is especially gratifying because the brand was nearly laughed off in the beginning. About 80 percent of Tucker Design's work is creating wine packaging for wineries around the world, and the challenge of constantly reinventing the category is exciting, Tucker says. Greg Norman Estates is a good example of how the entire notion of who might enjoy wine—the product's customer base—can also be reinvented.

Perrier is a brand known around the world, yet it is a beverage caught between two **better-known** product categories. It is not a **simple bottled water,** nor is it a soft drink.

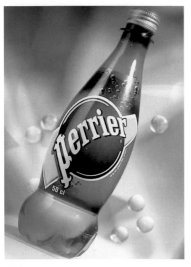

⊗ Dragon Rouge revitalized Perrier's image not only by subtly redesigning and reshaping the product's familiar glass bottle (before and after are shown here, left and right, respectively) but also by creating a brand new PET bottle that would appeal to consumers on the go.

Instead, it is a sparkling mineral drink that is to be enjoyed as an aperitif.

In the last 20 years, soft drinks and bottled waters had definitely encroached on Perrier's customer base. It was time to take a look at revitalizing the classic brand and reemphasizing the drink's unique nature. Perrier asked Dragon Rouge of Paris to give the brand a new style, but one that was closely related to the essential, refreshing, classic nature of the product and its packaging.

One thing the company wanted to do was create a PET bottle that was more portable and certainly less breakable than the traditional green bottle. Dragon Rouge used the glass bottle for inspiration, but also looked at soft drink and water bottles for refreshment cues.

"It was very important to develop a new plastic bottle to encourage nomadic consumption. The glass bottle is for the table. The plastic bottle is for out-of-the-home consumption—from vending machines, small shops, and other places you don't want a glass bottle," explains Sophie Romet, associate managing director of Dragon Rouge.

The shape of the new plastic bottle is still recognizable as Perrier. Its shape is similar to the original, 11-ounce (33 cl) bottle, and it even reinforces the link with the historical bottle shape. Its molded base, a technical necessity, was exaggerated and enlarged with the idea of making it look like a rocket, not just a simple bottle.

Green and yellow are strongly associated with the Perrier brand, so naturally, these colors were used on the new bottle as well. The plastic is a strong green color; the final label uses the same mix of green and yellow as the original label. The type on the label also has a new orientation: It angles up and to the right to suggest motion and excitement. All of these components added up to a renewed vision of Perrier's traditional graphics.

The glass bottle was also reexamined. The classic shape of the bottle was so recognizable as to be nearly sacrosanct, and the type on the label is so closely identified with Perrier that consumers can recognize it as property of the brand even when it is used to spell out another word.

"We couldn't make a revolution with the glass bottle, but we could reinforce its uniqueness. People always remember the color of the glass and the label, so we increased the color values on these," Romet says. The design firm also changed the bottle shape, although slightly. Over the years, the bottle shape had become more and more industrial. Although it was easier to manufacture, it was slowly eroding the brand equity. "We found the original bottle from 1910, which was much rounder, more like a weight. So we went back to this rounded shape, which after all, is not just a normal bottle—it is the Perrier bottle," Romet notes.

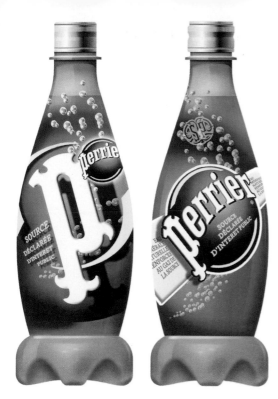

The new PET bottle was designed to look more like a rocket ready to take off than a standard bottle, which made the container more dynamic. A strong green is used for the plastic, and various type treatments were built off of the glass bottle's label design. Perrier's custom typeface is recognizable as such, so the Dragon Rouge designers took care to emphasize these forms even more.

The Dragon Rouge team thought of another clever way to extend the brand without completely reinventing it: They created collector bottles for special occasions. These sketches are from the trio of bottles they created for the new millennium.

There are two labels on the glass Perrier bottle—one at the top, which focuses on the brand, and one on the lower part, which reinforces the source of the product and what it is. Here the brand was made stronger by slightly reworking the typefaces and by making the green and yellow colors stronger. The green glass used to produce the bottle was also made stronger in color.

The Dragon Rouge team looked for other ways to revolutionize the brand. The designers suggested repackaging the existing product in event bottles that could be issued for holidays or other special occasions.

The client loved the idea, and soon new bottles were being issued every six months—one for the French Open-Roland Garrow, of which Perrier is a sponsor, and the others for New Year's Eve events—each one based on the classic Perrier bottle shape. Collectors loved the concept as well: For example, three bottles were designed for the new millennium. Each carried the same style of swirling, celebratory graphics, but each was a different color: White represented air, blue represented water, and green represented life and related to the Perrier communication claim. Each color, although not directly related to the original green and yellow color scheme, was still representative of the sparkling water product: H_2O equals life.

"People began collecting the bottles immediately," Romet says. "Perrier gained 1 percent market share in one month. The design spoke of a fantasy world that people like to dream about."

The latest step in revitalizing the brand was to introduce an entirely new product—not a flavored Perrier, but a new drink altogether, called Fluo. It was a drink conceived to meet a younger person's expectations, but it was not too sugary or falsely aromatic. Three recipes were developed—cherry, mint, and lemon—each low in calories. The new drinks were discreetly endorsed by the Perrier brand, mainly through bottle shape, which is the same as the one used for the PET Perrier product.

"It has all of the qualities that Perrier delivers, but Fluo has its own stories and special message for a younger set," Romet explains. The drinks are brightly, almost fluorescently colored— hence the name—and the design of its labels was equally

strong. Anyone placing the plastic bottles of the Perrier and Fluo brands side by side would see a familial relationship, but each is independent from the other. "The new product stretches what Perrier can be, but it does not take equity away from the mother project," she adds.

Fluo was introduced in France's most fashionable clubs and restaurants in late 2002, and quickly became the most trendy drink of the year.

A brand with strong heritage can remain contemporary without losing its essence, Romet says. "Innovation is the key to long-term success, as long as it is respectful of the brand values. It is their interpretation that may differ according to the core target and the product's specific nature," she notes. Today, Perrier is back to profitability after a long period of "convalescence" and is ready to continue its success.

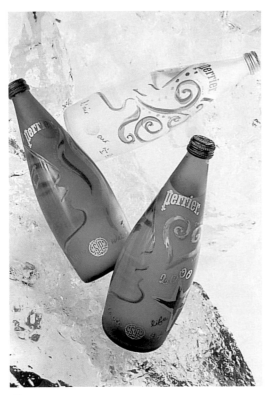

The finished designs for the millennium celebrations. Consumers latched onto the concept of collectibles immediately, and the project was an enormous success, almost overnight.

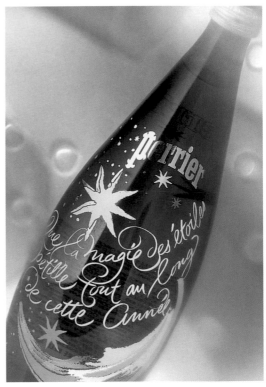

Another collector Perrier bottle designed by Dragon Rouge for New Year's 2003.

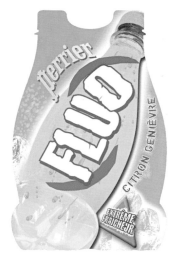

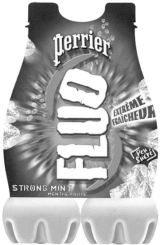

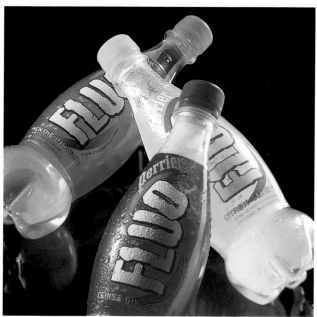

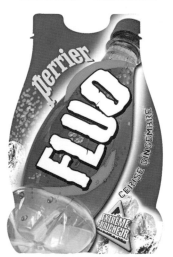

Another step in revitalizing the brand was to introduce a new product called Fluo, a brightly colored, naturally flavored drink aimed at younger consumers. It used the same bottle design as the core brand's PET bottle, but its label design is different. It is bold and brash, and it speaks of movement and fun. The finished Fluo designs successfully speak to their target audiences.

Paxton & Whitfield is the oldest **cheesemonger** in the United Kingdom, having **been in business** for more than 200 years. Its **products are of the finest quality,** and it has an **unparalleled reputation.**

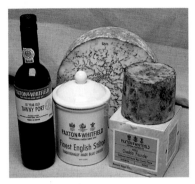

Paxton & Whitfield has been in business as a cheesemonger for more than 200 years. It is a brand of unparalleled reputation, but it was also apparently a bit intimidating for some customers who felt they didn't have the knowledge they needed to come in and make an educated purchase. Stratton Windett helped the firm make it more contemporary and broaden its appeal through new packaging.

The brand is even the holder of three royal warrants, which means that it supplies its goods to the royal household, an unmistakable mark of standing.

But even with all of these pluses, the brand was not growing. Its customers were generally mature and wealthy, but even more crucial, they knew what they wanted. They were confident in their choice of cheesemonger and their shopping experience. Purchasing truly fine cheese, it turns out, can be as intimidating as shopping for wine, especially if you are not knowledgeable about cheese provenance. And the original packaging for the product was doing nothing to invite new customers into its unique shop, located right off Piccadilly in London.

"There were many people who would not enter the shop to buy cheese because they were not confident about what to buy. All the cheese is cut personally for individual customers in the store, which means you have to commit to a conversation with the cheesemonger behind the counter," explains Peter Windett, principal of Stratton Windett, the firm that was brought in to repackage the brand and broaden its appeal.

The plan was two-part: First, the store itself would be redesigned so that a small range of prepackaged cheeses and grocery foods could be sold in a self-purchase environment: Those who were in a hurry or who did not want to converse with the cheesemonger would no longer have to do so. Modern shop fixtures were to be introduced and contemporary colors and materials were selected to brighten the store.

Second, the packaging for all products would be remade to be more friendly, descriptive, educational, and appealing to a broader base of customer. The intention was to produce a product range that would be sold in premium stocklists as well as the Paxton & Whitfield shop.

"The existing packaging was about 10 years old, and it was all printed in a tasteful dark green and cream. But it didn't make a bold or individual statement about the company. It didn't indicate that its main product was cheese," Windett points out. "In fact, the packaging could have been for a wine merchant or florist—actually any establishment that was a tasteful purveyor of goods. The identity needed to be more cheese-specific."

The store already had a lot going for it: an excellent reputation, the royal warrants, a distinctive storefront with three-dimensional gilded letters in a desirable part of town, a brand with plenty of personality, and a loyal customer base. Stratton Windett needed to find a way to communicate all of these pluses to the new consumer while still honoring and not alienating the existing customer base.

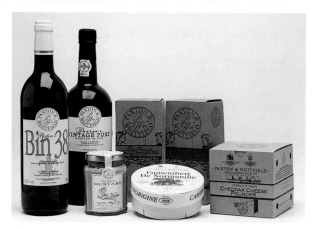

This is a selection of the client's packaging before the redesign project. The products were not unified with a single and consistent look.

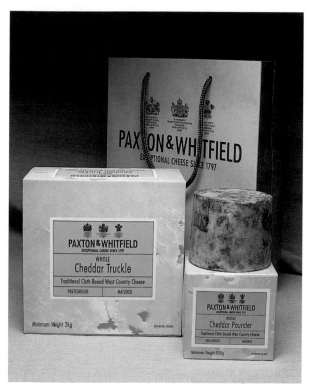

Here are two mockups of cheddar cheese packaging that were considered. These show the development of a color palette and of textured backgrounds that would be used for product identification.

They began by studying the gilded sans serif letters on the store's front. It said a lot about the store's personality, and in keeping with updating the Paxton & Whitfield's identity, it felt modern in a traditional manner, rather than the serif type that was being used throughout the store's existing system. The designers decided to bring the face, a three-dimensional Grotesque-based font, into the new design for packaging as the main logotype.

For example, on the wrapping paper and transit boxes that were used in the retail setting, the original design repeated a Paxton & Whitfield seal over and over. On the boxes, an uninspired rectangle repeated the store's name, showed the royal warrants, and delivered the matter-of-fact tag line, "Cheesemongers since 1797."

In the redesign for these pieces, the designers changed a number of things. First, they freshened up the color scheme by adopting a cheese-related palette—a cheddar yellow and a gray-green, representing the cheese rind, were used on all retail-related packaging and supplies. The wrapping paper carries an unexpected bit of whimsy: a repeat pattern of romantic cheese-type names, and the business cards are shaped like a wedge of cheese.

The tag line was also strengthened. "We changed it to 'Exceptional Cheese since 1797.' It's a punchier statement that they have to live up to. This is not just any cheese you could buy at the supermarket: This is exceptional cheese from Paxton & Whitfield, a mouth-watering, seasonally changing selection, matured to perfection, and individually cut to any size," he points out.

The boxes received even more specialized treatment. The box that is used to carry Stilton cheese, for example, incorporates the distinctive veining texture of the cheese—as it would look when cut—and is used as wallpaper to cover the container. "It's treated in an abstract manner, like a pattern, but it is specific to Stilton," he explains. The boxes for cheddar cheese are printed with the distinctive cheddar texture; other boxed cheeses incorporate photographs of the cheese rinds, giving visual clues to the cheese

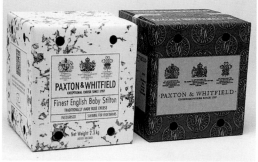

Before (right) and after (left) designs for the Stilton product. Although the previous box made plenty of supportable claims, it did not actually say what the product inside was like. The designers wrapped the box with the Stilton texture and added information about how the cheese could be enjoyed.

type inside and differentiating one cheese from another, making it easier for the customers to locate what they are looking for.

On all boxes, more information is added as an educational service for consumers. When is a cheese ripe and ready to serve? When should it be taken out of the refrigerator in preparation for serving? Which foods should the cheese be served with? These are questions that might be asked of the cheesemonger, as well as questions that may have previously caused a consumer not to buy a certain variety: Some buyers just don't want to seem ignorant when it comes to something so apparently commonplace as cheese.

"In all packaging, past the main title of the product, we are trying to bring out salient features of the products—whether it is vegetarian-appropriate or pasteurized, whether the rind be eaten, how it can be used in cooking, what wines can be served with it, and so on—so that consumers are getting real information about the diversity of cheese. There is also a small booklet underway that gives even more detailed information on cheese types, producers, and recipes," Windett says.

The store also carries a number of other foods and beverages that might be served with cheeses, such as jarred chutneys, mustards, biscuits, crackers, and wines. The packaging for these companion products also needed to be addressed.

The bottles in the original scheme bore little familial resemblance to each other. Statton Windett designed a simple label format that could be applied to any bottle shape, at any place in the bottle's height, and still visually relate one to the others. Across the board, the redesign is much cleaner, more simple, and decidedly more modern, while giving appropriate visual product category clues.

The biscuit boxes were originally made from a stiff corrugated board that was functional but not terribly emotive. The designers decided to apply the texture of the food here, as they did with the cheeses, but in a slightly different manner. For this, they created grainy photographs of the crackers inside and used these as all-over texture for the new boxes. A window in the front of each box allows the shopper to see the product inside.

The same labeling and texture concept was used on jars for products as disparate as jarred olives, pickles, and goat cheese in oil: An abstract photo is used as texture on part of the label. When differentiation is not needed—such as for jarred honeycomb, which is recognizable through the glass jar—the photo is not used.

This was an enormous project to manage, Peter Windett says—72 products, a new corporate identity, 16 suppliers, endless food safety regulations, and ongoing print and production management.

"With the various products all demanding different packaging containers, materials, shapes, and sizes, the application of the design concept across the range has to develop organically, to grow to suit each product group or type. It is not possible to rigidly apply a constant brand application," he says. Changes and refinements were made right up to the last minute. Stepping back and looking objectively at each product or category and its relationship to the whole sometimes required that.

"The criteria was always to emphasize their point of difference—from the customer's point of view," he adds.

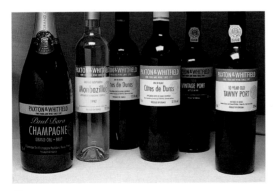
Mockups of different alcohol-content products show a direction toward strong and consistent branding while retaining the personality of each product type.

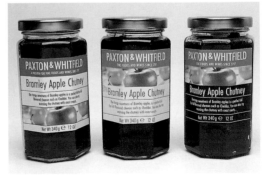
Jarred products presented different challenges. Here the designers explored alternative positions for type and illustration, as well as the use of different materials. Eventually, a clear PVC was selected because it provided the best product visibility.

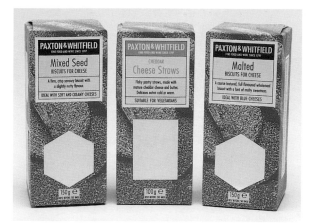

⊗ Another exploration, this time for the biscuit packaging. As on the cheese boxes, the designers wanted to wrap the box with the biscuits' texture, so as to give the consumer a better idea of what was inside.

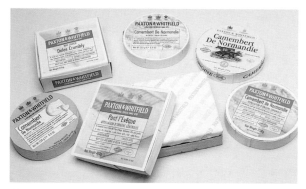

⊗ The top right package shows the client's original design. All other designs are explorations for the new design, starting at the lower left, bright yellow sample and proceeding to the right to the final design, with used soft, textured photographic images.

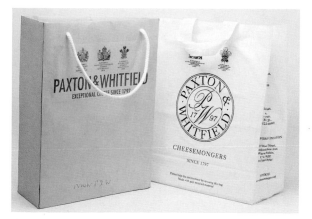

⊗ The original concept for the shopping bag showed many different types of cheeses. This bag would have been paper for the best printing reproduction, but ultimately, paper was not deemed to be a good choice: It had to hold a heavy product, and it was easily weakened by rain.

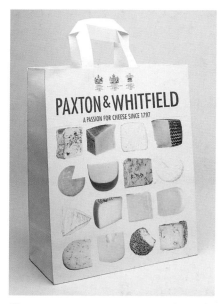

⊗ The final bag design was printed on polypropylene for added strength. The softer photographic image prints well on this material.

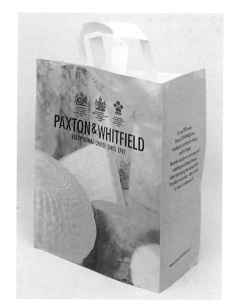

⊗ The designers also created a second bag for trade promotion packs and public relations purposes. When compared with the original packaging, it's clear how much the packaging system and identity has changed.

AG Hair Products had become a victim of its own success. It **started as a small company in 1991,** and after more than 10 years in business and **expanding its line from 4 to 28 products,** the brand needed coordination.

After 10 years in business, AG Hair Products had grown from 4 to 28 products, and from an orderly branding system to a hodgepodge of colors and package shapes. Dossier Creative reorganized the brand by means of its packaging.

With healthy pockets of business in Australia and the United States, there was plenty of room for expansion, but all of the company's packaging would have to be brought onto the same platform first.

Don Chisholm, creative and strategy director for Dossier Creative of Vancouver, British Columbia, describes Advanced Group Hair Care, the client's name when his group began working with it in 1998: "AG is like a cosmetics company, but instead of making over your face, they want to help you make over your hair. Their products are designed to give you the best-quality hair care. The company spends an enormous amount of money on high-quality ingredients: Each product is organically driven or contains very few chemicals," he says.

The client's goal was to relaunch itself into the U.S. market with a new identity, while maintaining existing clientele. The company's color-coding system had worked well when its product line was smaller, but now it had become a confusing mix of shades on the shelf, far too many colors for the customer to remember: This would have to be remedied, Dossier Creative advised. Also, the logo needed to be redone, ideally to accommodate the new name the design firm was suggesting: AG.

"The client was understandably nervous about changing its identity: They had an $18 million business they didn't want to upset," Chisholm recalls.

Once the client was convinced that the "AG" moniker would have much better customer recall than "Advanced Group," the Dossier team could begin working on a shelf presence for the brand, which is only available through salons. AG shampoos cost from $12 to 14, whereas styling products range from $15 to $26, which was in line with other salon products, but still pricier than retail store brands. So the new packages needed to look upscale.

Dossier suggested that the client organize its products by the existing 34 subbrands—such as Fast Food, Tech One, or Plastic—rather than by category—shampoo, conditioner, and so on. This idea was also accepted.

In one early design, the AG symbol was anchored by a circle or umlaut, to give the product a European feel. A system of dots formed matrixes and, in turn, letters, such as "V" for "volumizing." A similar trial was more typographically based, and a completely different experiment used photography. With this design, the photos would literally show thick or thin hair, or different styles that can be achieved to explain what the product was for. This design would also have a stainless steel band around its top.

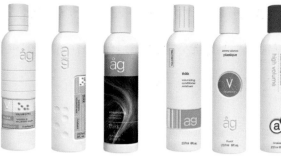

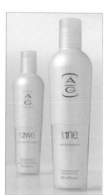

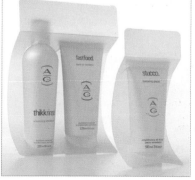

The design, Dossier and the client decided, would move the consumer too far from the existing system, causing confusion and potential loss of brand recognition. The change, they agreed, had to be evolutionary, rather than revolutionary.

A second round of designs was based on color coding, as AG had done in the past, but with far fewer categories—five to represent each product grouping versus one for each of the 34 subbrands. The designers experimented with such interesting effects as depressed areas in the bottle where an imprinted rubber band would sit, providing color coding and traction, and a depressed area in the bottle to hold a debossed sticker.

In a third series of experiments, the final type treatment started to be worked out. Here uniquely shaped containers with arched sides were studied. The client loved the logo and type treatments, but from ergonomic and production-cost standpoints, the more uniquely shaped bottles were impractical. But Chisholm says that these studies were fruitful in stretching the notion of what the container could actually be.

Squared-off bottles were also tried, but eventually the team decided on an elegantly round-shouldered bottle, a standard tube, and a squat jar for the final designs. "These were clean and contemporary, with an upscale, elegant shape which fits with the simple European design," says Chisholm. "The tapered shape elevates the brand, providing it with a refined sensibility and a simple Zen elegance that targets a fashionable and sophisticated consumer."

The subbrands are color coded in a subtle way, using just enough color to guide the buyer yet still maintain a cool, clean polished presence on the salon store shelf. This classic approach is a departure from the pool of competitors' packaging designs, many of which relied on novelty shapes and colors.

The white bottles were also a nod to AG's former design, but in this redesign, a pearlized white was chosen. "White is used to symbolize a lab coat or the professional formulation of the product. We stayed with white, but added the pearlized finish to give the packages a more premium feel," Chisholm says.

The tallest bottles in the line were adorned with a mysterious little extra: a plastic cap that fits onto its bottom. Right now, Chisholm explains, the cap is purely cosmetic, but in future products it may be a functional part of the product, used for mixing or measuring. The frosted, translucent cap on the tube and silvery lid on the jar mimic the subtle shine of the bottle's seat.

"Color coding has been a huge part of AG's business, and this new design still allows consumers to 'cherry pick' what they want, following the 'prescription' of their stylist," Chisholm says. "But with this system, consumers will have an easier time seeing the products on the shelves and gravitating toward and remember the subbrand they prefer."

⊘ This design was anchored by an umlaut over the letters "AG." A system of dots formed a matrix that, in turn, formed letters, such as V for "Volumizing."

⊘ This design incorporated an indented area where a sticker, printing, or even an imprinted rubber band could sit.

⊘ Although the designers liked this round of designs, it proved to be ergonomically inadvisable: The bottles were hard to hold onto, especially when wet.

⊘ This trial showed how relating the line through subbrands would work. Although the Plastique line, Waxx line, and 1ne lines would all have a distinctive look and color, it is apparent that the three products clearly come from the same family.

⊘ One distinctive feature of this new design is that the tallest bottles in some lines have a clear plastic cap that fits over the bottom of the bottle. Right now, the cap is for appearance only, but for future products it may be functional as well, serving as a measuring cup or mixing container.

⊘ Two examples of separate, but clearly related, subbrands.

The South Australian Company Store was founded in 1835 at the inception of the then-fledgling Colony of South Australia to stimulate **the new colony's agricultural economy** and to sell the region's **unique agricultural products** to the rest of

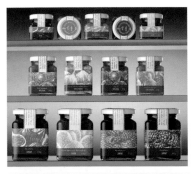

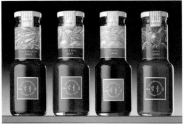

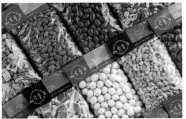

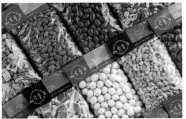⊗ The South Australia Company Store had been defunct as a registered trade name in South Australia for more than 50 years, until an entrepreneur revived the brand and Motiv Design created an entirely new identity and packaging system for it.

the world. The "mother country"—Britain—and the rest of the empire were ready markets for a wide array of products from wheat and wine to meat, wool, and fruit. But by the late 1940s, the name fell into disuse and operations were disbanded.

However, in 2001, a pair of American entrepreneurs, Paul and Kerrie Mariani, resurrected the brand, this time to be the purveyor of gourmet products from the entire state. It would be based in the Barossa Valley, Australia's premier wine-producing region. It would offer a panoply of products, from wine, chocolates, and jams to olive oils, nuts, and organic honeycomb, in 50 to 60 SKUs.

The entrepreneur knew he needed significant design assistance. He contacted Motiv Design of Stepney, South Australia, for help.

Early discussions with the client made it apparent to the Motiv team that the "Company Store" part of the name was to be both a contemporary interpretation of a heritage theme as well as a brand identity that would have to work across a multitude of packs. These might include silk-screening onto wooden slats and reproducing cello packs, wrapping paper, bottles, jars, and other types of containers using diverse techniques.

Motiv designers began by developing a distinctive logo and look that would speak of pedigree, quality, and relevance to contemporary tastes. Various concepts, including a southern-quarter compass rose, which focused on South Australia's geographic location, to variations of a round, badge-like or stamp-like mark. Eventually, designer Hannah McEwan developed a circular mark that included a fish, an olive sprig, cheese on a board, and a honey pot at its center. This would be used as a sort of stamp throughout the range.

"The South Australian Company Store is a showcase of South Australia's finest gourmet products, including magnificent cheeses and dairy products, produce, fruit-based products, olive oil, vinegars, bottled sauces, chutneys, conserves, honeys, confectionery, seafood products, and more. The logo illustrations were chosen to represent broad product categories and to have distinctive silhouette shapes," Hannah McEwan says.

Once the basic look of the logo had been decided upon, Hannah McEwan and creative director Keith McEwan began to explore other ways that consistent values could flow through diverse pack ranges, collateral materials, and a cobranded restaurant called the Company Kitchen. Distinctive illustration, they decided, would be an immediate visual cue to consumers. But any art used would have to be consistent in style, scale, and color palette, or it would not work.

S. H. C. S. | Logo dir directional concepts ①

emphasise the SOUTH
in SOUTH AUSTRALIA.

Compass rose southern
Quadrant to mark
South = South Australia.

enclosed panel. Quarter circle more 'modern'
Type follows forms free state compass
Quarter circle shape rose.
too.
* explore colour ways and drawing styles.

In export southern
quarter of compass also
transfers to 'Australia'

② ROUNDEL / BADGE TYPE.

Split Title ILLUST.

illustration

Square format.
Type might be awkward

inverted square
to form diamond
shape.

* This may be too traditional. Let's have a look at it in
different colour ways.

④ OPEN ROUNDEL with illustrations

The panel box looks a bit
odd with open type.

THIS looks promising
these shapes
may be tricky

Traditional illustration
style might work well.

⌂ The first step in the packaging project for Motiv Design was to create a new logo. Themes revolved around the compass rose, local produce, and history.

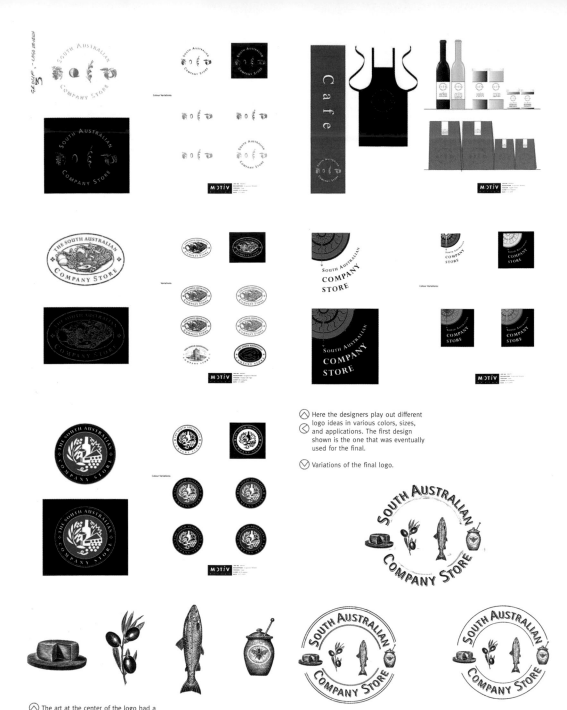

Here the designers play out different logo ideas in various colors, sizes, and applications. The first design shown is the one that was eventually used for the final.

Variations of the final logo.

The art at the center of the logo had a historic, woodcut feel, but the space between the lines is kept open so that the art does not fill in when it is reduced.

 These jar neck labels exhibit the color scheme and the open woodcut art that is now a hallmark of the brand.

The solution was to create their own illustrations. Keith McEwan, who is also a well-recognized illustrator, took on the task.

"The four original illustrations we created had a more 'open' woodcut style, which worked better at big and small sizes, and looked handmade," McEwan explains. For some packages, the label contains a full frame of lush-looking ingredients—tomatoes on a sauce bottle, raspberries on a jam jar. On other packaging, the woodcuts are portraits, such as a bunch of grapes ghosted behind type on the front of a wine bottle or a scoop of ice cream on a cold pack. On still other designs, smaller woodcut vignettes are printed on bag gussets, the band that seals the top of a cello pack.

Hannah McEwan realized that color could play a major part in how the brand would work, especially in the appeal that was created when the woodcut illustrations were overprinted or reversed out of a keynote color. It was ancient and modern at the same time. "Just what we wanted," she says.

A suite of colors working in permutations could give an attractive and distinctive point of difference to the brand and help to organize the ranges of products in flavors or varieties.

"Hannah took the logo illustrations and reversed them out of squares of color, starting with 16 to 18 variants of color until we had a palette of colors that worked beautifully with each other," Keith McEwan says of the colors they selected, which included warm ochres, misty blue, golden yellow, and deep, rich blue and green. "They are based on colors that you would see throughout the seasons in South Australia—the misty green of gum trees, the golden ochre of summer. They are not normal colors, but instead burnt or misty."

The food, too, has its own color in many cases, which adds to the mix. "A blueberry jelly next to a red chili jelly looks wonderful," McEwan says.

The new brand has a definite regional and patriotic appeal. It has been a real success, both through the Company Store and a new export catalog. "The Barossa Valley is where the wine industry started in Australia—it's very well known. It's also a very picturesque place: It was originally founded by Lutheran Germans, so there are little churches and buildings nested in the hills," says Keith McEwan. This revitalized brand lives here very comfortably.

PANTONE® 5545 C	PANTONE® 5415 C	PANTONE® 1807 C	PANTONE® 1595 C	PANTONE® 138 C

The color palette chosen for the packaging reflects the colors of South Australia: warm ochre, misty blue, rich red, and deep blue and green.

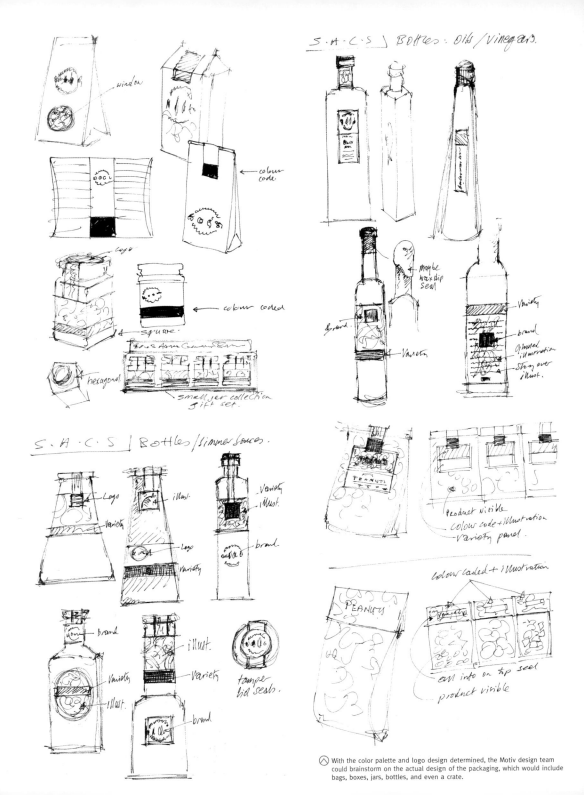

With the color palette and logo design determined, the Motiv design team could brainstorm on the actual design of the packaging, which would include bags, boxes, jars, bottles, and even a crate.

The flexibility of the system that Motiv developed is evident in this broad range of package shapes and sizes. The designers even included take-away containers in the suite, for ice cream.

Is it possible to **build an empire from a garbage can?** The founder of **SimpleHuman,** a new brand of well-made, well-designed **products for the home,** would tell you, "Absolutely."

SimpleHuman began as a company called Can Works, which produced high-end trash cans. The company grew quickly, and soon, will be expanding into everything from food canisters to small appliances.

"The client produces products to match your lifestyle. There is nothing too 'out there'—very elegant, but no extreme style. His products are comfortable, but are engineered to be innovative. For instance, the company makes its own trash bags because they fit the SimpleHuman trash cans better," explains Paul Hamburger, creative director of Smart Design, New York City. In developing the SimpleHuman brand, Hamburger and his staff were asked to help the entrepreneur not only package the existing line of about 40 trash containers but also create a packaging system that would perform equally well for all future extensions of the brand.

"At first, we thought it sounded crazy: Why not just focus on the trash cans and forget about fragmenting the brand into too many product categories? But in today's superstore environments, we could see how Frank Yang's, founder of SimpleHuman, vision of rapid growth could create areas of strong brand impact throughout a typical housewares store.

At the core of the entire Smart Design approach was a simple sensibility statement: products that are like tools for everyday living. Every bit of packaging in the SimpleHuman line should speak clearly that these are essentials for life: something to hold trash, a place to sleep, an essential for making toast. They are all products designed to make the consumer's life better, although by their definition, they might sound mundane. The packaging would have to prove otherwise in order to get the consumer to pick up the box.

The design of the packaging could not be too "out there" or say anything about extreme style. "You might think of these products like clothing from The Gap: It's well designed, but it's comfortable," Hamburger says.

Another requirement for the packaging: Because the products would be sold in large retail stores where help from knowledgeable sales associates is often scarce, the packaging would have to provide all the information the consumer would need to make a choice about what to buy. For brand consistency, that information should be treated the same way on every box.

One of the first things designer Nao Tamura had to consider was what information should be on the packaging. For example, what made SimpleHuman trash cans so good was that they were designed by engineers who were passionate about the efficiency of the

ideal positioning

FASHION / ELEGANT ————————————— HARDWARE / UTILITY

SERIOUS

SimpleHuman SimpleHuman Simple+Human

SIMPLE+UMAN SimpleHuman simple human

SIMPLE+UMAN SimpleHuman simplehuman

simplehuman™

The development of the word mark
for SimpleHuman demonstrates how
Smart Design used a matrix to eval-
uate different traits of a design.

⊘ Here the Smart Design designers considered how to graphically communicate the various features and benefits of the product. Would it fit underneath a counter? Did it open easily? Was it big enough to hold a pizza box? Did it look good? and so on.

⊘ The matrix was used to evaluate four different package designs. In which direction should the final design go? Getting closest to the center was not the goal: Getting closest to all of the desired attributes was.

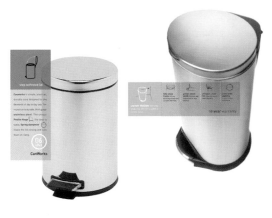

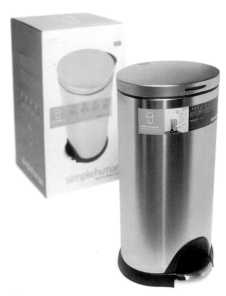

Experiments on how to convey attributes of the product.

The final package design's clean, elegant lines are a clear reflection of the quality product within.

gear mechanism that opens the lid. Although this information was too scientific for most buyers, it did translate into one customer concern: Is the product practical? Does it work well? The designers knew that buyers would also be interested in seeing the product on the box (what does the lid look like?), understanding how it fit into their lifestyle (would it fit into that space under the sink?), and gauging whether or not they felt the object was beautiful (do I like it?).

To visualize how their initial design trials met these customer needs, the designers drew a simple matrix of crossed lines with the words "practical," "lifestyle," "beautiful/design," and "product" written at the ends of the lines. Each trial design the team created could be placed on the matrix nearest to the attributes it met.

The idea, says Hamburger, was not to create a design that hit the center of the matrix, but rather to help them prioritize all attributes in a way that met the strenuous needs of a new brand struggling to become known in a crowded retail environment.

To jump-start their explorations, the designers began by considering how to graphically show the cans' various features and benefits. "Many cans have wide openings that will accept large pieces of trash, but if you say, 'Able to accept a large pizza box,' consumers can picture that and imagine the value of that benefit. This kind of explanation humanizes the products," Hamburger says.

Not every piece of information could be reproduced on every panel, so the next step would be to divvy up the type, graphics, and photos on the various panels. Splitting up the information in different ways would make different style statements, but overall, a simple style was developing: lots of white space with the product as hero on the front panel.

"Basically, we were looking at the box as a big billboard," Hamburger says.

It was here that the matrix became useful. One design clearly emphasized the product more, whereas another was completely about lifestyles and the people that lead them. As each approach was entered onto the matrix, the designers could see how each compared to the other.

One approach that combined a mix of product-as-hero, a stress on beautiful, and some amount of lifestyle attributes won out. Hamburger says it is a good philosophical match for the client.

"It's clean and simple, like science. We made sure, in our guidelines, that the proportion of the product photo to the size of the container would be consistent throughout. Even if boxes are different sizes, the amount of white space around the product photo would always be the same. This amount of white is one of the key brand signatures, immediately recognizable as SimpleHuman," he notes.

"Walking through a large store, a consumer would have a very strong brand perception of SimpleHuman," he adds. The packaging advertises the brand clearly.

When a shopper buys a pack of gum, he or she is in pursuit of the confection. **Blue Q asked a new question:** What if the equation were turned around and, **instead of the gum,** the buyer was much more interested in the pack?

⊗ **Loud Mouth Gum, by Vito Costarella**

"The idea for this design came from thinking about my sister," says Vito Costarella, a San Francisco–based designer. "I remembered a time when we were just shouting out, 'Loud mouth!' at each other."

Costarella also considered, given the prevalence of cell phones today, using images of blathering individuals on the box. But he wanted to keep the image simple and high contrast. This design also established a relationship between the mouth and the gum, which Costarella liked.

The designer says he could imagine a teen or preteen girl buying this gum to give to a friend or just to have something interesting to pull out of a purse.

Brothers Mitch and Seth Nash are the cofounders of Blue Q, the Massachusetts-based company that has already made consumers reconsider their basic suppositions on exactly what a consumable-like soap can be: Dirty Girl is the leader of the Blue Q line of personal-care products. Now, the company has turned its attention to an alternative persona for an edible consumable.

There is a Dirty Girl gum, but there are also completely new and contrary varieties, such as Gum Philosophy (which also has multiple permutations), Bad Ass gum, and Make Out gum.

The Nash brothers equate the new line of 40 SKUs of gum to buying baseball cards. "When baseball cards came packaged with gum, people didn't want the gum. They were buying the cards. That's what the Blue Q gum is: The key is the gifty package. The gum is merely a transportation vehicle for the graphics."

Think of the new products as greeting cards, but with the added benefit of a little treat—gum. Priced at $1.25 per box, the gum is affordable, fun, and certainly more novel and inexpensive than your typical, trite greeting card.

"You could buy the Total Bitch gum, for example, for yourself just to show you have a good sense of humor," the brothers say. "In almost every case, though, we imagine that the gum is being bought as a gift."

The idea to produce gum grew from the challenge of keeping Blue Q's world of consumables fresh and surprising. The Nash brothers and their team looked into other confections, such as chocolates and endless varieties of penny candy. However, the gum category stood out as being untouched and unexpected. Even better, while Blue Q's soaps and personal-care products generally sold only in certain types of specialty stores that tended to be spaced out geographically—retailers don't want to carry the same products as their neighbors—gum could be sold anywhere and is inexpensive enough to be a successful impulse purchase that consumers come back for again.

So the Nash brothers contacted 10 talented artists and designers from across the country, gave them lists of ideas that might be translated into a gum variety, and let them run with the concept. All they asked was that each package design have "pop from the shelf" pizzazz.

"It is cool to be in an industry that is so influenced by the impatience of the consumer," Mitch Nash says. "The public's appetite for newness is the only sure constant."

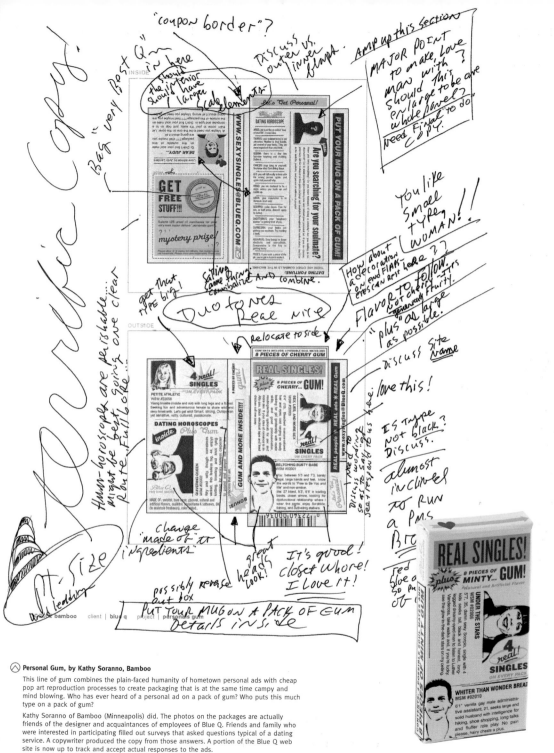

⌂ **Personal Gum, by Kathy Soranno, Bamboo**

This line of gum combines the plain-faced humanity of hometown personal ads with cheap pop art reproduction processes to create packaging that is at the same time campy and mind blowing. Who has ever heard of a personal ad on a pack of gum? Who puts this much type on a pack of gum?

Kathy Soranno of Bamboo (Minneapolis) did. The photos on the packages are actually friends of the designer and acquaintances of employees of Blue Q. Friends and family who were interested in participating filled out surveys that asked questions typical of a dating service. A copywriter produced the copy from those answers. A portion of the Blue Q web site is now up to track and accept actual responses to the ads.

"The ads add a component of flexibility that can change over time and hold the customer's interest in the product. It's what keeps the customer buying more products," says Soranno.

Gum Philosophy is an intriguing and eminently extendable line created by **Design Ranch** of Kansas City, Kansas. Mitch Nash provided lists of quotes about life and creativity, and designers Ingrid Ziti and Michelle Sonderegger created 12 different variations that are almost completely typographic and full of personality.

"This purchase makes you think of someone; it's a message that you want to share. It's fun to have more than one quote per box—three on the face and one on the inside of the box," says Ziti. All of the SKUs have additional graphics inside their boxes. "If you are intrigued enough and inquisitive enough to take the box apart, it's like a fortune cookie: There is more inside for you."

⊗ **Gay Gum, by Kelly Lear**

"Mitch has lots of very girly products in the Blue Q line. I wanted this to be for a guy. We just decided to go with beefcake," explains designer Kelly Lear of Miami. At the time, she and Mitch Nash were working on another project with illustrator Owen Smith, an artist known for rich, dimensional, pulpy, retro images. He seemed like the perfect artist to handle the job.

Lear says they felt some trepidation in creating this design. "We aren't making fun of anybody. We did a lot of research on the period and the look, and this presented a different look for the line," she notes.

⊗ **Bad Ass Gum,** designed by **Haley Johnson of Haley Johnson Design** sprang from the notion of chewing gum. "I thought about gritting down with your teeth. That gave me the springboard for the copy and for the face. You can look at the big face and get the concept pretty quickly," says Johnson of the cinnamon-flavored gum.

After this design was done, Johnson and Nash decided that women can be bad asses, too. So she created a mate for this design, which features a grandma-type character.

⊗ **Animal Love Gum,** also designed by **Haley Johnson,** was created for the younger teenage market. It's a very cartoony, "friends forever" message. It was made "intentionally sappy," the designer says.

"I have a hard time leaving things the way they are," Johnson says of the over-the-top cuteness. "There is something charming and likable about the box—it calls back a childhood feeling, more emotional than logical. Actually, you may not really like the design, but it will still play back on your emotions."

Nk'Mip, a brand of wine made from grapes grown north of the 49th parallel in Canada, in a **pocket desert that extends** across the Washington–British Columbia border, where temperatures can reach **105 degrees Fahrenheit in summer** and dip to **near 0 degrees in winter,** has worked hard to get here.

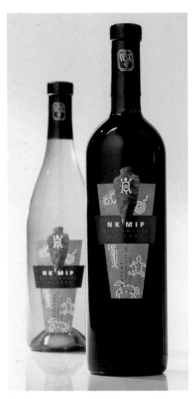

⊘ A wine from an unusual place—a pocket desert right across the Washington State–Canadian border on an Indian reservation—deserved a package design just as unique. Dossier Creative found a way to communicate the makers' heritage with a contemporary twist.

The people who have grown the grapes, entrepreneur Sam Baptiste and his family and employees, most of whom are members of the Osoyoos First Nation, a central–British Columbia Indian tribe, have worked hard to establish a successful vineyard that today produces a remarkable line of ultra-premium wines.

This wine was unique. That's why Don Chisholm and his design team at Dossier Creative of Vancouver, B.C., worked so hard to create one-of-a-kind packaging for its client, Nk'Mip (pronounced "Inkameep"), the first native-owned and operated winery in Canada. The winery's offerings included a Chardonnay, Merlot, Pinot Noir, and Pinot Blanc; an ice wine—a wine made from frozen grapes—may be produced in the next two years. The proper packaging and labeling could give the wines the boost they needed to attract the attention of the highly educated, highly experimental wine lover. These early adopters, if they can be encouraged to try a product and like it, are the trendsetters who give a brand the word-of-mouth reference that a wine needs to succeed.

Inkameep is the name of the Osoyoos Indian band in the native Okanagan Salishan language. The Salish tribe has lived in this area since the 1870s. Like many reservation areas offered by governments of the time, the land was deemed worthless: scrubby, rocky, and too dry to grow anything without irrigation. Today, though, the Osoyoos band, which is part of the larger Salish tribe, produces some of the finest fruit in the region.

Inkameep is a sophisticated brand, Chisholm says. It represents the tradition and heritage of the Okanagan Nation, while encompassing new-world design. "The packaging we created supports the premium positioning for the brand and conveys rich, native heritage through images of strength, mysticism, pride, and the deep historical roots of the Osoyoos Indian band," he says.

At the center of his team's design are two symbols of Inkameep people and of native people in general: the turtle and the spearhead. In native legend, the turtle challenged the eagle, who had enslaved the animal people, to a race and then won by outsmarting the eagle. The spearhead symbolizes strength and success.

To begin collecting what they knew would be rich imagery, Dossier designer Peter Woods spent two days in the Okanagan meeting members of the band, visiting the band's museum library, and interviewing historians. He gathered many different images, including a snake, coyote, bear, horse, feather, and dancer. All of the symbols hold meanings of strength, mysticism, and honor, among other qualities, for native peoples.

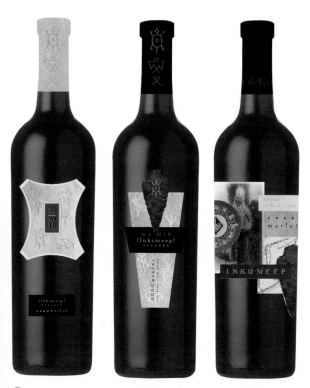

"The snake, for example, we felt held ambiguous symbolism—both positive and negative—that we liked. We felt that it would be interesting to highlight a symbol that had broad, universal associates that could border on controversial. The snake could be poisonous and evil, but if we used a coiled snake, we could form another universal symbol—the spiral—a powerful icon in all cultures around the globe that is generally seen as a symbol of life, death, and eternity," Chisholm says.

After extensive study, however, the design team and client agreed on the turtle and spearhead as symbols for all of the wines.

The design process was an evolutionary one that went through many stages. One early option presented symmetrical and flipped pieces of what might be ripped fragments of ancient documents. The two pieces are joined by a thin vertical rectangle carrying the Inkameep name. Chisholm liked the power of this look. It was almost like a petroglyph on its own. "It's the power of the symbolistic brand mark," he says.

This idea was initially popular with the client. They were enamored with the power of the shape. However, there were many problems to be solved with this solution: Maybe the word mark should be broken up, but maybe breaking the name in this fashion would render it too hard to pronounce.

Another design explored the idea of a stretched deer hide. "We felt this was a strong direction. Deer hide was an important material within the band's life, as they were known for clothing they created from deer hide," Chisholm explains. "The simple graphic form that represented the hide and the word mark were working more as symbols for the brand."

However, the client felt that the skin might make consumers think of dead animals—not a concept they wanted associated with their new product—and decided not to go with this approach.

Yet another option—there were eight design ideas presented in all—relied on pictograms. "The client liked this direction because of its unique label shape, but we decided that one pictogram was a stronger image for the final design," says Chisholm.

A fourth design direction used a mix of imagery—pictograms, photos, maps, and the brand mark—to uniquely express different varieties of wine. Each set of visuals would tell a different story for each variety. Each arrangement of art would be dramatic and distinct. However, this approach was ultimately judged to be too much of a period piece.

The third option was eventually chosen, with slight modifications. "It is a good representation of the brand strategy and of native heritage and symbolism," Chisholm says. It is both traditional and contemporary. It has also been commercially successful.

"The overall brand image created through the packaging program has allowed the client to enjoy many successes—articles in publications on their wine and winery, public relations exposure, and so on. Initial indications are that sales are healthy," he adds.

This early option used symmetrical, flipped pieces of what might be ripped fragments of ancient documents. The Nk'mip name was placed at the center. The background used Indian picture writing; each symbol was chosen for its specific meaning.

Left: This design used a shape as its base that is reminiscent of a stretched deer hide. The vertical rectangle, carrying the brand name, was brought over from the first design. Although the client liked this approach, eventually it was decided that associating the new wine with a dead animal might not be a positive connection.

Center: This comp was ultimately taken to final stages. It incorporated the picture language that everyone had liked since the beginning, plus it brought in an arrow or spearhead as well as some additional texture. The single pictogram presented a stronger brand image.

Right: This design brought together maps, pictograms, photos, and artifacts. Although this approach brought together many visuals that both the design and client teams liked, this was deemed too busy and too historically based for a new wine.

Zaki Elia compares **designing a new proprietary bottle for the soft drink Fanta** to containing a genie in a bottle— "A genie that wanted **desperately** to get out," he laughs.

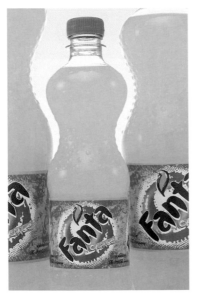

Faced with designing a preexisting label graphic, Z+Co. designers were challenged to create a new bottle shape for Fanta, a shape that would make it distinctive in the wash of soft drinks available today.

That's because Fanta, like any carbonated drink, contains carbon dioxide gas that wants to escape the solution it has been injected into during manufacturing. This gas, in combination with atmospheric pressure and temperature, can cause a plastic bottle to deform, look half full, or even burst.

Elia, principal of Z+Co., a London-based design firm, recalls an early meeting with Coca-Cola (the owner of the Fanta brand) engineers. He and his team were presenting preliminary sketches that suggested very clear brand signals in the form of bottle shapes.

"For some ideas they said OK, But for most they said, 'You are dreaming. This will never work.' It was frustrating, but we knew that every design could not just be looked at from its aesthetic merits alone. It also had to be able to keep its shape," he says.

Fanta asked Z+Co. designers to apply an existing label graphic to a new bottle shape that would be Fanta's alone. The project's brief specified that the new bottle should somehow express the fruitiness and fun of the drink—something sassy and fun—while also providing "natural" cues. But one of the biggest challenges the designers faced was designing a three-dimensional object that echoes the graphics of the two-dimensional label.

Although there are hundreds and hundreds of stock bottles already available on the market, Elia's client felt that a proprietary bottle was essential to elevating the brand.

"A proprietary container is one of the chief means for constructing a brand properly," he says. "Because as you consume a product, you are forming a relationship with it—how you hold it, how you enjoy it, how you fantasize around it. This is not the place to save money: A proprietary package is an investment in the future dreams of the product."

A stock container, he adds, may have some aspects of a brand, and it may actually turn out to be an appropriate match. But over time, it's value becomes negligible because everyone else can own it, too. Elia cites the example of the aluminum can: Because anyone and everyone can use them—for soft drinks, hard drinks, motor oil, bath products, and even candy—the can is really only able to perform as a billboard onto which graphics are posted. As a three-dimensional object, its potential to become a strong component of the brand is wasted and becomes the expression of a certain category of products rather than the expression of the brand.

"The object is devalued, yet the package is the most important part of forming the relationship with the customer," he notes.

⊘ Searching for the perfect proprietary bottle shape, principal Zaki Elia and his team began by experimenting with an hourglass-like shape they called the "splash" design. It was easy to hold onto and also suggested a slim body profile, which would appeal to the young audience they were after.

⊘ These are plastic (left) and glass (right) designs developed from the original sketch. The bubbles in the bottles graphically suggest the fizz and bubble of the drink.

When Z+Co. began work on this project, Fanta wanted to reinforce its unique relationship with its consumers. The client asked the designers to address the younger generation and make Fanta a drink that teens and young adults would want to drink and so differentiate themselves from their parents or younger siblings. Give them something they can own, the client requested.

"Images on TV or a billboard would not be enough to do this. The object of the package would have to be the message that addressed individual fantasies—think of the Coke bottle or the Perrier

bottle. You can influence these fantasies through advertising, but they only become tangible through the physical experience with the package," he says.

After that early meeting with engineers, where structurally unsound designs were eliminated, Z+Co. designers created several designs that addressed specific aspects of the brand. One trial had an hourglass shape that was ergonomic—it was easy for the hand to hold—and had a tactile element: bumps, which were meant to graphically express the fizz and bubble of the drink.

⌂ This experiment was called the "swirl" design. It was also easy to hold, but it did not test as well as the first, perhaps because it did not mimic the body shape of a person and therefore did not have as much personality.

⌂ The plastic (left) and glass (right) designs developed from the "swirl" design.

"It is also suggestive of a body shape, which gives the object more personality because it is more like a person," Elia notes.

A second design was called "the swirl." It had multiple waves in its profile and was also easy to grip. But it didn't test as well. "People wanted to fiddle with the other one more. This one just didn't have the body profile most people prefer," the designer adds.

So the first design was refined even more. Bumps were placed in various patterns at the top of these trial designs, sometimes in combination with lines or tilde-shaped marks to suggest "splash." The label was placed very low on the container, which Elia feels is appropriate so as to allow a balanced interplay between the printed brand mark and the branded shape.

"The bigger the label," Elia says, "the less visible the bottle is, and the more noisy it becomes. Promotional activities on large labels, although necessary, if not kept in check can cannibalize the brand mark and reduce the perception of the brand quality. Large labels tend to reduce the object it envelopes to a billboard, hardly an object of desire. Because the physical experience of drinking is intimately linked to the object, it has to be given the importance it deserves."

Other ideas, including a leaf-shaped belt clip for the plastic bottles—a natural cue—and a branded round cap with a bubble pattern on it were studied, but for cost or production reasons, they were not practical. Elia believes that, as three-dimensional objects, they would have been even more voices speaking out for the brand.

⬡ Here, the designers start to combine attributes from the swirl and splash designs. Note the introduction of the proprietary, bubble-shaped cap.

⬡ This shape held a lot of appeal, so the design team tried different patterns of bubbles on the bottles. The labels are kept low to allow as much of the proprietary brand shape to show as possible.

The aspect of the Planet Krunch packaging that Bruce Crocker of Crocker, Inc., likes best is that its art embodies the notion that **adventure, imagination, and discovery** are interrelated.

Planet Krunch is not only a healthy snack for children on the go but also a destination for their ever-roving imagination. Designed by Crocker, Inc., the packages contain many landscapes for children to explore.

But it was the realization that the product's nature and its package design could be aligned in a spirit of youthful adventure that got his design team excited.

The products were conceived as a healthy alternative to the overwhelming abundance of sugar-based kids' snacks that overpopulate supermarket aisles and convenience stores. By being called into the product-positioning process early on, Crocker, Inc., could make marketing contributions that would help formulate the criteria for defining the Planet Krunch brand attributes.

The art style that Crocker ultimately chose is intentionally based on simple forms that are "accessible" and easily mimicked by a child who likes to doodle and draw. In fact, the illustration style has the feeling of doodles a fourth or fifth grader might draw on the inside cover of his assignment folder.

Planet Krunch is a healthy snack developed by a parent who was frustrated by the lack of available nutritious, on-the-go foods for children. Made from dried fruit, oat flour, corn meal, natural sweeteners, and other wholesome ingredients, it is billed as "the adventure snack." It would have to compete against every other food that children nibble on—chips, candies, gum, and other products with much larger advertising budgets that Planet Krunch had.

But because it was not candy, chips, or another food product that snack-browsing shoppers might understand and see near the cash register, its new packaging had to communicate the fun qualities of a snack to a child, while at the same time speaking to the health-conscience parent. In a way, Planet Krunch is championing the idea that its OK to play with your food. The solution, Bruce Crocker and his designers decided, was to inspire a sense of imagination for this snack, which Crocker Inc. helped position as "the adventure snack."

"We hoped to create packaging that would bring a sense of curiosity, not only about this product but also about life in general with kids," Crocker says.

Color, the team reasoned, would be an excellent place to start. The product would be sold in health food venues, where so much packaging is visually subdued: earth tones, natural colors, and the like. The logic was simple, using bright colors would not only be appropriate for a kid's product but would also visually stand out in these stores. The Planet Krunch color palette uses large fields of solid process blue as its main equity color. From a production standpoint, it is clean, bright, and always consistent, regardless of whether packaging or other communication vehicles are being printed. Support colors were also specified as clean, bright colors made up of only two-process colors each whenever possible.

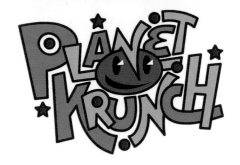

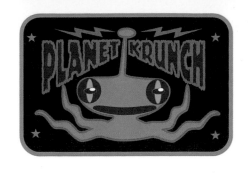

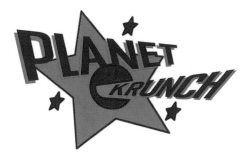

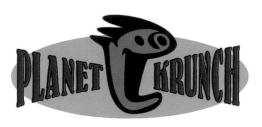

⌃ Clear, bright colors are a centerpiece of the packaging.

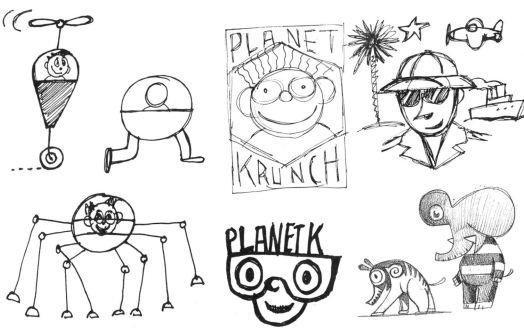

⌄ A child's guide to the new world of landscapes could have been a person, an animal, or a mix between the two. Whoever he or she turned out to be, the little guide needed to be wide-eyed, full of wonder, and ready to explore.

A second visual idea for the packaging would be to incorporate one or more characters whom children could identify with and embrace. "We spent a lot of time playing with different characters that had a personality and quality that kids could emulate. We weren't sure if it should be a human, an animal, or an alien, but we wanted the main character to be wide-eyed and ready to explore the world," Crocker says. "When we landed on the eclectic outer-space concept, it seemed natural that the main character would be from another planet or, more specifically, not from our Earth."

For a while, Crocker considered creating many different characters that would populate different areas of the packaging. But then it seemed smarter to change the scenes on the packaging and let the single character investigate them all, just as a child would love to do, especially via spaceship. All of these scenes would be from—where else?—Planet Krunch.

"We didn't really want to depict one specific landscape, but instead a combination of different integrated landscapes. We wanted to keep all possibilities open so pine trees, volcanoes, odd land formations, and snow-capped mountains could coexist.

The basic idea was to create a multitude of curious environments," he says.

The nature of the project and the excitement around the possibilities were inspiring. The design team developed dozens and dozens of sketches of little characters and landscapes. But when it came to the point of actually designing the packaging, the design team and client decided to edit the images and stick with one central character face that customers could identify and, therefore, remember. The important thing was that the final character have the kind of personality characteristics Planet Krunch wanted to be associated with—friendliness, quirkiness, curiosity, fun, and wholesomeness.

The other images will be used over time, on shirts, stationery, and so on, as well as on future packaging. In fact, as the brand evolves, the intention is to let the visual vocabulary grow in an organic way that will allow for the integration of many exploratory ideas that were not used to launch Planet Krunch. The eventual vocabulary may be extensive, but it will also be consistent in execution through color, artwork, and the "soul" of the imaginative adventure.

⊘ The type that the designers selected needed to be full of life as well, part of the curious environment.

⊘ The designers worked hard to develop a combination of landscape, character, and "props" that was changeable.

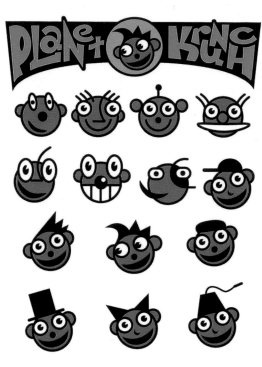

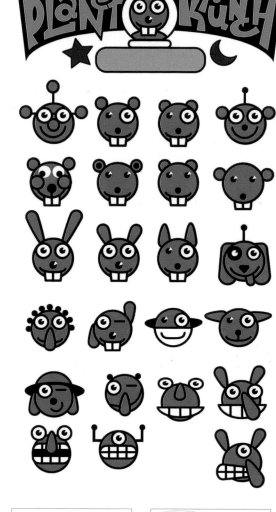

Here the character that ultimately was used in the design is played out in dozens of iterations—as a person, an animal, and something in-between.

The Crocker designers developed many characters and scenarios for the Planet Krunch project that were initially not used. But these will eventually be used in collateral, future packaging and promotions.

PLANET KRUNCH
Bob Krinsky President/CEO
4644 Geary Blvd., Box 175,
San Francisco, CA 94118
Phone/Fax: (415) 688-8871,
Email: bob@planetkrunch.com

The artwork was created by staff artist and illustrator Mark Fisher who has a great deal of experience doing work for educational publishers as well as clients of national public broadcasting.

Cars don't come wrapped in boxes. But is there any reason they couldn't? That's the **hypothetical question** designers at Fitch Worldwide (London) asked themselves when their client, **Nissan Europe,** asked them to package the brand in ways that

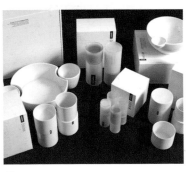

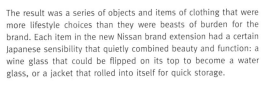

Unexpected. That's the idea at the center of this Nissan merchandising program, designed by Fitch Worldwide (London). It's unexpected that a car company would sell household products. The design of the products is unexpected. Even the design, construction, and material used in the packaging is unexpected. (Photo by Robert Howard.)

most consumers had never considered. How could the brand be extended? How could it be repackaged?

When Nissan's global director took over the company in the late 1990s, he began a revival project for the brand. Nissan, he believed, was missing the emotional link that, for example, connects the VW Bug to its vociferous fans. Capture the emotion of Nissan, he said, by creating new bonds between the brand and the consumer.

Most people are familiar with the notion of adding a company logo to T-shirts, umbrellas, tote bags, or golf balls. But the Fitch designers were charged with going much further than traditional merchandising. To inspire an emotional response, their designs would have to touch the consumer in a more personal manner and enter into his or her life in a meaningful way.

The result was a series of objects and items of clothing that were more lifestyle choices than they were beasts of burden for the brand. Each item in the new Nissan brand extension had a certain Japanese sensibility that quietly combined beauty and function: a wine glass that could be flipped on its top to become a water glass, or a jacket that rolled into itself for quick storage.

"This is a merchandising program that the consumer could react to because it was relevant to them," explains Lucy Unger, Fitch's client director for the project. "Nissan wanted to communicate the Japanese brand of design and engineering in a European way. It's a form of elegance, functionality, and simplicity that people like today."

The packaging for these products not only had to contain the products but also reflect the same practical yet beautiful principles. But the designers did not want the packaging to be a literal interpretation of what was inside. It had to be all about the parent brand, not that particular product.

Simon Mariati, Fitch design director, explains. "The packaging had to conform to the experience. Really, the package is part of the product itself, or of the experience. Many products we created were based around a certain 'Japanese-ness.' The packages did, too. The Bento box, for example, usually used to hold Japanese food, is used to hold new Nissan products. It looks simple on the outside, but it has lots of compartments inside."

"An actual Bento box is stark black, but when you open it up, you find these delightful morsels of Japanese food inside," Unger explains, noting that the Nissan packaging works in the same way.

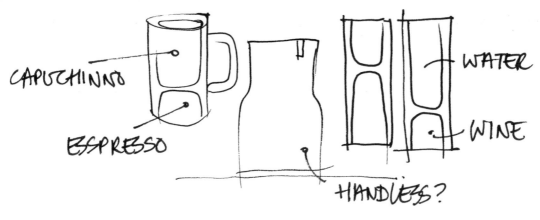

CAPUCHINNO

ESPRESSO

WATER

WINE

HANDLESS?

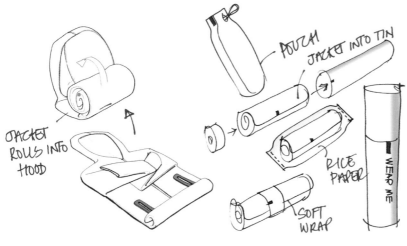

JACKET ROLLS INTO HOOD

POUCH

JACKET INTO TIN

RICE PAPER

WEAR ME

SOFT WRAP

⌃ The design of the new Nissan products was highly innovative, as these sketches reveal. The design team wanted the packaging to be an aesthetic and engineering match.

◁ To package this unique line of consumer products, Fitch designers carefully considered innovative packaging. Can a jacket be sold in a tube? Why not?

⌄ Boxes made from wood or metal, paper sleeves, transparent bags, even packaging that turned into something else once opened were all studied.

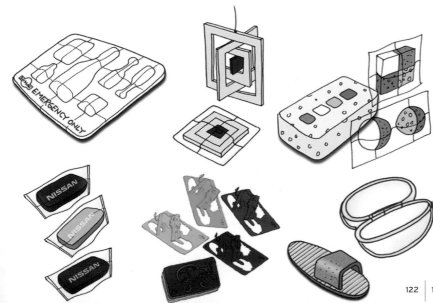

EMERGENCY ONLY

NISSAN

NISSAN

NISSAN

"Because the box is so stark, you might expect to find something similar inside, but instead there awaits a treat."

The most successful product and package in the line is the yin-yang mug, which can be used in two ways. In one orientation, it presents an interior cavity that forms a coffee mug; flipped upside down, a smaller compartment is revealed, the perfect size for an espresso. Adding even more to its function is the air space that is trapped between the two cavities, which prevents the vessel from becoming too hot to touch. As for outer beauty, the combined cup is sleek and simple. Inside, though, it is complex.

The box design that was created to hold the cup also has a simple, outer style and a complex interior. The same analogy fits the nature of the client's original products as well: Its vehicles are simple on the outside, but very sophisticated under the hood.

White boxes hold most products in the new line, and they have a suede stock that is intriguing to the touch. "When you touch it, you get a shock: You expect to touch paper, but you feel suede.

That's one of the founding principles of this entire range of products and packaging—to be unexpected. Whether it is unexpected that the yin-yang mug has the two functions or that Nissan is selling this type of merchandise, it surprises you," Unger says.

The trademark red bar Nissan mark is the boldest adornment on the boxes, subtly shadowed by technical drawings of the product inside. More pronounced are simple commands—Drink, Eat, and so on—which further indicate the nature of the product inside.

Today, it's all about targeting individuals, Unger says. "The only thing that defines the audience is that they are all individuals. They are not slaves to brands: They will pick Nissan only if it suits their lives. Rather than just wear a Nissan T-shirt, the brand has to speak to them proactively," she adds.

The packaging and products are just the opening volley in large brands moving into unlikely product extensions, Mariati believes. "People don't expect this, which is an important reason why we are doing this."

The inside and the outside of the packaging were also thoroughly considered.

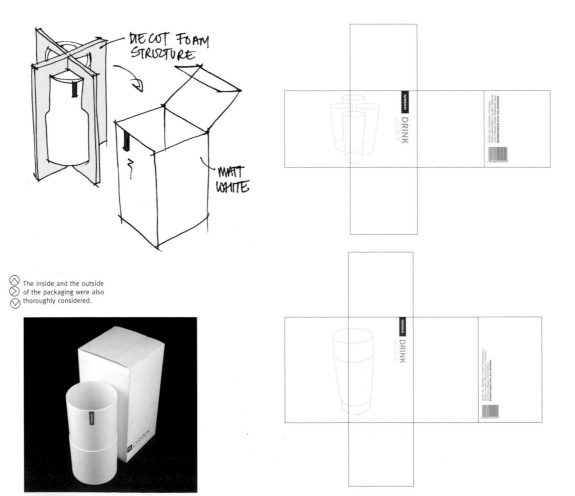

NISSAN

[LONG SLEEVED MENS T-SHIRT]

WEAR ME
私の楽しみ

DESIGNED FOR YOUR COMFORT
WEAR THIS T-SHIRT FOR EASE
& STYLE. PART OF A RANGE
OF CLOTHING ESPECIALLY
DESIGNED FOR NISSAN

利益
PLAY

私の時間

私の時間

THOUGHTS

ること

KEEP TIME

AN INSPIRATIONAL RANGE OF PRODUCTS FOR YOU TO ENJOY AT YOUR LEISURE

The labeling on the packages was also in-
tended to be unusual: It simply ordered
people to do something.

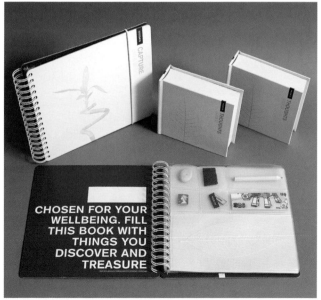

CAPTURE

THOUGHTS

THOUGHTS

CHOSEN FOR YOUR
WELLBEING. FILL
THIS BOOK WITH
THINGS YOU
DISCOVER AND
TREASURE

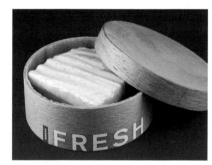

FRESH

TRAVEL

MOTION

JET LAG

Samples of finished Nissan consumer products' packaging. The Asian influence is evident in these
designs, and they are smartly European as well. ("Fresh" and "Travel" photos by John Reynolds,
book photo by Robert Howard.)

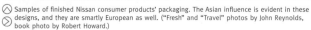

Mother Megs Fine Foods is a brand that nearly went under because of packaging. Its **original packaging** did not help sales. A **redesign in 1999** pushed it completely off the tracks,

but fortunately for the small, Queensland, Australia–based business, the third try was the charm.

Founded in 1992, Mother Megs is the prototypical business-started-in-the-garage. With recipes and home-baking techniques that have been passed down through three generations, its founder turned wonderful family recipes for fruitcakes, puddings, and biscuits (cookies) into a brand that quickly gained attention for extremely high product quality.

But by the late 1990s, sales were dropping off. The company's founder also wanted to start selling her products in more cosmopolitan markets, such as Sydney and Melbourne, so she needed to quickly reinvent her brand. The product was already excellent, so she turned to her packaging for a new image.

The design firm she contracted with certainly gave her line a new look—the trouble was, it was much, much too new. The black-and-pink packaging had impact, but it didn't convey the traditional, hand-baked qualities of the Mother Megs product range. Nicki Lloyd, director with Tim Grey of Lloyd Grey Design of Brisbane, the second design firm contacted, explains.

"When she came to us, she was despondent and skeptical of design in general. Her new range had lost market share. Consumers who saw Mother Megs in specialty stores thought the packaging contained hosiery or cosmetics, not food," Lloyd says.

The situation was so bad that, after an appalling 2000 Christmas season, one major retailer told her that it would not reshelve her products unless the packaging was remade. By the time the client came to Lloyd Grey, the design team had only three weeks to perform magic: completely redesign the company's identity and packaging, and then push the packaging through printing and into the stores before Mother Megs was completely forgotten.

Lloyd's team pursued two main ideas. The first was conservative, but clever. The front of the package would show an old-fashioned, white dinner plate with a "Mm" monogram on its edge—an acronym for the brand, but also an apt comment on the contents of the package. At the center of each plate is a window that allows the consumer to see the food inside. The idea was to make the food look as if it were actually sitting on the plate.

The tablecloth behind each plate would be color-coded to help visually organize all company offerings. Lloyd says the design worked well because it looked contemporary and made the product the hero, and the monogram could easily be extended onto other elements in the identity system, such as stationery and advertising. But she also felt that perhaps the design was a bit too safe.

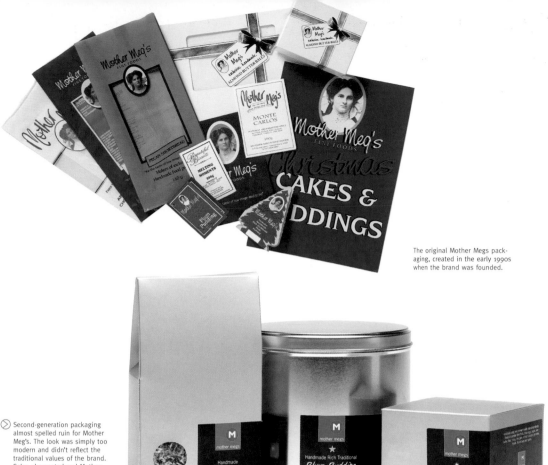

The original Mother Megs packaging, created in the early 1990s when the brand was founded.

Second-generation packaging almost spelled ruin for Mother Meg's. The look was simply too modern and didn't reflect the traditional values of the brand. Sales plummeted and Mother Megs owner came to Lloyd Grey Design for help.

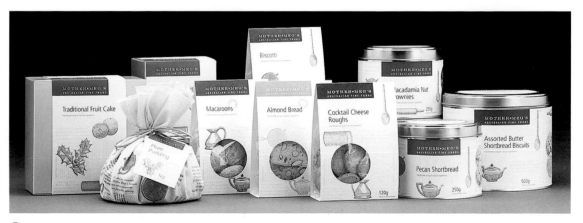

With the introduction of Mother Megs Fine Foods new packaging, redesigned by Lloyd Grey Design in 2001, sales for the company increased 113 percent.

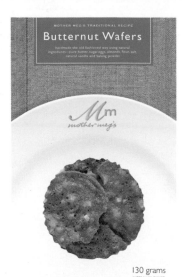

Scottish Shortbread

MOTHER MEG'S TRADITIONAL RECIPE

handmade the old fashioned way using natural ingredients—pure butter, plain flour, rice flour, sugar, natural vanilla and baking powder

Mm
mother megs

200 grams
AUSTRALIAN OWNED

Pecan Shortbread

MOTHER MEG'S TRADITIONAL RECIPE

handmade the old fashioned way using natural ingredients—pure butter, flour, sugar, pecan nuts, natural vanilla and salt

Mm
mother megs

160 grams
AUSTRALIAN OWNED

Butternut Wafers

MOTHER MEG'S TRADITIONAL RECIPE

handmade the old fashioned way using natural ingredients—pure butter, sugar,eggs, almonds, flour, salt, natural vanilla and baking powder

Mm
mother megs

130 grams
AUSTRALIAN OWNED

△ Lloyd Grey Design explored two options. The first used a monogrammed plate with a window at its center, allowing the product inside to show through. A tablecloth behind the plate could be color-coded to suggest flavor or variety.

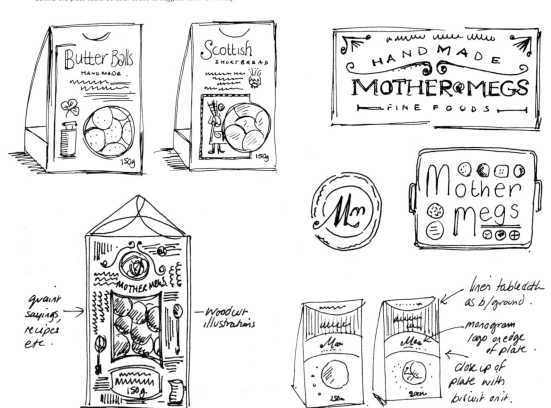

△ Some of the original sketches that Nicki Lloyd created in her explorations for Mother Megs. The sketch at far left was taken further: Woodcut illustrations and pithy sayings from old cookbooks could be used to unify the disparate packaging in the line.

A second approach had more promise. "We researched a lot of old cooking books, which are full of quaint sayings and art. They really go back into the history of when grandmothers cooked," Lloyd says.

The designer decided to use these same sayings as well as incorporate original woodcut illustrations in the background of all packaging, an effect that would eventually tie everything in the line together.

"We set out to create packaging that contained a lot of interesting baking information and quirky statements from yesteryear. The typographic arrangement added visual interest and texture when displayed. We reproduced the actual recipe on each pack. The recipe 'secret' was preserved by positioning the diecut window through to the product over the recipe text. On packs where we didn't have a diecut window, photographs of the product were placed in strategic positions to hide a crucial part of the family recipe," Lloyd says.

A clean and contemporary color palette provided the modern touch the project needed, and a mix of modern sans serif and traditional serif type balances against each other well.

This design could also easily be extended into other elements, such as wrapping paper, stationery, hang tags, aprons, and more.

In the previous redesign, the brand name was small and ran near the bottom of the packaging, where most people couldn't read it. "We brought the product name to the top and made it bigger. We also made the hole at the center of the package larger. In the pantry pack, we left the cardboard off the sides, so people can actually see the product from the front and the side," Lloyd says.

Today, Mother Megs is again a healthy brand. The black-and-pink packaging caused a decrease in sales of 21 percent. With the introduction of the Lloyd Gray design in 2001, sales increased 113 percent in the first year. Lloyd credits this success not only to the redesign but also to the establishment of a Web site and other marketing initiatives. The designer and her client anticipate that the future will bring even greater returns as sales are expanded into the European market.

"It has been a huge success for her. It's exciting for her and for us. We feel very close to her because her business is so small," Lloyd says. The packaging provided the client with a "wow factor" and continues to open doors that would otherwise remain closed.

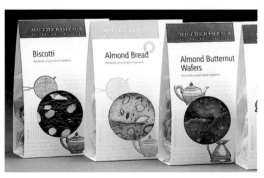

⊘ A rich color palette, combined with charming illustrations and blocks of sweet messages, produce a warm and friendly, yet polished, presentation.

⊘ Tins, boxes, and cartons are also part of the packaging system.

⊘ Some packages are essentially sleeves that protect the bagged product inside. Consumers like this design because they can see exactly what they are buying.

When a designer **specializes in a certain category** or type of **product design,** he finds himself on a constant quest to do **something completely new and different.** But, it's tough. Realistically, **how many ways are there** to do something completely visually unique for something as ubiquitous as a CD jewel case? It's a question that **Ohio Gold Records** founder Andy Mueller has considered many times,

The success of the participatory "This is the Flow" exhibit in Holland led designer Andy Mueller to consider doing the same for the insert design of one of his favorite bands, Pinebender. Each CD was packaged with sheets of graph paper and a small pencil, plus a request to the recipient that he or she complete the unfinished work.

having designed artwork for nearly a hundred jewel-case inserts for various recording companies, including his own, Ohio Gold Records, an offshoot of his design firm, Ohio Girl.

"When you do the same thing over and over, you get trapped. Sometimes I don't know where to go next," says Mueller, who also designs snowboard and skateboard graphics. "It once got to the point where I had to completely tear apart the idea of what a CD case is and disassemble its parts."

His turning point came while he was creating an insert for a Pinebender CD. Pinebender is an independent rock band and one of Mueller's favorites—it has an "injured pop sound," he says. The recording of this CD was plain and unadorned: Composed entirely of outtakes and demos, "the glamour has been pounded out of it," he says. "It has no special production values. An unpolished, highly personal design would be the truest one."

Earlier that year, he had participated in an art show of skateboard graphics in a gallery in the Netherlands. Each artist in the show was given a specific amount of space to do with it whatever he or she wanted. Mueller came up with many different ideas, from using traditional photography to some truly offbeat concepts, including allowing show visitors to create the visuals for his area.

This last idea held real appeal for him because it seemed to be a fresh way to approach a design and art show. Mueller thought it would be interesting to see what would be created from unknown variables: What would the viewers' take on the show and on skateboard graphics in general be? He also wondered how the gallery setting, the audience's varying levels of art skills, and attendance might affect the end results of his piece.

His part of the show consisted of two skateboard decks, a two-sided hanging banner, and a double-sided easel, complete with small paper pads printed with replicas of the two skateboard graphics. On one side of the easel was a question-and-answer test that mocked an "Are you an artist?" test. On the other, he asked for the viewer to create his own board graphics on top of his designed template. Attendees were also invited to sign their names and display their works.

The "This is the Flow" show—that exhibited the work of the California-based snowboard company Andy Mueller designs for—encouraged visitors to take an art quiz and create their own board designs. At a work station that was part of the exhibit, patrons created their own art, which in turn became part of the exhibit. This exhibit was the inspiration for the do-it-yourself CD insert for the band Pinebender.

"Usually, when we create graphics, they are completely untouchable. The work is done. The viewer just looks at it, and that's all. So it was really fun to see what the viewer could come up with in terms of art," Mueller recalls.

This participatory concept is actually quite allied to the designer's skateboard graphics work: Riders often customize their own boards covering his designs with stickers, paint, or just plain hard use. Scratches, dents, and other abuse marks every board with personal statements of the user. To see what riders do with his designs is a full-circle, encompassing experience, he says.

With the Pinebender project, Mueller felt that a similar idea might be interesting and appropriate. The designer wanted to see if this "do-it-yourself" concept would create different results because of the different audience demographics and the nongallery setting. Mueller also thought that it would be interesting to explore the idea of audio-to-visual interpretation: How would the listener react visually to what he hears?

After a short period of sketching, Mueller zeroed in on a simple concept: He would replace the traditional CD booklet with a pad of graph paper and a small pencil. An insert was also included inside the jewel case that contained instructions the recipient should complete and submit for the cover. He would let the listener have free reign, personalizing the CD according to his or her own experience with the music.

"It plays with the same notion of inviting the consumer to modify and customize the piece. It plays with the relationship between product, consumer, and designer," he says. "Visually, this fits with what the band is all about—raw and low fidelity. Even using pencil on paper, which can get smudges and such, felt right."

So the do-it-yourself CD design was released in spring 2002, and Mueller has been pleased with its inspirational pull. More than 100 buyers of the 1,500 run have sent their designs to him from all over the world. Some are facile; some are show-offy pieces; but many are genuine pieces of art that directly address the music, his concept, or both, says Mueller. They are as random in idea and appearance as he could possibly have hoped for. But what pleases him most is that instead of him producing art for the consumer, the consumer is creating art for him.

"Some people reacted to the music, and some people were just reacting to the instructions. Some people did whatever art they wanted, and some showcased their own illustration," Mueller says of the submissions, which were still coming in at the time of this writing.

Mueller is proud of this project. He felt it was a perfect fit for the band because it allowed the listener to interpret sound on an individual level and turn the interpretation into personalized visuals—which is what audio is all about, he points out. The success of this package has allowed Mueller to start thinking in more conceptual terms: He plans on using this approach again on a variety of projects.

To see more submissions from Pinebender listeners, go to the OhioGold Records section of www.ohiogirl.com.

At the time of this writing, the CD had been in circulation for only a few months, but buyers from around the world are sending back their takes on the design. Some people react to the music, Mueller says, some to the band, some to the concept of the do-it-yourself piece, and some simply to the invitation to create art.

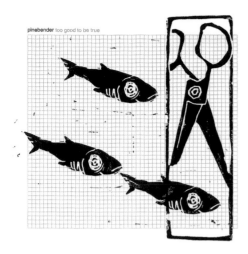

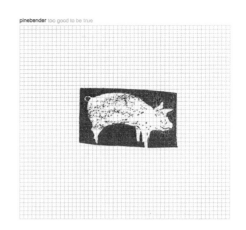

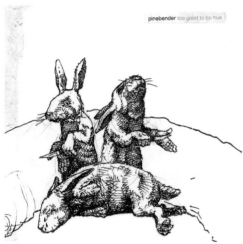

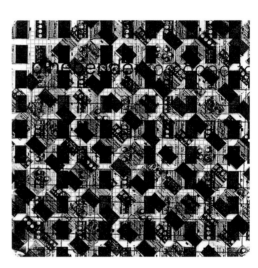

Balance. It was was at the core **of the Aqualibra redesign** project, as well as **at the center** of the work done by Blackburn's, the London design consultancy that **reworked the beverage's packaging** not once, but twice.

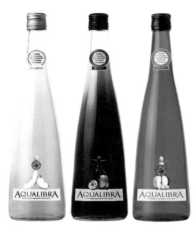

The current Aqualibra packaging has been redesigned twice in two years.

The original design for Aqualibra was completed in 1985, when the drink was first released onto the market. It was an adult soft drink, and so was packaged to distance it from children's fruit drinks. The brand was an enormous success, but throughout the 1990s sales declined and the brand was viewed as old-fashioned. Compounding problems was the growing popularity of bottled water as well as the introduction of competing fruit drinks to the market.

A radical redesign was needed, and Orchid Drinks, owner of the Aqualibra brand, called in Blackburn's to turn the brand around.

"Clearly, the overall look of the package needed consideration. No amount of cosmetic styling would significantly change the brand's fortunes," says the design consultancy's principal, John Blackburn. "We needed to get to the heart of what Aqualibra was and what it had to offer consumers that other drinks didn't."

Hidden away on the original packaging was an intriguing proposition: "Aqualibra helps maintain your body's natural alkaline balance." This was certainly a claim that no other drink could make. Balance was certainly a consumer benefit, and it could be expressed visually.

A logo was created that literally expressed balance: An "A" filled with fruit was set down solidly as a fulcrum, and the name "Aqualibra" was set in a strong block of color and balanced on the fulcrum's point. The logo was easily adaptable to accommodate new flavor lines, and indeed, two new flavors were added to the product mix at that time.

A beautiful, sloped, proprietary bottle was also part of the redesign.

"Our consultancy does a lot of beverages, and we feel that the container should look good enough to remain out on the dining room table. The old Aqualibra bottle was fat and stubby when the brand needed to be tall, thin, and elegant, which is what most consumers want to be. The new bottle resembles an 'A'—very subliminal," Blackburn says. The consultancy also designed 330-ml bottles for single serving, which the designers call "terribly cute."

Everyone was happy with the new design until 2002, when the soft drink giant Britvic purchased Orchid Drinks and wanted to put its mark on the Aqualibra brand. Was there another way to say balance, the new client asked?

Blackburn put a new team on the project. "We needed to find a new way to say the same thing. We could use scales, but we had already been down that path with the fulcrum and bar. Fairly quickly we came up with the idea of balancing the fruit itself," he

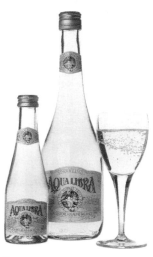

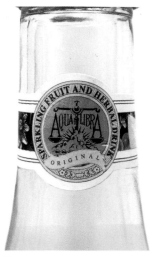

⌃ The one-time famous Aqualibra brand, originally launched in 1985, was in decline in the mid-1990s. It was seen as dated and old-fashioned.

⌃ Hidden in the neck label of the original design was the concept that drove the redesign: balance as conveyed through a scale.

⌃ The designers also explored an evolutionary development of the original design and bottle, just to see what might be salvaged. This design did not yet focus on the balance concept.

⌃ As they sketched, the design team happened upon the idea of using the "A" from Aqualibra as a fruit-filled fulcrum.

⌃ This abstract sketch was the start of explorations of the notion of balance.

▷ Balancing the Aqualibra name in a bar on top of the fulcrum completed the picture of balance.

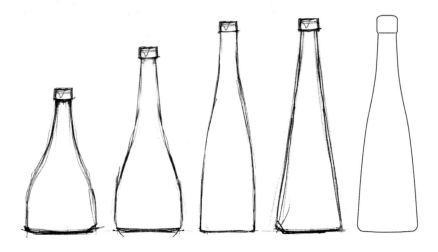

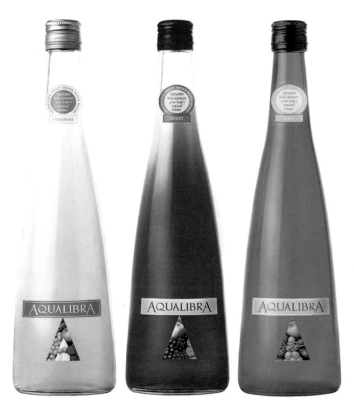

⌃ The shape of the bottle was also researched at this time. The original bottle was static and chubby—not a good match for a drink that was trying to convey health and fitness.

⌃ The taller, redesigned bottles better support the healthy, slimming theme, and the new shape also echoes the "A" of Aqualibra.

⌄ One of the most positive outcomes of the re-design was that it could be worked into synergistic advertising.

says. "We showed the client the balanced fruit, and they smiled. When people smile, you know you have them."

This second approach is more whimsical than the first redesign, especially in that the balanced fruit formed a little character. The drink is still not aimed at children, but Blackburn likes the way the design appeals to the child within.

"We don't want to be too serious. This still has a lot of sophistication to it," Blackburn says. He liked the first redesign but feels this one is even better. "It is more captivating—like balancing on a trapeze. Somehow that attracts your attention more than the balance of a scale. However, the scales did play an important part in establishing the balance idea, which allowed the second design to take the role it did."

Again, the concept is flexible enough to accommodate new flavors and container sizes. The much-admired proprietary bottle shape was maintained, so a certain amount of brand equity was carried across. Released in mid-2002, the new design is improving sales, the client reports.

Is there yet another way to say "balance"? Most probably, Blackburn says. But what is important about these designs—and any that are yet to come—is the central idea behind the art: The images and type may change, but the brand's core concept will not.

The project was a success, he concludes, because he and his team were twice able to get to the heart of the brand and find a unique, relevant way of expressing it in the simplest way possible.

All was well until the Aqualibra brand owner was bought out, and the new owners wanted yet another redesign. So Blackburn's designer started again, first by reconsidering the drink's ingredients.

They also had to find new ways to express balance. The angle of acrobats or trapeze artists balancing had a dynamic nature that the design team liked.

So they combined the two concepts. Why not balance the fruit itself? A friendly, little character emerged from the mix.

If you were designing **a line of grocery retail packaging** that was **expressly for kids**—in this case, **Tesco Kids**—would it be **naughty or nice?**

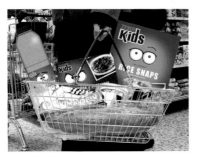

Rather than create a cartoon character that would be printed on the 200 to 300 SKUs in grocer Tesco's new Kids brand, the design consultancy Brandhouse WTS turned the packing itself into a charming, changeable character. Every SKU has a different expression and comment.

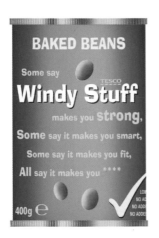

The designers considered other fun ideas for the packaging, including showing the product come to life on the label—someone sitting in a bathtub full of baked beans, for instance. Another idea was to run a short, witty poem on the front of each package (shown here). The trouble with these approaches was although some products are inherently funny, others aren't.

Would the design be more successful if it was covered with primary colors and cartoon characters, or would it have more impact if it referred to flatulence, bad breath, and other bodily disorders?

Designers at Brandhouse WTS chose the latter alternative for Tesco Kids, a new line of goods for the largest grocery retailer in the United Kingdom. With more than 150 products in the line—and the possibility of many more if the idea was a success—the design assignment could have been huge and unwieldy. Instead, designer Gary Utting found a way to make the design for the £250 million brand not only controllable but also fun.

"Tesco Kids was a new line. One of Tesco's competitor's had bought out a whole range of kids products recently and had aimed the design of the line at parents. We weren't sure that was the right way to go," says David Beard, creative director at Brandhouse WTS, a London-based consultancy. "We wanted to create an umbrella design for all of these products, and push it at mothers and kids. That was going to be difficult, because these are really opposite concerns."

For moms, the packaging design would have to speak of healthy eating for their children. But this type of design would be boring for the kids.

"Children would like something a bit more naughty and even rude," says Beard. Even more, the brand would have to feel that it belonged to the kids alone: No grownups. "If the design talked to kids through some adult voice, it would be like Bart Simpson telling them to wash behind their ears—no good," notes Utting.

The Brandhouse WTS designers explored three directions. In the first, the product contained inside the packaging was included in whimsical illustration. For instance, for a pasta label, the art might show a person climbing up long strands of spaghetti. For a can of beans, the same character might be luxuriating in a bathtub full of beans. Here, the product was hero.

In the second approach, a short, witty poem would grace the front of each package. The design team liked the approach quite a bit, but they could see themselves being painted into the corner from two directions: First, although some products were amusing—beans, for instance—others weren't quite so funny. Also, writing poems that were consistently funny for all 150-and-counting SKUs could prove to be not so amusing.

The third experiment was the preferred direction almost from the beginning. Here Utting turned the packages themselves into characters by using a different set of expressive cartoon eyes, the product name, and a cheeky remark on the front of each package. All of the "boring stuff"—the nutritional information that mothers want—is pushed to the side of the package.

trolley.
ouch!
How's my driving?

The shelf dwellers.
Get us out of here!

Rotten Grapes.
grape juice.
Wine.

I'm full up!
Don't get carried away!

Checkout.
See you later, Alligator.

Baked Beans Cans.
What was that! oh.! Was'nt me!

Toilet Paper. 4pk.
Vacant engaged.
Vacant Store

eggs come from a Chickens what!

The way kids see the world.
Where's the TV?

Sausages. Pigs fingers?
But fish don't have fingers!

Nectarines are Shaved Peaches?

Strawberry Jam, not a traffic jam.

Mind where you put that straw!

Tesco entrance.
kids entrance.

I'm with stupid!

get me a Coat Ice cream.

Puppy Pet food.
Fetch!

Cereal.
Nice Pyjamas. Wakey, Wakey!

Insect Repellent.
Just Buzz off!

Shepherd's Pie.
Made with Real Shepherds.

Shark Bites.
ouch!

Variety Packs
Mo!
eenie meanie minie

Pass me a Peg?
Cheese.

Brussel Sprouts. Small Cabbages.

enjoyable Shopping experience for kids.

Fish Cake.
"funny looking Cake!" or a Round Fish finger!

Pizza.
Ciao!

Security Guard.
"Put it Back!"

Sweet & Sour Chicken.
"No 47 please"

Banana Milk Shake.
"What Monkeys Drink".

Bubble Bath.
"Where's the Duck gone?"

Burgers!
"Burger off!"

Suntan lotion.
"Hello Sunshine!"

Thick Sausages
2 + 2 = 16.
I'm a Silly Sausage.

Milk.
Cow Juice.

Billy No Mates!
Garlic Bread.

Toothpaste.
1'2'3'4's... Hide and Seek.
ssh! I'm Hiding from toothpaste.

The idea that really had legs—or should we say, eyes—was using pairs of expressive eyes together with a wise-guy comment to communicate what a kid might say about the product. Designer Gary Utting sketched out hundreds of thumbnails for situations as disparate as restroom doors to fish fingers.

These comps demonstrate how, within the same SKU, packages might say different things. All of the comments are slightly cheeky, and oftentimes, the packages seem to be talking to each other, even arguing, just as siblings or young friends would do.

Utting studied stock photo books, his own face, and the faces of family, friends, and coworkers for the inspiration he needed to develop a menu (more expansive than those shown here) of eyes that covered hundreds of emotions and situations.

"Many products use cartoon characters to engage children. We tried to make the character an actual part of the brand," explains Utting, who created dozens of pairs of eyes. The designer scoured stock photo books for inspiration on expressions. He even studied his own face and got himself on the apple packaging.

The designer wants every package to behave differently. Each is essentially in a different mood. Even within a single line, there might be 11 bottles arguing with each other like siblings, or a pair of boxes whispering like best friends.

"For example, the toothpaste doesn't really get along with the toothbrush, even though you might think otherwise. Or there can be big bottles looking after the small bottles, like big brothers taking care of smaller brothers," he says.

The lovely thing about this project, Utting notes, is that although designing 150 different packages seemed quite daunting at the beginning, it has turned out to be easier than he expected. By looking at the packaging by category, he can imagine all sorts of scenarios for the eyes.

About 30 to 35 related colors are used for the palette for the packaging—a broad color scheme, but one that is tied together by a gradation that emerges from the center of the front of each container. Beard says it is easy to see how the packaging works to unify products across the Tesco stores.

The eyes are making appearances elsewhere in the store, up to all kinds of wild behavior—hanging in pairs from the ceiling, looking out from the end of shopping carts and making comments about the driver, and hiding in freezer cases. The Tesco Kids brand is now being expanded to 200 to 300 SKUs, but the designers are not worried: They can see how the character would behave on everything from yo-yos to duvet covers. Essentially, he would act like a kid.

A secondary benefit to the new design is that it keeps kids entertained in the stores while moms shop. If the child does not get bored and whiny, then the parent is less likely to get angry and annoyed. Everyone is having a better experience under Tesco's roof.

In addition to being applied to packaging, the eyes are popping up all over in the Tesco retail setting. The funny little character is even being expanded into other consumer products, such as lunch boxes, T-shirts, and toys.

In the past decade, **the category of soap** has split into two subspecies—**your standard commodity** product and your **pricey luxury item** that looks, feels, and smells wonderful, offering a personal getaway each time it is used. **Watercolours definitely falls into the latter category,** although minus the right packaging, it might not have made it there.

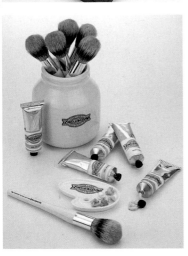

⊗ Sayles Graphic Design worked closely with client Gianna Rose to create Watercolours, a unique set of colored, scented soaps that are packaged like watercolor paints.

Watercolours is a set of five scented cream soaps, packaged in silver paint tubes, sold as a set in high-end boutiques and department stores together with a ceramic artist's palette and a paint brush. Bathers are encouraged to mix their own colors and scents for themselves or for others. It is likely to be a gift item for a child or a wedding shower gift, explains Sheree Clark, principal with John Sayles of Sayles Graphic Design, Des Moines.

"The best concepts always have a basis in reality," Clark notes. "You could package just about anything in a tube. But soap is logical and it underlines the client's original concept of paint. If this soap had been more viscous, we could have put it into a can— that may have worked, too. When you are doing something for the retail market, though, the package becomes the 'ahh!' factor, the added value that can allow the retailer to get a higher price point."

Sayles Graphic Design's client, Gianna Rose, is an ideal partner, says principal John Sayles. The owner is willing to spend plenty of time brainstorming with the designers to make her sometimes unlikely ideas—such as soap in tubes or fragrance suspended in beeswax—become a reality.

"She comes up with wild ideas and just goes with it. She just moves ahead and doesn't worry about things like focus-group testing. She has products she believes in and has faith in us. It's our job to take her ideas and improve on them or give them a new twist," he says. Too many times, Sayles points out, designers automatically view the client as the enemy, believing that his or her ideas on design aren't valid. The best designs emerge when there is mutual trust. "We can't know everything about their vision," Sayles adds.

When the client first contacted the design firm, she already had the name "Watercolours" combined with the concept of soap in her mind, but she hadn't worked out how such a product would actually be presented. She and Sayles discussed all of the ways that real watercolor paints are sold: in tins, cans, trays, and tubes. Tubes took soap to an entirely different place, and they decided to develop the idea further.

smaller
tubes
Don't
work

PAINT CAW
too
industrial?

⊲ Although the client already had the name "Watercolours" and the concept of soap together in her mind when the project began, she was not sure how to package the product. John Sayles imagined all of the different ways that real watercolor paints might be packaged.

⊽ The idea of a tube was both fun and practical: The buyer would be delighted with the novelty of squeezing out and mixing her own scent and color, and the tube also protected the product in a stable container.

PAINT
SET

I can't find
a metal case
LARGE enough
for tubes?

LABEL
go
SIDEWAYS

Other ideas that had resonance included packaging the soap with a porcelain palette for mixing and a soft brush. "In my mind, I walked up and down the aisles of the art store and considered how paints could be applied or used," Sayles says.

Although the client looked into production issues, Sayles developed the labels and box for the product. Clark notes that the design for the product could have taken many different directions considering the paint connection: kitchy with kid-like spatters of paint and a stir stick. They could have used a metal paint-roller pan to hold the products. But that pushed the design in the direction of "too casual." The product was already fun all on its own: The design of its packaging needed to be more elegant.

The client had in mind a 1940s, Art Deco feel for the labeling, Sayles says. So for the tube and box labels, he hand-rendered a mark that has a connection to the period, but with a contemporary feel. And in a product category that is typically flowery and feminine, the black 14½ x 7½-inch Watercolours box stands out in a dramatic way.

Clark says that the product and its unique packaging succeeds because, although it may have seemed like an unlikely concept at the outset, the packaging has several advantages: It makes it tidy and fun for the bather, attractive and protected for retailer display, and delightful in its overall concept.

The product is all about fun, she adds. "People aren't looking at Watercolours and asking themselves, 'Do I want Irish Spring or this?' They are essentially buying the packaging."

That being said, when a designer creates a package that is completely new and untested for a category, it is his or her responsibility to be certain that the package can deliver the client's product safely and effectively.

"You have to ask yourself the tough questions and go beyond being just a graphic designer: Will the product expand or shrink with temperature? What is its shelf life with this packaging? Can it be shoplifted too easily?" she says. "Everything has to be taken into account, not just the presentation."

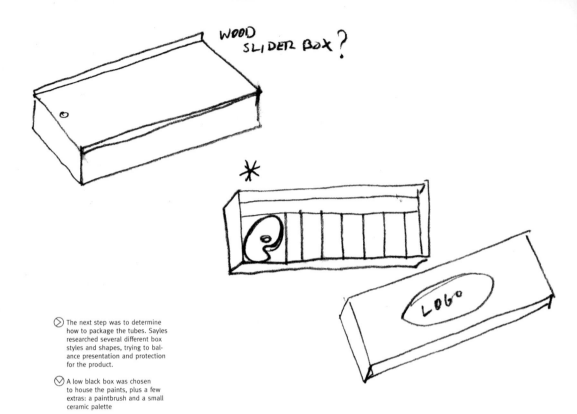

WOOD SLIDER BOX?

*

LOGO

> The next step was to determine how to package the tubes. Sayles researched several different box styles and shapes, trying to balance presentation and protection for the product.

> A low black box was chosen to house the paints, plus a few extras: a paintbrush and a small ceramic palette

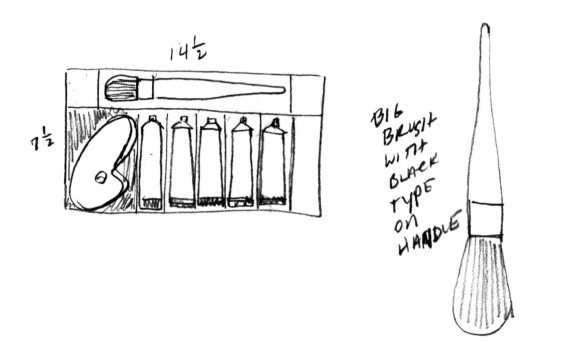

$14\frac{1}{2}$

$7\frac{1}{2}$

BIG BRUSH WITH BLACK TYPE ON HANDLE

Sayles could now begin designing a label for the box and the tubes. His client had requested an Art Deco feel for the design, but he explored other approaches that might have adapted as well.

Sayles studied and hand-rendered several different typefaces to find the right mix of the period feel and contemporary flair that the client wanted.

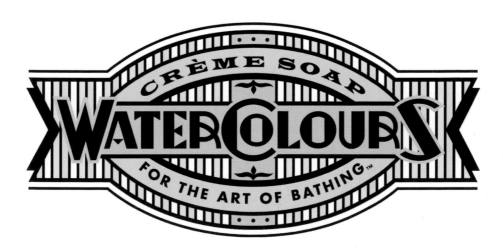

The final label, complete with type hand-rendered by Sayles, is very different from the flowery, fussy labels that most competitors' products use.

Pol Roger is known as the **wine writers' champagne.** Wine **aficionados regard it highly,** and it has a glamorous, romantic history that **appeals even to those who know very little about fine wines.**

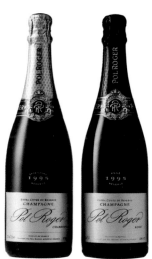

Pol Roger is a premier champagne, but its brand image had not stayed as relevant as it should have over the years. Lewis Moberly redesigned the product packaging so that it reflected the brand's history yet allowed Pol Roger to move forward.

Odette Pol Roger was a famous beauty who enchanted Winston Churchill, who drank only Pol Roger. As a result, his name is given to one of the family's most celebrated wines—Cuvée Winston Churchill. Odette was a regular guest at the British Embassy. This was a glamorous period in history, and the design of the Pol Roger brand is reminiscent of elegant formal invitations of the time, with their fine handwriting and sensual lines.

But the wine's packaging was no longer a good match for this top-of-the-line brand image and quality. The White Foil variety illustrates the challenges the brand faced. As Pol Roger's benchmark wine, White Foil is the soul of the company's five-wine portfolio, explains Mary Lewis, principal of Lewis Moberly, an accomplished design consultancy based in London and the firm challenged with realigning the brand image with its packaging and identity.

White Foil's white capsule or top neck foil is distinctive in the variety's sector. Its packaging design, as well as that of the other varieties—Chardonnay, Rosé, Vintage, and Demi Sec—had become disparate over time through inconsistent use of the house marque, different logo styles, and confused range organization.

"Brands with a heritage must be altered with care, but equally they must move forward, remaining salient with contemporary consumers and their changing appreciation of luxury," Lewis explains. "The balance of tradition and modernity is important. The Pol Roger archives were an excellent starting point to understand the brand spirit."

In the client's archives, Lewis Moberly designers found early labels that revealed sensuous, refined script, reminiscent of formal invitations. These would be an enormous help in redesigning the brand marque and script.

Today, the brand's owner describes the brand as "vivacious, pleasurable, and exciting." With knowledge of the past and the present in hand, Mary Lewis and her team could begin the redesign. They started with the house marque, which had been represented in four different ways. A single marque needed to be reestablished.

Inspired by the archive images, which are rich in detail, the team created a molded, elaborate marque that projected the Pol Roger deep blue house color, the brand name in entwined initials, the company's year of founding, and majestic lions.

The next element to examine was the brand name script. "It was important to retain the signature branding of Pol Roger, which is both distinctive and personal," Lewis explains. "In the context of global abstraction, these attributes are to be valued."

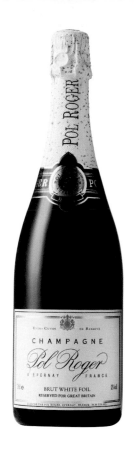

Left: The original White Foil package design.

Center: The Lewis Moberly design team found beautiful samples of Pol Roger labels from the past in the company's archives. The script in particular inspired the designers.

Above: The old house marques were rather generic and said nothing about the elegant history of the Pol Roger brand.

Left: A pencil sketch of the new marque showed the detail and richness that bespoke the Pol Roger brand.

Right: The new marque included the brand's deep blue house color, the company's initials, the year of the company's founding, and lions. Each element spoke of the brand's genteel heritage.

ORIGINAL SCRIPT

MORE HARMONIOUS

MORE EXTENDED

FINAL SCRIPT

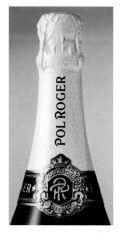

◇ The marque lettering and the product name typography matched well: classic, yet modern.

◇ Far right: The designers explored a number of different scripts for the main label.

◇ Right: A detail of the new White Foil neck dressing and of the new Reserve label.

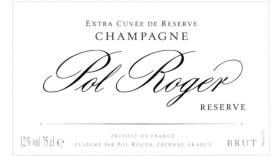

EXTRA CUVÉE DE RESERVE

CHAMPAGNE

Pol Roger

RESERVE

12% vol 75 cl ℮ PRODUIT DE FRANCE BRUT
ÉLABORÉ PAR POL ROGER, EPERNAY, FRANCE

The designers explored several handcrafted scripts, some extended, some traditional, some more modern. They decided on a style that was eminently legible, elegant, and simple.

With these basic design elements determined, Lewis Moberly could begin the White Foil redesign. The designers began by removing the gold speckles from the packaging—a common design element among sparkling wines—and replaced them with a repeat pattern of the "PR" initials. This distinctive, ownable brand detailing on the neck foil was handled in a subtle way, by printing pure white on an oyster metallic foil: The effect is simple, yet sophisticated with the new and particular Pol Roger logo in place.

"The capsule bottle label echoes 'the party,' the vivacious, exuberant part of the design. The new body label is the 'invitation' to the party," Lewis says.

The project team decided to rename the product "Reserve," because White Foil was really an affectionate trade name used only in the United Kingdom. Furthermore, because the brand was international, "Reserve" would travel better. The reinforced name takes center stage on the new main label, surrounded by restrained, formally positioned type. The label itself is also smaller, and therefore, more precious, Lewis says.

From here, the designers moved on to the Vintage line, described as the "heart of the brand," which originally was too similar in appearance to the old White Foil line. A more revolutionary approach was needed.

Using the same basic design structure they had implemented on the new Reserve line, the designers moved the Vintage design to a gold and black palette, which immediately distinguished it. The

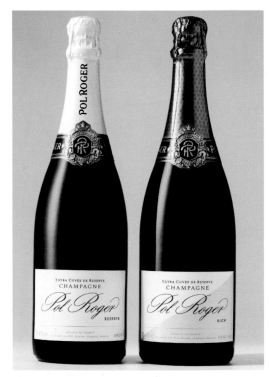

◇ The new Reserve and Rich designs. Clear differentiation is now made between the two varieties, and each now has its specific flavor attributes communicated through subtle visual cues.

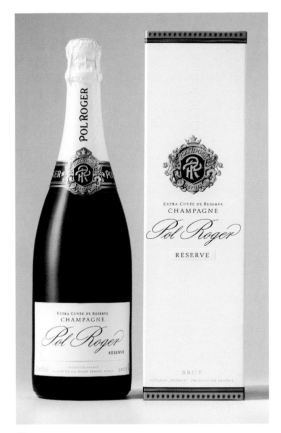
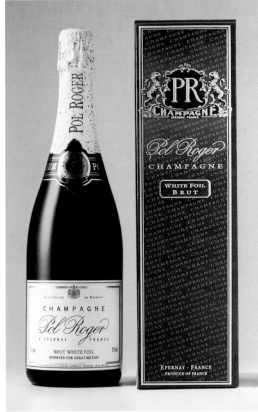

⊙ The product's boxes also needed to be addressed. A comparison of new (left) and old (right) designs shows a clear upgrade in elegance. Although the brand identity was also heightened, the design remained classic and simple.

neck foil retained the subtle detailing of the repeat PR branding, but in black, through a tactile surface change of a mix of gloss and matte inks.

The original design for the Chardonnay—the brand's "spirit"—and Rosé—its "body"—lines was too shiny and overstated. The Chardonnay labeling was gold and the Rosé labeling metallic dark pink. The color choices communicated the correct values for the champagnes, Lewis explains, but they needed to be tempered in both hue and finish to fit in with the more sophisticated brand image.

So the Chardonnay went back to a pale satin gold finish, and Rosé adopted a pale satin, desaturated pink. These refined colors involved several print trials before they were mastered, Lewis reports. Again, the PR initials repeat was used on the capsule foils.

The final member of the portfolio, Demi Sec, suffered from a lack of differentiation from the old White Foil line: It is richer than Reserve, but closely related. This product needed both connection to

and differentiation from the Reserve, so the project team renamed the product "Rich." In addition, placing a metallic, deep oyster diagonal in the label as well as using a dark gold capsule foil communicated a more intense image for the new Rich variety.

Mary Lewis is pleased with the completed design. "Our focus was to ensure that the new design reflected Pol Roger as the pinnacle of champagne—you taste what you see. Visual expectation now met product quality head on. This contemporary, elegant design is rooted in the rich history of the brand. This brand is talking the same language across the portfolio, exuding the brand's personality," she says.

Lewis takes two lessons away from the project, lessons that she has witnessed and learned from in many other projects. First, she says, to successfully move a brand forward, a designer must first completely understand its past. Second, as many designers know, it is best to have a direct line of contact with the brand owners and the people who make the decisions. Both factors were in place for Pol Roger.

There was no question that, when client Sun-Rype presented its new **Fruit & Veggie Bar** to karacters design group, based in Vancouver, B.C., for a packaging design, the new snack was a little off-putting. **What exactly is a fruit and vegetable bar?**

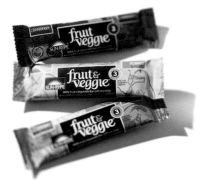

An unlikely product—a healthy snack bar made from dried fruits and vegetables—required an intelligent packaging solution by karacters design group. The rotogravure-printed foil packages looked like small art prints, and their bright colors and illustration style heightened the taste appeal.

What do dried vegetables actually taste like?

In truth, says Matthew Clark, associate creative director at karacters, the product tastes wonderful and has since proved to be one of Sun-Rype's most valuable product launches. Although the individually wrapped bars have no veggie flavor at all, they deliver two government-sanctioned servings of fruit and one serving of vegetables in each bar. But getting these benefits past the wrinkled noses of most consumers was a challenge in the beginning.

The karacters design team began by suggesting alternative names to the client. "We were convinced at the start that including the word 'vegetable' would be a mistake. We suggested things like 'Basics,' even 'Vega,' but these were all rejected in focus groups, whose participants made it clear they did not want to be snowed," Clark says. "They said, 'Just call it a fruit and vegetable bar.' We did end up changing to 'veggie,' just to make it more colloquial and approachable."

The focus groups also liked the concept of the bar, a healthy, convenient way to get those hard-to-manage vegetables into their diets. And when they tasted the actual product, they were sold.

Even with this clear vote of acceptance, the designers felt that showing photos of vegetables on the packaging would scare off buyers. Illustration would be a more palatable presentation for parsnips and peas. The designers also knew that the new package design had to be aligned with the client's popular, preexisting juice lines, which are marketed as being mainly for kids and families. But this new product was definitely targeted to adults, not children.

"The packaging had to be distinctly Sun-Rype, but instinctually adult," Clark says. "It had to stand for the principles of the established brand—wholesome, family, taste, and purity."

Another consideration was the printing process that would be used to produce the packaging. Rotogravure printing on foil has its own eccentricities and limitations. It can handle good detail—much more so than flexography—but it is much less able than lithography to print accurate four-color process photography. And the registration on a rotogravure press can be a bit loose, so it lends itself to a design in which colors overprint each other.

The first round of designs studied the actual style of the label. One design spoke of simple, cleaner life of wholesome goodness. It was hand lettered and slightly naïve, but it was a bit too "hippie" to align well with the Sun-Rype brand. Another design was quite a bit more sophisticated and fashionable; it addressed the

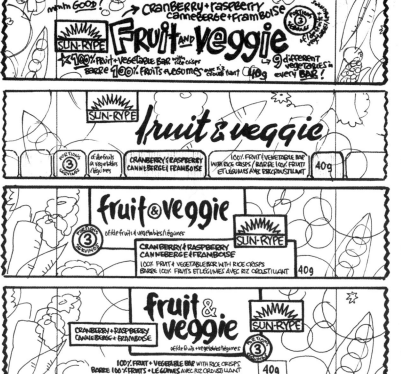

premium nature of the ingredients. But this went too far into the direction of affectation, again, not a good match to the brand.

A third style fell into the middle ground. It was dynamic and bold, stated the product information clearly, left plenty of open space for enticing illustrations to show through, and was asymmetrical enough to provide visual interest. This design was the one that was eventually selected for the final design.

Next, the designers searched for an appropriate illustration style. The right art would be crucial in communicating the flavor, quality, and progressiveness of the product. Anything too modern would not have the friendliness of the Sun-Rype brand, whereas anything old-fashioned might send the message that "This is good for you, which is not necessarily a product attribute that consumers flock to," Clark explains.

One illustration style, for example, used a wallpaper display effect to show different fruits and vegetables. The client deemed it too old-fashioned, although its bright, hot colors were preferred. Some of the more modern styles they experimented with did not feel personal enough. A mix between the two styles might work, they thought, and so illustrator Adam Rogers was called in for the final illustrations.

"Adam is an illustrator who doesn't normally do line art. He is an illustrator who works in two distinct styles: One is a graphic, textural painting style, and another on the computer that has a chic, 'wallpaper' look. We challenged him to take his painterly style,

apply this aesthetic to a more gestural line art, and then bring it onto the computer to clean up the lines," Clark explains.

The resulting illustrations are sensual, with a slightly nostalgic feel, as if they came from the 1960s. But with their fresh colors and minimal line style, they feel very much like modern art prints.

Clark blocked in the background colors on several trial designs to simulate the three main color schemes: green for apple-pear, red for cranberry-raspberry, and orange for blueberry citrus. "I was trying to figure out a priority of information here," the designer says.

Sun-Rype has historically used its trademark blue as the main background on all packaging, but a recent redesign to the entire juice line allowed Sun-Rype to see that its blue could be used as a panel over a background of fruit. For the new bar's design, blue panels float over the illustrated background. The information was organized to highlight the product name, the Sun-Rype brand, the flavors, and then the details such as the three-servings-a-day icon. The flavor name emphasizes the "fruit" in "Fruit & Veggie," and the center panel is flanked by the two fruits, because this is the predominant taste, but vegetable illustrations make up the majority of the background pattern.

The project was a success, Matthew Clark says, because it stayed true to the brand equity in an intelligent manner by expanding on what the brand is, rather than just copying the core juice line packaging. It has the proper aesthetic and used the correct printing processes to achieve it. The information hierarchy is clear.

△ The karacters design team experimented with many different illustration styles, including this traditional wallpaper style. This style tied into references of heritage and goodness but was not used because it had an old-fashioned feel to it.

△ Although this illustration trial was simple and stylized, the ingredients were still recognizable.

△ Here the idea of overlapping transparent colors began to emerge. This more abstract approach would have relied more heavily on the printed information on the label's front panels.

△ The illustration and color blocking explorations were continued, but here the blue core brand panel was introduced.

△ The idea of stylized fruit and vegetables was joined here with intersecting shapes. Both ideas were carried through to the final design.

⊘ The final illustration selection was combined with color blocking.

⊘ These fresh illustrations with their minimal line style were chosen as the final art for all packages.

⊘ The designers first placed the color blocks in the final comps without illustrations complicating the effect.

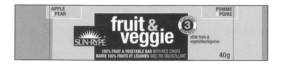

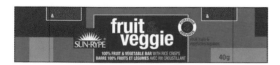

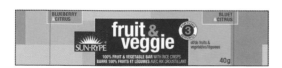

⊘ Color drawdowns for the final palettes show the effect of transparent ink colors.

When business is good, as it was with **Koppers,** clients tend not to pay attention to such onerous issues as **rethinking packaging:** If things aren't broke, **why put yourself through the agony?**

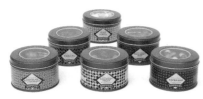

Koppers Chocolates wanted to expand its customer base, but needed a new packaging system to increase its shelf appeal. Its previous system used clear boxes and bags—the product was clearly visible, but the packaging did nothing to reinforce the brand. Designer Nicky Lindeman devised a flexible, eye-catching suite of packages that captured immediate acclaim.

But a new manager of family-owned Koppers, the oldest candy maker on New York's Hudson River, had bigger ideas for the company that she just inherited. Business was good, but it could be better, she felt. Koppers, which specializes in chocolate-coating nuts, fruits, candies, and other items—in fact, it will coat just about anything customers bring in, including roses—is also well known for its kosher candies. The confectioner sells its goods to a mostly adult audience in quality retail settings such as Sak's and in smaller specialty shops.

Kopper's original packaging program hadn't been addressed in many years. For the most part, it consisted of clear bags and boxes. Because candy is commonly given as a gift, and because of the confectioner's largely adult audience, this generic approach was missing the mark. In addition, Koppers wanted to expand its business beyond its regular buyers.

"You just don't give an adult a plastic bag of candy as a gift," notes Mirko Ilić, of Mirko Ilić Corp., whose spouse, Nicky Lindeman, undertook the Kopper's redesign project.

One of the first things Lindeman examined was the client's logo, which was extremely narrow and used a candy-colored palette of pink, purple, yellow, and green. She convinced the client to consider a more open design, one that clearly stated the company name but with less color, and graciously left space for the candy name or variety.

The client was committed to a metal container for her goods, but because she still wanted shoppers to be able to see her candies, she selected a container with a clear window in its lid. However, because the containers are normally stacked on store shelves, most of the windows would be covered up.

So Lindeman began searching for an additional way to convey the canisters' contents. "Koppers has many different kinds of chocolates, so this needed to be a design that worked on anything. That's when I thought of the wallpaper background. I could use patterns of fruits, coffee beans, or whatever was inside," she explains. Some of the same colors used in the company's original identity were still used, but were toned back.

There were two other challenges to be faced: The client had asked for a great deal of copy to be included on the new packaging—too much, in fact, for the new design to accommodate. Another hurdle was overcoming advice that had been given to the client by a previous vendor. For example, the printer for the original packaging had advised Kopper's that nothing could be printed under the UPC code.

The original Kopper's logo was tall and narrow. Lindeman convinced her client to extend the mark so that the brand name could be larger and longer.

An early wallpaper design for the chocolate cordial assortment used star bursts, but the client requested that the pattern be changed to bottles.

Other early label designs. Other than minor color adjustments, these comps are similar to the final designs.

The client liked the fact that her original packaging revealed the product inside. So Lindeman wanted to capture the same effect in the new design. A wallpaper effect that showed the main ingredient of the candy was both flexible and graphic.

The final printed labels. The wallpaper patterning provides subtle yet clear distinction between varieties. If the client chooses to, she can easily expand the visual to package new products later.

Lindeman says that by actually showing the client other printed samples of UPCs and by giving the client a concrete word count, both obstacles were overcome. It was simply a matter of education and cooperation, the designer says: After all, it had been many years since the client had been through the redesign process, and plenty had changed in the interim.

Immediately after the redesign was finished, in early 2003, the client took the new packaging to a candy fair, and reactions were extremely positive. There is talk now of redesigning the company's Web site, stationery, and so on.

"This was a successful project because the client is happy—she got a new, fresh look for her product," Lindeman says. "We felt it was an improvement on the previous packaging. Also, the canisters are something that people might keep even after the candy is eaten."

Volkswagen

"While the first few cars will fly out of dealerships," predicted an article written about Volkswagen's new Beetle, from the January 12, 1998, issue of *Newsweek*, "the long-term picture for the car is dicey. VW has only vague notions of who might buy it."

But for a company that had the guts to run the headline "Lemon" in the same ad as a photo of one its distinctive bright yellow Bugs, "dicey" is a relative term. Volkswagen of America knew it had a challenge when it decided to revive an icon, the Beetle. But its bold move ultimately reconnected Volkswagen with its customers and increased sales of all of its cars.

In 1991, Volkswagen opened a car-design studio in California, the first outside of Europe, for several reasons. The California lifestyle is very car-centric, plus it's one of the few places where weather and road salt haven't destroyed Beetles and VW buses. So the atmosphere is rich with VW culture.

One idea that emerged from the new group was to re-create the Beetle concept for the twenty-first century. Volkswagen sales were at an all-time low in the United States: In 1993, less than fifty thousand cars were sold nationwide. Volkswagen of America saw the revised Beetle as a way to generate new interest in the brand.

Lime.

Drivers wanted.

If you sold your soul in the 80s,
here's your chance to buy it back.

Drivers wanted

Less flower. More power.

Drivers wanted

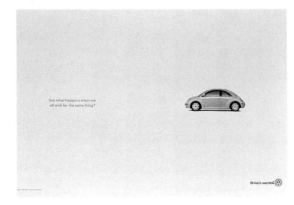

See what happens when we
all wish for the same thing?

Drivers wanted

"The concept car shared no parts with the original Beetle, but it evoked the shape and thereby evoked the emotion of the old one but in a new way. Some people said we should escape the Beetle altogether. But we wanted to show that it could also be something meaningful today," explains public relations manager for Volkswagen of America, Tony Fouladpour.

In time, the proposal appeared as a concept car at the 1994 Detroit Auto Show. Volkswagen was stunned by the reaction: The car generated a tremendous amount of excitement among the public, dealers, journalists, and within the company itself. Fouladpour says that though Volkswagen had not even made the decision to actually produce the car, many dealers saw the concept car as a light at the end of the tunnel. They would stick with VW to see what happened.

In the fall of 1994, production did begin. Arnold Communication was brought in to help define what the brand would mean to consumers. The result was the "Drivers wanted" campaign. In the advertising, the background behind the cars was dropped out, a nod to the original campaign. The cars were shown in an extremely straightforward manner, as before.

"You're not going to come up with something better," said Lance Jensen of Arnold Communications at the time. "It's like trying to write a better pop song than John Lennon."

"'In life there are drivers and passengers: Drivers wanted,'" quotes Fouladpour. "It meant that Volkswagen wasn't for everyone. It was invitational. This might be the right attitude for you and it might not." Prior to the car's release, focus groups endorsed the approach as dead on: Everyone reacted to it differently. Older people liked it because of its nostalgic caché, but younger people—who weren't even born when the original Beetle was in its prime—liked it for its style and shape. Others didn't like it at all.

When the new Beetle was launched at the 1998 Detroit Auto Show, people instantly fell in love with both the car and the new ad campaign. The ads didn't preach to people, Fouladpour says. Instead, they let people choose the brand. That's why people are never pictured in the advertising or marketing.

What color do you dream in?

"We didn't want to peg the car by having Cindy Crawford driving the car in a black mini-skirt intimating that this could be you or you could be sexier if you drive this car. The Beetle is for everybody, not just a certain type of person," he says.

Marketing followed advertising's lead: Rather than call a car color "candy apple red," for example, "red" was sufficient. The campaign avoided pretense and valued directness. Fouladpour says they also worked hard to help the power brokers of the automotive media understand what the car was and what it was not.

"They had to understand the car," he says. "No, this is not the lowest-priced car in the market. No, we are not going to sell a billion of them. It will, however, reconnect people with the VW brand. It will be a lifestyle car—not just because it is small and practical, but because it is fun. All driving is an experience, and this experience is going to be very different. People wave at you. There is pride in owning and driving it."

But VW marketers met with blank stares when they said they weren't aiming at any particular demographic, heresy in the automotive market. But Volkswagen's goal was to appeal to younger people and older people in different ways with different advertising placed in different media. An ad that read simply, "The New Beetle 2.0," was intended for the software-savvy set. Another, which showed a green new Beetle with the tagline, "Lime," was an in-joke for people old enough to remember fondly the breakthrough "Lemon" ad nearly thirty years ago.

Volkswagen even addressed specific areas of the country individually. A billboard for Los Angeles read, "Just what LA needs: Another car that stops traffic."

Rather than focus on demographics, VW concentrated on what Fouladpour calls psychographics, which speaks of a frame of mind rather than an actual state of being. If someone has an active or fun attitude, then the new Beetle should appeal to him or her.

Of course, the car is an incredible success and is back on the road as a cultural icon. Sales have been brisk. But even better, the new Beetle is drawing people back into showrooms where they can engage with other VW models.

Part of Volkswagen's problems, Fouladpour says, is that it just wasn't connecting with the consumer like it had before. "We needed to create some excitement and remind people why they were so passionate about the brand. The new Beetle has become that magnet for the brand."

Less flower.

The engine's in the front

but its heart's in the same place.

More power.

Superdrug

Is it possible to make a washcloth sexy? Can a toilet cleaner have graphic appeal?

Designers at Turner Duckworth's London office certainly thought so when they took on the job of creating an in-store brand identity for the chain Superdrug. The designers have created approximately twenty designs for twenty different Superdrug lines in the past year or so, each one a delight in its style, humor, packaging, or personality. And the fun isn't over yet: In the next few years, Turner Duckworth will create personalities for nearly two thousand additional Superdrug lines.

The designers' approach to creating an identity for the Superdrug brand is unique. Instead of trying to build visual equity by consistent use of a corporate color or by stamping each product with an overwhelming logo, Turner Duckworth has made great design Superdrug's signature. If it looks better and more clever than anything else on the shelf, it's probably the Superdrug brand product.

By setting the design's flight pattern high on the consumer's radar screen, the designers have also set their own goals at a remarkable level. Principal Bruce Duckworth says that although the Superdrug design work certainly isn't easy, it is fun. "The Superdrug personality is one of fun and wit. Those elements go a long way toward having a proper conversation with a consumer," he says. "It is a brand name that is very up-front, very descriptive. Customers recognize that. Then the details of all the product designs get them more involved."

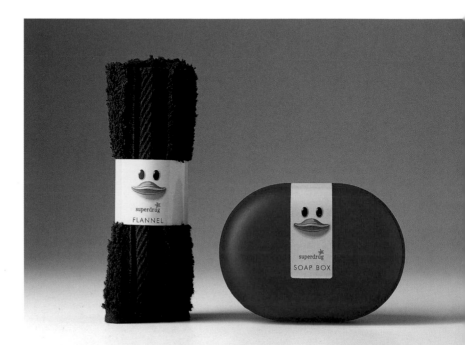

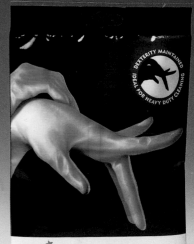

superdrug
LIGHTWEIGHT
HOUSEHOLD GLOVES
100% COTTON FLOCK LINING, LONG CUFF
`MEDIUM`

superdrug
MEDIUMWEIGHT
HOUSEHOLD GLOVES
100% COTTON FLOCK LINING, LONG CUFF
`MEDIUM`

superdrug
HEAVYWEIGHT
HOUSEHOLD GLOVES
100% COTTON FLOCK LINING, EXTRA LONG LENGTH
`MEDIUM`

What could be less sexy than rubber gloves? For the Superdrug brand, though, Turner Duckworth designers made the product not only graphically appealing but very descriptive as well. The shadow puppet is witty and familiar, plus it describes the benefits of the product.

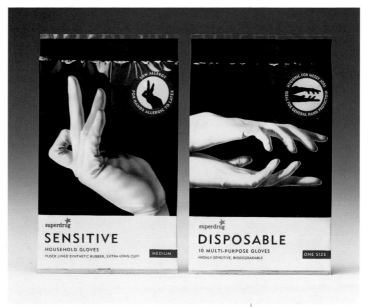

superdrug
SENSITIVE
HOUSEHOLD GLOVES
FLOCK LINED SYNTHETIC RUBBER, EXTRA LONG CUFF
`MEDIUM`

superdrug
DISPOSABLE
10 MULTI-PURPOSE GLOVES
HIGHLY SENSITIVE, BIODEGRADABLE
`ONE SIZE`

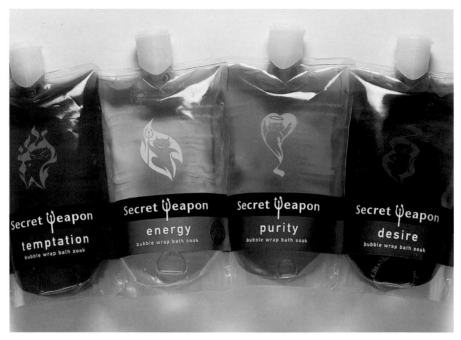

Secret Weapon, a line of body care products targeted at the thirteen- to twenty-four-year-old female consumer, is noteworthy for its very unusual packaging. The bubble bath, for instance, is packaged in blood bags, a somewhat naughty extension of the line's daring personality. "Your mum certainly wouldn't buy that for you," says Duckworth.

Some of the simplest and perhaps most emblematic of the Superdrug designs are those created for some pretty mundane products: combs, toothbrush holders, soap dishes, and so on. About thirty products were lumped together in a category the designers called "bathroom accessories." "Their job was to give the collection of disparate objects one image," says Duckworth.

"We thought that the rubber duck was kind of the epitome of what everyone has in their bathroom," he says, noting that the duck face had the right feeling of whimsy and fun that lent personality to such personality-less products like washcloths. Each product in the line was affixed with a baby-duck-yellow band printed with a cheerful duck face. "Even the real rubber duck in the Superdrug line has a picture of a duck on it," he says.

The Superdrug vitamin line is at the other end of the whimsy scale: Vitamins are an ingested product, so the designers wanted to treat it more seriously. Even so, the design treatment is colorful and bright, suggesting the health benefits of the product. The product's aesthetically intriguing cap also has a practical purpose: It's designed to hook onto a rack in the customer's home. The idea behind the design was that once the buyer had the rack in his or her home, he or she would continue to fill it with Superdrug products. In addition, the rack, adorned with cheerful vitamin packaging, is actually attractive enough to remain out on the counter where the consumer sees it every day. The Superdrug brand is always in sight.

Many Superdrug products have this "decorative" quality." Many are personal care products so beautifully packaged that they add real style to the user's bathroom just by sitting on the edge of the tub. Secret Weapon, for instance, is a range of fragrance-based toiletries targeted at thirteen-to twenty-four-year-old women. The idea behind the evocative names of the products—Temptation,

Energy, Purity, and Desire—was to play against common moods for this age set. "A young girl could buy all of these. On Friday night, you might want to use Temptation, then pick Purity for Saturday," Duckworth explains. The little icons on the products are the kinds of drawings that a girl might doodle on a school notebook. "They're meant to bring out the devil in you."

Each product has its own alluring presentation. Solid perfumes are packaged in embossed tins; products with texture and color like roll-on body glitter and shower gel are packaged in clear containers to let their visceral quality show. Other, one-application products like moisturizing masks, are contained in shiny foil packages, a packaging convention that is carried through in other lines of Superdrug skin and hair care products. Another subtle type of coding: Nail varnishes are contained in somewhat traditional bottles, but each color is named after a particular club that young women might frequent. It's definitely an in-joke meant to appeal to people who want to be "in."

The most radical packaging, though, is the blood bags that contain the Secret Weapon bubble baths. "Your mum certainly wouldn't buy that for you," laughs Duckworth. But the modestly priced product line is an enormous hit with younger as well as older women. In 1998, it grew into a £6 million brand with absolutely no advertising. Fans wear the icons on dog tags and T-shirts.

Duckworth says he is sometimes surprised at how far consumers have bought into the brand, even with products as common as laundry detergent, rubber gloves, and aluminum foil. Buyers have genuine enthusiasm and remarkable loyalty to the Superdrug brand. "Each design has several layers of information. There's the product itself, its shape, and then its packaging," he says, trying to explain the appeal.

Turner Duckworth's, and subsequently Superdrug's success, is purely a matter of putting the product first, Duckworth says. "There is never a condescending voice speaking to the customer or the product. We want people to know that so much care has gone into the product and its design. We want them to know that the product is not a joke."

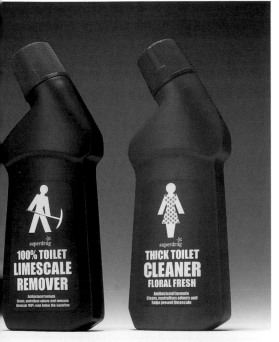

Turner Duckworth was even able to give Superdrug's toilet cleaner a touch of fun. The flowers on the woman's dress hint at the freshness the cleaner provides, while the pickax is a more overt reference to the lime-scale remover's power and purpose.

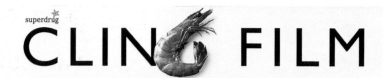

 superdrug

30m
300mm x 30m APPROXIMATE SIZE

CLIN**G** FILM

10m
300mm x 10m APPROXIMATE SIZE

KITCH**E**N FOIL

30
LARGE
WITH TIE CLOSURES

F**OO**D BAGS

There's no reason to show food-wrap products or even describe their exact purpose: Buyers already understand the products well. So for the Superdrug line, Turner Duckworth designers had fun with the typography in the design.

superdrug
Starflower Oil
250 mg

30 CAPSULES

superdrug
Cholesterol Free
Lecithin
600 mg

30 CAPSULES One-a-day

superdrug
Royal Jelly

30 CAPSULES

superdrug
Aloe Vera

30 CAPSULES

superdrug
Odour Controlled
Garlic
PLUS MULTIVITAMINS

60 CAPSULES One-a-day

Vitamins and supplements are products that will be ingested, so they must receive more serious graphic treatment. Even so, bright color and simple, appealing shapes make the products look very appealing.

superdrug

ORANGE & MANGO
SHOWER POWER
kick start every day with the tangiest, fruitiest, zingiest **shower gel** ever!

superdrug

LEMON & GRAPEFRUIT
SHOWER POWER
kick start every day with the tangiest, fruitiest, zingiest **shower gel** ever!

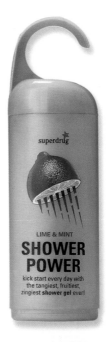

superdrug

LIME & MINT
SHOWER POWER
kick start every day with the tangiest, fruitiest, zingiest **shower gel** ever!

Turning fruit halves into showerheads is a natural pun for this shower gel product. Turner Duckworth also keeps sight of the product's function, packaging the gel in bright, shower-hangable bottles.

Harley-Davidson

There's only one brand potent enough to inspire someone to tattoo its logo on his or her body—Harley-Davidson.

Founded in 1903, the company is revered by nonriders and motorcycle enthusiasts around the world. Harley-Davidson isn't just a lifestyle; For many, it is life, or at least the fun part.

But as much as customers benefit from the company and its products and services, Harley-Davidson may well have benefited more from them. The company owes its very survival to the loyalty of its customers. In the 1970s, AMF, a sporting-goods conglomerate that sold everything from golf balls to motorcycles, owned Harley-Davidson. During that time, the brand didn't receive much individualized attention; as a result, quality and sales faltered. At the same time, lower-priced, better-quality Japanese motorcycles were flooding the market. The brand was facing a very real crisis.

Through it all, Harley fans remained true. The brand was finally back in capable hands when a team led by Vaughn Beahls and Willie H. Davidson bought the company in 1981. These two, among others, helped revitalize the enterprise and later took it public in 1985. Since then, with the unwavering support of employees and stockholders, Harley-Davidson now claims status as one of the world's most admired companies, with unheralded customer satisfaction.

Eagle Thon is one in a series of limited-edition posters given away at a Harley-Davidson open-house event that benefited a charitable organization.

The Harley-Davidson 2000 desk calendar, published by Chronicle Books, was one of the first examples of a true retail product created out of the rich H-D archives. One of its most successful Chronicle titles for 2000, the complete run of the calendar sold out.

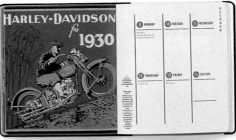

EAGLE

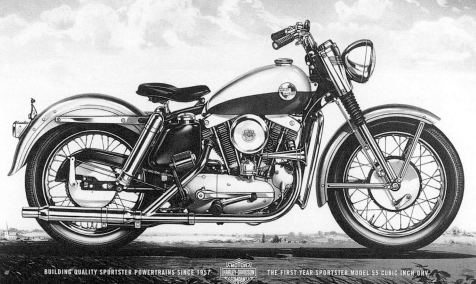

BUILDING QUALITY SPORTSTER POWERTRAINS SINCE 1957 HARLEY-DAVIDSON MOTOR COMPANY THE FIRST YEAR SPORTSTER MODEL 55 CUBIC INCH OHV

THON

SUNDAY, SEPTEMBER 12, 1999

POWERTRAIN OPERATIONS OPEN HOUSE & FESTIVAL AT THE CAPITOL DRIVE PLANT

ADMISSION

Ticket cost is $5 per person, children under 12 are free. Admission includes raffle ticket and commemorative pin. Grounds open from 10:00 am to 5:00 pm.

THIRD ANNUAL MEMORY RIDE

All motorcycles wishing to take part in the ride need to register at Signicast Corporation, 1800 Innovation Way, Hartford, Wisconsin.

ACTIVITIES & ATTRACTIONS

Bike raffle, demo-rides, Harley-Davidson motorcycle display, live auction, plant tours, commemorative items, and games for all ages.

ALL PROCEEDS TO BENEFIT THE MUSCULAR DYSTROPHY ASSOCIATION

This poster was made possible through the generous donations from the following Harley-Davidson "Suppliers/Partners" Design Ken Fox and Michael Peterson of VSA Partners, Inc. Printing and Prepress Print International Paper: Fox River Paper Company Image courtesy of the Harley-Davidson Motor Company Archives

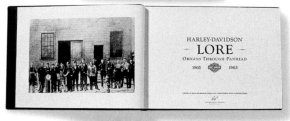

VSA Partners of Chicago has helped the company reestablish itself from the beginning of that turnaround. As Harley has grown, so has VSA, from a three-person traditional design studio to a seventy-five person strategic and integrated marketing firm. Partner Dana Arnett says the two companies have learned plenty from each other—about branding, about business, about the company's cultural physiology. Today, VSA helps create everything from Harley's Web site and annual report to rider-education programs and a new Harley-Davidson museum, scheduled to open in Milwaukee in 2002.

When someone buys a Harley, he or she isn't just buying a product, says Arnett, who is an enthusiastic rider himself (as are a number of other people in his office). Fellowship and cama-

Another Chronicle issue, *Lore*, was a chronology of the first fifty years of Harley-Davidson. Images and stories capture the spirit of significant events in the company's history. (*Lore II* will be released shortly.) The book is designed like a fine-art book, with plates. The cover displays an engraved steel plate, a direct tactile and visual reference to the motorcycle's primary substrate.

raderie are also part of the package. When someone visits a store or dealer for parts or service, they are also there for a free cup of coffee and some square talk. For that reason, the company spends more on maintaining customer touch points, including rallies, rides, dealership events, and club activities, than it does on advertising to the masses. Harley does not embrace the commodity mindset in producing its bikes, nor does it use a scattershot approach in promoting itself: Its product and message simply are not for everyone.

"They look at every customer and cultural touch point as another way to heighten the experience that brings you closer to the brand. Nothing gets you under the ether better than being right there with your customer," Arnett says.

All design and marketing is produced with what Arnett calls the "voice of truth," to match the way the company has always dealt with customers. "They have a strong brand with involved customers that are impassioned and empowered by just about everything the company does. You have to give it to them straight, because they spot a rat a mile away."

The brand has always enjoyed a rebel image—but that's only one of the many qualities that company officials want to preserve. They know from the experience that this brand has a far broader reach and appeal when it comes to individuality and lifestyle. Until recently, motorcycling was seen as a very narrow consumer category. Today, Harley is proud to be producing its well-designed, powerful machines and products for customers from all walks of life.

VSA stepped carefully in the beginning, working to leverage existing equity. Even today they strive to enhance the brand, not change it. "If you embellish the brand too much, you infect it," Arnett explains. So everything the design team creates must work more as a canvas for the rich photography, typography, and even the paper used in the final artifact.

By examining the core appeal of the brand, Harley and VSA strive to distill specific attributes. Heritage, freedom, and passion are just a few words that logically explain what's at the heart of these expressions. These more positive and emblematic attributes are often played out in visual and typographic messages; they shine through in just about all of the Harley-Davidson advertising and marketing mediums.

Harley-Davidson catalogs aren't mere sales tools: They are also meant to educate and inspire. VSA works to constantly elevate the subject matter through imagery and text.

this postcard set (published by Chronicle Books) is a gift tem created from archival H-D images.

Other visual and cultural elements are givens, even to the neophyte: chrome and leather, for instance, or specific models of bikes. VSA has transformed these long-familiar and potentially trite conventions from old to classic. But classic isn't the only voice of the brand. Arnett says his office is hard at work on the contemporary image as well.

"We naturally play close attention to the heritage of the brand—but I think it would be fair to say that our best work has a contemporary voice with a classic undertone. The trick is in the subtle way one learns to move in and around the brand," Arnett says. Harley-Davidson invests a great deal of time and attention, he adds, on mapping consumer trends and researching all demographic and lifestyle influences. In order to be one of the world's leading brands, the company must always be thinking many years out.

Arnett feels that Harley-Davidson's success goes back to how well it has stayed in touch with customers. "While motorcycles are core to the brand, the real success of Harley-Davidson has come because they are so customer-minded. "They are very in tune with what's essential in creating a fulfilling customer experience," he says. It's his firm's job not only to continue to present fresh work but also to constantly develop new marketing methods that stay in touch with this customer-centric mindset. For example, at this writing, they were working on a new strategy for selling parts and accessories. Thoroughly immersed in the brand, the design team is able to anticipate and address the client's needs.

In a sense, VSA's mission is the same as Harley-Davidson's company mission statement, which reads, in part, "We fulfill dreams."

Art and Science is the title of Harley-Davidson's 1998 annual report, the 12th that VSA Partners has created for its client. The report took a classical/historical look back at moments that still ring true in terms of how customers are inspired through the brand. VSA commissioned fine artist Tom Fritz to create the art for the book. Hand-signed prints of the work were offered in the report: Approximately thirty thousand were sold and the money was donated to charity. "We are not looking at an annual report as a standard reporting tool," says VSA principal Dana Arnett. "This is very much an opportunity to generate interest and inspire people."

CREDITS

ALL WORK BY **VSA PARTNERS**—SPECIFICALLY, KEN FOX, MICHAEL PETERSON, MELISSA WATERS, JASON EPAWLY, ROB HICKS, RON BERKHEIMER

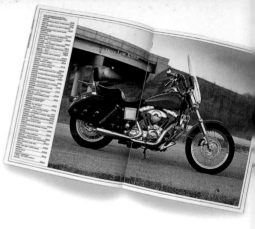

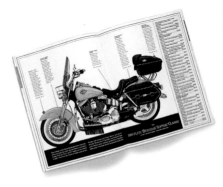

More Harley-Davidson catalogs and
screens from the company's web
site: Every piece that VSA creates
is replete with the romance of
the brand.

THE GENUINE
HARLEY-DAVIDSON
ROADSTORE

COME ON IN.
THE ROADSTORE IS OPEN.

SIGN IN / SIGN UP

motorclothes

accessories

CHOOSE A MOTORCLOTHES* COLLECTION ▶

CHOOSE A MOTORCLOTHES* CATEGORY ▶

NO KHAKIS AVAILABLE.
PANTS/CHAPS/JEANS

LEATHER PANTS
LEATHER CHAPS
FXRG
RAIN GEAR
JEANS & SHORTS

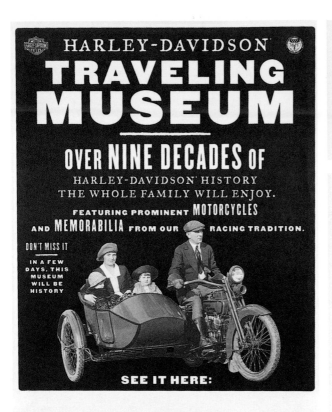

HARLEY-DAVIDSON
TRAVELING
MUSEUM

OVER NINE DECADES OF
HARLEY-DAVIDSON HISTORY
THE WHOLE FAMILY WILL ENJOY.

FEATURING PROMINENT MOTORCYCLES
AND MEMORABILIA FROM OUR RACING TRADITION.

DON'T MISS IT

IN A FEW
DAYS, THIS
MUSEUM
WILL BE
HISTORY

SEE IT HERE:

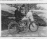

HARLEY-DAVIDSON
TRAVELING MUSEUM
More than nine decades of company history.
Completely Renovated for the 95th Anniversary
Featuring hand-selected, extraordinary archive material.

Road Less
Traveled

HARLEY-
DAVIDSON

GENUINE AMERICAN

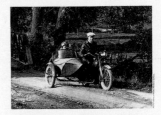

HARLEY-DAVIDSON
TRAVELING
MUSEUM

More than nine decades of motorcycle history.
★ On the Road Again and Headed Your Way ★
Featuring hand-selected, extraordinary archive material.

Get a First Hand Look at Branches of the

HARLEY-DAVIDSON
Family Tree You May Not Have Seen Before.
All items are guaranteed
GENUINE AMERICAN
Milwaukee, Wisconsin

COMING HERE ON:

History is a large part of the H-D
brand, so VSA is able to incorporate an
authentic sense of heritage into its
designs.

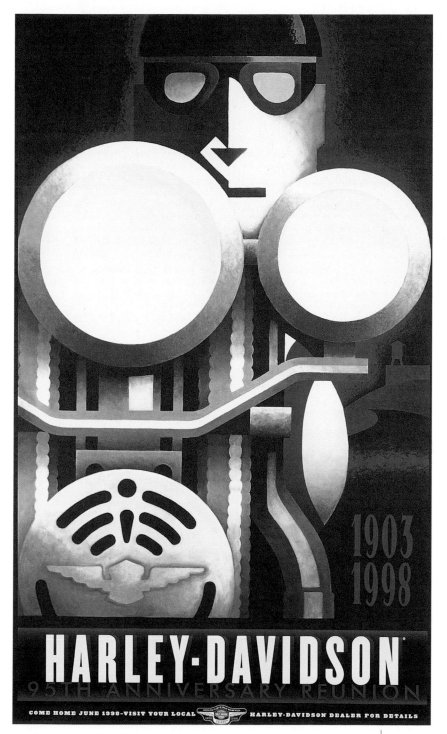

Orange

Orange has been hailed in the press as "the brand of the nineties" and "a textbook success story" that set a new standard for branding innovation.

Simple, clear, and bright, Orange cut through the noise and complexity surrounding the U.K. mobile-phone market. Its powerful brand identity, name, and visual style created an unusually high degree of consumer awareness. Within ten weeks of launch, it enjoyed 45 percent spontaneous recognition. By April 1996, just two years later, Orange scored 70 percent recognition, 20 percent higher than its heavyweight competitors Vodafone and Cellnet.

Wolff Olins, a leading brand consultancy, worked closely with parent company Hutchison to create the Orange brand. The philosophy behind Orange was radically different from anything else on the market, so it was a risk for the client. Rob Furness, head of brand marketing at Orange, says, "We understood that marketing was going to be the biggest part of it, and we would have to make a strong visual and marketing impact to take the lead."

Daren Cook, Wolff Olins' senior designer for the project, explains the radicalism. "The United Kingdom didn't need another mobile-phone network. We all felt that 'If you're the last fish in the pond, don't jump in. Go make a new pond.'"

ORANGE AND THE ORANGE LOGO DEVICE ARE TRADEMARKS OF ORANGE PERSONAL COMMUNICATIONS SERVICES LIMITED AND ARE USED WITH SPECIAL PERMISSION.

orange™

The Orange brand is unique in name, color, and spirit. The obvious design direction would have been to put the brand name in an orange circle, resembling the fruit. But reversing the name from an orange square was a breakthrough: The mark does not look like an orange. It is Orange.

Orange product packaging uses all of the brand's main elements: the one-word name, the large square, and an orange, black, and white color scheme. Consistency is one the brand's strengths.

Talk

Listen

Laugh

Cry

Weeks before the Orange launch, these
mysterious messages appeared through-
out the United Kingdom, in ads, on TV,
and on billboards, produced by the ad
agency WCRS. They speak of the brand's
benefits, not of the product. Phones are
never shown in Orange advertising.

Everyone involved in the process brought this attitude to bear on the project. Hutchison and Wolff Olins together chose a completely different vision: a brand full of personality, spirit, and attitude, one that didn't even need to show phones in its ads. The aim was to change the rules for marketing mobile phones. Instead of talking about products, Orange talks about its overall vision of a wire-free future.

During the naming process, "Orange" became a "catalyst name" that could be used to encourage people to think differently. But fruit was not mentioned in naming discussions. The team's goal was to talk about the company, not fruit.

At the start of the design process, an obvious direction would have been to put the name in an orange circle. But that would have introduced the unwanted concept of fruit. So the team went to the opposite extreme and reversed the name out of an orange square. When people see the mark, they don't say, "That looks like an orange." Instead, they say, "That is orange."

The visually compelling combination of the simple name, shape, and color has strong, positive connotations. Orange feels warm. Also, consumers didn't need to read the word; it was enough that they could see the color. These basic elements made the platform on which the brand identity would be built a consistently visionary one. They communicate the specific values—straightforward, dynamic, refreshing, friendly, and honest—that inform every Orange design.

Helvetica is another major component of all of Orange communications, as is the use of words— almost as art elements—in its advertising. A single-word teaser billboard campaign, produced by the ad agency WCRS, went nationwide at the time of the brand launch. They were tersely inspiring— "Talk," ""Listen," "Laugh," and "Cry"—highlighting the overall benefit of its phone product to make meaningful connections with other people.

The easygoing nature of Orange's identity is evident in this promotional postcard.

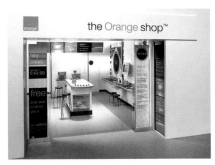

The same color scheme and mood are carried through in Orange's retail environments.

The television campaign launched two weeks later picked up on the billboards' fun and mystery, this time revealing all. To this day, Orange communications—advertising, packaging, stationery, and brochures—retain the original simplicity.

When the team came up with, "The future's bright, the future's Orange," the phrase became a hallmark of the brand. More recently, WCRS has used the line, "Do you speak Orange?" It at once introduces Orange as a brand and as a potential lifestyle, hinting at the unspoken benefits of belonging. It complements well the original "The future's bright, the future's Orange" phrase.

When it was released, Orange had an immediate initial appeal to the thirty-something market, but its spirit soon spread into the wider population. The brand was positioned to appeal both emotionally and rationally. Its visual style made it a comfortable part of everyday life, but Orange also made its business practices much friendlier. Billing was done by the second, not rounded up to the next minute, to keep bills fair. Unlike other mobile-phone companies, Orange's prepaid phone minutes don't have an expiration date. Plus, the company works hard to keep its literature approachable and easy to understand, a definite anomaly in a business fraught with confusing offers and contracts.

Selling Orange in other countries and regions, such as Belgium, Switzerland, India, and Australia, naturally presented challenges. Orange says different things to different people in different places. What is dynamic there? What is refreshing? What is friendly? Preaching the word of Orange is different everywhere. Wherever it is, however, the essence of the brand is the same.

The brand's personality has become so distinct that Wolff Olins and Orange U.K. produced "The Orange Anthology," an in-house coffee-table book for employees and cooperating networks abroad. It is a collection of thoughts and images to capture the more intangible aspects of the brand, put together as if Orange were a human being. It considers its likes and dislikes, forming a personality.

Orange knows that there are many factors that make it win, but one of the major elements is the extremely distinctive way it communicates. Its product is not unique, but its spirit certainly is. It's a secret ingredient, their ace that other people don't have.

Orange recently produced a book illustrating the brand's personality and philosophy through a collection of scrapbook material. Senior designer Daren Cook notes that "Orange has become very much like a person and can be introduced as such."

To order your phone or for further information
please call 0500 80 10 80.

orange

Orange Personal Communications
Services Ltd.
PO Box 10
Patchway
Bristol
BS32 4BQ
www.orange.co.uk

The information contained in this brochure is correct at the time of going
to press, but Orange reserves the right to make subsequent changes to it,
and services may be modified, supplemented or withdrawn.

For further information about Orange, our products and services,
please see our website at www.orange.co.uk

© Orange Personal Communications Services Limited 1998.
Orange and wirefree and any other Orange product or service names
referred to in this brochure are trade marks of
Orange Personal Communications Services Ltd.

Designed and produced by 999 Design Group, Glasgow.

Issue 1

l OO k

orange

Whimsical type play further enlivens the brand.

"Do you speak Orange?" A major
tagline used in Orange promotions
intimates that the brand is more of
a lifestyle than some sort of arbi-
trary corporate creation.

No matter what country Orange goes to, the same strong color scheme and friendly feel is continued. These samples are from India.

Corus

Regal Hotels, one of the largest hotel operators in Britain, had a problem.

The company had assembled a disparate stock of hotels, inns, city center hotels, and seaside properties with no common identity or personality among them. Although each property was known and respected locally, marketing the advantages of the entire chain to a nationwide audience of frequent travelers was difficult.

As part of a four-year, £80 million investment to brand the hotel chain, Regal management brought in The Partners of London. In the end, The Partners designers turned an affordable, undifferentiated chain into a brand with wit and distinction. Each hotel in the group could still express its special character, but with a voice consistent to the parent group.

Before its rebranding, Regal competed within an increasingly branded and homogenized hotel market. No one group stood out, although some competitors were progressing toward differentiating themselves. In addition, a U.S. chain called Regal was building its awareness in the U.K. So additional brand building around that name would have been energy wasted.

The new Corus word mark has a friendly, comfortable feel. The enlarged, orange *o* serves as both visual pun and as a logo of sorts. It looks a bit like a talking or singing mouth, but it can also be separated from the word and used as an identifying mark in specific applications.

The enlarged *o* from corus is used in the labels of other hotel components that contain the letter. In addition, the play with letters sets the stage for fun with other characters.

Following extensive market research, The Partners helped identify Regal's values as friendly and local, witty, fresh and uplifting, unpretentious, different, and special. These values were used to develop a new name, Corus, drawn from the word chorus. The values also formed the benchmarks against which all future design solutions were measured.

"'Corus' was a perfect match for our brand vision," writes a Corus official, "because our group is made up of many individuals, each with its own character, joining together to create the whole. We decided to drop the *h* to fit more comfortably with our desire to change convention. It's chorus with a twist."

The Partners' David Stuart says their goal was to make the hotels' friendly nature stand out: After all, the frequent, often business traveler is always looking for a comfortable home away from home.

"At most hotels, you speak to the person for a minute and a half, hand them your plastic card, then go to your room. That's it. Corus realized that there were a lot of opportunities to speak to the consumer, to engage them and to speak to them with warmth," Stuart says.

The centerpiece of the new identity was a new word mark: Slightly off-center in the word "Corus" 0 is an enlarged *o*, which resembles a speaking or singing mouth, perfect considering the chorus origin. The letter's shape and pictorial nature served as a precedent for clever, quirky designs on other customer touch points. From signage and uniforms to toiletries and stationery, wit prevailed. Corus customers could quickly appreciate the language of the hotels. As they interpreted each new encounter with the identity, they could become more and more engaged with the brand.

Type play is a big part of the new identity. Different letters are put to work as visual puns. For instance, the *e* in the menu label appears to be noshing on the *n* that follows. A mousepad printed with the word "mouse" contains a similar trick: The *s* inside the word is made very small and peeks out behind the preceding *u*, like a little mouse tail.

In-room toiletries, familiar staples of every hotel chain, have also been given the Corus personal touch. The Corus *o* is used in labels for "sOap" and shampoO," and a plastic bag that holds smaller items is imprinted with "looking good," its double *o*'s transformed into upturned eyes. The effect is simple, yet fun.

Only a company with complete confidence in its abilities can use humor in this way and without pretension, says Stuart. It's a confidence that guests recognize and appreciate.

Ultimately, the new brand was played out across signage, uniforms, menus, stationery, internal communications and across literature, exhibitions, videos, dressing gowns, and towels, toiletries, interior design, a Web site, and even sculpture. Implementation began in March 1999.

Project manager Jayne Gorecki says that a thorough understanding of Corus' market was key to their solution. "What we did was make an affordable, three-star, undifferentiated hotel chain different and human in its approach to what the customer required."

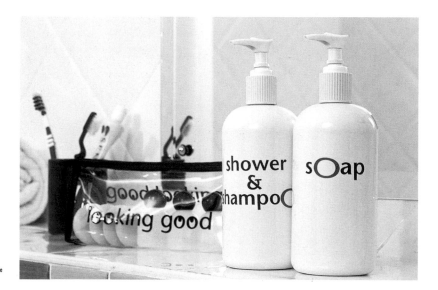

Once ensconced in their rooms, hotel guests receive several more personal messages.

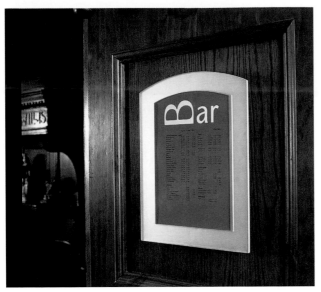

The gently rounded top of the Corus *o* is picked up in the shape of hotel signage, another subtle reminder of the identity.

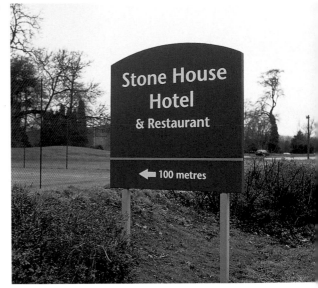

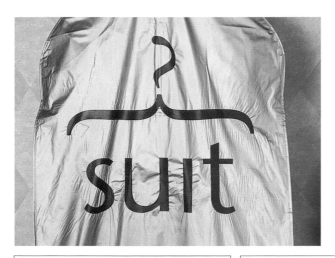

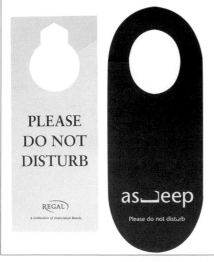

Additional samples of Corus' clever designs: The letter play creates a language that hotel guests quickly begin to understand and appreciate. The understanding provides a sense of belonging and comfort—exactly the designers' intent.

Phoebe 45

LISA BILLARD OF LISA BILLARD DESIGN, NEW YORK CITY, ON
THE SHOPPING BAG SHE CREATED FOR P.45, A DESIGN THAT
HAS EARNED HER AND HER CLIENT CONSIDERABLE ACCLAIM:

"I have pretty minimal tastes. I'm drawn to the idea that 'less is more.'"

"The p.45 bag reflects that. The storeowners of the Chicago-based clothing boutique p.45 [formerly Phoebe 45] don't have a traditional department store aesthetic. It's a sleeker, more minimal one that promotes a different kind of product. Their shopping bag is modern, in the same way that their clothing is. The people who are drawn to that kind of minimalism and color are the ones who would shop in the store.

"A shopping bag can be one of the best places to advertise the attitude of a store. People are so used to seeing a store's name or logo on shopping bags, and I think this design is more open-ended than that. Reactions to it are very intuitive; on a gut level, it has real appeal. People are struck by its simple color and form, its sharpness. That's nice, because it's reflective of the clothing and attitude of p.45.

"The bag is popping up in other places. It has been used as a styling prop in a Crate & Barrel catalog and has appeared in many design magazines. The bag has an aesthetic that is so closely related to the target customer that it often gets reused for other things. It's a fashion statement

Boy Scouts of America

Like many older, humanitarian organizations supported by charitable contributions, the Boy Scouts of America is faced with a catch-22.

The Boy Scouts are so ubiquitous, so much a part of the American vernacular, that almost everyone already has some concept of what the organization is about. So the Scouts could very easily fall into the background as old news.

But in order to build funding, volunteer efforts, and membership, the Boy Scouts of America must constantly reinsert itself into the foreground. On a national level, it's a tough, never-ending job.

Fortunately, Scout councils across the country have begun to take up the charge, taking advantage of an extremely powerful tool—graphic design—not only to maintain the organization but also to re-energize and reeducate the public about what Scouts are doing today. Working with talented design firms and printers, often on a pro bono basis, these councils are presenting a very contemporary view of scouting that is relevant to their own particular areas.

One such design group is Slaughter Hanson of Birmingham, Ala., which is producing some of the most extraordinary work. Design director Marion English-Powers and account executive director Jennifer Jackson have worked together for the past five years to create exceptional work for the Central Alabama Council of the Boy Scouts of America. The annual reports English-Powers creates are equal in strength and aesthetic to those produced for leading national corporations.

Slaughter Hanson created this remarkable annual report, *Handbook of Character*, in 1998 for the Greater Alabama Council. Moving black-and-white photography and a sprinkling of historic Boy Scout imagery are combined with strong color and abstract symbols to contemporize the Scout message.

Producing work for an organization as iconic as the Boy Scouts might lead a designer to pull clichéd visuals out of the closet—photos of middle-class white boys camping, for example. English-Powers definitely resists that. "We try not to go down that familiar path. It is sort of injustice to what the Scouts really are today. They address a lot of present-day issues. They have evolved to more than pinewood derbies and canoeing. Now the Scouts deal with inner-city issues. There are troops for migrant kids, disabled kids, and more. To go down the path of what we remember scouting to be when we were kids is just wrong," she says.

The title of the Greater Alabama Council's 1996 annual report was *12 Points*. Slaughter Hanson used the twelve points of the Scout law—trustworthy, loyal, helpful, friendly, courteous, kind, obedient, cheerful, thrifty, brave, clean, reverent—but placed the tenets in the present. Strong color and photography bring the message home in a serious but youthful way.

Like all of the groups interviewed for this article, the designer focuses on positive outcomes, usually delivering them in a story format. Scout activities may have changed over the years, but the values that guide the group have not: A Scout is still trustworthy, loyal, helpful, friendly, courteous, kind, obedient, cheerful, thrifty, brave, clean, reverent.

"The companies that contribute to scouting want to know how their contribution has affected a real person," says Jennifer Jackson. That's why Slaughter Hanson's reports focus on stories about real people—adult leaders, community and business leaders who were Scouts, and of course, the boys and girls themselves. (Scouts now offer Explorer programs for young men and women.) Portraying positive outcomes has an emotional appeal that works, says Jackson: Her client's board of directors and major funders reads like a who's who of business luminaries in the portions of Alabama and Tennessee that the Council services.

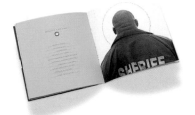

Bill Moran of BLinc Publishing, St. Paul, Minn., also stresses outcomes in the annual reports he designs—and in part prints on his letterpress printer—for the Indianhead Council. "Keep it vital," he says. "Keep it relevant to people's lives and interests."

"Funders want to see outcomes. How does this increase responsibility? How does this improve education? What do Scouts grow up to be?" says Moran, listing a few of the questions he tries to answer. A Scout himself from age five until eighteen and an adult leader after that, Moran says that scouting is "under his fingernails." That passion helps him inject real emotion in his work.

Moran also produces posters and other print materials that are used to increase membership. Kids have plenty of other activities competing for their attention, so getting them to join Scouts is not always an easy sell. He concentrates on the action the organization provides. "Scouts actually have a ton of fun with high-adventure camping and other activities. But you have to be careful. Kids are very savvy as far as messaging is concerned. They can smell a lesson coming a mile away," he says. The important thing, he adds, is to show kids and funders that scouting is a pathway to other things.

The Grand Canyon Council in Phoenix, Ariz., is another large, progressive council that is producing remarkably designed materials. Dave Duke of Catapult Strategic Design in Phoenix is directing its efforts. All but one of the Council's annual reports he designed in the past five years contains a remarkable degree of handwork: a binding hand-tied with a Scout-sanctioned square knot, a sleeve that resembles an awards sash, and a badge hot-glued directly to a cover. His 1998 report, filled with hand-taped photos throughout, won an award for outstanding design from the Scouts' national organization.

"You can't be sappy about it. There is definitely an emotional component. But it's more important to think of the impact that scouting has had on the world. I consider how we can take the characteristics and perceptions and history and leverage that into something meaningful today," says Duke, who is also an Eagle Scout.

The designer admits that the hand-crafted designs are definitely a labor of love, but the extra effort is the reason they work so well. "Each is a handprint of how much we care about it, how much scouting affects people," he says.

David Marks, art director for Muller + Company, the group that designs annual reports for the Heart of America Council in Kansas City, Mo., also strives to show how scouting affects people personally. After thoroughly studying the origins of scouting and its core values, he was able to make his message more contemporary and relevant.

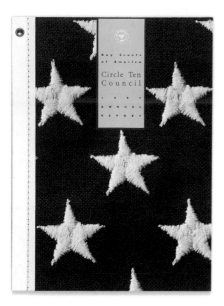

"A lot of young designers might want to trash everything and start fresh," he says. "With the Boy Scouts, you can't start fresh. You have to show that the core values are still apply today."

He references a creative approach called belief dynamics, which stresses looking at every project in terms of what the audience believes now and what you want them to believe. With Scouts, he notes, there are plenty of embedded beliefs. "But if you can direct those beliefs a bit further, expand on the beliefs, then you can contemporize them," he says. With an icon, it's crucial to leverage its equity.

Marion English-Powers of Slaughter Hanson offers perhaps the best advice for keeping an icon relevant. "As long as you keep the project personal to your area, it works. You need to drive home so that people can relate. Once you've gone national, people aren't interested anymore. They'll say, 'Well, someone else will give them the money they need.' But the money has to come from here."

The cover of this Circle Ten Council 1997 annual report is a very direct visual and tactile expression of Scout principles. A brass grommet and a stitched fabric edging accent the extreme close-up of the star field of the American flag, just like a real flag.

Bill Moran of BLinc Publishing, like other designers creating work for individual Boy Scout councils, believes that showing the impact of scouting today is crucial to its continued growth. On this spread for St. Paul's Indianhead Council 1998 annual report, he featured Venturer Zongxee Lee, a member of the Hmong community in Minneapolis-St. Paul. Highlighting the exemplary work of an atypical Scout is one way to show how the organization has evolved.

The Indianhead Council's 1996 annual report, also designed by Bill Moran of BLinc Publishing, reveals the real faces of scouting today: Boys and girls of all races participate.

Dave Duke of Catapult Strategic Design also created this remarkable 1998 annual report for Circle Ten Council, a report which won a special award from the Boy Scouts of America national organization for its design. Duke brought the reader right into the scouting experience by transforming the book into a journal written by a Scout attending camp. Photos are actually taped into the journal pages, providing a sense of immediacy and reality that printed photos could not emulate.

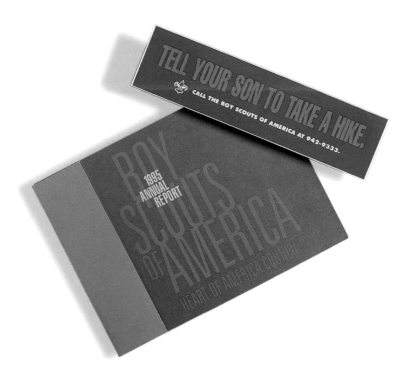

Muller + Company used the same brightened retro color scheme on all of these designs, created for the Kansas City, Missouri's, Heart of America Council. The bold, orange type is contemporary and energetic, a good match for Boy Scouts today.

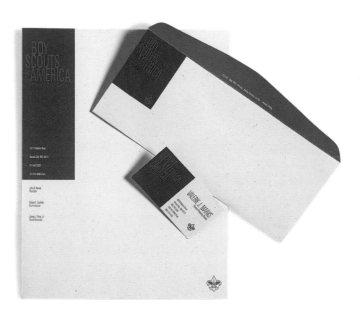

For the Heart of America Council's 1998 annual report, Muller + Company created an actual report, housed in a file folder. Inside, case studies feature real leaders, Scouts, and Explorers, as well as their quotes and stories.

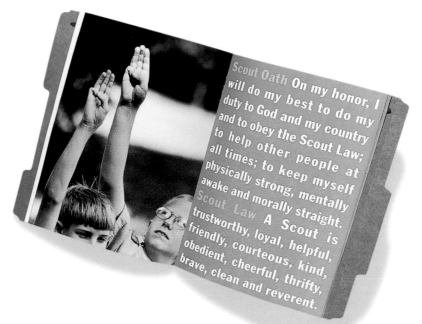

Fossil

There was a time when most people received a watch for high school graduation or some other significant occasion and wore it for many years, usually until it was lost or no longer kept time.

Then you got another one. But only one.

Today, though, many people treat watches as fashion accessories. Tim Hale, senior vice president and image director for fashion-watch manufacturer Fossil, estimates that each potential buyer in his company's market owns from three to six watches. And that's conservative. "It's an impulse buy. There's a sweet spot for the price point, and that's where we are," says Hale of Fossil's $55 to $105 watches.

But more than price makes people covet Fossil watches enough to garner sales that exceeded $300 million worldwide in 1998. Swatch may have introduced the concept watch as fashion. But Fossil came onto the market shortly afterward, differentiating its product as a classic-styled product wrapped in a highly desirable package.

"We offer a quality watch with the best technology available at a good price point. But then we wrap it in something that is desirable and collectible—a tin," Hale explains. The idea for the tin emerged when Hale and the company founders explored packaging ideas that would convey the brand's American-heritage quality. At the turn of the nineteenth century, marketers frequently used tins for packaging, so it was an understandable language in the retail environment. But as soon as plastics developed, the tin was abandoned in favor of clamshell packaging.

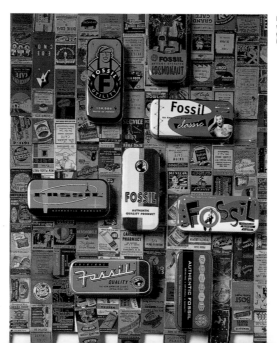

Designers who create Fossil tins and watches draw inspiration and color guidance from designs that originated in the 1940s and 1950s.

Fossil's first tins were flat and rectangular, each designed to hold one watch laid flat. But the company quickly realized the package's intrinsic merchandising ability and value to the customer.
Designer: Tim Hale
Illustrator: Randy Isom

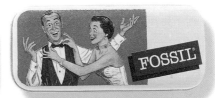

Charles Spencer Anderson designed eight of these 1991 designs for Fossil.

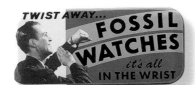
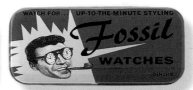

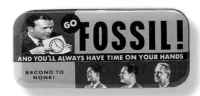

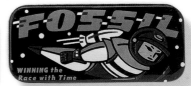

1993: DESIGNERS: BRIAN DELANEY, CASEY McGARR

1994: DESIGNER: AMANDA McCOY

1995: DESIGNER: TIM HALE

1997: DESIGNERS: ANDREA LEVITAN, JOHN DORCAS

1997: DESIGNER: CARRIE MOLAY

1997: DESIGNERS: BRAD BOLLINGER, MARC FERRINO, STEPHEN BATES, AMANDA BARNES

To keep the design of the tins fresh, Fossil design works hard to explore and expand the retro theme, not to imitate it. This chronological progression shows the development of the packaging.

"The tin matched and reinforced the retro-America theme," Hale explains. "But second, there was an aftermarket value: At the time we were developing this, everyone was talking about recycling and ecology. Why not make something that people don't want to throw away? Finally, this would create a unique marketing environment, unlike anything else in the watch section. It gave us extra ammunition at the point of sale."

The tin concept has proven so successful that it has even spawned a wide range of collectors: those people who collect tins, those who collect retro packaging, and those who collect watches. Collectors snap up new designs and actively buy and sell them through a collector's club and on the Internet. Rarer models sell for around $15 on e-bay.com.

1997: Designers: Tim Hale, Andrea Levitan, Marc Ferrino

Fossil's rectangular tins are so distinctive that consumers naturally associate them with Fossil's identity, the same as the Coke bottle shape is associated with the drink. In fact, the U.S. Patent Office has even recognized Fossil's signature tin as a registered trademark of the company. No other company is allowed to package its watches in this type of tin.

Fossil goes to market five times per year and replaces about 10 percent (25 to 30 skus) of its 350 to 400 watch lines with new designs. It replaces tins every quarter, introducing approximately seventy-five to one hundred new ones each year.

"The tin has become our calling card," Hale says. "I have seen them in antique shops. That's what's exciting to me—that people feel that there is an intrinsic value to them. Especially in America, there is a real emotional or sentimental tie to the work."

Hale attributes the brand's success to several factors. First, the company constantly innovates the design of the watches and tins. A marketing analyst warned Hale years ago that Fossil would not be

able to extend the retro theme far or long. But his team of fifty-plus designers works hard to reinterpret the theme constantly while they simultaneously reinforce the brand identity. The key is to expand and explore, not imitate.

Second, Fossil understands how the retail environment works: It tries to help retailers. Hale says that, "Store clerks can take different watches and tins and make our display case look completely different over and over, just by using the product. The watches go into the stores separate from the tins, so there is a constant stream of newness coming in."

To promote the aura of collectibility, all of the tins have serial numbers and dates. In addition, consumers are allowed to select their own tins. Fossil never circulates any more than twenty-five thousand of any one tin design at a time.

Finally, Hale has assembled a state-of-the-art design group: Members handle everything from design of the tins and clothing to Web and retail graphics. That keeps people energized and excited, he says. As important is designers' exposure to how Fossil conducts business. Hale "find[s] that to be a void in some offices—designers go into a project without understanding the business. Our designers understand the limitations and goals, so they can design better. They know how business problems get fixed."

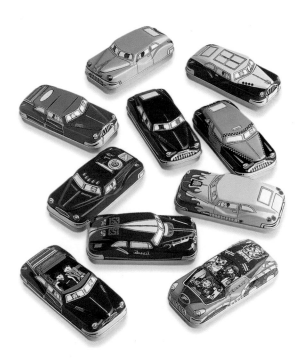

The goal of the car tin, first released in 1992, was to advance the tin concept and underscore the brand image by packaging watches in containers that looked like tin toys from the 1940s. The concept also reinforced the idea of using the packaging as a retail merchandising aid to grab the consumer's attention.

ART DIRECTOR: TIM HALE
1992 MODELS: DESIGNER: TIM HALE
1997 MODELS: DESIGNERS: BRIAN DELANEY, STUART CAMERON, JAMES WARD, GLEN HADSILL, STEPHEN FITZWATER, CARLOS PEREZ

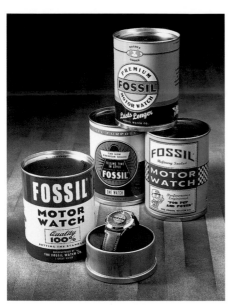

The oilcan tins, produced in 1994, were based on a suggestion from the managing director of Fossil's Italian office. The abundance of oil company graphics from the 1940s and 1950s provided a rich source for graphics and color inspiration. The stackable aspect of the oilcan made it a natural merchandising tool in all of Fossil's channels of distribution.
ART DIRECTOR/DESIGNER: TIM HALE

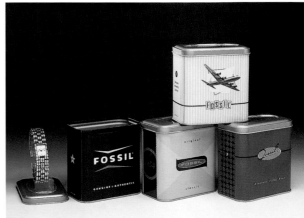

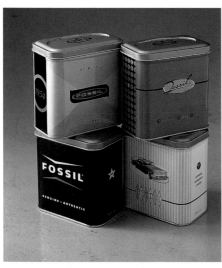

The 1997 watch tin was created to hold bracelet-style models. This tin shape better accommodated the C-cuff needed to display this new type of watch. The cuff can be snapped into the lid of the box for retail display.
ART DIRECTOR: TIM HALE
DESIGNERS: TIM HALE, ANDREA LEVITAN, JOHN DORCAS, CASEY McGARR
ILLUSTRATION ON THE ALL-TYPE DESIGN (RIGHT): HATCH SHOW PRINT

Once a Fossil tin shape is created, it can be transformed to expand the line—here, into a desktop clock.
DESIGNER: TIM HALE

Fossil expands ways to create collectibles. Limited, licensed editions for characters such as Felix the Cat or companies such as Harley-Davidson introduced Fossil watches to entirely new audiences.
ART DIRECTOR: TIM HALE
DESIGNER: DAVID BATES

The collectibility of Fossil eventually led to the Fossil Collector's Club. Each year a kit for collectors' clubs is designed to promote membership. This play on the tin lunchbox was created in 1998.
ART DIRECTOR: TIM HALE
DESIGNER: JOHN DORCAS

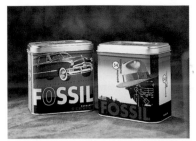

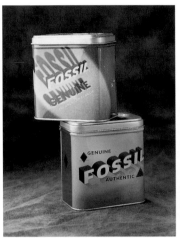

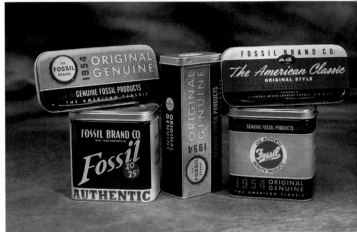

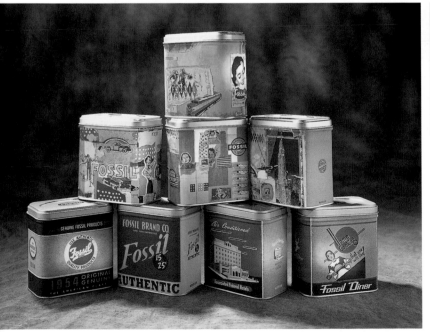

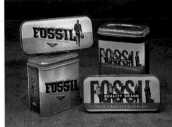

This smattering of recent profiles and designs shows the constant expansion of tins designs in new directions. Such evolution enhances the desirability of the product it contains and of the brand it represents. The tin concept can also be applied to other saleable items, such as glasses.

DESIGNERS: DAVID EDEN, BRIAN DELANEY, PAT REEVES, ELLEN TANNER, STUART CAMERON, MARC FERRINO, JOHN VINEYARD, CLAY REED

ILLUSTRATOR: ELLEN TANNER

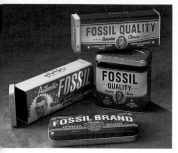

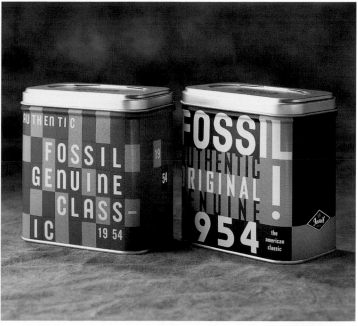

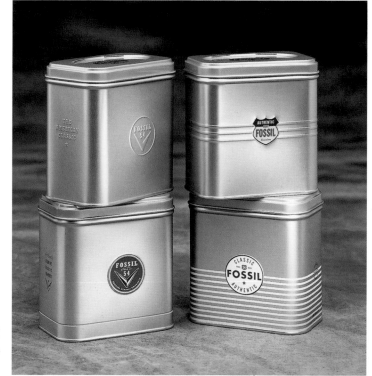

The latest augmentation of the existing Fossil profile: a bare, flat-finished, embossed tin with the simplest of logos, created for 1999. Art director Tim Hale reports that yet another Fossil tin profile is in development, to be released in the second quarter of 2000.
ART DIRECTOR: TIM HALE

Mambo

In a recent documentary on the subject of swimwear, Mambo earned kudos along with a select group of strictly high-fashion designers as a leading influence in the development of clothing for surf and sun.

Actually, in many surf circles, especially in its Australian homeland, it is the clothing for surf and sun. But Mambo's presence has been so significant since its launch in 1984 that it is now representative not only of a style of clothing, but of an entire lifestyle.

Founder Dare Jennings started the company with a single style of boardshorts and a selection of colorful, oversized T-shirts. In the past fifteen years, he and his designers have evolved the brand from that modest offering to an international company that produces wild, colorful and irreverent men's, women's and children's wear; swimwear; glasses; surfboards; caps; bags; watches; jewelry; ceramics; posters and postcards; books; and CDs.

Mambo's Web site offers more insights: "We also mount regular exhibitions of original Mambo art, give creative and/or financial support to worthy individuals and culturally significant events; worship strange gods; square dance in round houses; covet our neighbor's ox, and generally go where no man has bothered to go."

Two important facts emerge from this passage: First, Mambo is as impertinent as it is rebellious. Second, art is at the center of its efforts. This informs all of Mambo's designs.

These spreads from Mambo's 1999 summer catalog says a lot about the brand: It's fresh, young at heart, noncompliant, and full of art and the ocean.
PHOTOGRAPHER: SANDY NICHOLSON

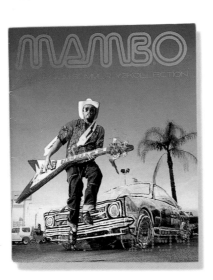

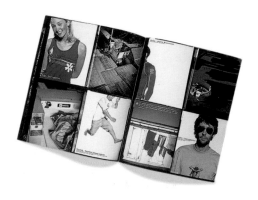

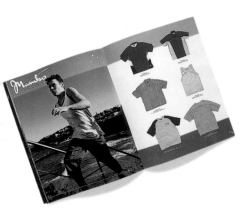

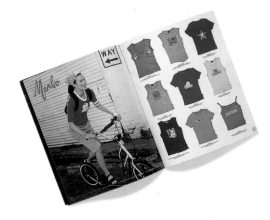

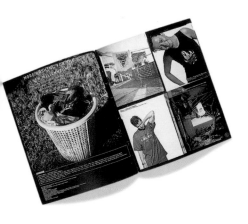

This wall of T-shirt designs shows a small range of the subversive attitude behind Mambo art.

The company sprang from Jennings' trio of passions: surfing, art, and music. "I wanted to combine all those things under one label. I wanted to inject color and movement through graphics," he explains. "Mambo became the surf brand through this." To power his graphics, he called on the talents of little-known but talented artists, people he had worked with when he ran a small record label in the 1980s. About twenty artists have supplied the Mambo look during its reign; approximately ten have been working with the company since its inception. "People who were not commercially viable on their own could be viable under the Mambo umbrella. These guys had no idea of what the style was in fashion. From this, we always get a terrifically fresh look."

Jennings admits that even today there are bigger surf brands, but Mambo always enjoys much more recognition, especially in Australia and in the United Kingdom. It drives the ad agencies, which Mambo disdains, crazy. Why does it hold such resonance with enthusiasts? Jennings attributes this to a tangible enthusiasm within the company, driven by the love of the art. "We spend way too much money producing artwork," he says, "but it has real value."

Reg Mombassa is an artist who has been with Mambo since the beginning. A graphic designer and illustrator who also exhibits his work and plays with bands, Mombassa's work is a significant part of Mambo's signature. The company is successful because it uses art on all its clothes "and lots of it," he says. "It can be insulting, mocking, humorous. There can be political and social comment, too. Really, it's accessible art."

Interestingly, Mombassa has no interest in fashion at all. "If I had my choice, everybody would wear potato sacks," he says. "What's interesting to me is to get my work out. At an art show, you might get several hundred people. But when you illustrate a shirt, you have a mobile advertisement that thousands of people see. Artistically, it's very satisfying."

Mambo's artists are all freelancers and fine artists, but most list the Mambo connection on their business cards: The moniker has real caché. The company receives a huge number of portfolios for prospective use on Mambo products, especially shirts. The few artists who are invited into the fold are fortunate indeed.

The Mambo persona has commercial appeal as well, although Jennings is quick to say that it is not for sale. "Ad agencies will ask for 'that Mambo thing.' Reg is offered huge amounts of money from corporations like Coca-Cola, but he has philosophical differences with that. So he refuses it, which I think is very altruistic."

Both Jennings and Mombassa note that Mambo's understated humor, style, and occasional "bum joke" don't appeal to everyone. But surprisingly, their work does not just appeal to the younger set. "There are fifty-year-olds who will make my ear bleed telling me about how much they like Mambo," Jennings says.

Still, like any really powerful art, Mambo style raises hackles, particularly among some religious groups who boycott the company's retail outlets and write angry letters to newspaper editors. Mambo's main offices have even received a few bomb threats from sources unknown.

Mombassa says that he and the other artists are not deliberately upsetting people. "I consider it freedom of speech. I am interested in religion and history and in expressing my opinions about it. It's the culture we all grew up with here," he notes.

Among people who do appreciate Mambo, art director and senior designer Jonas Allen says Mambo is loved for its passion. Any brand with real passion behind it rings true for consumers, he says. His own energy is evident in how he describes one of his recent projects.

"All over southern India you see these amazing hand-painted signs done on flattened-out, old, recycled tin, with naively written text, and five drop shadows, askew perspectives, and clashing colors. We had some great inspiration from these," he says. "Every few months there is something [like this] that I really enjoy."

Mambo is very Australian in attitude, but it is certainly not parochial. It is a global company that revels in serving a niche market. But Jennings says their goal remains the same: getting the art out there.

"We don't try to be the hippest thing around. We've already done that. In the beginning, we tried to create a culture and succeeded. You go to Mamboland," he says.

Mambo constantly changes the logo and text on its stationery system. Artist Reg Mombassa says that founder Dare Jenning's vision of the company was to do everything differently. "There is no definite logo," he says.

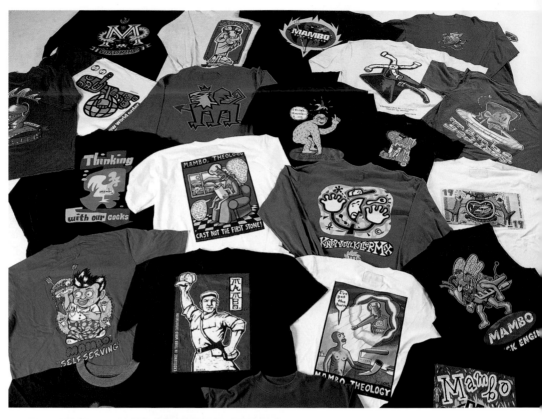

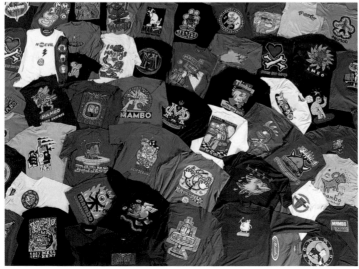

A hallmark of the Mambo brand is their absolutely incorrigible T-shirts. For the most part, they are rude, politically incorrect—and millions of Mambo fans love them.

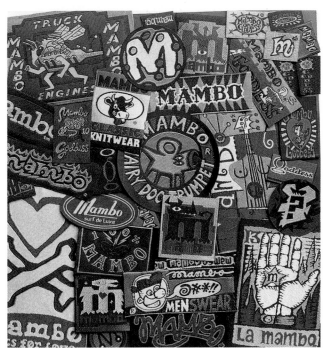

Even Mambo-woven labels are works of art. They exhibit the huge range of personalities the brand's logo takes on: It is a mark that constantly evolves.

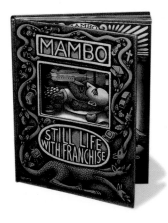

So popular is Mambo art that the company has published two books.

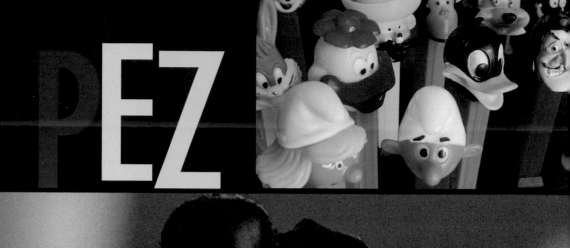

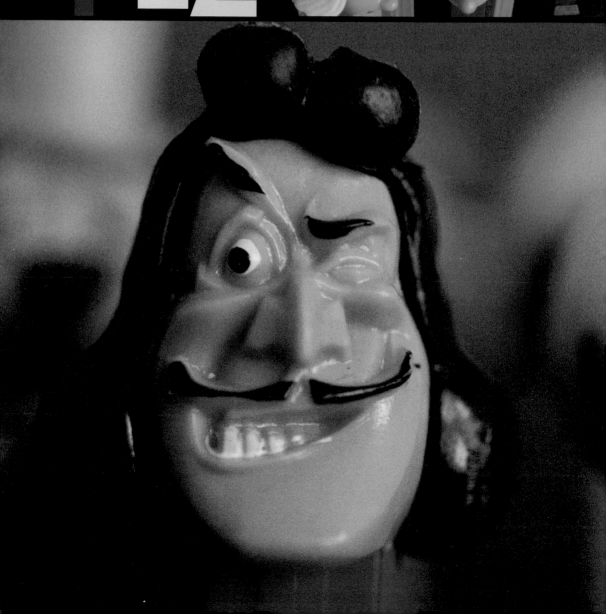

"In 1927 in Austria, Edward Haas came up with this new peppermint candy. It was an adult breath mint that was supposed to help adults stop smoking. From the word 'pfefferminz,' they took the first, middle, and last letters, and came up with PEZ.

"PEZ was carried around in pocket tins until 1948 when they came out with an 'easy, hygienic dispenser' that looked like a cigarette lighter. In 1952, PEZ wanted to expand its sales to the United States, so they added more flavors, placed heads on the dispensers, and marketed it to children.

"Today, the PEZ Company in Orange, Conn, operates twenty-four hours a day. To date, it has created about three hundred different dispensers [that] are sold in Canada, the United States, Mexico, Japan, Germany, and France.

"The whole Seinfeld thing brought PEZ back to life. Everyone had kind of forgotten about it. But once Jerry Seinfeld put that PEZ container on his knee in that one show, it has started to show up everywhere, all over the media. The "Sightings" area in my Web site is full of places it has been seen on TV and in movies. E-Bay was actually started by a guy who wanted to help his girlfriend get more PEZ for her collection.

"I'm not sure why people like PEZ so much. People must see PEZ and remember the good old days when they were younger. A lot of older people are into collecting these, and they bring up their kids as 'pezheads.'

"People might like a certain cartoon character and buy that PEZ character. I correspond with people in different countries because, of course, they have different dispensers and candies. Now people are making their own PEZ dispensers: fantasy PEZ. They either mold their own heads or rip the heads off of other things.

"I think of the dispensers as being cool and incredibly odd at the same time. I picked up the first one only because I was into Spider Man. I wasn't into the candy that much. I just found it bizarre that you crank back the happy head on these things and candy pops out of the neck. It's their strangeness that piques interest. As a collector, it's interesting to see from the dispensers what was hot at the time, whether it is Mickey Mouse or Psychedelic Eye dispensers. As a designer, I enjoy the old advertisements.

"There's a certain charm to these things that I haven't completely put my finger on, but on the other hand, I can't stop collecting them."

TazoTea

"Marco Polo Meets Merlin."

That was Steve Sandstrom's client's succinct description of Tazo Tea, a brand launched against what might be considered conventional wisdom, in the midst of the coffee craze of the 1990s. But it was a gamble that paid off: Tazo began as a start-up in 1994 to an acquisition for Starbucks in six short years.

Sandstrom Design created Tazo's distinctive Old World look, an identity that has been translated onto the packaging of a range of drink products, including bagged, loose, frozen, and bottled teas. Alchemic is a good word to describe the identity's design as well as the product itself.

"One of the founders, Steve Smith, is the concoctor of all of the Tazo products. Everything he does packs a wallop. He only uses really fine teas and about half again as much tea as others commonly use. We wanted people's experience with Tazo to be very different. At the same time, this was a start-up company. We had to work with the bagging and packaging that the tea world provided. So my packaging had to be totally unique," Sandstrom says.

Studies at the time had revealed that U.S. citizens regarded tea as a beverage that was consumed when one was sick. This opinion was completely the opposite of the rest of the world, where tea is second only to water in terms of quantity consumed. Tazo's founders, former partners in another successful tea company, Stash Tea, were well aware of the drink's lore elsewhere. They considered the mystery surrounding herbal and medicinal teas, as well as ancient religious tea ceremonies. "There had to be a way to convey the magical properties of tea and make it less fuddy-duddy," Sandstrom says.

"In the very beginning, [another founder] Steve Sandoz said 'the reincarnation of tea.' Those words set up everything. From there, we could visualize all of the elements," he adds.

In flavor and appearance, Tazo is a mystical brand. Its creators and Steve Sandstrom Design drew their inspiration from the magical and medicinal properties that tea has provided over the centuries. "Tazo is an abstract word," says Sandstrom. "In one eastern European language, it means 'river of life.' I also believe there is a Hindi version that means 'fresh.'"

Whether it is sold in individual boxes, as a packaged set, or on the restaurant table, Tazo maintains its unusual presence. Dull browns and tans suggest something that has emerged from the ages. A rich, Far Eastern palette used for identifying accent colors promises that there is a treasure to be found inside.

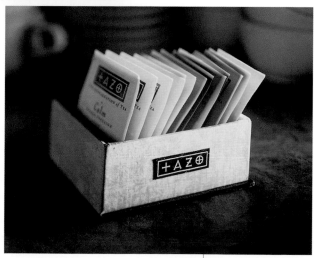

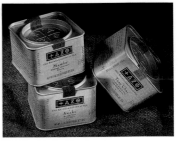

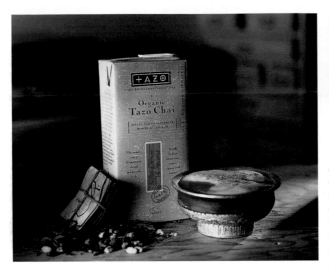

The Tazo brand is historically inspired in design and content. Chai, a heavily spiced tea, and whole-leaf tea are both products that have been consumed for centuries. Tazo brings them back as new offerings.

Although the developers had wanted to release a ready-to-drink bottled tea product first, production wrinkles forced them to bring bagged products to market earlier. Initially, there were eight flavors, but they were flavors described in completely new ways. Instead of standard-issue English breakfast tea, the founders called theirs "Awake." Instead of chamomile, they had "Calm." "Zen" replaced plain, old green tea. Even the herbal blends have lush names that imply benefits.

The naming scheme and his discussions with the brand's founders led Sandstrom to a logo that looked hand-lettered with a very old hand. "I wanted something that looked cryptic or coded. I used Exocet, a typeface designed by Jonathon Barnbrook in England, slightly modified it, and reversed it out of a black box. It looked like alchemy symbols—four symbols that made up the word that is the logo. The logo turns into a symbol itself," he says. Each flavor was assigned its own saturated identifier color, forming a rich, India- or Far East-inspired palette for the product line. Boxes and bags also carried cryptic stories of the tea's origins and even small lessons for life.

"I knew some people would look at it and think 'devil worship;' other people would think it was really cool. There probably wouldn't be any middle-of-the-road feelings about it," Sandstrom says. Still, because of the very short turnaround for the packaging, the design was not where he wanted it to be. "It left the shop with a shoulder shrug—I thought, 'I hope this works.'"

It worked beyond anyone's imaginings. Retailers would pick up the product without even trying it, just based on the intrigue of the packaging. Consumers began exploring the flavors as well as the packages' messages; many found "their flavor" and became fiercely loyal to it. Soon, major hotel chains and other large buyers were knocking on Tazo's door.

Sandstrom says that one of the great things about the brand is its "discoverability." First a consumer discovers his or her favorite teas, then they explore the packages' intricacies: mystical text, colors, the construction of the packaging itself. "You're like an archeologist having your own little search. People do enjoy reading the text, and the letters Tazo gets prove that they want even more," the designer says, adding that the words have such resonance with some readers that the text has even been quoted in self-help books.

But with the brand's success came criticisms from competitors who questioned whether Tazo was all marketing and no substance: Did the product live up to its extraordinary presentation? Sandstrom says that Tazo is definitely a case where judging the book by its cover actually works: Feedback from buyers continues to be strong. Consumers' bonds with the product continue to grow, as does the width and depth of the product line.

"People will say that it just looks cool," Sandstrom says. "Then, when you layer on good taste, it is a strong experience. We're offering to treat more than just one of the senses."

The Tazo brand actually has become the number-one natural foods brand in the United States. Tazo sales continued to increase even in summer months when hot tea sales typically drop off. Sandstrom says even the founders have been amazed at its success. One told him that it took nine years to get the Stash brand to where Tazo went in eighteen months.

Then, of course, there is the juicy, new Starbucks connection. The coffee giant had tried to launch its own tea brand, but it just didn't wash with consumers: Starbucks is coffee, not tea. Today, with Tazo in its 2,200 stores, sales have never been better. Sandstrom says his mission now is to keep Tazo, well, Tazo, and not to let it meld into the coffee company's identity. Sandstrom says, "If we can't maintain that, Starbucks will have lost its investment."

Some "new-fangled" Tazo tea products include ready-to-drink products, iced tea mixes and frozen tea bars, the latter an early experiment that did not prove cost-effective and was dropped from the product mix. All, says designer Steve Sandstrom, hold the same taste wallop as the hot-tea products. Combining that wallop with packaging that is a treat for the eye delights more than one sense.

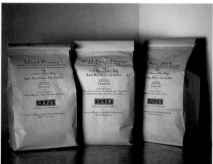

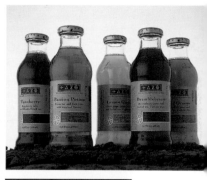

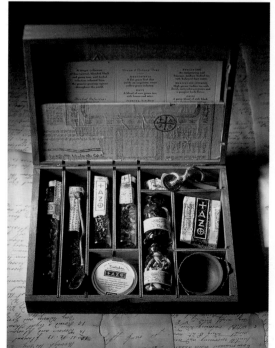

This wonderful wooden box presents a menu of Tazo teas at a fine restaurant or hotel. The customer gets a visual sample of the unusual brand through tea samples.

A big part of the Tazo identity is the text that appears on all of the products. It presents a proposed history of Tazo, then builds on the mythology with facts about tea and the very special ways to handle the Tazo products. This maplike brochure was developed for Starbucks stores to introduce Tazo and tea in general to Starbucks' customers.

Target Cups

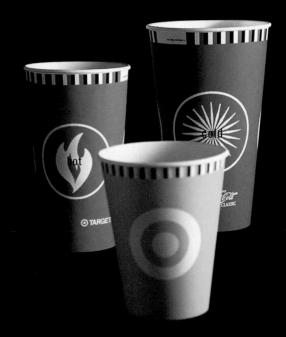

LAURIE DeMARTINO, PRINCIPAL OF STUDIO D DESIGN, MINNEAPOLIS, SPEAKS ABOUT HER DESIGN FOR TARGET STORES BEVERAGE CUPS, A PROJECT THAT MET WITH HIGH DESIGNER, CLIENT, AND CUSTOMER ACCLAIM AND WHICH RAISES THE QUESTION, "SHOULD A CUP HAVE A CONCEPT?" IN THE TEN MONTHS SINCE THE DESIGN WAS RELEASED, *COMMUNICATION ARTS, PRINT, HOW, THE NEW YORK ART DIRECTORS CLUB ANNUAL, THE AIGA NATIONAL ANNUAL*, AND THE AIGA/MN CHAPTER SHOW HAVE ALL FEATURED THE CUP.

"The old cup simply consisted of primary colors and blocks that mimicked the color tiles used in Target cafeterias, but there really wasn't a concept involved. Coco Connolly, a creative manager at Target, called me with the cup project. The objective of the redesign was to accommodate a reduced printing budget from four to two colors, but Coco also wanted us to completely revisit the design. We wanted to design the cup as if it were a product you [might] want to purchase. We wanted to create something fun, refreshing, and memorable.

"Two directions were presented. One very graphic approach utilized the bold Target logo itself, along with additional icons that indicated the two categories of hot and cold beverages. Inspiration for the selected concept was drawn from the broad range of Target's customers. Keeping in mind the printing challenges, they expressed the concept in this whimsical and quirky style of illustration, which further lends itself to the irregularities of flexographic printing. The cups not only serve a distinct purpose but they also continue to advertise once they have left the store.

"Sometimes you can put a lot of passion into a concept and a client will reject it because it isn't safe enough. I was a little surprised to see this one go through, but I think Target is a store that is very concept-driven. They understand the value and power of design, even down to their cafeteria "ice" cups. The fact that they are driven by ideas is what separates Target from the other value stores."

Fresh

In a market known for its temporal nature, Fresh has emerged smelling sweet as, well, a tobacco flower, or bergamot citrus, or cypress almond, just a few of the exotic ingredients used in its unique body care and scent products.

In less than a decade, Fresh has grown from a small storefront shop selling six soaps to a $10 million cosmetics brand favored by such celebrities as Julia Roberts, Gwyneth Paltrow, and Oprah Winfrey.

Founders and life partners Lev Glazman and Alina Roytberg saw a gap in the body-care market and filled it with products that combined the artistry of French soap craftsmanship with science and folk wisdom. They packaged their products in highly designed yet simple ways, wrapping some soaps in cotton papers with delicate, silver wires; semiprecious stones are affixed to some packages. The packaging combines everything from clean shapes and modern graphics to hand-wrapped products.

"We created our line to conceptually and functionally fit into the life of the consumer with consideration for value, quality, and reason," Roytberg explains. "We believe consumers want the same newness, quality, and diversity in their body care products as they do in their choice of other home accents. Our edge is putting good design to function."

Today, in addition to boutiques in New York and Boston, and with plans to expand to Europe and the West Coast, the company sells its 560 body care, fragrance, and cosmetic products through fashionable retailers such as Barney's and Neiman Marcus. Its wholesale and retail divisions are tightly connected and benefit each other by exchanging ideas, sharing customer wants, and anticipating the next generation of sought-after merchandise.

IN-STORE PHOTOGRAPHER: CHRIS SANDERS, NEW YORK
PRODUCT PHOTOGRAPHER: FRANCINE ZASLOW PHOTOGRAPHY, 27 DRYDOCK AVE., BOSTON, MA 02210

Crystal, Petal, Cocoa, and Leaf: Each is a wonderfully emblematic name in Fresh's Soft Formula f21C body care products. The pillow-shaped soaps from the line are nestled in "pillowcases" inspired by graphic prints used in bedding textiles.

Fresh's Sugarbath contains real brown sugar; it actually inhibits the growth of bacteria on the skin. So the product's shape and packaging are especially delightful: sugar cubes in a simple, semitranslucent jar.

Original Formula f21C soaps have brought Fresh acclaim for its exceptional products and packaging. Wrapped in soft papers, wire, and semiprecious stones, the scented soaps are a treat for the eyes and nose.

Milk Formula f21c is another product line with a nutritional sensibility. Brand founders Alina Roytberg and Lev Glazman note that people are accustomed to staple products like milk, sugar, and honey in their everyday lives. Their body, skin, and hair care products translate the safe, conceptual connection of these products into a new area.

"We are often inspired by naturally wholesome elements which are part of everyday life," Roytberg says. "People are used to having these items in their life as a daily staple, like milk. When developing a body care line, we always want to encourage the staple, functional use of the product. Our ingredients translate this and provide a safe, conceptual context. Some of these elements offer nutritional benefits, and we look to see if there are topical benefits for the skin, too. If so, there is a match." Fresh's major collection reflects this comfortable, nutritional connection: Milk, Honey, and Soy. Sugar, with its antibacterial qualities, was an extremely effective ingredient in the bath treatment products.

There is a certain design independence between collections that Roytberg feels attracts a wider range of customers. Without the limitations of one look or one design, Fresh attracts a very diverse clientele—disparate in terms of tastes, ethnicity, gender, and age.

The company knows that many Generation Y customers are quite educated on products and have high taste levels. Many of these people have grown up in homes that have high-quality products as part of their daily life. A clean and simple look, one that is highly conceptual yet easy to understand at first glance is essential to pleasing this group.

Fresh has, in effect, created a "whole package lifestyle" that includes sensibility, function, and fragrance. The customer is lured by the aesthetic, then bonds to the brand because of the effectiveness of its products.

Fresh does not advertise, but it has an entire army of beautiful people—movie stars, TV personalities, Hollywood make-up artists and more—who regularly gush over the company's products in beauty and fashion magazines. The celebrity connection was an accidental one, but it is certainly a promotional avenue that Roytberg, Glazman, and their staff monitor closely. An internal PR department oversees celebrity usage, press mentions, product placement on movies and on TV, as well as corporate (in this case, Hollywood) gift-giving.

The company's new Web site, www.Fresh.com, went live in late 1999. It offers information about products, store locations, and on-line shopping. The site has the same modern yet classic approach that has propelled the Fresh phenomenon forward thus far. "Quality, function, and affordability," Roytberg says, "are what keep customers coming back."

esh products, like the Milk hand
eam, are packaged with rich, soft
lors.

Gift packages of soap also receive a very special treatment:
The keepsake box is wrapped with wire and a single pearl.
Fresh's use of simple, elegantly designed packaging identifies
the brand, even though the company name does not appear on
the lid.

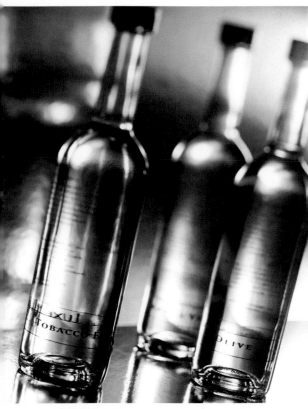

The simple, pure shapes of Luxe Formula f21c Eau de Toilette are representative of the quiet sophistication of the product.

The Luxe products are designed primarily for men, but both men and women buy them, including this shaving cream. The line's packaging is more metallic, black, and white than other Fresh products.

The Jus soaps are simple and sweet. Marketed as an alternative to "sugary fruit fragrances," the products use cranberry juice as a natural bright and tart flavor, just as certain food products use fruit juices as sweeteners and brighteners.

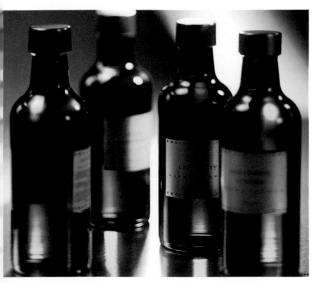

Jus Formula f21C products are based on four fruit flavors—cherry, cranberry, apple, and lemon—combined with cranberry juice. So containing the bath foam in old-fashioned, extractlike bottles is a conceptually and aesthetically pleasing choice.

DirtyGirl

Soap is perhaps the quintessential consumer product.

It's universal—the most basic of all products. But beyond its basic concept, soap's variables are endless, which probably accounts for the huge number of body-care products on the market today.

With a name like Dirty Girl, a soap can't help but stand out. The name immediately identifies the target audience—young women. But is the product for those dirty in body or dirty in mind? Through specialty shops and mail or Internet order, the playful innuendo tapped into the buying consciousness of a surprising number of consumers during its first year available.

Mitch Nash, co-owner and art director of Blue Q, the soap's producer, says that "People are asking for it in stores, which is unbelievable to us. Now, we're getting into extensions like body cream." Why has this product proved so popular when so many other bath products already fill the market? "Those products are about smell or feel. Dirty Girl marries concept, a strong theme, with product. It really stands for something. Our philosophy is to work with high-level designers who bring incredible sophistication to incredible products. Then we embrace mass production, making the product affordable but still very intimate."

Nash's chose designer Haley Johnson of Haley Johnson Design of Minneapolis. Nash came to her with a relatively complete brief in autumn 1998. Blue Q wanted an upscale, feisty feel to the soap, something that would appeal to a sophisticated and jaded clientele. They knew the name of the soap at that time, but not its smell, color, or packaging.

Mitch Nash, art director for Blue Q, says that his company is not selling soap: Instead, they're selling concept. The concept sells the soap, decidedly the case for Dirty Girl soap. It has a wonderful lily scent and quality ingredients for the skin. But the product's graphics first catch shoppers' attention.

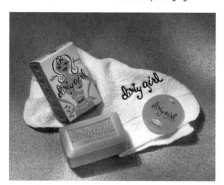

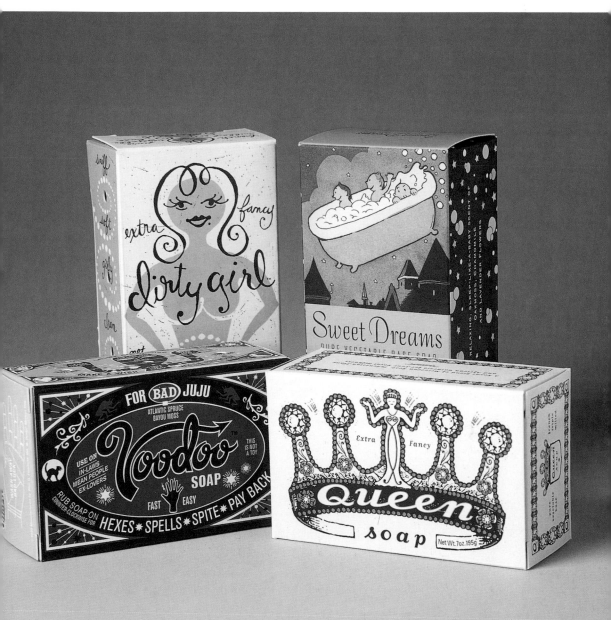

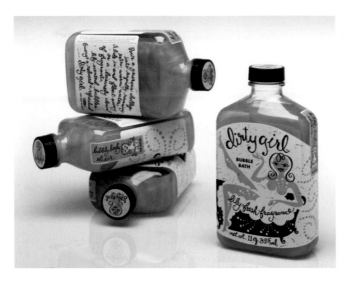

The Dirty Girl concept has proven so popular that Blue Q has developed new products with the same flirty, fun sensibility, including bubble bath.

"I had been working with Blue Q for the past several years on other projects. They were mainly into refrigerator magnets up to this point, so the soap was something very different. But they always want to take a very household kind of product and turn it into something unexpected," Johnson says. "They didn't have a truly focused marketing plan, which I think is the beauty of the project. We wanted to just see what would happen."

They brainstormed for names to create an expansive list of possibilities. Dirty Girl offered the right spirit of fun. "When I heard 'dirty girl,'" Johnson says, "I thought, 'well, girls get dirty and they need to take a shower.' But then you might think of something more burlesque or something not so sweet and innocent. Also, if you are dirty and need to bathe, you have to take your clothes off, too."

The character she developed is a charming mix of innocence and flirtation. "I wanted to show on the packaging how naively happy she was with her soap. She has a bit of attitude, but she's not too far over the top," explains Johnson, who illustrated the entire box, including the boxes' end flaps.

Johnson also focused on the construction of the soap's packaging. A box provided better shelf appeal, but unlike a paper wrapper, it permitted shoppers to open and close the package many times, which could damage both the product and the packaging. To solve this problem, Blue Q designed a box with three small holes in its sides: Buyers could easily smell and even peek in at the soap. The holes were placed strategically so that they would work within Johnson's illustrations as bubbles.

Even the copy on the box has the same quirky, fun flavor. Nash admits that some of it intentionally doesn't make complete sense. "But it's amusing," he adds. "It makes people spend time with the product."

The soap has been so successful that other body products have been added quickly to the line. Blue Q is looking into developing an apparel line. "We've been surprised at the passion of the public. Dirty Girl isn't just another thing to them; it seems as though we're tapping into a submerged dynamic. When women see this, it is so obvious that someone has spent a lot of time to make this especially for them. That really matters," Nash says, noting that this kind of attention does cost money. "With our approach, you add value faster than you add expense. The return on great design is good. We're not selling soap; we're selling concept. The concept sells the soap."

CREDITS
ART DIRECTOR: **MITCH NASH**
DESIGNER: **HALEY JOHNSON**

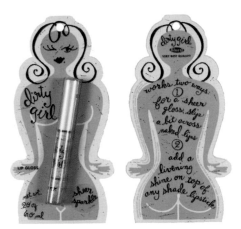

Instead of using a standard rectangular card to hold
lip gloss, Blue Q and Haley Johnson designed this
slightly naughty package.

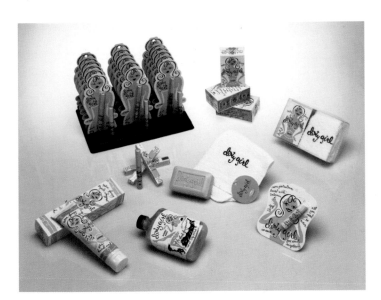

More products from the Dirty Girl line.

Continuing with the idea of using a strong concept to sell product, Blue Q also has developed Tough Guy—with a very manly scent, of course—and Wash Away Your Sins soap. The latter's box says it is "Tested and Approved for All 7 Deadly Sins" and lists instructions that include lathering, rinsing, and repenting.

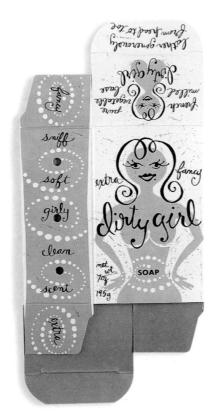

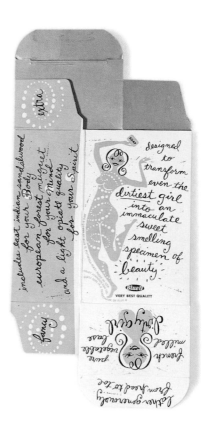

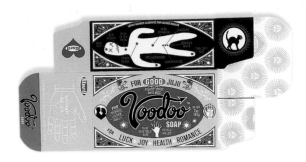

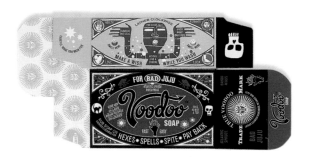

Other soap products in the Blue Q line. Everyone needs and uses soap, the company reasons. Why not personalize the product? The Dirty Girl concept has proven so popular that Blue Q has developed new products with the same flirty, fun flavor, including bubble bath.

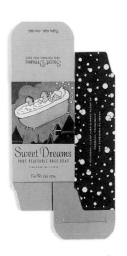

Altoids

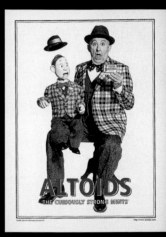

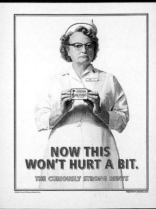

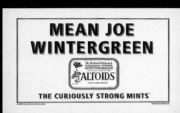

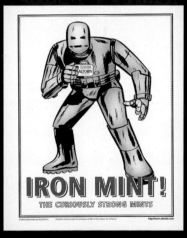

Mark Faulkner: "The brand is actually two hundred years old. … Music and computers were coming from Seattle then. So it had that coolness. But you can't say you are cool; you have to be cool."

Haan: "One thing we definitely tried not to say in the ads and posters was 'cool.' The ads speak [for] themselves, more or less. They just talk about the product and are a complete tribute to the product. In advertising, the best designs are the ones that focus on the product itself. It's not an ad for the ad's sake.

"We were given carte blanche to say that they are very strong mints. We kept the tagline 'curiously strong mints.' A lot of people might have tried to take that away, to update it somehow, but that was the best thing that series creators Steffan Postaer and Mark Faulkner could have done. They built off the package design and the tins."

Faulkner: "The first two ads were the muscleman and the 'mini mints so strong they come in a metal box.' When we thought of strong, we thought of bodybuilding. My partner Stephan made a little sketch of a deltoid, which sounded like 'Altoid.' I looked at body builder magazines from the 1940s. Those guys were kind of fun to look at, not scary like the bodybuilders today. The other 'strong' concepts have evolved over time."

Haan: "The ads have that mint green background—it almost looks medical. Altoids are a more serious mint. It doesn't have a candy look to it. The ads are also very flat-footed and easy to read; the advertising doesn't get in the way. What's great about working on the Altoids ads is that they are more graphic design than advertising. There's real symmetry and balance in them.

"We embraced puns in the campaign; I know a lot of people reject them. But you can go further with a pun. On the J. J. Walker ad, instead of him saying 'dy-no-mite!' as he would have on his TV show, he is saying, 'dy-no-mint!' Altoids has become a stage where all these characters like Walker can appear, and even the simplest puns are forgiven as hilarious because they are up on the stage.

"The biggest compliment we have gotten on the Altoids work is when someone said it was the next Absolut campaign. Of course, timing was a big part of its success. People were starting to spend three dollars on a cup of coffee. People liked the little metal box. And the product stands by the advertising—it's a really good product. The ad campaign kind of wrote itself."

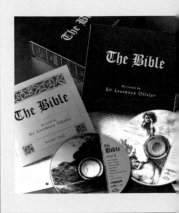

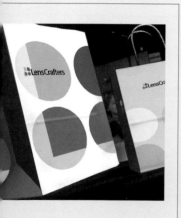

PART II

Balducci's

DESIGN
Pearlfisher, London, United Kingdom
MARKET
United States
(New York and Washington, DC metro areas)

Sutton Place Group owned three different brands that were strong and long standing: Sutton Place Gourmet, Balducci's, and Hay Day Country Farm Market. Each brand's logo graced shopping bags and private labels throughout each retail chain, making the logos highly visible to the loyal shoppers.

The final rollout of private-label Balducci's products presented a colorful, unique, and fun-loving packaging system that quickly summed up the contents of each container.

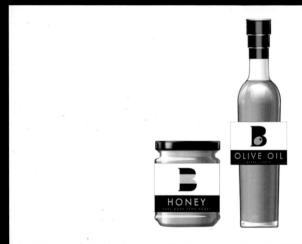

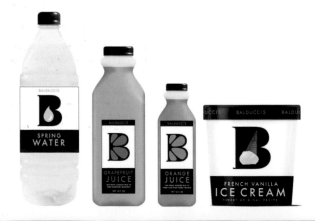

Balducci's Design Process

Having begun in 1980 as a small gourmet food store in Washington, DC, Sutton Place Gourmet quickly grew to a chain of specialty supermarkets throughout the metropolitan area. The holding company that owned Sutton Place Gourmet acquired two other well-known East Coast food brands in the 1990s, Hay Day Country Farm Market and Balducci's. With these acquisitions, Sutton Place Group LLC then owned eleven specialty supermarkets and six restaurants in Virginia, Maryland, the District of Columbia, New York, and Connecticut—prestigious destinations for urban food lovers.

In late 2003, the group announced it would adopt the best-recognized name from its restaurant group—Balducci's—as the brand for all of its properties. The mission of the chain was to create a group of full-service neighborhood supermarkets in the New York City and Washington, DC, areas that offer a range of specialty foods from around the world, superior-quality perishables, and everyday products at affordable prices.

REASON FOR REDESIGN

The former Balducci's was a high-priced specialty Italian food store. The Sutton Place Group wanted to shed this image in favor of positioning Balducci's as "the ultimate food lover's market." The group hired Pearlfisher, a firm with offices in London and New York, to redesign its brand identity and execute this into a variety of applications to give Balducci's a new, more distinctive, and universal image.

REDESIGN OBJECTIVES

- Combine three existing brands into a single, universal brand that balances tradition with a modern image, plus demonstrate how the identity could adapt to signage, a full line of private label products, shopping bags, print advertising, store environment
- Develop a clean, simple, accessible look to reflect and promote the new positioning of Balducci's stores, along with an interesting visual and verbal identity that communicates an element of fun and love for food
- Eliminate some of the "negative equity" that the old, high-priced brand had built up in favor of an image that welcomes a range of consumers

THE RESULTS

Consumers responded well to the new name and look of the Balducci's brand—a pleasant surprise for the client, who was initially worried about the reaction from loyal customers.

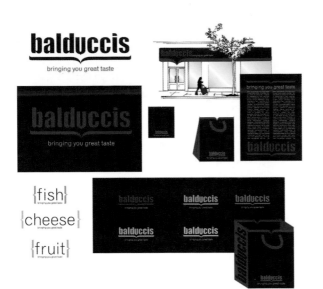

1

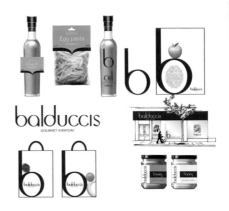

2

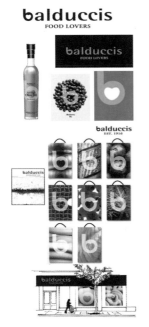

3

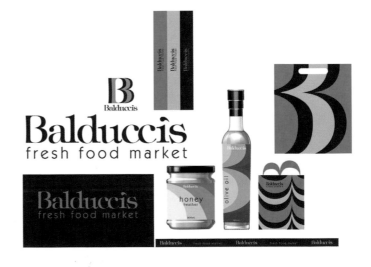

4

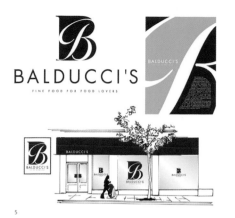

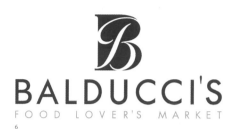

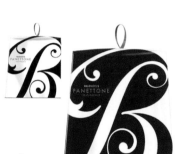

6

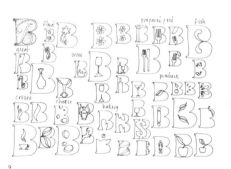

7

8

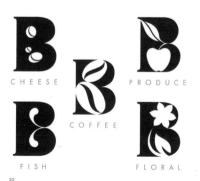

9

10

1, 2
Pearlfisher was given the task of finding a single look that could be applied to everything—shopping bags, packaging, signage, ads, uniforms, and interior design—across the rebranded Balducci's stores. The designers explored several different permutations for visually communicating the theme of "simply loving food." In these comps, designers latched onto the "simple" part of the equation, repeating a single design element—the bracket and the uniquely shaped *b*—for subtle flair in otherwise spare designs.

3
In this exploration, designers played out the literal concept of "loving." The letter *b* with a heart-shaped counter is laid over lusciously colorful images of food.

4, 5
The client ultimately chose the script *B* as the final direction, balancing an element of tradition with modernity.

6–8
One of Pearlfisher's biggest challenges was creating an identity that could be adapted across various applications, from bags to wrapping paper to uniforms. The black-and-white logo remained flexible enough that designers could scale it back (such as on the brown bags shown here) or dress it up (on fancier bags) to take advantage of the full impact of positive and negative space.

9, 10
To create a fun image and a strong emotional connection to the brand, Pearlfisher then embarked on designing a personality for each product category in the store—which includes more than 1,000 different private label products, from coffee to flowers to fish to dairy. The designers sketched out ways to visually represent each category within the familiar black *B*.

Bosque-Lya was an El Salvador sweetheart—a coffee grown, roasted, and produced in the Los Naranjos region west of San Salvador—but the brand wasn't distinctive in name, taste, or look. A busy label layered pretty berries, textured text, and an illustration of the brand's bird mascot that blended in with the background. The label, which was confusing and unreadable, didn't narrate the real story behind the coffee brand.

Café de Lya

DESIGN
Ideas Frescas, San Salvador, El Salvador
ART DIRECTOR
Frida Larios
CONCEPT/DESIGN
Gabriela Larios

COPYWRITERS
Frida Larios and Alejandro Kravetz
MARKET
El Salvador and the United States
(expanding into Europe)

The design used offset printing on a canister that kept the coffee fresher and presented a sleek new face to consumers.

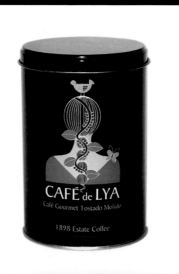

Café de Lya Design Process

For more than forty years, a family-owned business in San Salvador called Sweet's El Palacio de los Postres (which translates to "Sweet's Palace of Desserts")—has been celebrated as a favorite El Salvador bakery. Among the products that the business wanted to begin exporting was a line of coffee called Bosque-Lya, named for Lya de Castañeda, the business's founder and manager of her own coffee plantation. Though it had a strong tradition, the new generation of owners knew they had to improve the quality of the coffee brand before directing it to international markets.

REASON FOR REDESIGN
The Bosque-Lya brand as it stood wasn't strongly affiliated with a recognized set of values and an established identity. The manufacturer wanted to capture the interest of international distributors, especially as a coffee grown and roasted in El Salvador, a country that lost its foothold as a leading coffee producer due to a twelve-year civil war and is currently trying to regain its place among gourmet coffee brands. The coffee needed to stand out with a unique story and distinctive flavor by showing the true values of the brand. Sweet's and its branding and design consultancy, Ideas Frescas, decided thatin addition to changing the coffee itself, they wanted to return to the coffee's roots.

REDESIGN OBJECTIVES
- Rebrand the coffee as Café de Lya, a distinctive, memorable, and competitive brand to appeal to international markets
- Rediscover and communicate the coffee's, and the company's, true identity
- Represent a new "gourmet" product

THE RESULTS
In the first months after the relaunch, Café de Lya became the first gourmet coffee brand to be sold in Dutch supermarket giant Royal Ahold's local El Salvador chain, Hiper Paiz, and distributors in the United States have begun ordering the product.

1

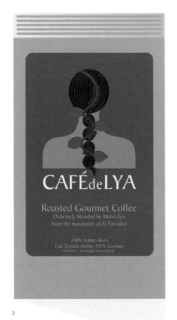

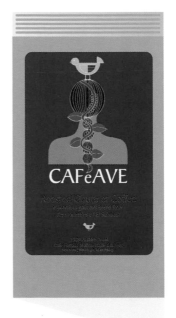

2

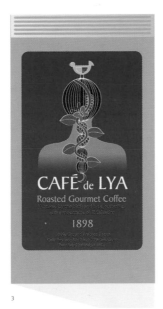

3

1

Branding consultancy Ideas Frescas worked with the coffee's manufacturer to study the heart of the product. The team reached the conclusion that the brand's real draw was its family tradition and its ecological values. The owners' grandmother, Lya de Castañeda, founded the coffee brand, so the designers went down the path of including her spirit on the package as an earthy feminine image. Based on the brand's familiar bird, they explored renaming the brand Café Ave (bird coffee). They also looked to the product's heritage, eventually choosing the name Café de Lya.

2

Original comps incorporated some of the elements from the old packaging—the berries and the bird—but invoked a more feminine, Mother Earth feeling. The designers wanted to reference the flora and fauna that inhabited the tropical forest, from where the gourmet coffee blossomed. "We felt there was a mystic and magical nature in all the process," says art director Frida Larios.

3

The designers and the client labored over every detail of the packaging: typography, text spacing, punctuation, colors, and textures. Even the clothes Lya wore were in question, because of discomfort over the amount of skin the woman should show.

4

The final label used an all-black background with rich, jewel-tone and earthy colors. It complemented the brand's slogan: Grown in the mountains of El Salvador. Nurtured by birds and blue butterflies.

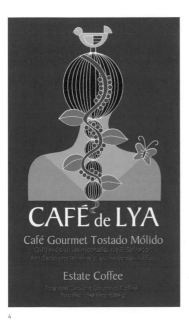

4

Ciao Bella

DESIGN
Wallace Church, New York, New York
MARKET
United States

before

Ciao Bella's former packaging was not
aimed at consumers at all—it was
food-service packaging simply meant
to get the product from the factory to
the restaurant deep freezer. When the
company decided to make a push
for consumer sales, it needed a new
design for its pints of gelato, sorbet,
and frozen yogurt.

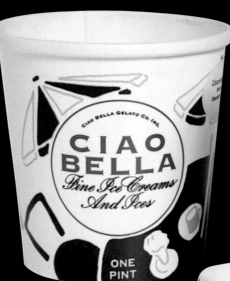

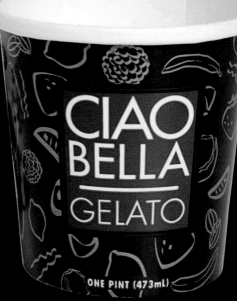

after

The pints, sold in upscale food markets, are too bright, quirky, and fun to miss — and the bold design embodies the quality and innovation of the icy treats within.

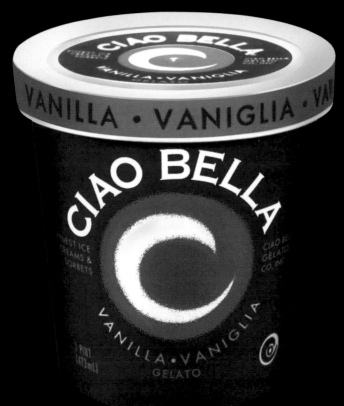

Ciao Bella Design Process

Ciao Bella started out twenty years ago as a tiny gelato shop in New York City's Little Italy and grew by word of mouth into an in-demand supplier of gourmet gelato and sorbet to some 1,500 gourmet restaurants around the country. The handmade treats incorporate inventive and exquisite ingredients such as Tahitian vanilla, Belgian chocolate, fresh fruit, spices, and imported Italian flavorings—formulas that discriminating chefs can't resist.

REASON FOR REDESIGN

The company also dabbled in retail, but the owners wanted to expand their reach more broadly into retail to complement its thriving food-service business. Ciao Bella packaging, which had been focused strictly on the trade market, was little more than a white carton with black lettering. To develop a presence in the natural food markets where the company planned to sell the products, Ciao Bella hired Wallace Church, a strategic brand imagery and package design consultancy in New York.

REDESIGN OBJECTIVES

- Design graphics for the company's new pint containers that were as unique, exciting, and innovative as the products themselves
- Create a packaging system and structure to accommodate the constantly growing number of fun flavors
- Help the emerging consumer brand stand out next to the category leaders, Nestle and Unilever, as well as look at home among gourmet and natural food brands in upscale retail environments

THE RESULTS

The results have been very good since the August 2003 launch. In fact, according to Ciao Bella cofounder and CEO F. W. Pearce, sales have nearly doubled since the company began marketing to consumers.

1

2

4

5

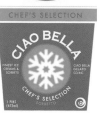

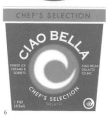

6

1
To create the new visual brand for Ciao Bella, the designers at Wallace Church experimented with many ideas, all based on fun, unique color combinations and shapes. In this comp, X-ray images of the products' main ingredients against a black background call attention to the products' natural origins and lend a more upscale look.

2, 3
These designs keep the black background but opt for brighter, more abstract shapes to provide eye-catching contrast.

4, 5
The bright colors were working, especially because they embodied the brand's innovative spirit and unique flair. Designers explored color combinations and symbols that would best suit the front of the pint cartons.

6
The design finally selected features simple but striking symbols of the product inside: a C-shaped swirl for the gelato and a snowflake for the sorbet. Contrasting, but harmonious, product colors were selected as pairings for the product families.

DESIGN
Addis, Berkeley, California
MARKET
United States

before

g targeted mothers
s for their children.
aging incorporated
fulness to that end,
s of falling fruit and
When the company
hat the mothers—
women in their peer
, in fact, buying the
mselves, Dole knew
needed to address
consumers looking
hy alternatives. The
also wanted a more
ique, ownable look.

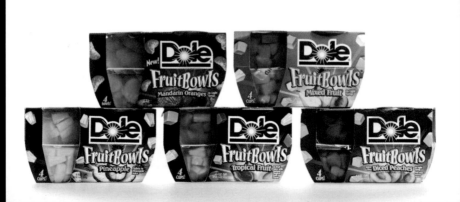

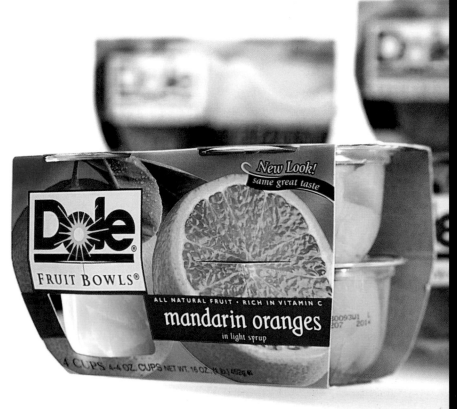

The redesigned package is powe
moving on the shelf, with mouth
images and clearly labeled pack
leave no question about freshne
healthfulness in the minds of bu

Dole Fruit Bowls Design Process

In 1999, fruit company Dole Packaged Foods in Westlake Village, California, introduced a product aimed at capturing part of the growing grab-and-go market. Dole Fruit Bowls offered several varieties of healthy snacks in plastic bowls with peel-off lids. When the product first launched, it was designed to appeal to kids—and their moms who shopped for them—as a lunch box snack. The company actually promoted the 4-ounce (113 g) bowls as having dual purposes: Once the kids finished their healthy snacks, they could use the sturdy bowls to plant seeds or collect coins.

REASON FOR REDESIGN

Three years after Fruit Bowls hit the shelves, Dole learned through market research that their target audience was not what they had expected. Though moms with kids were still a significant demographic, the largest group of consumers for Fruit Bowls was single women ages 25 to 35.

Dole decided to reposition the product with an aim for 25- to 45-year-old women, with or without families, who led busy lives and had a difficult time eating well despite their best intentions. New packaging was needed to address this older audience searching for a healthy, convenient snack.

REDESIGN OBJECTIVES

- Target on-the-go adult women who are looking for ways to eat well and naturally but are limited on time
- Exceed previous packaging's on-shelf impact, image of quality and freshness, and system of classifying product varieties
- Create a proprietary style that reflects the Dole brand and sets Fruit Bowls apart from other fruit-based snacks

THE RESULTS

The new look, with its oversized images of fresh fruit, is stopping fast-moving women consumers in their tracks and is carving a special niche in the grab-and-go aisle. The company has seen favorable market response to the new, unique look.

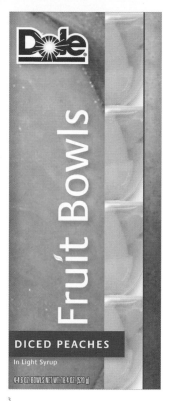

3

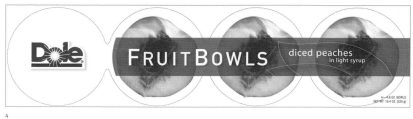

4

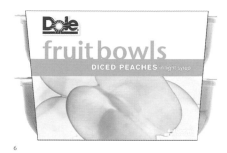

6

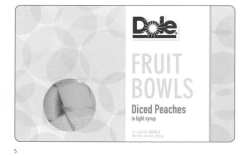

5

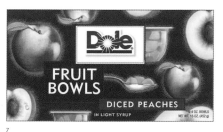

7

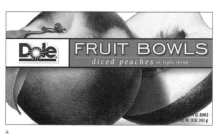

8

1, 2
Dole wasn't sure how far it wanted to go with its redesign, so design firm Addis set out to explore a range of possible directions, reflecting everything from a complete change in focus to more evolutionary approaches. Initial sketches reveal a revived focus on Fruit Bowls' fresh ingredients, as well as the possibility of a more innovative physical structure for the package.

3, 4
The fresh-approach concept (3) conjured up images of freshness and great taste on a unique, cylindrical package. The fresh-spirit direction (4) also experimented with an innovative new packaging structure—a clear package that evoked a light, pure feel suggesting wellness for the mind, body, and spirit.

5
Some concepts were emotionally based. The fresh-attitude approach featured abstract representations of the fruit for a bright, modern, and sophisticated design approach that was still friendly and accessible.

6
Other concepts, such as fresh view, targeted the senses. The package backlit thinly sliced fruit to allow its natural texture to shine through, a compelling summary of the product's fresh, intense taste.

7
A more evolutionary approach retained the original packaging's playfulness but added a sense of depth and dimensionality to the floating fruit.

8
The concept finally selected by the client was the direction Addis termed "fresh picked:" rich photographic images of whole pieces of succulent fruit, conveying a sense of right-off-the-tree freshness.

ACCOUNT DIRECTOR
Brendan Kelly
SENIOR PRODUCER
John Ziros

Sonoco Flexible Packaging
MARKET
Canada

Fruit to Go, a dried-fruit snack, has always been a mother's favorite: the number one fruit snack in Canada was a 100 percent natural alternative to candy and chips. Even the flavors were simple and tame -- all variations n the doctor-ordered apple. The pack-aging reflected this image -- attractive and mature looking, the package ppealed to parents looking for lunch-ox ideas. Kids, who notoriously shun anything their parents appreciate, weren't asking for the snack when their parents shopped, and sales were beginning to slip.

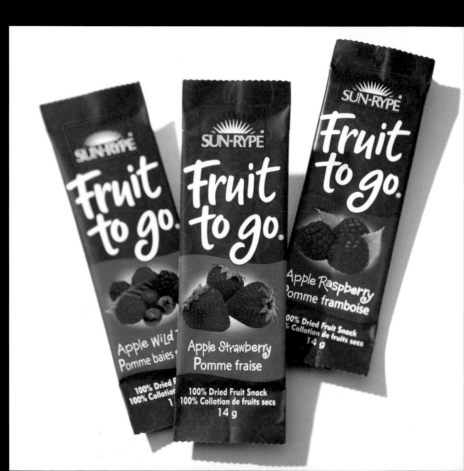

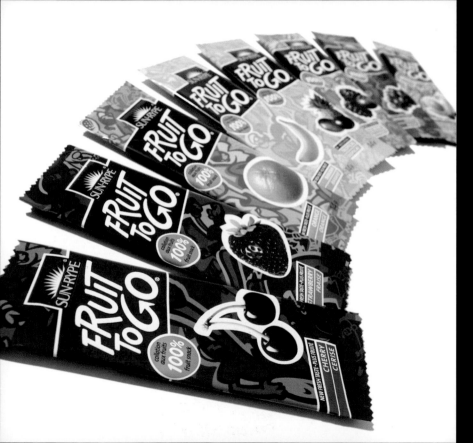

The final packaging is cool enoug
respectable enough for moms, an
enough to skate, swim, and jump
into any family's shopping cart.

Fruit to Go Design Process

The manufacturer of these fruit snacks, Sun-Rype, is as wholesome as they come: the 55-year-old company, based in an agricultural corridor of western Canada, specializes in natural fruit juices and fruit snacks. Sun-Rype's Fruit to Go has long been the number one fruit snack, a favorite in Canada among parents looking for healthy snack alternatives.

REASON FOR REDESIGN

Although Fruit to Go still led its category, sales had flattened and begun to decline. Sun-Rype conducted research that showed adults still loved the goodness of the snack and kids still liked the taste, but both parents and kids found the packaging too adult targeted and not something that kids would actually request. Because 80 percent of purchases were for households with children, Sun-Rype realized it needed to encourage kids to ask for the snack from their parents.

The manufacturer decided to expand the line, adding new flavors and a stronger fruit taste. Sun-Rype dropped the base ingredient, apple, from its product descriptions and, instead, promoted the line's flavor variety. The packaging also needed to tap into the key insight that Fruit to Go was considered "healthy fuel for active kids."

REDESIGN OBJECTIVES

- Create a cool, energetic image that would attract kids and preteens
- Communicate to parents that the product was the same healthy, responsible fruit snack as always
- Expand the flavors and varieties offered under the Fruit to Go brand

THE RESULTS

Fruit to Go kept its top spot in the market, and Sun-Rype saw a 25 percent rise in sales from the spring 2003 rollout. Thanks to a national advertising and public-relations campaign aimed at kids combined with a radical on-shelf debut, awareness of the fruit snack brand also rose 14 percent throughout the country.

Activity Focus

Fruit Fuel / Powerful Fruit / Explosive, Radiating

Dynamic, Cool Fruit Style / Energy Bar for Kids, Aspirational

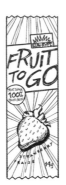

1

2–4

6

5

7

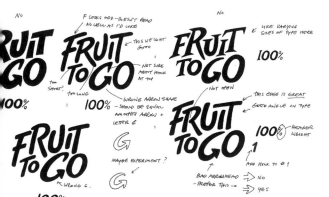

9

8

1

The manufacturer Sun-Rype turned to Karacters Design Group to help design a new architecture for a planned rollout of an expanded line of flavors. Additionally, Sun-Rype wanted to explore how to appeal to kids ages 6 to 10. They adopted the concept of "healthy fuel for active kids" for the products. Karacters set out to explore all the directions this concept could take them, referring to comic books, video games, skateboards, and other pop culture favorites to avoid the cute or child-ish approach common among fruit snacks.

2–4

The designer and client narrowed ideas to different directions: "contemporary action," "fruit as fuel," and "activity." Relying on the feedback of focus groups, the team finally decided to combine the ideas of activity with the concept of fruit as energy.

5, 6

After selecting the concept, the next challenge was finding the right illustrations that would serve all those purposes. "We knew we didn't want anything photographic, serious, childish, or too adult," says designer Nancy Wu. And the illustrations couldn't be trendy either—they needed to stand the test of time. Illustrator Adam Rogers experi-mented with styles before discovering the boldly outlined shapes of skateboarders, snowboarders, soccer players, and other characters that would eventually serve as the background graphics.

7

Karacters convinced the client to move away from its trademark blue as the most promi-nent color on the wrapper. Therefore, Wu was free to use a vibrant color palette that was cool to kids and conveyed energy. The blue remained as the recognizable element from the previous package, and a consistent green also tied the differently colored packages together.

8

The old Fruit to Go logo was drawn in a bouncy, adult style. Karacters redesigned the logo to speak directly to kids, in a way that didn't pander to them. According to Wu, covers of the early French-edition Tintin comic book covers inspired the new typeface.

9

Karacters turned to a unique color mix to bring out the brightness in the real fruit images while representing the brand color effectively. Previous fruit images were muddy when shot differently and printed at a much smaller size, Wu explains. Instead, perfectly shaped fruit was shot with strong 3-D modeling to look hyperreal.

La miel de Centroamérica

520 gr.

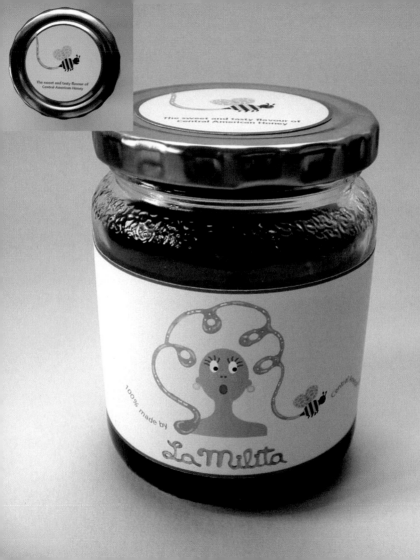

La Milita Design Process

Beekeeping for the production of natural honey is a big business in El Salvador, and over the years, the country's sticky sweet product has earned a reputation for purity, freshness, and quality. A trade association called VACE (an initialism that is also referred to in English as the Beekeeping Cluster) has for the past twenty years promoted the export of the honey overseas. In the past few years, however, the El Salvadoran government has recognized honey as one of the many agricultural products that have potential in the U.S. and Canadian markets. With the passage of the Central American Free Trade Agreement on the horizon, there has been an increased push to market El Salvadoran honey in North America.

REASON FOR REDESIGN

The Beekeeping Cluster commissioned a new design for its honey jars to appeal to a wide range of American and Canadian consumers and also to communicate the origin and quality of the product inside. The package in which the honey was originally sold featured a cute illustration of two bees on a white label that covered a clear glass jar. But the exporters needed to convey more immediately an image that was modern, memorable, and unmistakably Latin.

REDESIGN OBJECTIVES

- Create a package that reflects the unique propositions of Central American honey: pure, natural, fresh, and high quality
- Design a memorable and innovative honey jar that is original and modern, yet friendly and appealing
- Fill an existing gap in the U.S. and Canadian honey markets with Central American honey and clearly communicate an authentic Latin flair

THE RESULTS

The package has been very well received by potential U.S. and Canadian buyers, with whom the exporters are still in negotiations. The El Salvadoran government has expressed its faith in the potential success of the product and has backed it with a $20,000 subsidy—a major part of the exporters' overall $26,000 budget—to support the promotion of the brand.

1

superficie plana

2

superficie plana

2

3

4

5

6

1
The Beekeeping Cluster hired Ideas Frescas to rebrand the honey and find a successful packaging design to help it accomplish its goals. Ideas Frescas explored a couple of different routes. One idea was to brand the honey MIELCA (an initialism for Miel de Centro America, or Central American honey) and to portray the friendliness and freshness of the brand. For this direction, the firm's illustrator created whimsical bee characters to represent the product.

2
This direction involved a structural redesign that was as original as the package's label. However, the client worried that the overall impression didn't communicate the honey's origins—a major objective of the project.

3–5
The other route Ideas Frescas explored was La Milita, a more exotic brand that was distinctly Latin. Designer Ana Gabriela Larios sketched a wide-eyed Latin beauty startled by a bee's elaborate flight pattern. The direction was fun and presented an immediately recognizable Latin American flavor. This is the brand that the client ultimately selected.

6
La Milita's new logo—a cheerful, bubbly script drawn from glistening honey—presents a friendly, organic image for the product.

Origin

DESIGN
Wink, Minneapolis, Minnesota
CREATIVE DIRECTORS
Richard Boynton and Scott Thares
DESIGNERS
Richard Boynton, Scott Thares, and Dawn Selg

MARKET
United States

before

The former packaging for Target
stores' Origin dietary supplements,
true to retail private-label standards,
was purposefully generic—no images,
special branded type treatments, or
other graphical treatments intended
to create a unique image for the
products. Instead, the plain bottles
were meant to appear as the low-
cost equivalent to better-known
national brands.

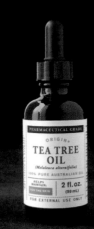

The redesigned labels combine an antique, apothecary look with a touch of modernity, giving the products a natural, high-end look. The products' sales have benefited from the gorgeous new packaging, leveling the playing field between Target's private label and the national brands.

Origin Design Process

Target Corp., like many other major chain retailers, offers a number of private-label products alongside national brands for price-conscious consumers. One of these product lines is a dietary supplement offering—vitamins, minerals, and herbal remedies with the same ingredients as national-brand supplements. True to typical private-label treatments, the original bottles for the Target dietary supplements were purposefully plain, immediately suggesting a generic alternative to the trademarked designs of competitors' bottles.

Company-wide, however, Target began to move more toward unique designs for its private brands. Products in the Target pharmacy were also moving in a new direction: the stores were beginning to specialize in a more natural and holistic approach to health with their private-label pharmaceutical products. The Target vitamins and nutritional supplements needed to fall in line with this rebranding, which required a new name and new packaging design.

REDESIGN OBJECTIVES
- Create packaging that would reflect the selected name and direction for Target's rebranded private-label nutritional supplements
- Develop a design that would clearly communicate product information and create an easy, recognizable organizational structure for the many different kinds of product
- Adhere to the Target pharmacy's new, holistic approach toward healthcare

THE RESULTS
Target has raved over the sales of the new Origin line, telling creative firm Wink that they're selling much better than the company ever expected. "I went into a Target to see how they were displayed the first week they were released and was treated to seeing a late-thirties mom (the primary target market) shopping for her dietary supplements," says Richard Boynton, the creative director for the project. "She picked up the Origin bottle and a competitor's bottle, compared the two—which obviously have the same ingredients—and then put the Origin bottle in her cart, along with three other supplements from the same line!"

1

2

3

4

1
Wink also started exploring package designs for the potential identities. For the name Millennium, designers experimented with modern-feeling aluminum cylindrical tins as well as glass bottles and colorful graphics.

2
Designs for the New Millennium approach were more natural feeling, with a leafy tree logo and earthy colors to convey the all-natural ingredients of the products. Shaded stripes on each bottle contained the many necessary layers of product information.

3
Designers also explored the potential name Origin, going down the path of a simple, clean, graphical structure with meaningful touches of color.

4
When Target decided to rebrand its pharmacies, the chain engaged Wink to create a new design for the extensive line of vitamins and minerals. However, Target was still weighing a number of different names and identities for its pharmacies as a whole, as well for as the supplements. Wink began developing logo ideas for all of the potential names and approaches.

5, 6
Target ultimately rebranded its pharmacies to focus on a more holistic and organic approach and selected the Origin name for the supplements line. Wink's designers altered their focus on a simple graphic design with little ornamentation but a great deal of character, allowing for straightforward organization of product information on the label but building a strong image using type and hints of rich colors.

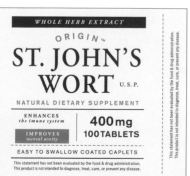

5

6

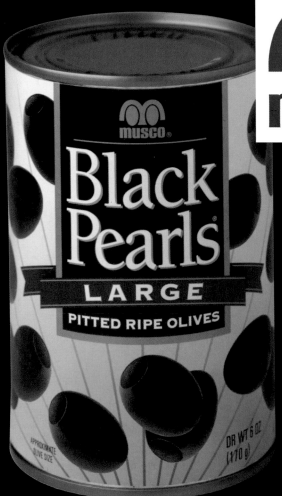

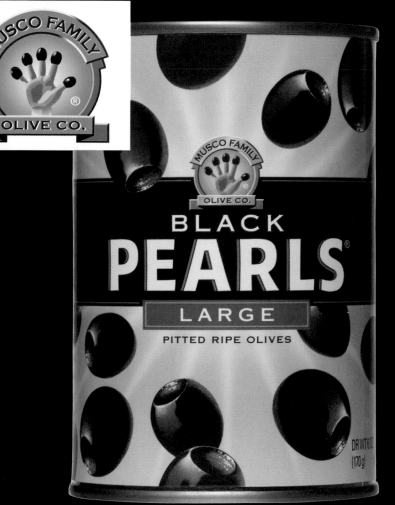

The label redesign presented an opportunity to rebrand the parent company itself. Research proved that customers knew the Black Pearls name, but had no awareness of Musco Olive Products. In fact, many thought Musco sounded like a big corporate conglomerate. It was time to get credit for the fact that Musco was a family-run business and develop a memorable mark that consumers could relate to and connect with.

Pearls Olives Design Process

Since 1940, the family-owned-and-oper-
ated Musco Olive Products in northern
California packaged olives for the food-
service industry, and in the past decade
hit the retail market with its Black Pearls
line of black olives. But since purchasing
its largest competitor in 1999, the com-
pany has branched out with green and
specialty olives—and has become the
first company to offer a complete line of
retail olives at all price points.

REASON FOR REDESIGN

Because it no longer focused exclusively on black olives,
Musco needed a brand identity that more accurately
summed up its quality and breadth. Market research
showed that the Pearls name stood out in consumers'
minds, while the manufacturer identity barely made the
charts. The company decided to rebrand itself and its
olives and wanted a system of packaging that would
distinguish the subbrands (Green, Black, Mediterranean)
at first glance on the store shelf.

Additionally, Musco and its creative firm, Tesser Inc.,
agreed that olives as a food were due for a rebrand.
"Traditionally, olive branding approaches had ranged
from 'utilitarian foodstuff' and 'mamma-mia Italian
ingredient' for black olives to 'fancy-schmancy appetizer'
for specialty olives," says Tré Musco, CEO and creative
director of Tesser (who, as a member of the Musco family
himself, understood the client's needs all too well).
"American consumers, however, have long used olives
as a convivial snack item for get-togethers. The creative
team felt strongly it was time to give olives credit for
being the healthy, versatile, and family-friendly snack
item that they are."

REDESIGN OBJECTIVES

- Retain key brand elements such as the Pearls name,
 color yellow, and "bursting" olives
- Update the parent company brand and integrate new
 product offerings
- Complement a widespread marketing campaign

THE RESULTS

The new Pearls line is proving to be a major retail success,
with penetration into 70% of the U.S. market, and volume
sales that rank it first in its category. The manufacturer
reports that brand recognition is at an all-time high.
Additionally, consumers have been writing to Musco to
report their delight with the label design and its effect on
their purchasing decisions.

2

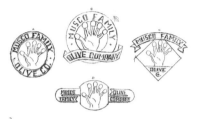

3

4

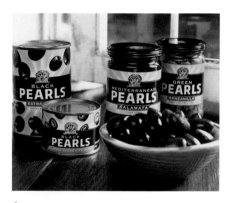

5

6

7

1
The new treatment works particularly well to create a billboard effect on store shelves. "The olives overlap and join one another like pieces of a puzzle from can to can," says Tré Musco. "The result is an impressive swatch of Musco gold with bursting olives and black stripes across entire sections of shelving." Promotional support for the brand has included in-store POP displays, floor graphics, television advertising, and the website olives.com.

2
With Tesser's help, the company was renamed Musco Family Olive Co. New identity explorations included rustic scenes of olive harvests and romantic Italian landscapes.

3, 4
Ultimately, the team decided that the olive category itself was due for a rebrand, and opted for a nontraditional approach. For years, Tesser had used a child's hand with olive-capped fingers in Musco's promotional materials. Initially, translating this image into a corporate mark seemed like it would be difficult. Early sketches looked cartoonish and odd.

5
Finally, Tesser hit upon the idea of rendering the hand in the style of 1930s and 1940s Streamline-era illustration. "Once we figured out the Streamline style, it all fell into place," says Tré Musco, CEO and creative director. "We hired Laura Smith to create the illustration, and I think she did a great job of making the hand fun and approachable, yet serious enough to represent a sixty-year-old company." The creative team created a frame and type treatment for the mark, and the Musco Seal was born. The seal is used by itself on retail packaging, and is combined with the Musco logotype on corporate materials.

6
In addition to the Musco Seal, the final label designs feature a black belly band, with the new Pearls logotype and variety descriptor. Olive sizes are called out in colored bars below the band. Green and Kalamata varieties come in jars, so the labels feature only the golden burst (without olives). Sliced and chopped olives have their own "bursting olive" illustrations, showing customers exactly what they're purchasing.

7
The new Pearls line uses descriptors to distinguish the products from one another, while the design combines a richer, proprietary gold color and hyperrealistic bursting olives with the rebranded Musco hand seal to give the product a sense of energy and fun.

Beefeater Crown Jewel

DESIGN
Fitch, London, United Kingdom
MARKET
Worldwide

The old bottle for Crown Jewel, Beefeater's premium gin, created a cool, precious image for the brand, but the colorless bottle and its offbeat shape put Crown Jewel at a disadvantage in the crowded, cost-conscious, duty-free space.

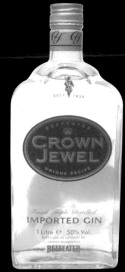

In the gin category, other brands have "owned" colors (including Bombay Sapphire's blue and Tanqueray's green). In this tradition, and to make the bottle memorable, Fitch selected a rich purple glass for the bottle. The color is regal and jewellike, combined with a bottle cut as distinctively as a gemstone. Topped with a gold-colored cap, the overall effect lives up to the product's name.

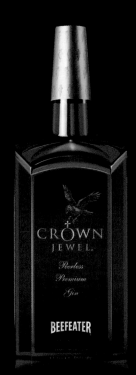

Beefeater Crown Jewel
Design Process

Beefeater, a stalwart brand of gin for nearly two centuries, prides itself on its heritage and quality—it's the only producer that distills its gin in England, where gin originated in the seventeenth century. Beefeater's staple brand, London Dry, is consistently rated at the top of its class.

But for true gin lovers, Beefeater offers its premium version, Crown Jewel, a berry-and-citrus-infused gin with a smoother finish. Backed by the heralded Beefeater brand, the premium gin was beginning to make its entrance into duty-free markets in the United Kingdom and around the world.

REASON FOR REDESIGN

As Beefeater geared up to promote Crown Jewel, the company realized the bottle's look didn't support its desired top-of-the-line image—or the price that went with it. The bottle looked nothing like London Dry, the parent brand, nor did it at all resemble other gins on the shelf, shrinking in its squat bottle beside its tall, thick competitors. The colorless bottle, while giving the bottle a pure, platinum look, rendered the gin practically invisible next to more colorful brands.

REDESIGN OBJECTIVES

- Promote Crown Jewel as an ultrapremium brand in the Beefeater family
- Appeal to the primarily male audience and support the brand's bold, adventurous image
- Increase sales and distribution of Crown Jewel in the duty-free market worldwide

THE RESULTS

At press time, the launch was too recent to gather real financial results. However, at Crown Jewel's relaunch during the October 2003 Cannes Duty-Free Fair, the trade positively received the new bottle and the product within it.

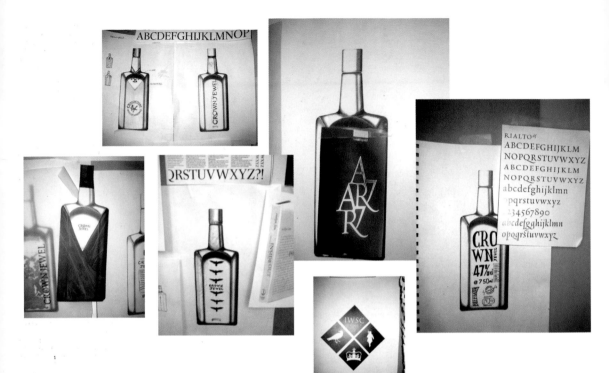

ABCDEFGHIJKLMNOP

QRSTUVWXYZ?!

RIALTO *df*
ABCDEFGHIJKLM
NOPQRSTUVWXYZ
ABCDEFGHIJKLM
NOPQRSTUVWXYZ
abcdefghijklmn
opqrstuvwxyz
1234567890
abcdefgghijklmn
opoqrstuvwxyz

IWSC

1

2

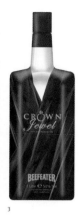
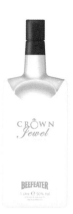
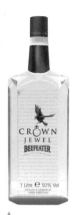
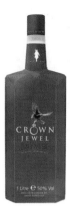
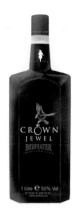

3

4

1
At the beginning of the project, creative firm Fitch:London looked at every possible direction for the bottle design. The designers looked into all aspects of Crown Jewel and Beefeater's heritage and brand name. Beefeater, named for the guards who watch over the Tower of London and the royal crown jewels housed safely inside the tower, provided initial inspiration for sketches and design directions.

2–4
After more in-depth research, the designers considered a number of different ideas. From the history of the Tower of London emerged the tradition of the ravens, pitch-black birds who guard the British crown jewels. One design concept involved representing the raven theme—symbolizing masculinity, self-assuredness, and intelligence—on the Crown Jewel bottle.

5
Other concepts focused on the heritage of the gin, calling on images of the St. George's Cross (an old English emblem) as a reminder of its British origins and on crests and Old English type to suggest the product's long history.

6, 7
The raven concept won the contest. The designers and the client also identified a number of other elements that had to be represented: the orb (part of the collection of Crown Jewels); the Beefeater guards, also known as Yeoman Warders, who guard the ravens and the jewels; and the prestigious International Wine and Spirits Competition awards the gin has won. The designers found ways to combine these elements smoothly into the design, including making the orb the *O* in the logo, with the raven swooping down to protect it.

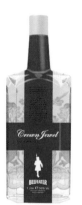

6

5

7

The old Canyon Road packaging is suffering on the shelf alongside newcomers and splashier labels designed to grab the attention of bang-for-the-buck consumers.

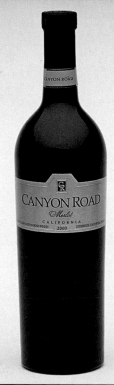

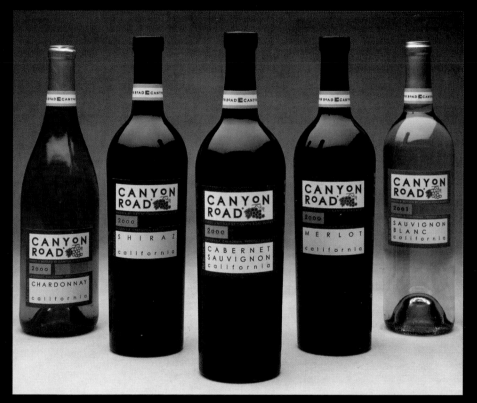

The attractive, artistic new bottle is a big hit with consumers and retailers alike.

Canyon Road Design Process

Based in the Alexander Valley of Sonoma, California, Canyon Road produces wines that have "casual sophistication"—they're easy to drink and affordable to buy. In fact, the wines occupy one of the most cutthroat store shelves—the $5.99 to $6.99 California blends—where packaging design and name are the only things that give a wine a chance.

The wines had a strong presence in Europe, where they were marketed as traditional California wine. In the United States, however, the brand was "gathering dust on the bottom shelf at retail," according to creative firm Michael Osborne Design. This situation was especially true in the current state of the wine industry. Grape reserves were swelling as demand dropped off, farmers overproduced, and prices plummeted—factors that added to the competition in lower-priced categories.

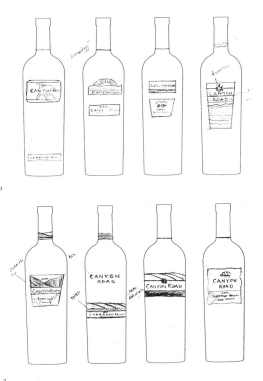

1

2

REASON FOR REDESIGN

Sales were flat, and the unremarkable label design was not helping. Canyon Road was ready to shed its traditional coats and do something revolutionary to jump-start sales. Research showed that Canyon Road's most valuable brand equity was its name, not the bottle or label design. Therefore, the company and its creative firm decided to try a drastic overhaul of the wine's image.

REDESIGN OBJECTIVES

- Drastically change the look of Canyon Road wines to create a memorable brand image
- Capitalize on Canyon Road's existing equity by emphasizing the brand name
- Appeal to American consumers with a cutting-edge design that would turn heads

THE RESULTS

Sales are soaring in both the United States and Europe. In some cases, retailers have actually moved the wine up a shelf or two, and the brand possesses extraordinary shelf presence with its savvy Arts and Crafts look.

3

4

5

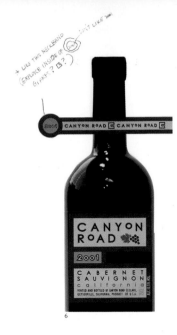

6

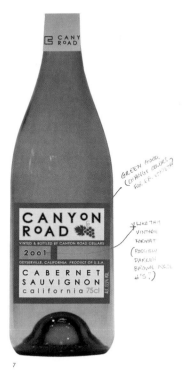

7

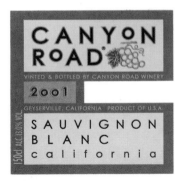

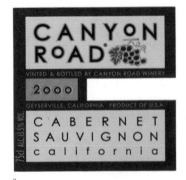

8

1, 2
With an anything-goes attitude, Canyon Road and Michael Osborne Design jumped into the redesign process, exploring every possible approach in early sketches. They adhered to a loose set of guidelines in attempting to capture the spirit of California with a fun, casual, and elegant style.

3
The client and creatives agreed that Canyon Road's singular brand equity was its name, so early design ideas played off of that with the attempt to work angular canyon cliffs into the label.

4, 5
Early approaches involved everything from a subtle approach using muted and distinguished colors to attempts to make the label jovial and artistic. The bottle on the left (4) was one of the first approaches, which later evolved into the final approach, that emphasized the C from the product name
in the design.

6, 7
After the designers struck on the idea of using the block letter C as the foundation for the design with an Arts and Crafts typeface for the name, the client and creatives fine-tuned the details, such as what the neckband would look like and where vintage and other product information would reside.

8
The final labels used subdued jewel colors to classify the different varieties of wine.

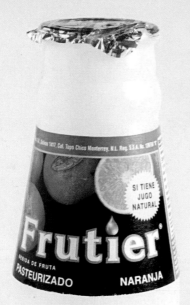

Mexican carbonated fruit
...med at kids, though you
...t have known it from the
...ure-looking black labels,
...ward photos of fruit, and
... logo. Although a poorly
...fashioned illustration of
...attempted to correct the
...ated by the label, it only
... to the overall awkward-
...ckaging. In addition, the
...l gave the graphics a flat
...ness and also peeled off
... he moist atmosphere of
...onsumers' refrigerators.

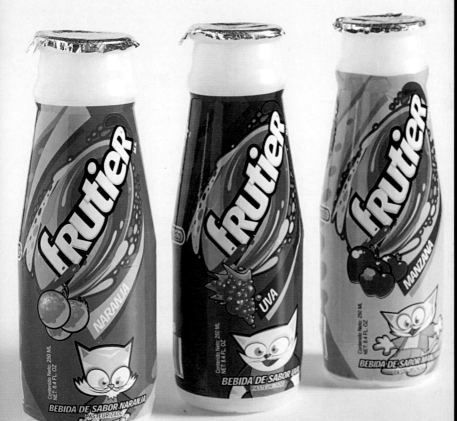

The team chose a plastic label a
print process for the final labels
energetic graphics to burst from
while protecting the label again

Frutier Design Process

Embotelladoras Arca, a giant beverage producer and distributor in northern Mexico, specializes in bottling internationally branded soft drinks such as Coca-Cola and Fanta. It also fosters a number of regionally marketed proprietary brands. Frutier, a carbonated fruit drink, is one of these. Available in four flavors, the juice has been on the market for nearly five years.

REASON FOR REDESIGN

The juice's plastic bottles suffered from outdated graphics and poor print quality. Focus groups frowned on the brand, responding that they didn't identify with the image the fruit juice portrayed. Additionally, the black labels with old, overly literal photographs of fruit didn't mean a thing to the demographic that actually drank the juice—young children. In an attempt to reach out to youngsters, the old label featured a family of cartoon cats, but they were poorly drawn and darkly printed in a corner of the label, almost as an afterthought.

To help this stalwart brand survive in the ultracompetitive beverage industry, the manufacturer consulted with Cincodemayo Design Studio in Monterrey to rethink the label's approach. The creative firm and the manufacturer agreed the packaging needed to serve as the driving force behind the firm's reinvention, so they explored a logo redesign and new illustrations of the cat characters.

REDESIGN OBJECTIVES

- Give the package a colorful, fresh, dynamic look that would help it stand out among its competitors
- Attract the attention of the target demographic—children
- Improve the printing process to do justice to the improved graphics

THE RESULTS

The manufacturer stood behind Cincodemayo's new design with a complete promotional campaign, including point-of-purchase, television, and print ads, as well as new fleet graphics for the delivery trucks. In the six months following the packaging relaunch, sales of the beverage have doubled, according to manufacturer reports.

1

3

2

4

6

5

7

1
Cincodemayo Design Studio and the manufacturer agreed the label needed to reach out to its target demographic—children—with a more vibrant logo and exciting characters that would intrigue energetic kids. Cincodemayo designers experimented with creating motion on the packaging in initial sketches.

2–4
Cincodemayo played with a number of logo concepts, all incorporating the bright colors of fruit flavors into the various elements. Some initial concepts retained the teardrop that originally topped the logos. Other ideas went to extremes with the concept of cheery fun.

5
Cincodemayo created a cast of cat characters for various uses on the packaging and in advertising. Features of the new characters resembled the look of popular video game and contemporary cartoon characters. In addition, the new "family" now included a female cat to appeal to girls. Active and playful, the cats would eventually drink the beverage, play sports, and jump around on the bottles, so the illustrator needed to determine what the cats would look like from every angle before rendering these action poses.

6
The final logo incorporates the original intent of a liquid splash while working in a rush of movement and color.

7
The designers created new labels that covered the entire bottle instead of wrapping only around the top. Bright colors, cartoonish illustrations, and bubbly type convey product information with energy and youthfulness, in line with the logo and mascots.

Secrets of Success

When a packaging design is ineffective, the packaging is holding a product back from achieving great things. The quality of the product might be out of this world, but the packaging is simply not doing it justice, or its shelf presence might not be backing up the success of advertising efforts. Therefore, the product should be snatched up in overseas markets or placed on the high-end shelf in the stores, but something is making it fall flat.

CONSIDER NOTHING SACRED

Unlike with outdated designs, in many cases, clients have nothing—or at least little—to lose by taking a risk. Chances are, if the client is seeking a redesign based on an ineffective current packaging, sales are probably less than stellar and the product is likely a shrinking violet on the shelf. Everything is up for consideration: the colors, the typeface, the logo, the illustrations. Whereas clients who are conducting mere refreshes or evolutionary redesigns are protective of their main brand equities, often clients whose packaging is flat-out bombing can be convinced to venture a little further out on the scale with a dramatic redesign.

TURN HEADS

Similarly, although clients who are refreshing outdated packaging are typically gun-shy about making too big of a splash (to avoid alienating loyal consumers or making them nervous about the product's continuity), ineffective designs often require a different approach. In many cases, companies want to take the retail world by storm—because for the first time in a long while, it means that somebody is talking about their product.

 "People remember it," says Dennis Whalen of Michael Osborne Design, the firm that redesigned the under-six-dollar wine Canyon Road with a radically unique label. "The label got a 30 percent bump in sales last year. It won't last twenty or thirty years on the market, but that's not the point."

SPELL IT OUT

Sometimes the reason a package design is ineffective is that people just don't get it—either the graphics are misleading or they trigger an inaccurate association in the consumer. This advertising miss can mean certain death for a product, especially when in some retail categories as much as 80 percent of the buying decision is made at the shelf.

before

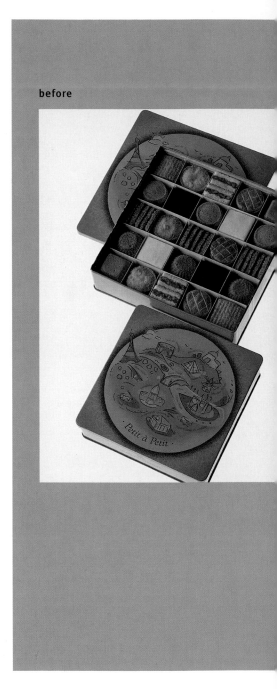

after

Henri Charpentier is a tony chain of patisseries in Japan. The shops sell miniature works of pastry art, popular among urban gift givers and hosts. The patisseries combine the classic elegance of French pastry with painstaking Japanese aesthetics. The company worried that quality of the packages in which it sold its edible art didn't measure up to the caliber of the products themselves. Boxes came in many different colors, typically printed with whimsical illustrations. Creative firm Curiosity, Inc., also considered that Japanese society places considerable weight on the way products are packaged, taking great pride in handmade wrappings, especially for business gifts. The designers created unique packaging with an austere, modern look that was still fun, with its interesting shapes and textures, to appeal to all consumers.

Nando's Salad Dressings

DESIGN
Cross Colours, Johannesburg, South Africa
MARKET
South Africa and the United Kingdom

before

Nando's has been known worldwide, especially in Great Britain and South Africa, for its peri-peri sauces, popular with lovers of its Portuguese-style chicken restaurants. However, the other products offered by the company weren't selling as well. Research showed the packaging for Nando's salad dressings (top) too greatly resembled that of its peri-peri sauces (bottom).

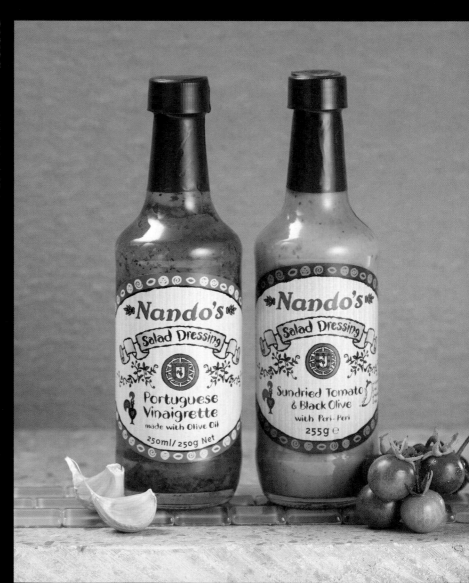

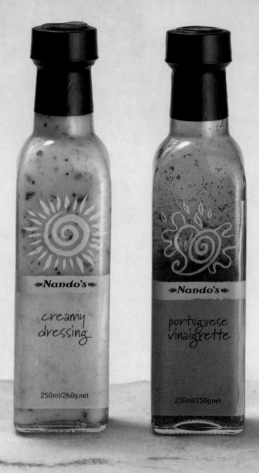

The ultimate new design—a contemporary, rectangular bottle with light-colored graphics and labels—lets the natural beauty of the dressings shine through with an organic appeal. Retailers and consumers alike sat up and took notice of the dressings.

Nando's Salad Dressings
Design Process

Nando's is a widely known brand with a heritage as eclectic as its products. The South African company owns chicken restaurants across the United Kingdom that specialize in Portuguese-style chicken in a peri-peri sauce. The popular restaurants have now expanded around the world and so have the bottled sauces that Nando's devotees crave. In addition to the in-demand peri-peri sauces, Nando's also produces lines of marinades, cooking sauces, and salad dressings.

REASON FOR REDESIGN
The Mediterranean-style salad dressings weren't selling as well as the company had wanted. Internal research showed the packaging for the dressings too closely resembled that of the peri-peri sauces, so the company decided these dressings needed their own look and feel that differentiated them from Nando's sauces.

REDESIGN OBJECTIVES
- Better differentiate Nando's salad dressings from the rest of the manufacturer's line of sauces
- Give the salad dressings a more upscale feel while still incorporating its branded down-to-earth look
- Attract consumers with a promise of excellent taste and an aesthetically pleasing look

THE RESULTS
The redesign was hugely successful, especially in the U.K. market, where sales increased by 40 percent following the redesign, according to Cross Colours.

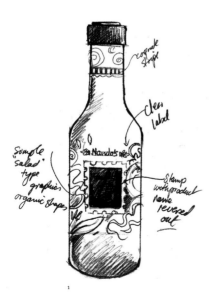

1

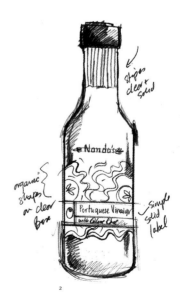

2

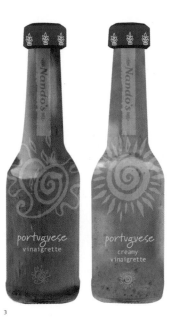

3

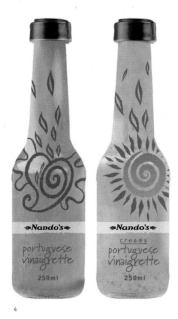

4

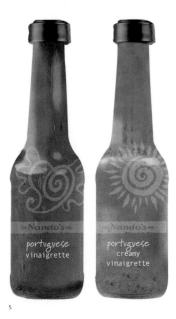

5

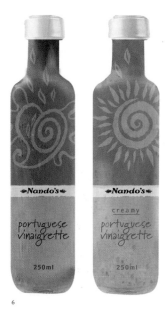

6

1, 2
The designers at Cross Colours set out to create a new salad dressing bottle that retained Nando's casual, earthy look while positioning the brand as more up-market. In initial sketches, they played with illustrations and symbols on the bottle, all the while noting the need for a clean label and the incorporation of Nando's signature stripes.

3, 4
The designers created folksy graphics, which were imprinted on the bottles, and experimented with using the whole bottle as real estate instead of limiting graphics to the centered label, as on the old package.

5, 6
To further set the salad dressings apart from the better-known sauces, Cross Colours experimented with a number of different bottle shapes and adapted the graphics to fit each. Finding the right bottle shape to meet retailers' expectations was perhaps the designers' biggest challenge.

Sir Laurence Olivier,
The Bible—Audio CD Box Set

CLIENT
Liquid 8 Records
DESIGN
Sussner Design Company, Minneapolis, MN
ART DIRECTOR
Derek Sussner

DESIGNER
Brent Gale
MARKET
United States

before

The old packaging for the box set was
dated and unsophisticated, with
cartoonish art and garish colors. To
attract national distributors, the record
company needed a more attractive,
classic package design.

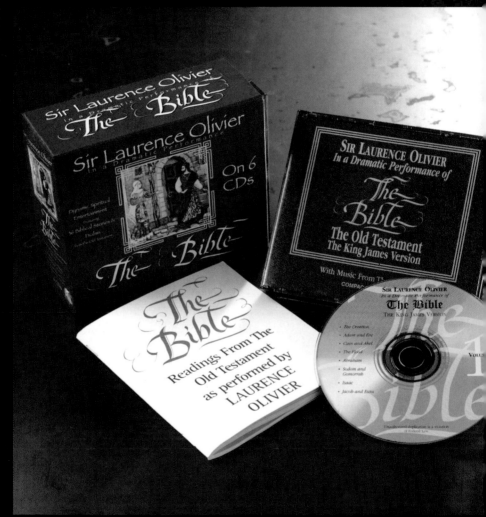

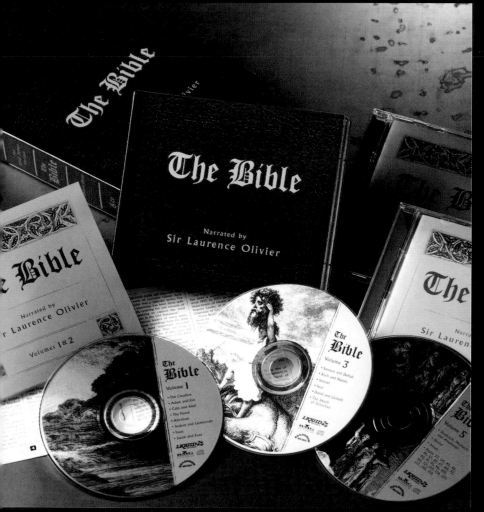

The final box set's design presents a professional and classic, yet still contemporary look for a beloved product, appealing to distributors, such as BMG, who had previously rejected the set.

Sir Laurence Olivier,
The Bible—Audio CD Box Set
Design Process

Liquid 8 Records in Minneapolis, a company that specializes in "budget" products such as tribute albums and greatest hits collections, purchased a number of assets from another company several years ago. One of those assets was a six-CD box set featuring Sir Laurence Olivier reading the Old Testament. Liquid 8's plan was to distribute the collection widely through distributors with national scope.

REASON FOR REDESIGN

Several large distributors turned down the collection, on the grounds that it didn't live up to the standards they set for the products they represented. The packaging had a lot to do with the rejection: it didn't convey the sophisticated image that a nationally marketed product commanded.

Another reason for the redesign was the timing. Liquid 8 acquired the product shortly after September 11, 2001, when Bible sales were soaring. Many people, no matter what their heritage or religion, were looking for guidance. Since the box set included readings from only the Old Testament, Liquid 8 saw this as a perfect opportunity to market to not only Christian consumers, but people of Jewish and other faiths as well.

Finally, the manufacturer wanted more flexibility with how it packaged and sold the CDs—they wanted to explore selling them individually as well as part of the box set.

REDESIGN OBJECTIVES

- Invoke the timelessness of the Bible by combining classic design treatments with modern elements
- Create an inclusive design that reaches out to consumers of all faiths
- Design each jewel case so that it could be marketed individually, if necessary

THE RESULTS

Before the redesign, Liquid 8 had been actively courting BMG as a potential distributor. BMG rejected them and the collection. After Liquid 8 launched the new packaging, however, BMG agreed to a relationship with Liquid 8 and picked up the box set as part of its line, based on the new, more sophisticated offering.

1

2

3

4

5

6

1, 2
Given that Bible sales were on the rise, Sussner Design Company researched the design elements of the old King James Bible to convey the timelessness of the book. They studied the textures and materials as well as the old etchings and type.

3
Through sketches, the designers at Sussner began sketching possibilities for a box and CD covers that, whether sold together or separately, would evoke images of the classic tome.

4, 5
Original directions adopted the more somber look of old Bibles. The design team mocked up minimalist, black, leather-looking covers. Jumping off from the original direction, the Sussner team gave the elements a more contemporary look. The designers incorporated metallic colors that referenced the foil covers often found on old Bibles. At the same time, they stuck close to familiar, traditional treatments, such as two columns of serif type with decorative initial caps.

6
Each CD had its own theme and look, so the record company could sell them individually. Sussner used elaborate stock illustrations showing Old Testament scenes. Principal Derek Sussner says it was particularly challenging to find the less "morbid" depictions of the sometimes graphic Old Testament stories, so the manufacturer could appeal to the widest range of consumers.

Tend Blends

DESIGN
Hornall Anderson Design Works, Seattle, Washington
MARKET
United States

before

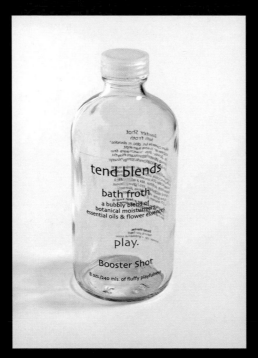

The original bottles used for Tend Blends were simple, with clear labels on clear glass. Although they communicated the natural approach of the bath and beauty products, they appeared homemade and didn't stand out on the shelves. Most important, they failed to communicate a high-end image, which the manufacturer needed to get the products into tony department stores and gift boutiques.

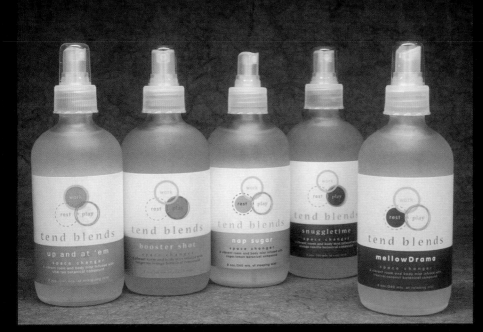

The final packaging system blends an attractive, high-end veneer with a fun, colorful, natural image. Since the relaunch, Tend Blends has increased its popularity in department stores and boutiques.

Tend Blends Design Process

A former beauty editor and gift-boutique owner, Sheena Goldblatt founded Tend Blends as part of a kindergarten project she was working on with her six-year-old son. The company's line of bath and body products are designed for stylish, professional women who have a hard time juggling the three parts of their lives: their careers, their social lives, and their personal time.

 The three Tend Blends lines—Work, Rest, and Play—address each, using special flower essences to "release emotional blocks" and help women switch gears seamlessly. The botanic products are each characterized by fun names such as MellowDrama (designed to let "the drama queen abandon her throne"), Creative Juices, and Nap Sugar.

REASON FOR REDESIGN

The company had already broken into high-end department stores such as Barney's and was positioning itself to expand into the high-end gift market. The bottles the company was using were clear, apothecary bottles with plastic tops and clear labels, suggesting a natural, modern approach but not communicating the true story of the product's wholesome blends, chic approach, and carefree attitude.

REDESIGN OBJECTIVES

- Develop a strong shelf presence using unique, memorable packaging graphics
- Create a cohesive design to help position the product for high-end retail channels
- Distinguish between the three lines: Work, Rest, and Play

THE RESULTS

The redesign has successfully invigorated Tend Blends' retail presence at high-end boutiques and department stores. Since the launch, sales have increased and the brand's distribution network has expanded.

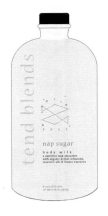

3

4

5

6

7

1, 2
Creative firm Hornall Anderson Design Works began by learning about Tend Blends' vision and personality—which mirrored those of its sassy, fashion-savvy founder. Designers began exploring ways to depict the playful chic of the company and its products.

3
In early comps, designers explored ways to distinguish between the three lines of products (Work, Rest, and Play) while unifying the products as a whole and infusing the brand's dedication to natural lifestyles and stylish fun. In this comp, abstract line drawings embody different lifestyle concepts.

4, 5
Designers also experimented with ways to use the letters of the three different words to vary the lines. In one comp, first letters of the words and their mischievous shadows stand alone, whereas in another, the letters of the four-letter words are stacked like colorful building blocks.

6
Invoking an earthier approach, this comp uses a face reminiscent of tribal masks to depict the emotional needs of the women using the product line.

7
The selected direction uses interlocking circles with the three buzzwords on each bottle—coloring in the featured product line with a color unique to the particular product.

The original packaging for Barr's solvents emphasized the chemical makeup of the product rather than the job for which it was meant to be used. As more DIYers began shopping the category, however, the manufacturer realized the packaging needed to be more user friendly.

Although at first glance the redesigned packages for the three products lines look different from one another, the use of a standard template, a second-level color-coding system, and common images tie the Klean-Strip and Citri-Strip lines together. The packaging for the Klean-Strip thinners line also subtly picks up the same layout as that of the strippers, but it maintains a different look to differentiate between the products' purposes. The careful combination of individuality and continuity make shopping the different lines of products much easier for both the DIYer and professional.

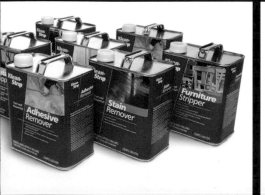

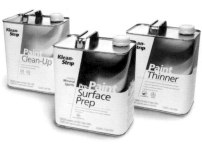

W. M. Barr Design Process

W. M. Barr is a Memphis-based manufacturer that specializes in home-improvement and automotive products—paint thinners, strippers, solvents, and specialty cleaners. The home products in particular comprise a comprehensive line that gives DIYers and professionals all the solutions needed to refinish furniture as well as interior and exterior surfaces.

Barr's products accomplish many different tasks and span two sub-brands, Klean-Strip and Citri-Strip. Because each product has a specific use with its own chemical formula, organizing the product lines was becoming especially complex.

REASON FOR REDESIGN

The previous packaging prominently featured the chemical makeup of each product as the distinguishing factor. However, as the home-improvement consumer changed from the professional contractor to the DIYer and wood-working hobbyist, the product was becoming increasingly harder to shop. The packaging didn't clearly state what each product was for or how to use it, and no visual differentiation existed between the various solvents.

REDESIGN OBJECTIVES

- Create easy-to-understand packaging that emphasizes the solvent's intended job instead of its chemical formula
- Capture the attention of DIY consumers, who in market research exhibited barely any brand loyalty or awareness
- Design packaging lines that are different from one another, making them task oriented

THE RESULTS

The new packaging reached consumers and made the total product line easy to understand, raising the bar for the home-improvement solvents category. The company also used the insight it gained during the thinners and strippers projects to reposition a number of other products, including solvents, which they ultimately redesigned the packaging for as well.

1

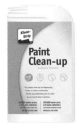
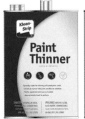

2

3

4

1–3
Proteus Design explored concepts for paint thinner packages with prominently displayed, descriptive product names and a color classification system.

4, 5
The stripper packages required a slightly different approach—they had to be grouped into family units, so that a color code encompassed several products instead of one.

6
The new logos needed to tie the brands together into a single family of Barr products.

5

6

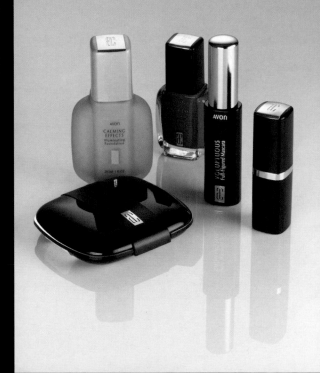

...n Color line in the late '90s
...vn AC logo stamped on the
...ottles. The cosmetics were
...ditional looking, with gold
...nd rectangular shapes with
rounded corners.

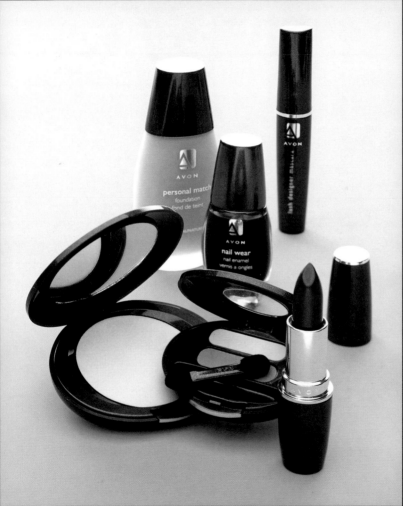

The final new packaging for Avon Color is classy and practical with a touch of sexiness, personifying the modern woman consumer.

Avon Design Process

A global company with a universally known brand, Avon is different from many corporate institutions of its caliber simply in the way it has grown: by the dedication and enthusiasm of the millions of women who for decades have sold the products door to door. The company has empowered millions of working women but also has offered housewives a way to easily buy their beauty products from the convenience of their home—a novel concept.

Avon's overall business model is the same today as when it was first conceived in 1886, but the company has evolved with the times to continue to thrive. In the 1990s, Avon saw the need to bring the company into the Internet age, especially as more women consumers were working outside the home. In addition, Avon, which markets its products in more than 140 countries, recognized it could strengthen its brand by moving away from disparate, regionally focused products and toward internationally aligned products and brands. When Andrea Jung, the woman who would eventually take over as CEO, became head of marketing, she consolidated all the lines into large international brands that the company could stand behind.

REASON FOR REDESIGN

As part of this realignment in the late 1990s, Jung ordered a complete package redesign for all of the consolidated brands. Avon was moving into Internet sales, and more than ever, the packaging needed to compete with highbrow designer lines on the market. The company set out to reshape Avon into a world-class beauty brand, so exquisite, modern packaging was an important part of that.

Since its initial redesign, Avon refreshes the brands every three to four years to bring perpetual newness and energy to the customer. The newness concept keeps consumers intrigued and sales representatives excited—two key ingredients for the company's success. "A good deal of the brand's growth comes from redesigns and reformulations," says Kathy Kordowski, vice president of global package development.

REDESIGN OBJECTIVES

- Update and evolve packaging to regularly give sales representatives something new to promote, creating excitement and ultimately increasing sales and market share
- Adhere to global design specifications established for each packaging system, adjusting the specs based on current packaging technology, materials available for each region, and cost
- Consider the needs and input of Avon divisions worldwide to produce a packaging system that will be successful in a variety of cultures and locales

THE RESULTS

"The results to date are very good," says Kordowski. "We have been experiencing strong sales increases globally for the redesigned brands. We feel there is continued opportunity to delight our customers as we continue to update and evolve our packaging."

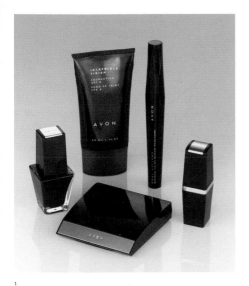

1

2

1
The company redesigned all of its packaging to consolidate the different brands into a single brand, using only the Avon name and a single logo. In this new design, the Avon Color line broke away from the mold with unexpected angular shapes, a spare typeface, and a metallic blue-black color with platinum accents.

2
To keep things fresh and exciting for sales reps and customers, Avon improved on the Avon Color line in 2004. The in-house packaging design team, choosing to add modern curves back into the mix, created clay models as a framework for the shape and style of the new packaging.

3
The design team then rendered the clean, feminine graphics and added the touches—rounded compact palette trays, hints of metallic, and contemporary all-lowercase type—that complemented the package shapes.

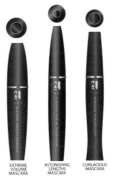

ULTRA COLOR RICH
FULL SIZE LIPSTICK

MY LIP MIRACLE
TRIMLINE LIPCOLOR

NAILWEAR
NAIL ENAMEL

EXTREME
VOLUME
MASCARA

ASTONISHING
LENGTHS
MASCARA

CURLACIOUS
MASCARA

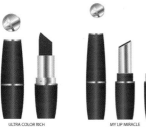

EYESHADOW QUAD COMPACT

EYESHADOW DUO COMPACT

POWDER BLUSH COMPACT

LIQUID
FOUNDATION/BOTTLE

LIQUID
FOUNDATION/TOTTLE

LOOSE FACE POWDER

3

The Barbie packaging hadn't been significantly updated since the 1970s. The bubbly logo and graphics were dated and not keeping up with modern fashion, especially compared to standards of design that contemporary girls were used to seeing in clothing and toys.

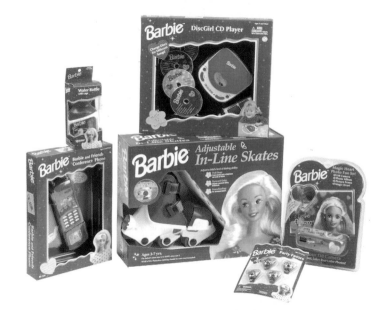

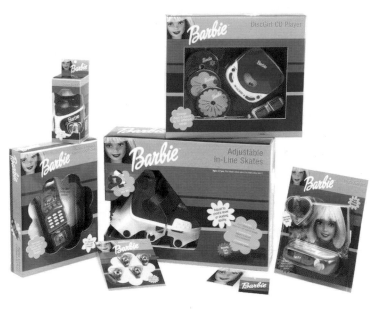

The feminine, pretty, modern redesign was rolled out for all packaging and retail fixtures, including bags.

Barbie Design Process

Mattel, the toy manufacturer that makes Barbie, calls its shapely blond sweetheart "the most collectible doll in the world." Since the 1960s, Barbie has done it all, representing just about every career, culture, and celebrity status imaginable. This ambitious doll and her circle of family and friends make up one of the most successful brands in the world. The hot pink color that identifies Barbie doll and accessories boxes is instantly recognizable to most consumers, no matter where the market. Focus groups and studies reveal that in its forty years on the market, Barbie has achieved 100 percent awareness with its target market—three- to twelve-year-old girls and their mothers.

REASON FOR REDESIGN

Barbie's packaging hadn't been redesigned since the 1970s. Although "Barbie pink" was still undeniably powerful with consumers, competitors were beginning to create their own pink packaging to establish an association with the popular brand. Research showed that Mattel's Barbie had established a deeply emotional connection with generations of girls. However, Barbie started her life as a fashion plate—a doll whose clothing, cars, houses, and pursuits reflected the times. As she approached her 40th anniversary, it simply would not do that the Barbie packaging still looked thirty years old. Mattel's branding team, Parham Santana, established a brand statement—"Barbie keeps pace with the times"—around which the millennium-timed redesign was focused.

REDESIGN OBJECTIVES

- Reposition the brand for growth, presenting a contemporary new image and capitalizing on the doll's 40th anniversary
- Define a more consistent and iconic use of the Barbie image and leverage the equity of the Barbie pink
- Reflect girls' intimate relationship with the brand and its characters

THE RESULTS

Retailers and consumers alike adored the new Barbie. "It's the best she's looked in years," one retail buyer said. At FAO Schwarz's flagship store on Fifth Avenue in New York City, the new packaging and merchandising in the new Barbie Experience section alone boosted a double-digit increase in sales.

1

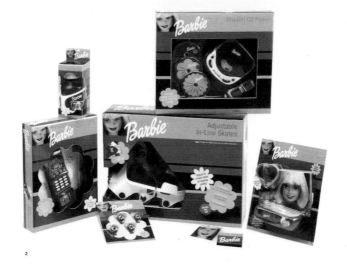

2

3

4

5

6

1
In early stages of the redesign, designers explored a series of striped patterns.

2
The final stripe pattern that Mattel selected and tested with focus groups was a pretty, modern motif that reflected the revised goal of the Barbie brand, to keep pace with fashion.

3
The Barbie logo changed from the original bubbly type to a cute, but refined, script designed to appeal to a range of ages and to modern mothers.

4,5
The company rolled out the final packaging for thousands of products in 150 countries and adapted it for point-of-purchase, merchandising, and store fixtures. The international rollout took nearly one year to complete.

6
Parham Santana also created comprehensive style guides to help licensing partners and retailers around the world adhere to the newly created standards.

Lionel Trains, founded in 1900, enjoyed a golden age in the 1940s and early 1950s. The trains' packaging then featured clean, Art Deco–inspired type and handsome blocks of color that characterized the model trains' visual brand. The style carried through all of the company's packaging and its logo.

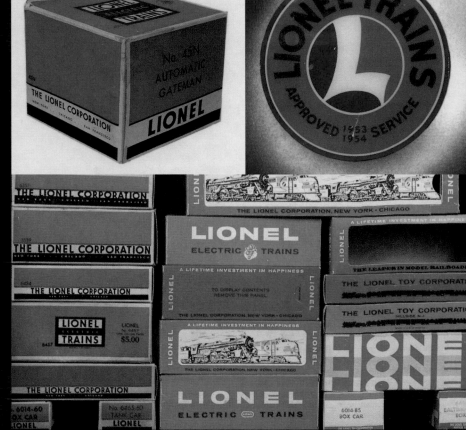

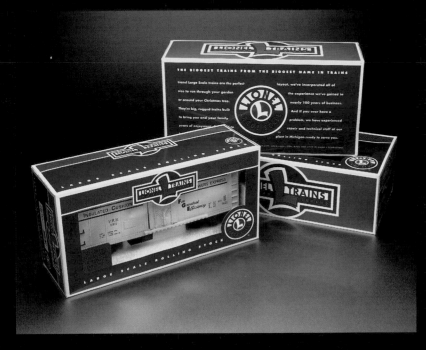

The final packaging revived the same bold, classy look of Lionel's glory days, with a sleek, modern edge.

Lionel Design Process

The story of Lionel, the century-old manufacturer of America's most treasured model trains, is one as rocky and astounding as the American twentieth century itself. Founded in 1903, the little company in a cramped office in New York City turned out the first B&O No. 5 electric locomotive. A few years later, Lionel invented the preassembled toy train track, steam locomotives, and a selection of cars powered by 110-volt electric transformers, giving birth to the concept of the model train that we know today.

After that first momentous decade, the company rode the waves of prosperity, depression, and war. It also survived the demise of the railroad and held its own against the competing boyhood fascination with space-themed toys and, later, video games. The founder sold the company in the late 1950s, around the time that trains' former glory was fading. The company declared bankruptcy, then licensed its manufacturing to food company General Mills, which later outsourced the manufacturing to Mexico. Two years later, the manufacturing returned to its home base in Michigan, but the company changed hands again in 1995.

Despite what was going on within the company, Lionel continued to innovate: introducing and improving upon classics that, although not as in demand for youngsters, captured the imagination and loyalty of hundreds of thousands of adult collectors around the world.

REASON FOR REDESIGN

All these changes left the company and its visual brand in shambles. Trademarks, package designs, catalogs, and other printed collateral were piecemeal and rarely recalled the company's "visual equity or heritage." This was a must for a product like Lionel—especially considering the tireless attention to aesthetic detail in the product design over the years. As a result, formerly loyal customers saw the product quality as deteriorating because they no longer related to the brand visuals.

Lionel's creative firm One Zero Charlie embarked on a sweeping brand restoration project for Lionel. Instead of depending on market research and focus groups (which the client and designers saw as the source of so many intermittent and off-target changes over the years), the designers relied on the intuition and vision of the company's new, strong leadership—including rock star Neil Young, the company's co-owner.

"Neil, with no MBA degree, marketing, or business background, needless to say, was not inclined to follow traditional thinking," says One Zero Charlie's creative director Michael Stanard. "His strong personality, combined with our firm's intuitive feel for the Lionel heritage, carried the day. In brief, we just rocked."

REDESIGN OBJECTIVES

- Refresh and restore the Lionel brand to elevate the company and its products to their former glory
- Explore cost savings in the structural packaging production
- Address the pervasive problem of product returns due to damaged packaging

THE RESULTS

The packaging's new look eloquently narrates Lionel's rich history of innovative design. At the same time, it changed the assembly-line production, which resulted in substantial cost savings. And the train sets' physical packaging better protects the product, leading to fewer product returns and happier retailers.

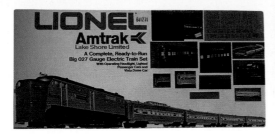

1

2

3

4

5

6

7

1, 2
By the 1970s, sadly, Lionel's original look had all but eroded. Occasionally, a box included an allusion to the old logo (2, from 1989). However, every box was different—packaging for different trains used their own permutations of a logo—and background colors and images varied wildly.

3–5
When One Zero Charlie took on the Lionel project, they set out to restore Lionel's visual brand. Along the way, they established a hierarchy of logos, referring to the most important pieces of the constantly evolving logos through the years. Ultimately, the merit badge logo (4), the one closest to Lionel's 1950s design, became the brand's primary emblem.

6, 7
Other, secondary logos were then created for special product series.

8
One challenge the One Zero Charlie and Lionel teams faced was making the packaging sturdier, because one of retailers' biggest complaints was the number of returns due to product damage.

HANDLE OPENING

VELCRO LOCKS

SHRINK WRAP
FOAM TRAY ONLY

CORRUGATED
PRINTED 1 SIDE

8

Secrets of
Success

PRESERVE EXISTING BRAND EQUITIES

When a manufacturer decides its venerable brand needs a makeover, designers must walk a fine line between an effective, contemporary design and an unsettling makeover that confuses or turns off faithful consumers.

"DON'T MESS IT UP!"
That's the mantra of Michael Osborne, principal of Michael Osborne Design, when his team approaches modernizing makeovers of well-known brands. "We start every project by discovering what the equity items are— what needs to be retained, and how much room is there for change," Osborne says.

Consumers have an emotional history with a package, no matter how old and dusty the product is. Realistically evaluating what consumers still relate to—and what isn't pushing the brand forward, even if it appeals nostalgically to consumers—helps you decide what to build from in the new iteration. In the case of outdated packaging, companies typically decide on a more evolutionary approach to keep a brand fresh but familiar.

SET EXPECTATIONS ABOUT RESULTS EARLY ON
Experts say it's unrealistic to expect dramatic sales increases due to packaging redesigns, especially projects meant to refresh a brand and keep it contemporary. While most clients might realize that from the get-go, it's a designer's responsibility to make sure clients' desired outcomes of redesign projects are realistic.

Postredesign research might show improved consumer perception or product visibility even if sales don't jump noticeably, says Scott Young, president of Perception Research Services in Fort Lee, New Jersey. Those kinds of results show success for an outdated packaging's redesign—they signify that the refresh helps to keep a product in the forefront of people's minds.

KNOW YOUR DEMOGRAPHICS (NOW, NOT THEN)
Understand that your target consumers are different than they were a generation ago—and depending on the product, even a few years ago seems like a generation— and so is the retail environment in which they're buying the product. Even if it's an exercise that your client conducted only a couple of years ago, and even if the manufacturer insists it knows its customers, it never hurts to step back and study the people the product is for and those shopper's contemporary experiences both in and out of the retail store.

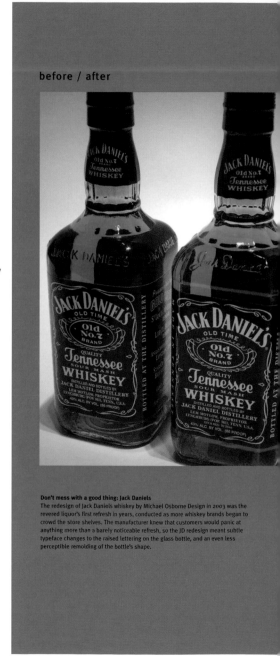

before / after

Don't mess with a good thing: Jack Daniels
The redesign of Jack Daniels whiskey by Michael Osborne Design in 2003 was the revered liquor's first refresh in years, conducted as more whiskey brands began to crowd the store shelves. The manufacturer knew that customers would panic at anything more than a barely noticeable refresh, so the JD redesign meant subtle typeface changes to the raised lettering on the glass bottle, and an even less perceptible remolding of the bottle's shape.

before

after

Brand equity is king: Carlos V
Nestlé Mexico's Carlos V candy bar had been on the market since 1955, and many
adults with children and grandchildren of their own knew the brand well. The candy's
brown wrapper, with a stripe of red tying it to the Nestlé brand, featured an old-fashioned
illustration of a stodgy king. After market research showed adults saw the brand as
tired, Nestlé asked creative firm TD2 to investigate "killing the king" and mimicking
imported brands. Instead, TD2 defended the king—the packaging's distinguishing
feature—and rethought the target audience: kids, not adults. Redrawn into a dashing,
Disney-style character, the Carlos V king, along with the other new design details, sent
sales soaring by 30 percent.

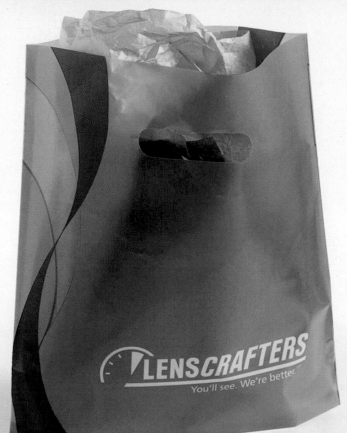

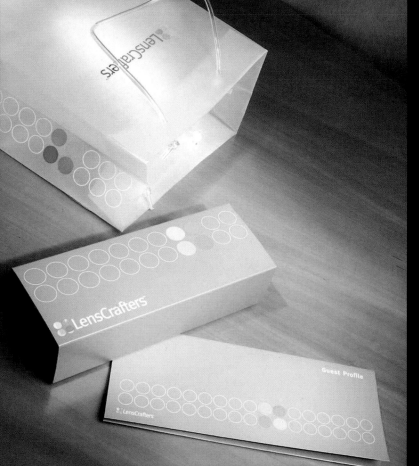

The end packaging kept the combination of positive and negative circles as its design motif. The colorful box sliding into the white bag work together to communicate a unified brand personality, and also makes the unwrapping of the glasses more of a "nested" discovery process.

LensCrafters Design Process

LensCrafters is the largest optical retail chain in the world, with more than 850 stores across the United States and Canada. A subsidiary of the Italian optical luxury group Luxottica, owner of brands as diverse as Versace, Ray Ban, and Sunglass Hut, LensCrafters achieved success by consolidating all aspects of shopping for eyewear or contact lenses into a single package. Customers can get their eyes examined by an optometrist, consult with an optician, and choose fashion-forward frames in a single place. But the chain's true success came from its well-known brand positioning that prevailed throughout the company's early years: a place to get quality eyeglasses made onsite in about an hour.

REASON FOR REDESIGN

Over the years, however, many of LensCrafters' competitors could also make the one-hour claim. The chain wanted to move away from being simply a clinic and laboratory to becoming a showroom—a place offering ongoing optical care, but also a place where customers could come to shop for eyeglasses as an accessory rather than a necessity. To help recreate its image, LensCrafters commissioned Chute Gerdeman to rethink its brand, including its packaging design.

The existing packaging consisted of little more than a two-color polybag, a mall-store shopping bag meant to hold manufacturers' cases customers received with their new glasses. The new packaging would create more of a fluid brand experience.

REDESIGN OBJECTIVES

- Create new packaging structures to better immerse products in LensCrafters branding
- Design a youthful, fun feeling to appeal to a broad demographic
- Build a brand personality to remind customers that purchasing eyeglasses is less of a medical need, and more of a personal statement

THE RESULTS

At press time, LensCrafters had released the new packaging design in select markets. Based on favorable results, the chain has plans to roll out the new design nationwide.

1

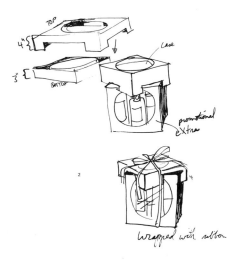

2

1, 2
The designers set out to create innovative new structures as well as new graphic treatments. Here, a "platform" box includes a two-part top that holds glasses and a case, and could be combined with a promotional item to create a presentation bundle.

3, 4
The idea for the "stapler" box involved a box that fully opens to display glasses with the brand case—a way to surround manufacturer-branded products with the LensCrafter brand.

5, 6
A "bowling bag" packaging idea conceptualized a shelf to hold the glasses and their case, which would then slide into a sleeve to act like a carrying case.

7, 8
Picking up elements of the new LensCrafter logo, four multicolored dots, these bag concepts used bright colors, circular shapes, and young, funky photographs that represented fashionable shoppers.

Schroeder's milk cartons had remained unchanged since the 1970s, when the company targeted primarily the price-point convenience store market. Sporting stale colors and outdated graphics, the milk cartons still suggested an aging, unsophisticated small business. In fact, Schroeder had an impressive story of innovation and technological expertise that no consumer could infer from its musty shelf presence. Also, no consistent architecture existed from variety to variety.

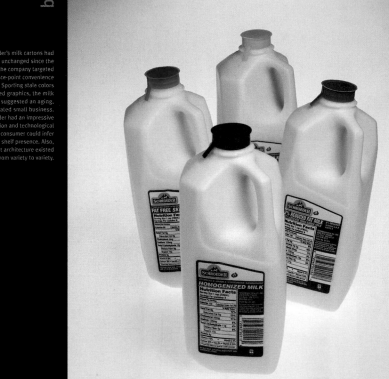

The packaging became an important part of subsequent marketing and advertising efforts, replicating the sayings and rotated type.

Schroeder Milk Design Process

Running to the corner store for a carton of milk late at night usually doesn't involve a lot of thought: You reach for the first half-gallon you see, perhaps drifting toward the carton whose color or old-fashioned script seems most familiar.

Schroeder Milk wanted to change all that. In the early 1990s, the Minnesota-based, family-owned dairy, in business for 118 years, still packaged their dairy-case staples in cartons designed in the 1970s, when the company was marketing heavily to regional convenience stores. The brand that emerged did little to promote the tradition of innovation, technology, and quality on which the company prided itself.

REASON FOR REDESIGN

When Jill Schroeder became brand manager in 1993, she identified opportunities to expand into the high-end grocery market by reinventing the brand's retail image. Making the attributes of the company—and the product—inherent in the packaging design was key to this initiative.

Another consideration was a practical one: The company wanted to protect the milk from light and the depletion of vitamins, minerals, and flavor, as well as cater to the needs of busy families with a package that was resealable and portable. New plastic containers were part of the company's drive to bring Schroeder Milk into the twenty-first century.

REDESIGN OBJECTIVES

- Communicate brand attributes—technological innovation and top quality—on the package
- Create a fun design that was much different than anything else happening in dairy, to emphasize the uniqueness of the Schroeder product
- Add an element of fun that made a powerful personality statement by differentiating Schroeder's from other dairy brands
- Create a new packaging system for easier identification of the brand and its varieties, for an overall more functional container

THE RESULTS

Since the initial launch, Schroeder has reported a 12 percent increase in overall sales, and sales of the company's new on-the-go compact pints have grown by 30 percent. In addition to winning important new accounts representing premium grocers, Schroeder and its creative firm Bamboo received prestigious nods from the design community, including awards from *ID* magazine, IDFA, the Beverage Packaging Global Design Awards, and the London International Design Awards.

1

2

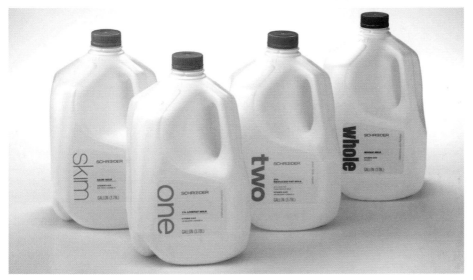

3

4

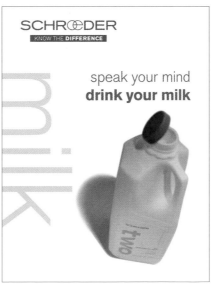

5

1
Schroeder and its creative firm, Bamboo, decided to defy the rules and go far beyond a simple face-lift. The company wanted to completely rebrand itself, primarily by exploring a look for its logo and packaging that was unlike anything else in the dairy case. Bamboo studied dairy packaging from all over the world and discovered that images of cows and farms were almost without fail the adopted symbols of dairy, like the Schroeder logo itself.

2
The designers took a 180-degree approach, eliminating Schroeder's old, rural farmhouse identity. Instead, they explored a clean, modern wordmark that stood out as distinctive and memorable.

3
As part of the initiative, Schroeder decided to switch to an opaque white plastic container to preserve freshness. The final design approach, chosen by Schroeder and strongly recommended by Bamboo, made the white a prominent part of the design, symbolizing a purity and simplicity that wordlessly summed up the product inside.

4
Creating a crystal-clear classification, the designers spelled out the varieties (1%, 2%, skim, and whole) in bright, friendly colors and set them on their sides with matching lids. The words are easy to read yet still unique in their placement and color. Compared to the original packaging, the company's name is also more prominent.

5
Consumers can locate the milk—no matter what size or variety they want— right away. Compared to agricultural-minded competitors in cardboard cartons, the Schroeder containers are bold and different. Even on in-store banners, funny sayings jab at consumers' milk-buying "personality" preferences.

Van Cleef & Arpel's Tsar, though a distinguished men's fragrance, paled next to its more modern competitors when it came to its packaging. The bottle still retained hints of an '80s-style design—marbled green box, musty gold and green accents, and lightly printed type—which reduced the bottle's impact by modern standards.

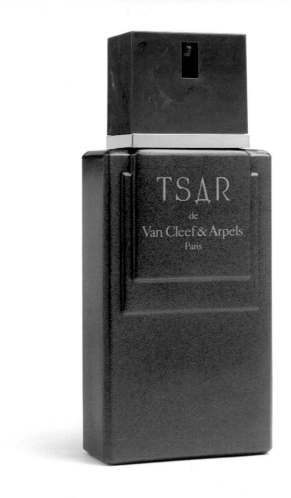

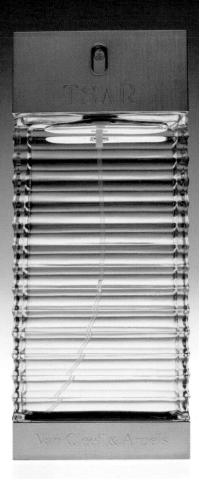

The final packag[e]
between engrav[e]
and masculine.

Tsar Design Process

Luxury goods purveyor Van Cleef & Arpels has sold Tsar, a sporty men's fragrance with hints of pineapple, thyme, lavender, and patchouli, since 1998. With the powerful Van Cleef name behind it, Tsar stands among the higher-end designer fragrances on the market.

REASON FOR REDESIGN

The packaging, both the box and bottle, were nondescript. The plain box with lightly printed lettering was dated and did nothing to help the product stand out among the dozens of other designer fragrances available for men, let alone define the product as a leader in modern luxury. Van Cleef & Arpels approached creative firm Curiosity Inc. to find a way to express the product's timelessness while still communicating modernity.

REDESIGN OBJECTIVES

- Strengthen the product image as top quality
- Reinforce Tsar's originality and modernity while conveying its timelessness
- Create a quality package that would be rich in texture while keeping the materials simple enough to keep costs down

THE RESULTS

Consumer magazines dubbed Tsar a "modern classic" following the 2002 packaging redesign.

1

2

1, 2
Creative firm Curiosity Inc. aimed to build a bottle that applied Tsar's existing brand assets (namely, the color green) with a design rich in texture and dimension. They presented a number of concepts based on the use of transparent green glass. In this concept, the bottle bursts outward in a complex, multidimensional structure.

3, 4
Another concept involved three units linked together, with the bottle pump supported by two bold legs of green glass.

5, 6
In its final concept, Curiosity explored the idea of using wavy glass for a uniquely textured bottle. The client pursued this idea, sending the designers on a mission to explore the most cost efficient and successful way to execute this highly specialized technique. Curiosity's biggest challenges lay in researching how the rippled glass would ultimately look on the store shelves, as well as making sure the green color was consistent across the surface of the bottle.

7
Lined up together, the bottles make an impressive cavalry of distinguished light and color.

3

4

5

6

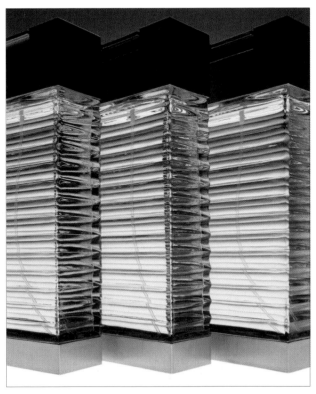

7

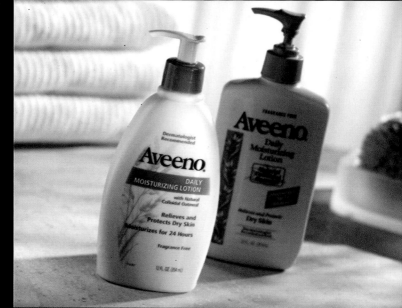

...eeno packaging
...ext to the newly
...g lotion bottle)
...d a surprisingly
...rigid angularity.
...retail stores to
...e-label product
...e product's look
...ced competing
...reas Johnson &
...elevate Aveeno
...-end category.

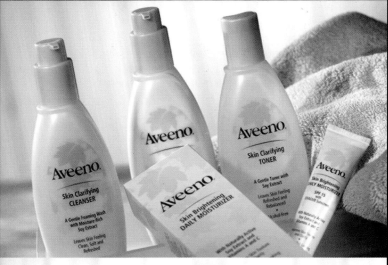

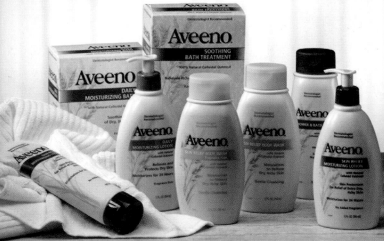

The final packaging went a long way
to shake up the skin- and face-care
categories in Aveeno's price range—
a unique, memorable shape and a b
logo that still makes an impression
natural softness and class.

Aveeno Design Process

Over many years, Aveeno became a household name when generations of kids slathered on the lotion to ease itching from chicken pox. The formula of natural colloidal oatmeal was a soothing, anti-itch remedy approved by medical professionals and appreciated by mothers.

The product had long been owned by S. C. Johnson, which had kept the product virtually the same. When Johnson & Johnson bought the Aveeno line in 1999, the company realized it was sitting on a gold mine: a line of products that spanned the categories in a drugstore and represented tremendous consumer recognition and untapped potential.

REASON FOR REDESIGN

Johnson & Johnson saw the opportunity to relaunch Aveeno as a higher-end natural skin-care line, sliding neatly into a niche that was different than products like Johnson & Johnson's Neutrogena line. Realizing that Aveeno had practically become a generic product in the marketplace, the manufacturer and creative firm LMS latched onto the concept of "active natural" for Aveeno and set out to built a brand worthy of higher retail prices in the drugstore skin-care category.

REDESIGN OBJECTIVES

- Relaunch Aveeno as a higher-end natural skin-care brand, leveraging the product's existing reputation and consumer familiarity
- Create an ownable bottle structure that felt feminine and set Aveeno apart from other products
- Stay several steps ahead of the drugstore private brands, making a large enough departure from the existing product that the generic competitors would have a hard time mimicking the new look

THE RESULTS

According to Johnson & Johnson's financial results, their consumer products division sales have enjoyed strong growth, fueled strongly in part by its skin care line, of which Aveeno is one of the three major brands. The company has stood behind the line with new product launches and promotions.

1

2

3

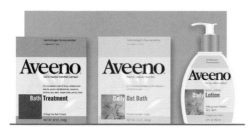

4

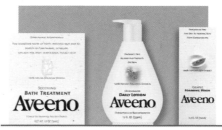

5

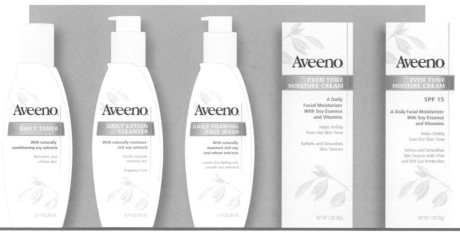

6

7

8

1–3
One of the first ways that LMS Design combined the dual needs of a proprietary design and a more stylized approach was to investigate a different bottle design. Bottles with sleek curves and rounded edges not only would help Aveeno stand out from the competition but offered a softer design to appeal to the product's female consumers.

4
In the bottle's graphics, the designers wanted to appeal to women but also emphasize Aveeno's natural ingredients— the brand's major selling point for decades.

5, 6
Speckled, oatmeal-colored designs were another attempt to refer to Aveeno's long history as a trusted, oatmeal-based anti-itch remedy. Simple, pretty graphics added a distinctly feminine touch.

7, 8
The design direction that the client finally chose involved a more sophisticated approach that still incorporated natural images. The designers then applied that approach to the Aveeno skin-care line packaging.

Clearly Canadian

DESIGN
Karacters Design Group, Vancouver,
British Columbia, Canada
LEAD DESIGNER AND ASSOCIATE CREATIVE DIRECTOR
Matthew Clark
CREATIVE DIRECTOR
Maria Kennedy
PATTERN DESIGNERS
Michelle Melenchuk, Roy White, Jeff Harrison,
Nancy Wu, Marsha Kupsch, Kara Bohl, Ken Therrien,
Matthew Clark

PROJECT MANAGER
Brynn Wanstall
SENIOR PRODUCER
John Ziros
COMPUTER PRODUCTION
Lisa Good and Peter Hall
PRINTER
Seallt, Inc
MARKET
North America

before

The original design of Clearly
Canadian's bottles was the freshest
thing on the beverage market when it
came out in 1988 — it was a breath of
fresh air next to its competition, which
was mostly nationally branded colas.
A minimal redesign by Karacters in
1995 attempted to improve some
functional attributes (deeper-blue
bottle, more visible type, more dramatic
fruit images) to help the brand
stand out on the shelf. But four years
later, this phenomenon of alternative
beverages was lagging behind
newcomers to the category. The
manufacturer needed to rethink its
presentation for an increasingly fickle,
fashion-conscious consumer,
prompting a 1999 redesign.

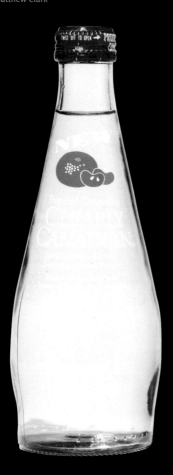
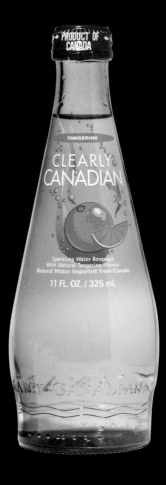

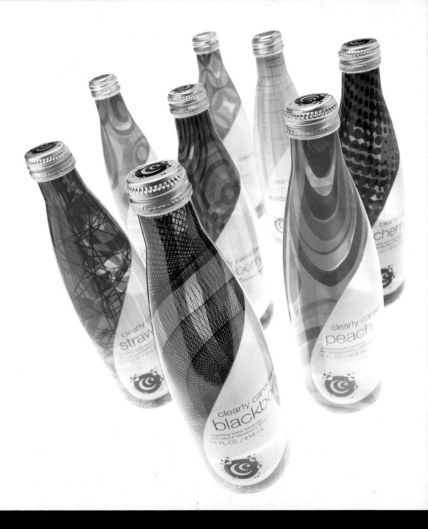

The 2002 relaunch picked up where the last design left off, with the same bold colors, and added rich patterns to symboliz the essence of each flavor. "Each pattern is composed of three solid ink colors, laid down like a silk-screen print to create a ric textural quality," explains former Karacters associate creative director Matthew Clark. The brilliant new bottles are promoted as fashion accessories.

Clearly Canadian Design Process

Clearly Canadian, along with emerging brands such as Snapple, led the invention of the alternative beverages category in the late '80s with their colorless, carbonated fruit drinks. The beverage became synonymous with hip, giving stylish consumers an artistic bottle, interesting new flavors, and a health-conscious alternative to sugary sodas. Over the years, the category became extremely crowded, however, as more brands rolled out new juice and tea formulas in outlandish bottles designed to scream from the store shelves.

REASON FOR REDESIGN
By 1999, Clearly Canadian was paling next to the category's young newcomers. Market research showed consumers had grown weary of the brand's bottle shape and no longer saw the blue glass as unique. The audience for this category is famously adventurous (and fickle), and the brand's image wasn't drawing a crowd anymore. What followed is legendary: Karacters Design Group redesigned the brand radically in 1999, winning design accolades and increasing bottle sales after the relaunch from 10 million to 30 million in the first quarter alone.

Clearly Canadian learned its lesson after the first redesign experience, and, in 2002, they returned for a refresh. Realizing that its target consumer approaches beverage selection as a veritable fashion accessory, the company knew it was already time to update.

REDESIGN OBJECTIVES
- Communicate flavor other than with fruit images (which consumers had difficulty accepting)
- Play up the bold flavors and more clearly distinguish different flavors from one another
- Feature Clearly Canadian's unique clear, carbonated formulation
- Create an innovative design that would bowl over fashion- and design-conscious consumers

THE RESULTS
The 2002 refresh gave retail sales a shot in the arm. Retailers overwhelmingly renewed orders and, in some cases, expanded their offerings of the beverage line, and consumer awareness shot up again.

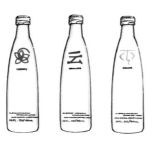

1

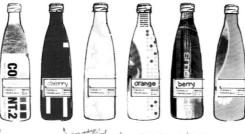

2

EXPERIMENTAL PACKAGING

3

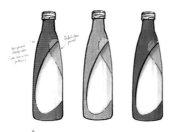

4

5

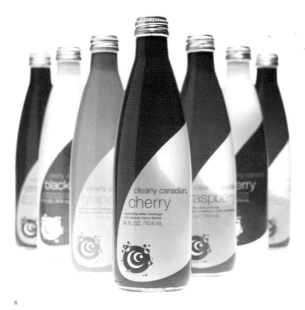

6

7

8

1–3
In 1999, Clearly Canadian teamed up with Karacters Design Group to study a new direction for the bottles. Karacters learned that consumers had tired of the blue-glass bottle (assumed to be a critical feature of the brand). Nothing was sacred as Karacters Design Group set out to explore new treatments for the bottle. They presented Clearly Canadian with a number of different sketches based on current design trends of the time and different positioning concepts, from lucid simplicity to crazy prints.

4, 5
The company latched onto the idea of a bold color identifying the flavor, as an expression of "big taste" instead of literal "fruit." Karacters experimented with a new, modern-looking logo that prominently displays the product name and symbolizes the effervescence of the beverage.

6
The final design that launched in 1999 was as classy and unique as the old bottles had once been. To execute this design, Karacters looked to a shrink-film label, which covered the bottle with a flexible, sculptural look while still offering a frosted window into the bottle so consumers could see the clear liquid inside (an unusual application— shrink film traditionally is used to hide the interior of a bottle). The new design won the company and Karacters a number of prestigious design awards.

7, 8
Only two years later, with a new understanding of its target consumers' evolving tastes, Clearly Canadian returned to Karacters for a refresh. This time, the goal was not to salvage the brand but to help it stay ahead of the pack with a package that was also a piece of art. For this redesign, Karacters returned to some its original, more extreme concepts presented during the first redesign process.

Secrets of Success

You could argue that competition plays a role in any packaging redesign—or a brand project or advertising campaign, for that matter. At the end of the day, it's all about selling more than the other guy, gaining market share, and earning profits. But sometimes, competition is the primary reason for a package redesign: Competitors are crowding the brand out of the market, and it's time for the brand to fight back.

TAKE SEVERAL STRIDES FORWARD

Especially in categories where competing brands adopt a me-too approach, brands need to move far enough ahead with their designs that it's difficult, financially and creatively, for copycats to catch up. Such was the case with Johnson & Johnson's Aveeno. Private-label products in some drug and retail stores were being designed to resemble the old Aveeno bottle.

The resulting redesign is often a substantial departure from the original and often involves discovering a characteristic that is unique to the client.

HOW IS IT DIFFERENT?

In the same vein, many times clients may be challenged with making a clear-cut statement about what makes them different from the other major brands in their category. This exercise can be truly challenging, particularly when only a handful of major players exist in any one space. Companies and their creative teams must make sure all the components are working together—the packaging supporting the advertising, which supports the point-of-purchase materials, and so on—to ensure that statement sticks.

SooHoo Designers, for instance, worked to establish Epson as the digital imaging champion with the brand's system of colorful, image-driven packaging.

SHAKE UP THE CATEGORY

One way to generate excitement is to set the bar higher than ever within a category by doing something very different. This is not to say that designers should select an outlandish or faddish design that will pale once the sizzle wears off; rather, they should reevaluate the established standards for packaging in their product's realm.

before

after

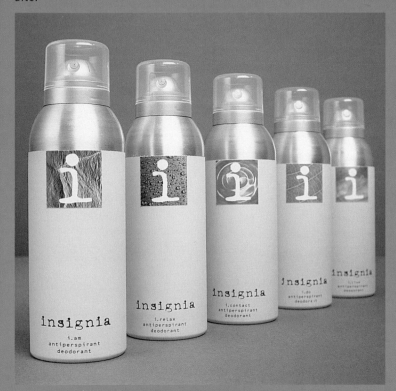

The applicator bottle for Insignia deodorant, marketed in the United Kingdom, was old and tired looking. The competition for the brand used hard, dark graphics and colors, so the designers at Lippa Pearce Design tried a completely different approach to help the deodorant cut through the noise. Lippa Pearce applied natural, abstract images and an idiosyncratic *i* for a young, quirky look aimed at sixteen-to-twenty-five-year-old males. The new package was a big hit in the U.K. market.

The previous Lipovitan can had a lot going on: differently shaped graphics of mechanical cogs, an array of icons, and product information presented somewhat haphazardly round the can. The drink's packaging didn't seem to be appealing to the manufacturer's target demographic in the European market: twenty-five to forty-four-year-old health-conscious consumers, especially in the United Kingdom.

LIPOVITAN

The sleek, blue Lipovitan Vitality can presents a sense of youthful energy but with a pureness and serenity that appeals to people who like to treat their bodies well.

LIPOVITAN

Lipovitan Design Process

Lipovitan is an energy health drink by Japan's largest over-the-counter pharmaceutical company, Taisho. The brand has been on the market since the 1960s, though with many different formulations, and was the first beverage of its kind—a natural health and energy drink.

A couple of years ago, the company conducted widespread market research and determined an opportunity for a natural energy drink for the twenty-five to forty-five demographic, especially in the U.K. and European markets. In 2003, Taisho relaunched the beverage as Lipovitan Vitality, a drink containing almost the total recommended daily allowance of vitamins B1, B2, B3, and B6, plus herbal ingredients such as royal jelly and ginseng, but less caffeine and sugar than competitors such as Red Bull and Lucozade.

REASON FOR REDESIGN

Lipovitan's old can was outdated and somewhat unremarkable, with a confusing hierarchy, muddy colors, and graphics to which European consumers didn't seem to relate. The manufacturer wanted Lipovitan to stand out as a friendly, natural, modern energy drink that promoted overall well-being, hoping this image would help the drink gain ground over competing brands that took a more aggressive approach.

REDESIGN OBJECTIVES

- Increase consumer product awareness at the point of purchase
- Redefine positioning in a way that would be understandable and appealing to consumers
- Ultimately boost Lipovitan to the number two slot in the energy drink category, after Red Bull

THE RESULTS

The manufacturer backed the new launch with a great deal of advertising, and the new brand and its package earned substantial press coverage, earning Lipovitan increased market share.

LIPOVITAN

1

LIPOVITAN
VITALITY

LIPOVITAN
VITALITY

2

3

4

5

6

1
Blackburn's Design in London began looking at how Lipovitan's manufacturer could update and improve on the packaging. The first target was the blocky logo, which was too heavy and uninviting for a health drink.

2
Blackburn's devised a lighter, friendlier logo with a distinctive and ownable look—specifically, the raised *V*, which served double duty as a built-in pronunciation guide for consumers not familiar with the brand.

3
The floating cogs on the original package were meant to symbolize the way in which vitamins worked together to fuel the body, as in a machine. But the symbols were confusing. The main cog was actually oval-shaped on the can, whereas real-life cogs are perfectly round. And the smaller cogs floated independent of one another. Blackburn's designers re-created the cogs and locked them together to demonstrate the way the three main vitamins collaborated to release energy.

4
Designers then investigated the best ways to represent the brand using the revitalized cog symbols. Ideas included a simple, modern look; a watercolor allusion to natural ingredients; more literal references to nature with wildlife images in the cogs; and a rendering of old-time strongmen to represent stamina and strength.

5
Inspired by da Vinci, the designers began going down the path of using different forms of the human body. These symbols would be understood internationally, and everyone could relate to them. They also helped convey different emotions and states of mind, which was important for a multitasking energy and health drink.

6
The designers suspended the body forms in varying states of activity within the circular cogs, using pleasant shades of blue for harmony.

Sackets Harbor War of 1812 Ale

DESIGN
Iron Design, Ithaca, New York
MARKET
United States (upstate New York)

The bottles for War of 1812 Ale that had been in circulation since 1999 referred quite literally to the history behind the microbrew's name: a pen-and-ink drawing of a majestic ship inside a ring displaying the brewery's name. A green banner flying beneath the insignia featured the War of 1812 Ale name. Although the design was faithful to the brand name's history, it wasn't helping the regionally focused microbrew compete against better-known New England–branded beers, such as Samuel Adams.

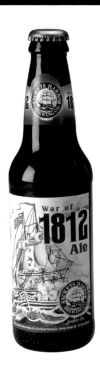

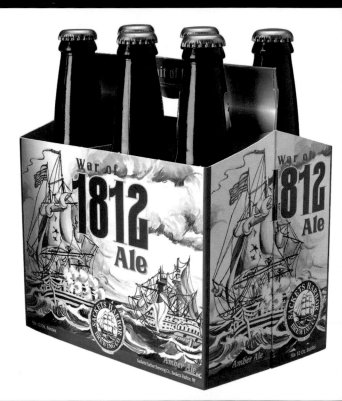

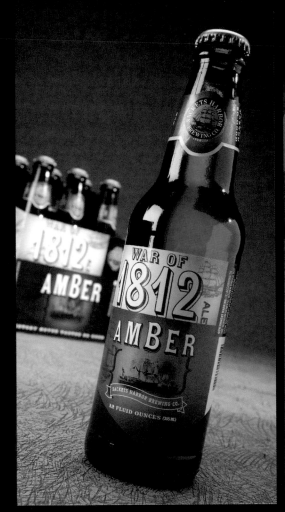

The new bottles, launched in June 2003, reach out to younger beer drinkers who still treasure the heritage of local microbrews. Iron Design also redesigned the tap handle to draw a parallel between the bottles in retail stores and the beer on draught.

Sackets Harbor War of 1812 Ale
Design Process

Sackets Harbor Brewing Company is a local microbrewery in upstate New York. Though the restaurant and pub has been around only since the mid-1990s, word has spread about the beer it brews—War of 1812 Ale—largely because of the pub's location in the touristy Thousand Islands region. After only a year in business, the pub outgrew its onsite brewing facilities and outsourced part of the brewing to companies in Syracuse and Saratoga Springs. And in 1999, the company began selling is nutty malt ale in bottles, while continuing to distribute its kegs so bars throughout New York State can serve the popular beer on draught.

Sales gradually began to climb as the beer joined the ranks of other Northeastern-brewed mainstream brands (Samuel Adams) and microbrews (Honey Brown). While the company grew exponentially, it began to depend on its bottled beer to decide where it was going next. Sackets Harbor established lofty sales goals—93,000 gallons of beer a year, about double what it was currently selling—to justify building a new brewery in the Watertown, New York, area.

REASON FOR REDESIGN

To help meet this goal, Sackets Harbor wanted to refresh its current packaging with a few simple changes, to build a little excitement among its current consumers. However, when it contacted its former design firm, Sackets Harbor learned the vendor had since gone out of business—taking the original files with them.

The company approached Iron Design for help. Together, the creative team and the client realized the situation was a blessing in disguise: It was an unanticipated opportunity to reevaluate the micro-brewer's brand.

The previous label, designed in line with the beer's name, used a historical painting of the Battle of 1812 as its main thematic device and generally appealed to an older demographic of beer enthusiasts. After extensive research, as well as informal market testing of competing beers, the creative team suggested positioning the beer as a contemporary alternative to mainstream competing ales and targeting a slightly younger consumer to meet sales objectives. Therefore, the new label needed to be more contemporary looking while retaining elements of the historic look to reinforce the brand.

REDESIGN OBJECTIVES

- Infuse modern elements into War of 1812 Ale's historic-looking label to appeal to younger consumers
- Strike a balance between a distinctly local microbrew, with nods to New York history, and a beer as appealing to the mainstream as the ale's well-known competitors
- Create a label exciting enough to help Sackets Harbor Brewing sell more bottled beer and, ultimately, achieve its aggressive sales goals

THE RESULTS

Retailers and consumers have been very receptive to the new look. As part of the sell, Iron Design also designed an 1812 Light, scheduled for release soon, companion twelve-packs and cases, as well as redesigned tap handles for the bars that serve War of 1812 Ale on draught, so consumers can establish a visual link between the beer they drink in the bar and the bottles they see on the store shelves.

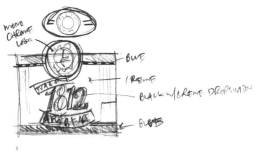

1

2

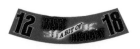

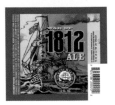

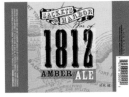

3

4

5

6

7

8

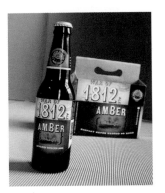

9

1, 2
Designers looked for ways to make the label more contemporary and appealing to younger consumers while still giving the appropriate nod to the established brand, which was grounded in history. Early sketches explore the idea of playing up the "1812"—the most memorable part of the brand's name—while still retaining the historic symbolism, namely the beer's trademark warship.

3
Because the redesign provided an opportunity for Sacketts Harbor to take chances with its brand, designers' early comps ran the gamut from mock-ups that maintained the spirit of the original label to ideas that were a little more daring. This comp ventured only a few steps from the original, playing up the existing label's colonial ship.

4
A second comp used rough, bold letters with gritty static—a masculine, rock-and-roll logo stamped over a less obvious rendering of the ship.

5
Still another comp blended sophisticated type and illustration with a historical feel, capped off by the slogan "Sip a Bit of History" inscribed on the neckband.

6, 7
The client selected this final direction, a layered comp using patterned drop shadows and experimental type.

8, 9
The designers then took this approach and ran with it, rendering bleeding colors, random illustration patterns, and varied type for a label with noise and energy. The bottle brought War of 1812 Ale's origins into the new millennium with the catchy slogan "History never tasted so good."

Somerfield

DESIGN
TAXI Studios, Bristol, United Kingdom
MARKET
United Kingdom

before

An informal study of fresh soup lines at a number of other U.K. supermarkets demonstrated that many were doing similar things graphically. Like the Somerfield soups, they tended to use natural colors and prominent photographs of the soups' ingredients. Somerfield's creative firm, TAXI Studios, resolved to take a different approach to help the private-label fresh soups stand out from the crowd.

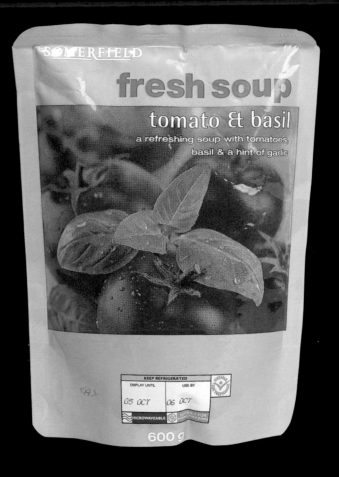

SOMERFIELD

fresh soup

tomato & basil

a refreshing soup with tomatoes, basil & a hint of garlic

KEEP REFRIGERATED
DISPLAY UNTIL · USE BY
05 OCT · 06 OCT
MICROWAVEABLE · SUITABLE FOR HOME FREEZING

600 g

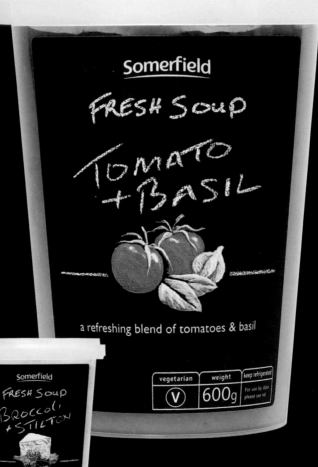

The Somerfield soup cartons that launched were striking, with a shock of white scrawled across a pitch-black label. The whimsical chalkboard-style writing, however, keeps the impression friendly instead of severe. Intricately detailed and colorful illustrations of the soup's ingredients brighten up the package and create an easy-to-decipher system for the many different flavors.

Somerfield Design Process

Somerfield, with nearly 1,300 supermarkets and convenience stores across the United Kingdom, specializes in fresh, organic foods "made easy," offering many reheatable options for busy consumers. One of these offerings is a line of private-label fresh soups in the refrigerated section—easy to heat in the microwave and eat immediately. With flavors such as chicken and vegetable, pea and ham, minestrone, and broccoli and Stilton, the soups promise hearty, healthy meals with a fresh taste and quality ingredients.

REASON FOR REDESIGN

Somerfield's soups competed directly with fresh soups with strong brand names, such as the New Covent Garden Food Co. The company wanted to find a way to boost consumer sales of the soups. Somerfield also needed to find a way to reduce waste. The soup was packaged in plastic bags, which often broke during shipping, wasting a great deal of product and driving up production costs. The bags also became extremely hot when consumers microwaved them, posing safety problems for customers.

Somerfield charged TAXI Studios with rethinking the soup containers. TAXI designers visited a number of prominent U.K. supermarkets to evaluate their fresh soup packages and were surprised to find an unfilled niche. "The conclusion was that everyone was copying each other's designs," says TAXI's Spencer Buck. "No one had understood that there was an opportunity to do something different. So we did."

REDESIGN OBJECTIVES

- Compete directly with major brands of fresh soup packaging by launching a unique new approach
- Create a packaging system to help promote the freshness and quality of the soups, thereby increasing sales
- Transfer the soups to more practical plastic tubs rather than bags to make them safer, more convenient, and more appealing to consumers

THE RESULTS

The supermarket chain rallied behind the newly rebranded soups. Outside of the retail environment, they earned some attention as well—the new packaging won a number of awards, including the London International Advertising Awards, One Show Design, *Adline* Magazine's Cream Award, and the F.A.B. International Food & Beverage Creative Excellence Awards.

1

2

3

4

6

5

7

1
At the same time as the redesign, the designers set out to rethink Somerfield soups' structural packaging, because the bags were inconvenient and ineffective. TAXI proposed plastic tubs or cartons, which would prevent spillage and would be safer when heated. They were also more contemporary and interesting looking than the bags.

2–4
Rather than focusing on the literal meaning of freshness with real photos of products, the designers looked at "fresh" from a different perspective. In initial sketches, they played with the idea of skewed hand-writing displaying the product name and details, with tiny depictions of the soup's ingredients underneath. This was a casual approach that communicated freshness as an attitude more than a physical state.

5
In the next phase, the design became white chalk writing and sketches on a blackboard, giving the design an even more free-form, youthful feeling.

6, 7
Expanding on the blackboard idea, the artists then began incorporating color. Different ideas included detailed drawings of the ingredients rendered in chalk.

directory of contributors >

AdamsMorioka
8484 Wilshire Boulevard, Suite. 600
Beverly Hills, CA 90211
323-966-5990
www.adamsmorioka.com

Addis
2515 Ninth Street
Berkeley, CA 94710
510-704-7500
www.addis.com

Avon
1251 Avenue of the Americas
New York, NY 10105
212-282-7000
www.avoncompany.com

Bamboo
119 North Fourth Street, #503
Minneapolis, MN 55401
612-332-7100
www.bamboo-design.com

Benoit Design
825 18th Street
Plano, TX 75074

Blackburn's Design Consultants
16 Carlisle Street
London W1D 3BT England
44 20 7734 7646
www.blackburnsdesign.com

Blue Q
103 Hawthorne Avenue
Pittsfield, MA 01201
413-442-1600
www.blueq.com

Brandhouse WTS
10A Frederick Close
London W2 2HD England
44 20 7262 1707
www.brandhousewts.com

Chase Design Group
2255 Bancroft Avenue
Los Angeles, CA 90039
323-668-1055
www.chasedesigngroup.com

cincodemayo
5 de mayo 1058 pte.
Monterrey, N.L.
64000
Mexico
52-81-8342-5242
www.cincodemayo.to

Crocker, Inc.
17 Station Street
Brookline, MA 02445
617-738-7884
www.crockerinc.com

Cross Colours
8 Eastwood Road
Dunkeld West 2196
Johannesburg
South Africa
27-11-442-2080
www.crosscolours.co.za

Curiosity, Inc.
2-45-7 Honmachi
Shibuya-ku
Tokyo 151-0071
Japan
81-3-5333-8525
www.curiosity.co.jp

David Lancashire Design
17 William St.
Richmond 3121 Victoria
Austrialia
61 39421 4509

Design Bridge Ltd.
18 Clerkenwell Close
London EC1R 0QN England
44 20 7814 9922
www.designbridge.co.uk

Design Edge
316 N. Lamar Boulevard
Austin, TX 78703
512-477-5491
www.designedge.com

Dossier Creative
305.611 Alexander Street
Vancouver, BC
Canada V6A 1E1
604-255-2077
www.dossiercreative.com

Dragon Rouge
32, rue Pages BP 83
F-92153 Suresnes cedex.
Paris, France
www.dragonrouge.com

88 Phases
8444 Wilshire Boulevard, 5th Floor
Beverly Hills, CA 90211
323-655-6944
www.88phases.com

Fitch Worldwide (London)
10 Lindsey Street
Smithfield Market
London EC1A 9ZZ England
44 20 7509 5000
www.fitchworldwide.com

Fossil
2280 North Greenville Avenue
Richardson, TX 75082
www.fossil.com

Fresh
25 Drydock Avenue, 5th Floor
Boston, MA 02210

Harcus Design
118 Commonwealth Street
Surry Hills NSW 2010 Australia
61 2 9212 2755

Hornall Anderson Design Works
1008 Western Avenue, Suite 600
Seattle, WA 98104
www.hadw.com

Ideas Frescas
Edificio Eben Ezer, Tercer Nivel,
Boulevard Sur, Santa Elena,
Antiguo Cuscatlan, El Salvador
503-248-7420
www.ideas-frescas.com

IKD Design Solutions Pty Ltd.
ABN 87 008 099 394
173 Fullarton Rd.
Dulwich SA 5065
www.ikdesign.com.auv

Iron Design
120 North Aurora Street, Suite 5A
Ithaca, NY 14850
607-275-9544
www.irondesign.com

Jones Knowles Ritchie
128 Albert Street
London NW1 7NE England
44 20 7428 8000
www.jkr.co.uk

The Jupiter Drawing Room
6rd Floor, The Terraces
Fir St., Observatory, 7925
Cape Town, South Africa
27 21 442 7000

karacters design group
1500-777 Hornby Street
Vancouver, BC V6A 1B2
604-609-9546
www.pjddb.com

Leo Bernett USA
35 West Wacker Drive
Chicago, IL 60601

Lewis Moberly
33 Greese Street
London W1P 2LP England
44 20 7580 9252
www.lewismoberly.com

Lisa Billard Design
580 Broadway, #709
New York, NY 10012

Lloyd Grey Design
1023 Ann Street
Fortitude Valley
Queensland 4006 Australia
61 7 3852 5023

LMS Design
2 Stamford Landing
Stamford, CT 06902
203-975-2500
www.lmsdesign.com

Mambo Graphics
83-85 McLachlan Avenue
Rushcutters Bay, Australia 2011R
www.mambo.com

Mirko Iliç Corp.
207 East 32rd Street
New York, NY 10016

MLR Design
325 W. Huron, Suite 315
Chicago, IL 60610
312-943-5995
www.mlrdesign.com

MOD/Michael Osborne Design
444 De Haro Street, Suite 207
San Francisco, CA 94107
415-255-0125
www.modsf.com

Motiv Design
6 George St., Stepney
Adelaide, South Australia SA5069
61 8 8363 3833
www.motivdesign.com

Ohio Girl Design
4602 Los Feliz Boulevard, #204
Los Angeles, CA 90027
310-663-5080
www.ohiogirl.com

One Zero Charlie
5112 Greenwood Road
Greenwood, IL 60097
815-648-4591
www.onezerocharlie.net

Parham Santana
7 W. 18th Street
New York, NY 10011
212-645-7501
www.parhamsantana.com

The Partners
Albion Courtyard
Greenhill Rents, Smithfield
London EC1M 6PQ England

Pearlfisher
12 Addison Avenue
London W11 4QR England
44-20-7603-8666
www.pearlfisher.com

Pez
990 South Central
Kansas City, MO 64114
www.pezcentral.com

Proteus Design
77 North Washington Street, 8th Floor
Boston, MA 02114
617-263-2211
www.proteusdesign.com

R Design
Studio 3 Church Studios
Camden Park Road
London NW1 9AY England
44 20 7284 5840
www.r-website.co.uk

Sandstrom Design
808 SW Third, No.610
Portland, OR 97204
503-248-9466
www.sandstromdesign.com

Sayles Graphic Design
3701 Beaver Avenue
Des Moines, IA 50310
515-279-2922
www.saylesdesign.com

Smart Design
137 Varick Street
New York, NY 10013
212-807-8150
www.smartnyc.com

Stratton Windett
6 Rossetti Studios
72 Flood Street
London SW3 5TF England
44 20 7352 6089

Sussner Design Company
212 3rd Avenue, Suite 505
Minneapolis, MN 55401
612-339-2886
www.sussner.com

TAXI Studio
Abbots Leigh
Bristol BS8 3RA England
44-114-973-5151
www.taxistudio.co.uk

TD2
Ibsen 43, 8th Floor
Col. Polanco
11560 Mexico D.F.
51-55-5281-6999
www.td2.com.mx

Tesser
650 Delancey Street, Loft 404
San Francisco, CA 94107
415-541-1999
www.tesser.com

Trickett & Webb Ltd.
The Factory
84 Marchmont Street
London WC1N 1AG England
44 20 7387 4287
www.trickettandwebb.co.uk

Tucker Design
The Church Street
Stepney, South Australia 5069
61 8 362 4000
www.tuckerdesign.com.au

Turner Duckworth
Voysey House, Barley Mow Passage
London W4 4PH England
www.turnerduckworth.com

Volkswagen of America
3800 Hamlin Road
Mail Code 4F02
Auburn Hills, MI 48326
www.vw.com

VSA Partners
1347 S. State Street
Chicago, IL 60605

Wallace Church
330 E. 48 Street
New York, NY 10017
212-755-2903
rob@wallacechurch.com

Wink
417 First Avenue North
Minneapolis, MN 55401
612-630-5139
www.wink-mpls.com

Wolff Olins
10 Regents Wharf
All Saints Street
London N1 9RL England

Z+Co. Design Consultants
Unit 4.1
2-6 Northburgh Street
London EC1V 0AY England
44 20 7336 7808

about the authors

CATHARINE FISHEL runs Catharine & Sons, an editorial company that specializes in working with and writing about designers and related industries. She writes for many design magazines, is contributing editor to *PRINT* magazine, is editor of logolounge.com, and is author of many books, including *Paper Graphics*, *Minimal Graphics*, *Redesigning Identity*, *The Perfect Package*, *Designing for Children*, *The Power of Paper in Graphic Design*, *Inside the Business of Graphic Design*, *401 Design Meditations*, and *How to Grow as a Graphic Designer*.

STACEY KING GORDON is a writer and editor in the San Francisco Bay Area. She is a frequent contributor to *How* magazine and the author of *Magazine Design That Works*. She can be reached at www.night-writer.com.